ON RECORD 1978 G. BROWN

CONTENTS

ON RECORD ENTRIES ARE
NOT ORDERED ALPHABETICALLY,
BUT ORGANIZED INTUITIVELY—
A MIXTURE OF SEGUES BY
MUSICAL GENRE OR STYLE.

ON RECORD | VOL. 1 | 1978

IN SPRING 1978, I was a somewhat naïve young writer from Colorado who had made my way to Los Angeles to schmooze and generate some industry contacts and story ideas. And I was broke—as in finishing-up-college broke. By my last day there, I was too tapped out to afford bus fare, much less a rental car or taxi—an untenable situation in the sprawling City of Angels. So when I found myself on Sunset Boulevard needing to get to CBS Records in Century City, my only option was to hoof the six miles. It was a beautiful SoCal day, though, and being of hardy mountain stock, I didn't think twice about it.

I got within a half-mile of CBS when it dawned on me that I hadn't seen anybody on the sidewalk during my entire journey. And then I noticed this guy coming towards me. He was just clipping along enjoying the afternoon. He stood about 5-foot-9…and he looked a lot like Bruce Springsteen.

So when we passed each other, I said in a hey-how-you-doin' voice, "Bruce?" And damned if he didn't stop and say, "Hey, how you doin'?" I couldn't believe it. I managed to blurt out, "Geez, what are you doing out here?" The Jersey boy explained that he had been in an L.A. studio doing some last-minute recording and mixing for his new album, and that he "just felt like getting out and taking a walk. I need some fresh air. I always do this back home, but, man, nobody does that out here. Everybody drives everywhere. People drive to the corner mailbox to mail a letter."

Unreal. Nobody walks in L.A. Except for me and Bruce Springsteen.

I wished him luck with the record, shook his hand and walked on air the rest of the way to CBS. In retrospect, the encounter didn't make the big impression on Bruce that it did on me. He ended up calling his album *Darkness on the Edge of Town*. I was hoping for *Born to Walk*.

That year would see a growth explosion of rock music and the music business, which roughly coincided with a period in American journalism when city newspapers hired their own people to cover popular music, artists and trends. Musicians recorded albums, toured to sell them and gave interviews to members of the growing rock press. And those interviews and album and concert reviews became part of the marketing machine. 1978 was my second year of contracting with *The Denver Post*, the start of a 26-year run with the major daily (back when that meant something) in the Mountain Time Zone.

Thus I was the one of the few with access to something most fans didn't have—the opportunity to go to all the concerts and get all the new releases and press kits. I reported on the British punk explosion and the rise of such rude, insubordinate, in-your-face groups as the Sex Pistols and the Clash. I wrote about the New York punks such as Ramones and their art-conscious brethren, including Television and Patti Smith. I also interviewed the period's great up-and-coming bands—Talking Heads and the Police—and the more established rock stars, such as Peter Gabriel and Springsteen. And many, many others. I was and am a very lucky boy. Please allow me to share. — **G. Brown**

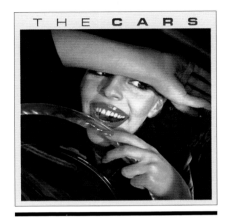

The Cars, led by Ric Ocasek, arrived with an eponymous album that stayed on the charts for 139 weeks.

Billboard 200: *The Cars* (#18)
Billboard Hot 100: "Just What I Needed" (#27);
"My Best Friend's Girl" (#35); "Good Times Roll" (#41)

FORMED IN Boston in 1976, the Cars played throughout New England, developing songs that conformed to the specific concept frontman Ric Ocasek had in mind. The Cars' music—highlighted by Ocasek's dispassionate vocals, David Robinson's stylish drumming, Greg Hawkes' keyboard squawks, guitarist Elliot Easton's economical solos and Benjamin Orr's crooning—merged guitar-oriented rock with the emerging synthesizer-oriented pop, revealing the band's appreciation for technology.

"I wanted a clean sound to go along with the visual aspects of what we're doing," Ocasek explained. "The Cars is a name that just seemed to fit—it's simple, almost futuristic, and it's all-American."

A demo tape spawned "Just What I Needed," which got heavy airplay on Boston radio stations prior to the version that appeared on *The Cars*, the debut album recorded with producer Roy Thomas Baker, acclaimed for his work with Queen.

"He had to respect us because we weren't in awe of any producer," Ocasek said. "The worst we could do was produce ourselves, which we did on our two-track demo."

The Cars featured three charting singles—"Just What I Needed," "My Best Friend's Girl" and "Good Times Roll"—and the album tracks "You're All I've Got Tonight," "Bye Bye Love" and "Moving In Stereo" became rock radio favorites. In the 1978 *Rolling Stone* Readers' Poll, the Cars were named Best New Artist.

"The band is trying to be crafty—to put some artiness back into singles," Ocasek admitted. "I like playing around with words, putting sounds and rhymes together. Sometimes the effect is vague, but the indirectness is what appeals to me. I just can't write songs any other way." ∎

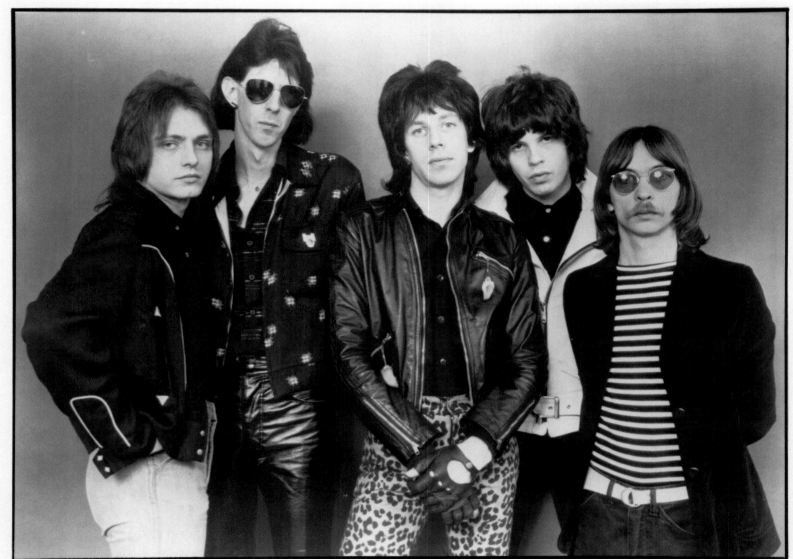

THE CARS

elektra

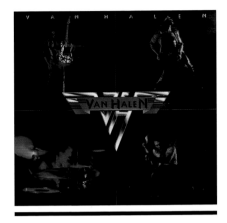

Billboard 200: *Van Halen* (#19)
Billboard Hot 100: "You Really Got Me" (#36);
"Runnin' with the Devil" (#84)

With a quintessential self-titled debut release, the hard rock band **Van Halen** exploded onto the scene.

THE FOUR musicians from Pasadena, California, built a nucleus of fans during the early Seventies, playing Cream-like jams at backyard parties and charging a buck a head. They moved the gigs indoors, renting halls and promoting themselves by passing out self-made flyers at local high schools. By 1977, they were drawing 3,000 people at clubs. Then Van Halen's popularity exploded beyond the California state line.

"There's a whole lifestyle pictured, a whole attitude of dealing with life. That sounds like hippie crap, but it's true," lead singer David Lee Roth stated in his speedball rap. "The songs are folk songs about the lives we lead. It's very real for anybody who's working class. We attribute our success to the live show—there's that tension and excitement from the beginning to the end, where it sounds like any second it's gonna fly apart, y'know? Someone's gonna pass out, someone's string has gotta break, somebody's gonna make a mistake—and we don't."

Eddie Van Halen's flashy guitar work and Ted Templeman's crisp, sizzling production gave the band an edge in the recording studio, and Roth's bigger-than-life charisma got as much attention. Soon after its release, *Van Halen* became widely recognized as one of rock's most successful debuts, containing many signature songs—"Runnin' with the Devil," the guitar solo "Eruption," a cover of the Kinks' "You Really Got Me," "Ain't Talkin' 'Bout Love" and "Jamie's Cryin'."

"I was brought up on television and radio—I've gotta have some kind of commercial in my life every 20 minutes or I go insane," Roth crowed. "That's the way this generation is. We think in terms of a few minutes at the most, so all of our songs are three minutes on the dot. No 30-minute opuses about cosmic space or transcendental blah-blah. I don't write in a vacuum—the TV is on, the radio is blaring, and I'm sitting there like Doctor Strange thinking up chord progressions and words. Then we go in the studio and record. I only write the lyrics down when they make us copyright them. It's just like school!" ■

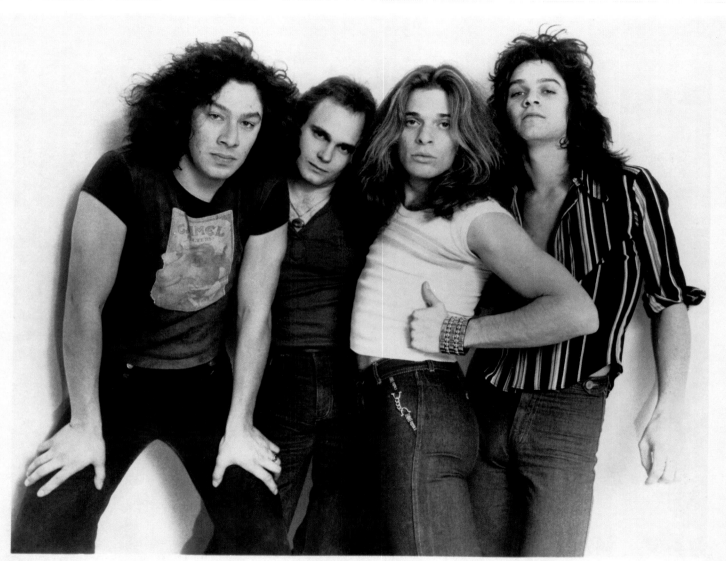

 ALEX VAN HALEN, MIKE ANTHONY, DAVE ROTH, EDWARD VAN HALEN

WARNER / REPRISE

The members of Kiss devised an ambitious plan involving the simultaneous release of four solo albums.

Billboard 200: Double Platinum (#22)

FORMED IN New York City in 1973, Kiss rose to prominence with elaborate live performances, which featured fire breathing and blood spitting, smoking guitars, shooting rockets, levitating drum kits and spectacular pyrotechnics. With their make-up and costumes, the fantasy rockers took on the personae of comic book-style characters. The band had established itself as the biggest commercial force in rock music, monopolizing the allowances of the world's 12-year-olds with a lot of hype and a lot more hustle.

"Our philosophy has been to make a complete spectacle out of ourselves—get up there and blow everything sky-high and do anything and everything that imagination and money can buy," bassist Gene Simmons said. "Because despite what Virginia has been telling you all these years, size counts. I'm here to tell you it's true—bigger is better. If God was giving you one choice, pick A or B, no C—bigger or smaller? Which one do you pick? Yeah, me too. I want bigger."

Alive II had been the band's fourth platinum album in just under two years. *Double Platinum* was the first greatest hits album by Kiss. Many of the songs were remixed and differed from their original versions; in the case of "Strutter," it was re-recorded with a slight disco beat and dubbed as "Strutter '78." Zealous fans were clamoring for the next step in Kiss' spectacular career.

"Tell the kids that we haven't gone away," vocalist and guitarist Paul Stanley said, "We're just trying to make it better."

For Kiss, "better" meant more. On September 18, the four members of Kiss released solo albums simultaneously. The albums caused a sensation within the recording industry. Each record shipped platinum (more than a million units), and each was a lesson in merchandising—coordinated cover art, with a section of a mural and an order form for Kiss paraphernalia. It was basically a four-record set.

Of the four, lead guitarist Ace Frehley's album spawned the highest-charting hit, a cover of "New York Groove."

"There's a lot of parents across the United States with youngsters who have our pictures plastered all over their walls," Frehley said. "And they're wondering, 'Who are these crazy guys with the makeup and spooky costumes?' When they hear our new albums, they may get some insight into what we're all about."

Gene Simmons charted higher than the other three solo albums.

"It's fun to be hot stuff and know that we've single-handedly changed the face of Halloween," Simmons said. "But I don't really care how much longer it lasts because I've surpassed everything I've ever dreamed of doing. There's only so much you can expect out of life and success." ∎

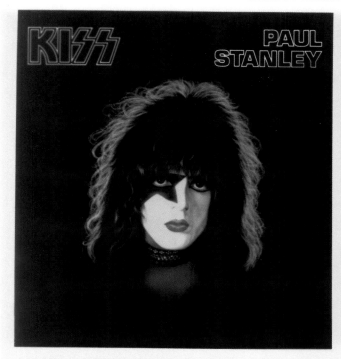

KISS — PAUL STANLEY

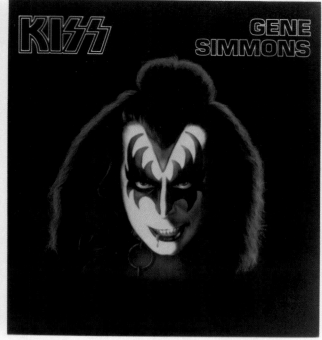

KISS — GENE SIMMONS

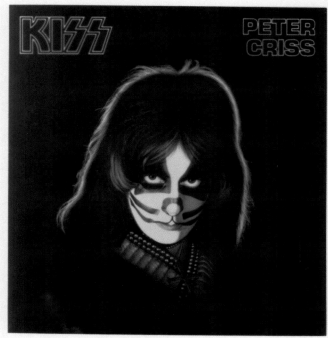

KISS — PETER CRISS

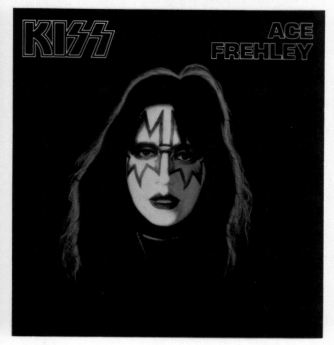

KISS — ACE FREHLEY

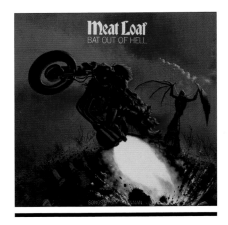

Billboard 200: *Bat Out of Hell* (#14)
Billboard Hot 100: "You Took the Words Right Out of My Mouth" (#39); "Two Out of Three Ain't Bad" (#11); "Paradise by the Dashboard Light" (#39)

Taking years to be released and months to gain traction, Meat Loaf's *Bat Out of Hell* scaled the charts.

MEAT LOAF (real name: Marvin Lee Aday) had plenty of acting experience—he had performed in a touring company of *Hair* and made a memorable appearance in the cult film classic *The Rocky Horror Picture Show*. About the same time, he and composer Jim Steinman started work on *Bat Out of Hell* with producer Todd Rundgren.

Bat Out of Hell was shopped around for years before it was finally released, and Meat Loaf presented an unforgettable image to the public—at a time when rock musicians took pains to appear as traditionally waif-like as possible, he looked like a grocer who was eating all the profits. And from inside his outsized stature came a powerful, passionate voice of near-operatic proportions. Steinman's over-the-top mini-dramas treated teen angst in terms of Wagnerian excess, and Rundgren's dense production made Phil Spector's infamous "wall of sound" formula seem like a white picket fence.

Bat Out of Hell was not an immediate hit in the US. Inevitably, "You Took the Words Right Out of My Mouth," "Two Out of Three Ain't Bad" and the bombastic "Paradise by the Dashboard Light" went on to receive significant airplay on radio, and *Bat Out of Hell* became an iconic album worldwide. No other singer could have served as the messenger for the humor and theatricality of Steinman's grandly cinematic songs.

"It's very difficult for Jimmy to write a song, really hard," Meat Loaf said. "He can turn out plays or scripts, but he hates writing songs. I don't know if he gets possessed or what. He loves it when he's done, but the actual process—he'd just as soon have open-heart surgery with no anesthesia." ■

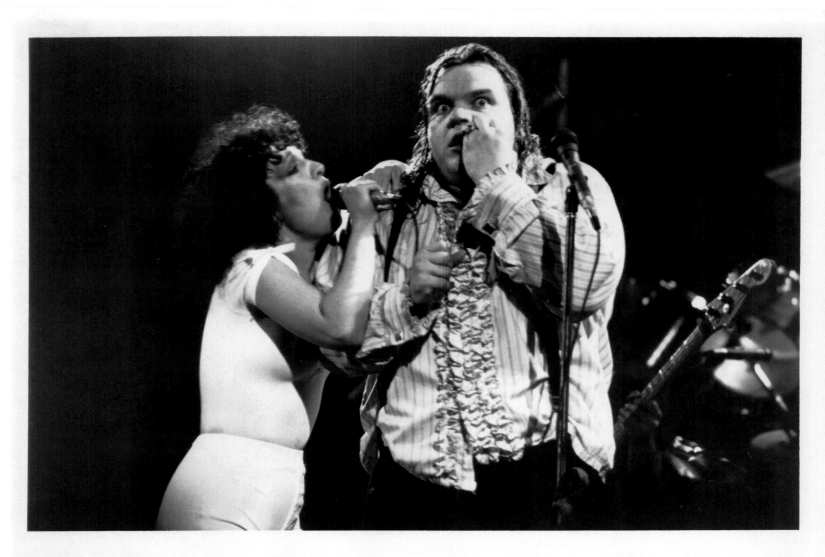

 MEAT LOAF

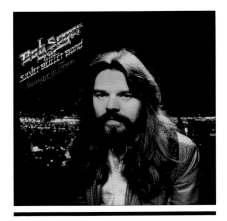

Bob Seger & the Silver Bullet Band's *Stranger in Town* epitomized his guileless style of heartland rock.

Billboard 200: *Stranger in Town* (#4)
Billboard Hot 100: "Still the Same" (#4); "Hollywood Nights" (#12); "We've Got Tonite" (#13); "Old Time Rock and Roll" (#28)

BEFORE HIS national breakthrough in 1976, Bob Seger already had 15 years of hard work behind him "in the trenches." He'd played high school dances and church socials, gigged in journeymen bars and clubs and, finally, sold out theaters and arenas in his native Midwest. He ultimately ensured his legacy as one of America's premier songwriters with *Night Moves*. Critics heralded the congenial singer as a down-to-earth artist who offered his music without pose or pretense, backed by his Silver Bullet Band.

"I was 31 years old when we hit the big time with *Night Moves*," Seger reflected. "Being older helped—I really appreciated the success. I was fortunate. I always had a steady, dependable manager, band and crew, everybody with the same goal pulling together.

We've had a lot of loyalty down through the years, not a lot of changing faces."

Seger followed up strongly with *Stranger in Town* and became one of the world's top-selling superstars. The heartland rocker opined in song that today's music lacked the soul of "Old Time Rock and Roll." It would become one of his most recognizable songs following its use in the 1983 film *Risky Business*, and the Amusement & Music Operators Association ranked it as the second-most played jukebox single of all time.

"You can't control the trends," Seger said. "You just have to let the chips fall where they may. We play rock 'n' roll and try to do it a little better each time and hope people like it." ■

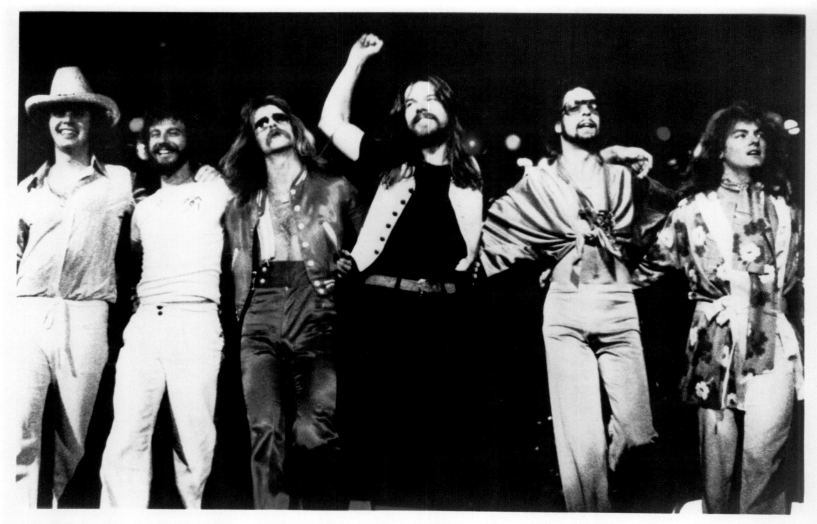

Drew Abbott David Teegarden Chris Campbell Bob Seger Alto Reed Robyn Robbins

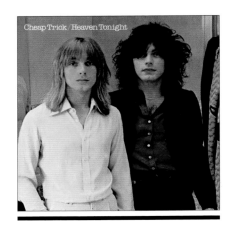

From *Heaven Tonight*, the great teen anthem "Surrender" became one of **Cheap Trick**'s signature songs.

Billboard 200: *Heaven Tonight* (#48)
Billboard Hot 100: "Surrender" (#62)

PROPELLED BY the success of a raw, self-titled debut album and the eclectic masterpiece *In Color*, Cheap Trick had surged to the forefront of American power pop bands. For their third album, the loony but sharp rockers from Rockford, Illinois, further refined their concept, again fusing guitarist Rick Nielsen's pop sense and producer Tom Werman's sympathetic studio work on *Heaven Tonight*.

Along with "Auf Wiedersehen," the title track and a blistering cover of the Move's "California Man," the album featured one of the decade's most anthemic singles in "Surrender," in which the protagonist's reproving parents flip out and make out on the couch while listening to Kiss records.

"People go nuts when they hear it," Nielsen said. "It's funny when a song means something different to everybody, but everybody can relate to it."

The clever songs masterminded by Nielsen won the affections of the record-buying public via a well-crafted musical chemistry, melding the clarity of loud, catchy Who-like guitar riffs and Beatlesque pop harmonies.

"The Beatles thing happens with us because we're melodic and there are four guys in the band," Nielsen mused. "I don't have all the Beatles records, although I respect them. To tell you the truth, I always liked the Rolling Stones better—there was more emotion or something."

The band had also carefully charted an extraordinary visual appeal; the good looks of singer Robin Zander and bassist Tom Petersson were complemented by the zaniness of Nielsen's cartoonish character and drummer Bun E. Carlos' everyman demeanor. Nielsen had to defend himself against people who claimed Cheap Trick's success was "calculated."

"We've never changed; we've always been the same," he insisted. "It wasn't like, 'All right, you guys, let's starve for a couple of years because it's going to be great!' If we ever sat around and thought about what we're doing, we'd probably blow it. We never had any idea, we're just out there. Our manager says 'Go' and we just go. Luckily, he doesn't put us in any red-light districts. Otherwise we'd stop." ■

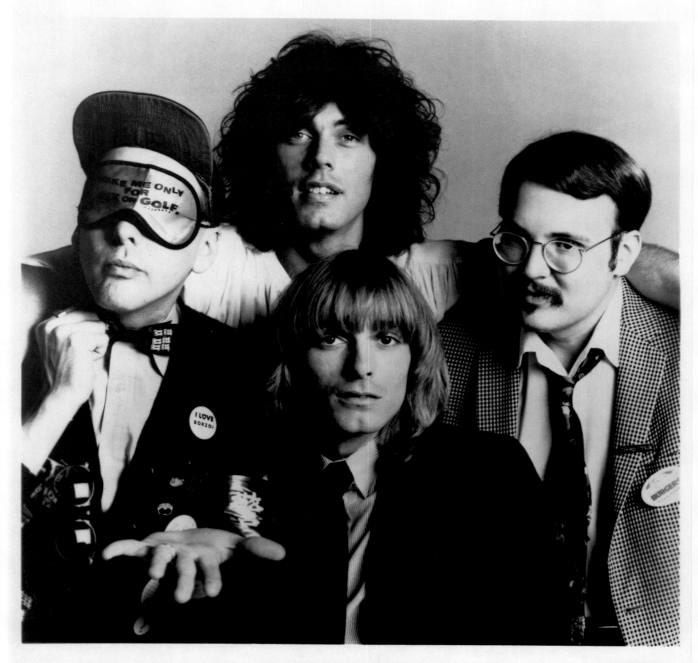

CHEAP TRICK

photo credit: JIM HOUGHTON

Billboard 200: *Infinity* (#21)
Billboard Hot 100: "Wheel in the Sky" (#57);
"Anytime" (#83); "Lights" (#68)

Infinity was **Journey**'s first album with singer Steve Perry, who helped the band attain its biggest success.

JOURNEY HAD been a hot instrumental outfit since its inception; guitar prodigy Neal Schon, who'd joined Santana at the tender age of 15, formed the band circa 1973. The song lengths and textures on Journey's first three albums earned a "space rock" tag, but the instrumental virtuosity wasn't matched with striking vocal work or sympathetic production. In looking for a strong lead vocalist to record *Infinity*, the band's management recommended Steve Perry. "And I stayed on as lead mouth," Perry said.

The group enlisted former Queen producer Roy Thomas Baker for his layered approach to sound, notably stacked vocal harmonies.

"I changed totally for the album," Schon said. "Everybody slowed it down, played less notes and tried to have more space for vocals."

"We basically decided not to play so progressively," drummer Aynsley Dunbar added. "Most bands start out very simply musically, getting to know each other, and then they go on to other things. Journey is different because we started out playing very technical stuff and became more straightforward."

The addition of Perry's soaring vocal style gave Journey a signature sound destined to rule the airwaves. *Infinity*'s most popular songs were "Lights," (a ballad about San Francisco, the band's city of origin) and "Feeling That Way"/"Anytime" (often played on radio stations consecutively in tandem, as presented on the album) and "Wheel in the Sky."

How did Perry, a guy with no formal training, manage to hit those distinctive high notes? "It's hot sauce, that's all it is," he quipped. "And that's not dry ice fog that you see up on stage, either." ■

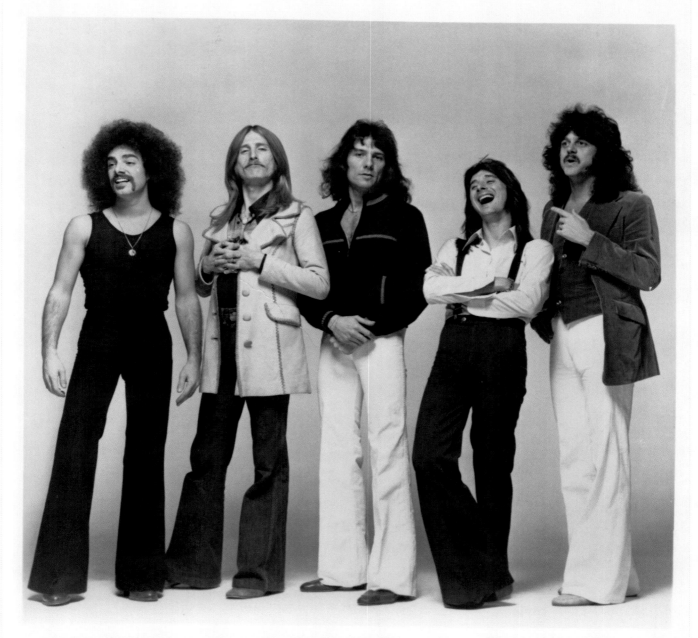

NEAL SCHON ROSS VALORY AYNSLEY DUNBAR STEVE PERRY GREGG ROLIE

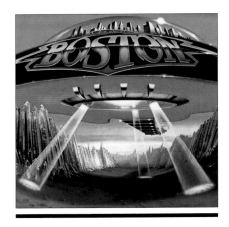

Established as one of rock's top acts within a short time, Boston kept up the magic with *Don't Look Back*.

Billboard 200: *Don't Look Back* (No. 1)
Billboard Hot 100: "Don't Look Back" (#4);
"A Man I'll Never Be" (#31); "Feelin' Satisfied" (#46)

AN M.I.T.-TRAINED engineer and a former researcher for Polaroid, Tom Scholz of Boston didn't have a typical musician's résumé. So it wasn't surprising that he always had a singular outlet for his music. He sat in the basement studio of his Massachusetts home and recorded his own meticulous tapes, writing songs and playing all of the bass, keyboard and guitar parts, with vocalist Brad Delp as the one mainstay. Boston's signature sound—based on Scholz's wall-of-guitar overdubs and harmonized passages and Delp's high, powerful vocals—emerged through a combination of their individual influences.

"Before I met Tom, I was in cover bands that did almost all Beatles songs—I was a big fan, I liked their harmonies," Delp said. "Tom's early group didn't have a vocalist, so they did a lot of Led Zeppelin and Deep Purple. But he was also taken by the Hollies and those real high harmonies that Graham Nash used to sing with them. So that was the one thing he wanted to incorporate into Boston."

Boston, released in 1976, became the fastest-selling rock debut up to that time, as "More Than a Feeling," "Long Time" and "Peace of Mind" dominated rock radio. Scholz, the ultimate perfectionist technocrat, wanted to go back to his basement, but he was forced to deal with the demands made of supergroups.

The record company made him assemble a touring band with Delp in order to take the sound formed by his instrumentation on the road. When Boston finally released *Don't Look Back*, its second album, Scholz was bitter. The title track became a Boston classic, and two other singles, "A Man I'll Never Be" and "Feelin' Satisfied," made the national charts, but Scholz felt he had been rushed and forced to release the work before he was satisfied with every nuance.

"There were a lot of people who were very anxious for the second record, since their livelihoods depended on it," Scholz fumed. "So it wasn't finished when it was put out; some of the mixes were incomplete."

And the legal fireworks started—litigation from his record company, the freezing of incoming royalties, injunctions that prevented Scholz from releasing a product—and band members changed. It took six years to record and produce the next Boston album. ∎

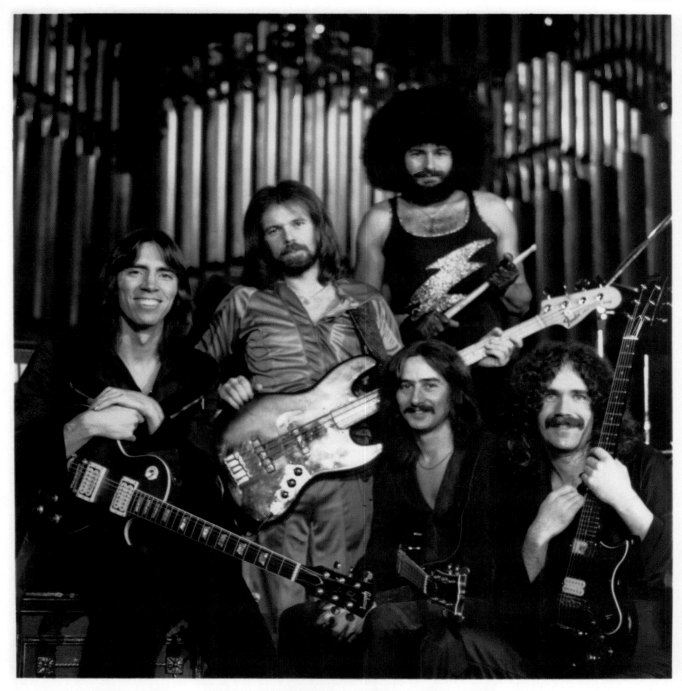

TOM SCHOLZ FRAN SHEEHAN SIB HASHIAN
BARRY GOUDREAU BRAD DELP

MANAGEMENT·
PAUL AHERN
LEFT LANE INC.

Photo / Ron Pownall

Epic

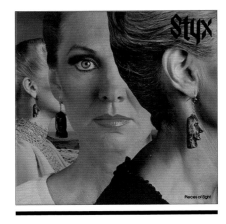

With the hit album *Pieces of Eight*, Styx coped with the pressure of turning into "overnight sensations."

Billboard 200: *Pieces of Eight* (#6)
Billboard Hot 100: "Blue Collar Man (Long Nights)"
(#21); "Sing for the Day" (#41); "Renegade" (#16)

A CHICAGO quintet, Styx toiled in relative obscurity for years before finally breaking the market wide open with *The Grand Illusion*, one of 1977's blockbuster albums. Then the group got to prove that its approach—the majestic pomp of art rock with Midwestern power chords and lusty melodicism—wasn't a fluke. *Pieces of Eight* reflected the band's take-it-as-it-comes attitude.

"I felt it might be easier for us to follow up *Illusion* because we've had experience in the business and seen a lot of people come and go, so maybe we wouldn't take it quite so seriously," guitarist James "J.Y." Young said. "But it's easy to say that and it's another thing to get in the studio and not be paranoid about each little musical idea you come up with. 'Does this sound like that? Are we changing enough? Too much?' All these questions plague you no matter how much experience and how many different viewpoints you have represented within the group. It's still something where you've finally got to divorce yourself from it and say, 'Here it is—we did our best and that's all we can do.'"

Young, keyboardist Dennis DeYoung and guitarist Tommy Shaw all contributed to composing. DeYoung had handled the lead vocals on Styx's biggest singles ("Lady," "Come Sail Away"), a situation that the group tried to rectify. To that end, the first single released from *Pieces of Eight* was Shaw's "Blue Collar Man (Long Nights)." The band was adamant that the industry pay attention to it rather than a DeYoung track. That song and Shaw's "Renegade" proved Styx deserved an extended stay at the superstar level.

"Anybody that's going to judge Styx music—be it our record company, people in promotion and radio, and even us in a sense—is going to say, 'What does the common man out there want to hear from this band?' And they know this one voice, and they're afraid not to give them that voice," Young said. "It's like Clint Eastwood—if he's not shooting a gun, people don't know what to think. We're trying to break out of that, but it's very difficult." ∎

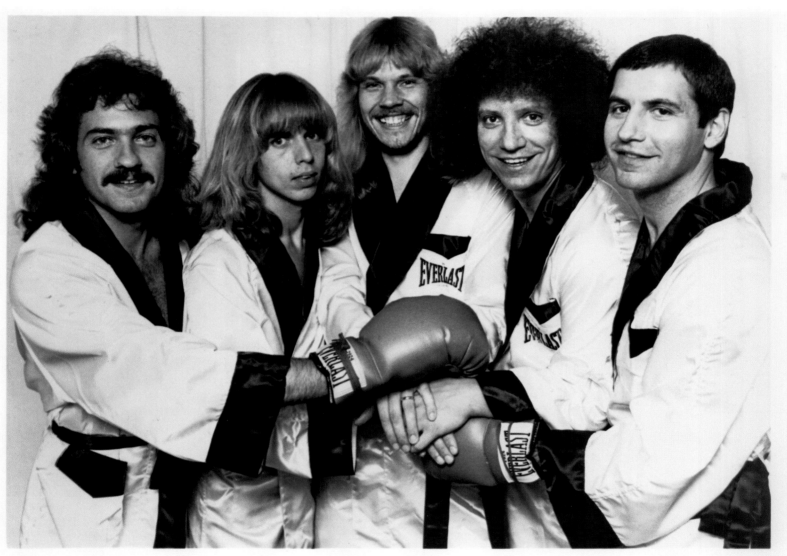

 L to R: DENNIS DE YOUNG, TOMMY SHAW,
JAMES YOUNG, JOHN PANOZZO, CHUCK PANOZZO

25

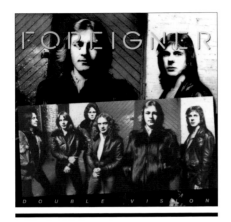

Foreigner's *Double Vision* spawned the lascivious "Hot Blooded," the Anglo-American band's iconic hit.

Billboard 200: *Double Vision* (#3)
Billboard Hot 100: "Hot Blooded" (#3); "Double Vision" (#2); "Blue Morning, Blue Day" (#15)

WITH A self-titled debut album, Foreigner had been one of 1977's surprises. The band, organized by English expatriate guitarist Mick Jones, stood out from the mainstream rock crowd. Jones had hooked up with heavy rockers Spooky Tooth for a time and worked with that group's keyboardist Gary Wright, who went on to find commercial success as a solo artist. Jones developed an idea of what he thought was a viable musical direction, and after meeting keyboardist Ian McDonald (of King Crimson fame) in New York, he started the Foreigner project. A key to the outfit's development was his discovery of lead vocalist Lou Gramm. Three hit singles—"Feels Like the First Time," "Cold as Ice" and "Long, Long Way from Home"—catapulted the group into the rock limelight.

Jones was proud of "being able to fuse an attention to melody with some hefty rock stuff. I hoped it would hold up to some of the things that impressed me when I was developing my musical style—put it on next to a Led Zeppelin or Traffic or Free record. That's been my underlying standard I have to reach."

The follow-up album, *Double Vision*, initially rode the success of the smash "Hot Blooded," a melodic invitation to nubile hordes everywhere. "When I was writing the lyrics, I thought it'd be a little too risqué to be on AM radio," Gramm admitted.

The tune was written, like most of Foreigner's material, during a sound check when Jones started tossing riffs around. "Hot Blooded" was followed on the charts by "Double Vision" and "Blue Morning, Blue Day," and Foreigner embarked on a massive world tour, maintaining an interplay between the exuberance of the younger members and Jones' solid background.

"I think all of this is absolutely necessary if a group wants to build," Gramm said of the touring. "It's a little mentally and physically fatiguing, but it's not something we abhor. Hey, I've never seen most of these places we're hitting."

"It's certainly a change of pace," Jones said, framing the year in the context of the past decade. "I mean, all of a sudden I've got so many old friends…" ∎

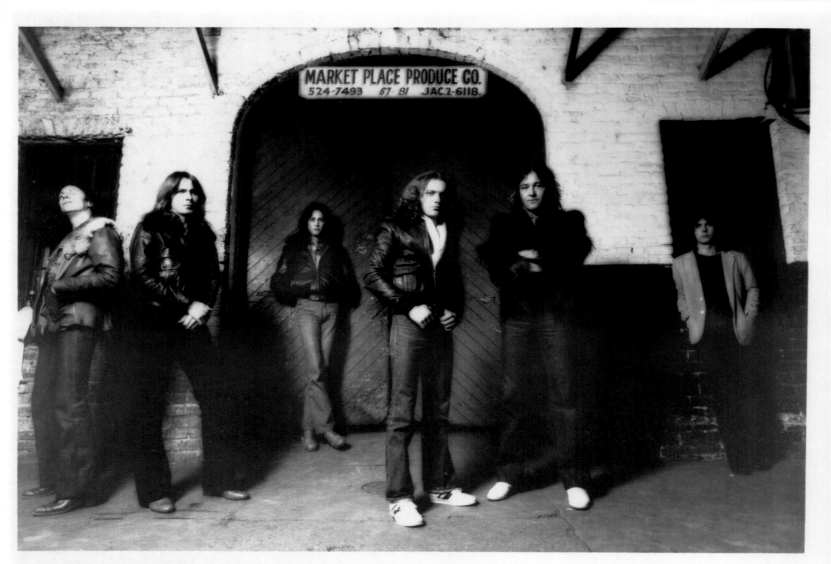

Dennis Elliott Al Greenwood Ed Gagliardi Lou Gramm Mick Jones Ian McDonald

FOREIGNER

ATLANTIC

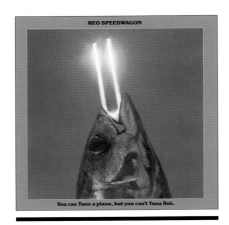

REO SPEEDWAGON

You can Tune a piano, but you can't Tuna fish.

You Can Tune a Piano, But You Can't Tuna Fish represented REO Speedwagon's first album to hit the Top 40.

Billboard 200: *You Can Tune a Piano, But You Can't Tuna Fish* (#29)
Billboard Hot 100: "Roll with the Changes" (#58); "Time for Me to Fly" (#56)

REO SPEEDWAGON first got together in Illinois in 1969, establishing itself on the local bar circuit. By 1976, the band was one of America's quintessential touring acts, with a prodigious following in the Midwest.

"It was all in the Corn Belt, like Nebraska and Indiana—very similar to what ZZ Top had in the Texas region before they broke out," lead singer Kevin Cronin said. "It's funny being a regional phenomenon— our records were No. 1 in Iowa, so we didn't know there was any more to it."

The hard-rocking band weathered neglect from New York and Los Angeles music circles, critical drubbings, personnel changes and years of opening-act status. Cronin and guitarist Gary Richrath made the decision to produce *You Can Tune a Piano, But You Can't Tuna Fish* on their own. The album included "Time for Me to Fly" and "Roll with the Changes"—"a song about survival," Cronin said.

The album ultimately sold more than two million copies, but it didn't consolidate REO Speedwagon's critical or artistic stature.

"I saw how the business of music had wrecked the art of music, and it made me mad," Cronin said. "The *Tuna* album was simply the victim of corporate changes—the president of our record company left and took all of the top executives and key promotional guys with him. It was heartbreaking, because I couldn't figure out what was wrong. 'Roll with the Changes' and 'Time for Me to Fly' were the best songs I'd ever written, and nobody got to hear them. It made me insecure—I didn't know if people liked my songs or if I was a commercial writer."

But the band's years of touring paid off. "We still play to ten kids in Gibson, New York," Richrath joked. "But if those Big Apple types haven't gotten a clue by now, who the hell cares? We're doing okay where we are. The funny thing is, we sit on the road and complain—I miss my girlfriend and everyone else misses their wives and kids. But then we go home and can't wait to go back on tour again." ■

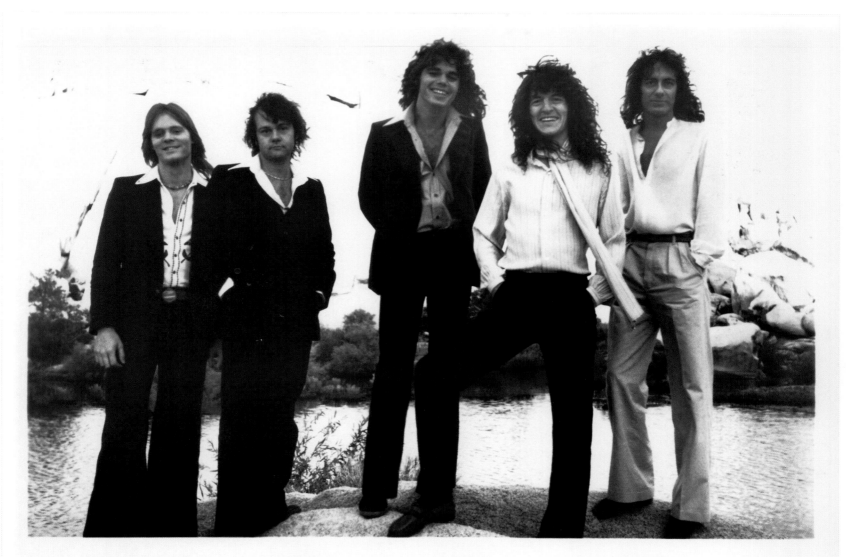

7803

Having forged a career as one of rock's leading showmen, Ted Nugent saw *Double Live Gonzo!* go platinum.

Billboard 200: *Double Live Gonzo!* (#13)
Billboard Hot 100: "Yank Me, Crank Me" (#58)

DETROIT-AREA native Ted Nugent performed for more than a decade before achieving fame as the lead guitarist of the Amboy Dukes (creators of the 1968 hit "Journey to the Center of the Mind"). In 1975, he embarked on a solo career defined by high-energy hard rock, an insane touring schedule and a carefully groomed, unrelenting image as the Motor City Madman. And he hit it big.

The only thing faster than Nugent's guitar playing was his mouth. The lone rock star to kill his own food with a rifle and bow and arrow, Nugent exuded a bloodlust demeanor that was fueled by hunting and sex, not smoking, drinking or taking drugs. He proclaimed each new album the greatest recording in the history of the world. He said he was the best guitar player…

"Now, hold on, I never said that," the unrestrained Nugent cautioned in a fit of modesty. "I said that I was my favorite guitar player." He grinned. "Which is the same thing, I guess."

The self-styled wild man of rock was a bona fide superstar concert attraction—a noble savage sporting a loincloth, shaking torrents of dirty-blonde hair and wielding a massive hollow-body Gibson like it was a shotgun. His three studio albums went platinum, as did *Double Live Gonzo!*, which contained live versions of songs from those albums—including the popular radio anthems "Cat Scratch Fever" and "Stranglehold"—and some new blistering tunes, including "Yank Me, Crank Me," an ode to his favorite pastime.

"Oh, yeah, I've got a trillion of 'em—'My Love Is Like a Tire Iron,' 'You Can't Keep a Good Dog off Your Leg' and 'You Can't Be What You Eat or I'd Be You, Baby' are my current favorites," the militant motormouth noted.

Nugent ended his sizzling shows by bowing to his guitar and mountain of amplifiers, paying homage to the electric deity that had made him one of rock's most entertaining legends.

"Listen, I'm the most incredible, intense thing to ever hit the stage," he asserted with a wink. "When I go out there, I'm on my turf, and there's no one else in the world who can even come close to doing what I do." ∎

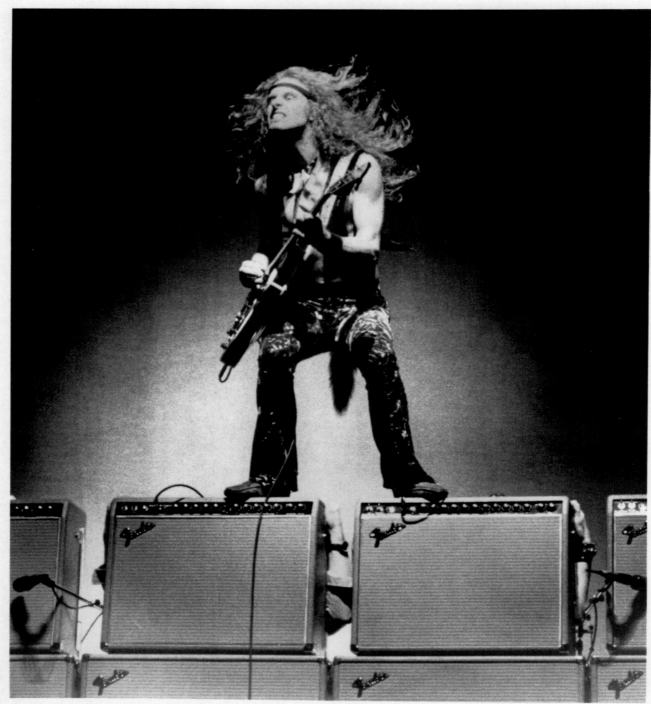

Ted Nugent

Epic

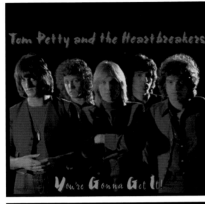

Billboard 200: *You're Gonna Get It!* (#23)
Billboard Hot 100: "I Need to Know" (#41);
"Listen to Her Heart" (#59)

Tom Petty & the Heartbreakers' sophomore album, *You're Gonna Get It!*, was the band's first gold record.

IN LATE 1976, the listless music scene got a kick in the pants when Florida-based guitarist-vocalist Tom Petty and his Heartbreakers (lead guitarist Mike Campbell, bassist Ron Blair, drummer Stan Lynch and keyboardist Benmont Tench) released a self-titled debut album. But it took America a while to catch up. *Tom Petty & the Heartbreakers* initially received little attention, but nearly a year later, the single "Breakdown" was re-released and became a Top 40 hit, while "American Girl" eventually evolved into one of the band's most popular songs.

"It's humorous when you think about it," Petty said. "Radio programmers were afraid to play it. It was too alternative at the time. It didn't sound like Foreigner or that huge corporate rock thing going on, bands that all sounded the same and weren't going to threaten anyone with changing. But we were determined to tear that down."

You're Gonna Get It!, the band's second album, earned more fans with the moderately well-received hits "I Need to Know" and "Listen to Her Heart," placing the band at the heart of the southern rock and heartland rock genres.

"Radio is such a curious animal to me anyway," Petty said. "They're so selective about what they play and when they play it. They're all looking at numbers and graphs and demographics. Better not to think about it and just make records. I've never tried to make a hit. I just try to do good work and hope something comes out of it that will be popular enough to get on the radio." ■

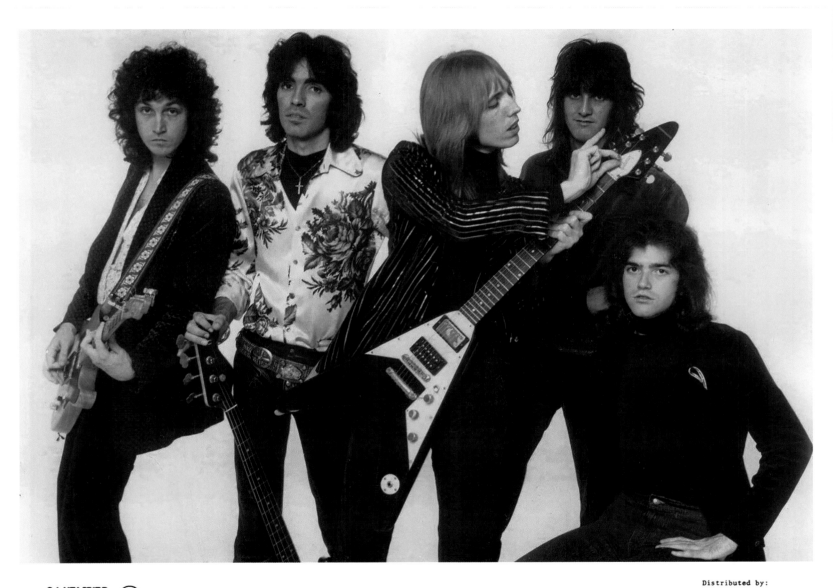

TOM PETTY & THE HEARTBREAKERS

Distributed by:

Electric Light Orchestra, in support of the double album *Out of the Blue*, set out with a lofty live show.

Billboard 200: *Out of the Blue* (#4)
Billboard Hot 100: "Turn to Stone" (#13); "Mr. Blue Sky" (#35); "Sweet Talkin' Woman" (#17): "It's Over" (#75)

ELECTRIC LIGHT Orchestra derived from the Move, a band in which songwriter and multi-instrumentalist Jeff Lynne and drummer Bev Bevan were members with Roy Wood. With Lynne leading the outfit after Wood's departure in 1972, ELO continued to create modern rock and pop songs with orchestral overtones, enjoying a string of Top 40 hits—among them, "Evil Woman," "Strange Magic," "Telephone Line" and "Livin' Thing."

The elements of the sonic architecture? A witty web full of layered voices and sound effects distilled through rocking guitars and string arrangements. A mainstay of classically trained players furnished the crisp presence Lynne required in many of his compositions.

"I never did stuff that was going on at the time," Lynne said. "I tried to get a 'timeless old-fashioned' sound. It didn't have to be the latest thing, or somewhere in-between."

Coming off a big album, *A New World Record*, ELO made a bid to solidify its superstar status with the double album *Out of the Blue*.

"It took four months to record, and that was working six days a week—it really drove us all crazy," co-founder Bevan said. "But Jeff is a perfectionist—each song is like a single to him. He's so relaxed in the studio that it's like a home away from home to him. He knows exactly what sound he wants to get.

"We didn't want to fall into the trap of running out of good songs and filling up the album with long, drawn-out solos. We were asked if we would consider doing a double album, but there was no real pressure to come up with one. Our record company was behind us regardless."

"Turn to Stone," the opening track, was the first song released as a single. "Mr. Blue Sky" and "Sweet Talkin' Woman" followed, becoming major hits. The large spaceship on the album's cover appeared during concerts in the form of an enormous glowing flying saucer stage set with fog machines and a laser display, inside of which the band performed on a nine-month, 92-date world tour. ■

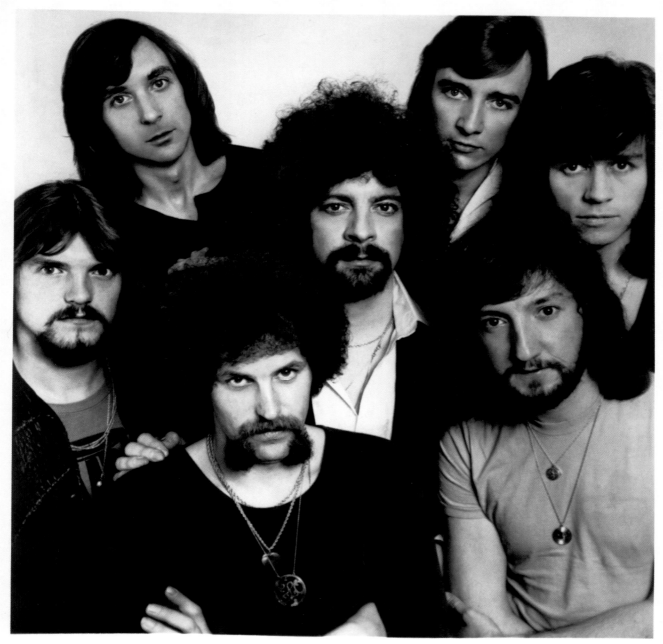

RICHARD TANDY JEFF LYNNE MELVYN GALE BEV BEVAN

HUGH MCDOWELL KELLY GROUCUTT MIK KAMINSKI

ELECTRIC LIGHT ORCHESTRA

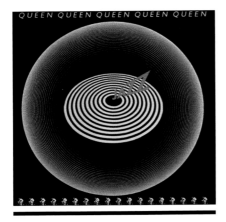

Queen released *Jazz*, issuing the hits "Bicycle Race" and "Fat Bottomed Girls" on a double-sided single.

Billboard 200: *Jazz* (#6)
Billboard Hot 100: "Bicycle Race"/"Fat Bottomed Girls" (#24); "Don't Stop Me Now" (#86)

QUEEN HAD made a career of presenting its mad ambitions, a reputation based on Brian May's "guitar orchestra" overdubbing techniques and frontman Freddie Mercury's one-man-choir vocal histrionics. A commercial breakthrough began with the quasi-operatic "Bohemian Rhapsody," an unorthodox six-minute single, and culminated with the double acceptance of "We Will Rock You"/"We Are the Champions," a platinum success. Yet Queen's image remained refined and a tad standoffish, and the British rock band tried to tarnish it a bit for the *Jazz* album.

"*Jazz* shows more of a sense of humor than we've had before," May said. "We just wanted to have fun. It all started with the singles."

"Bicycle Race," written by Mercury, and "Fat Bottomed Girls," written by May, were released together as another double A-side single, a bid for airplay on two songs when most groups would have died for one. A section of "Bicycle Race" featured bicycle bells; fans would bring bells and replicate the ringing chorus at Queen concerts. The band rented Wimbledon Stadium for a day to shoot the video, with 65 nude women, all professional models, hired to stage a bicycle race.

"It was a cheap publicity stunt," drummer Roger Taylor allowed. "And it worked," Mercury chimed in.

A poster of the start of the race was to be included with every copy of *Jazz*, but several large retail chains in America warned Elektra Records that they wouldn't stock the album because of the insert's pornographic nature. Queen ended up shipping one version of the album with the poster and another with a postage-paid send-away offer. The result: some desired notoriety.

"It's cheeky, it's naughty," Mercury purred, describing himself as a "musical rapist" and insisting that Queen "likes to throw money around. No group can afford to get in a rut. They must always be ready to change with the times, or even get ahead of them." ∎

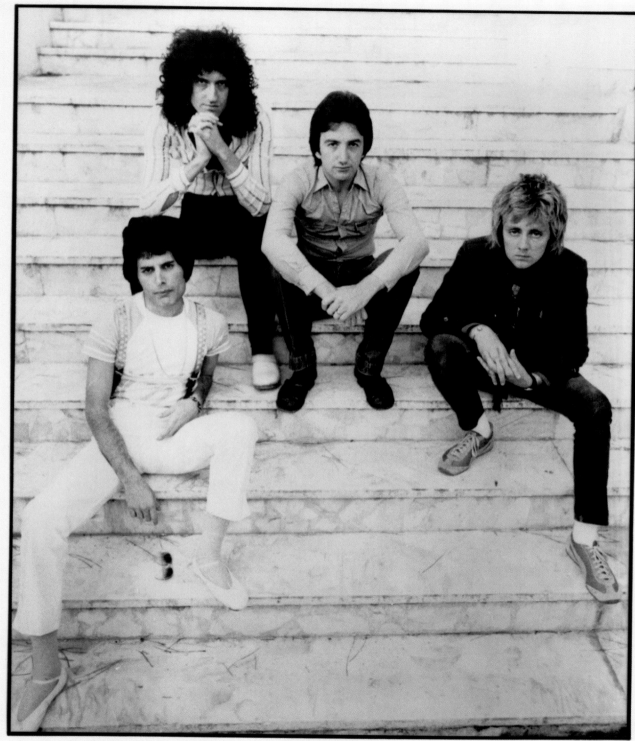

FREDDIE MERCURY BRIAN MAY JOHN DEACON ROGER TAYLOR

QUEEN

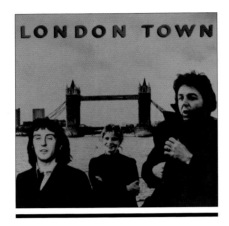

London Town represented yet another commercial boom for Paul McCartney's "other" ensemble, **Wings**.

Billboard 200: *London Town* (#2)
Billboard Hot 100: "With a Little Luck" (No. 1);
"I've Had Enough" (#25); "London Town" (#39)

ONE YEAR after Wings' "Mull of Kintyre" became the then-best-selling UK single in history, the band experienced a lineup shuffle. Drummer Joe English had become homesick for America and returned home, while lead guitarist Jimmy McCulloch left to join the Small Faces. Their departures returned Wings to the three-piece lineup that had recorded the top-selling *Band on the Run* in 1973: ex-Beatle Paul McCartney, guitarist Denny Laine and Linda McCartney. Linda played keyboards because McCartney was, by all accounts, a family man whose idealism sprang from his commitments.

"Screw it, I want my wife onstage with me," he said. "When you're young, let's face it, you just want to get famous and make money and pull girls. That's what being in a rock 'n' roll band is all about, really. But it's not like that now. It's more my life's work. I like it. It's a bit more mature, you know. It's cool. You grow up."

London Town featured a markedly softer, synth-based sound than previous Wings albums. "With a Little Luck" hit No. 1 in the US. "I've Had Enough" and the title track became smaller hits.

"How you write is just you and a guitar, or a piano. It's something I'm quite used to, but you naturally translate it, get a band and re-arrange it."

The album marked the end of Wings' commercial peak and the beginning of a minor sales slump for McCartney. ■

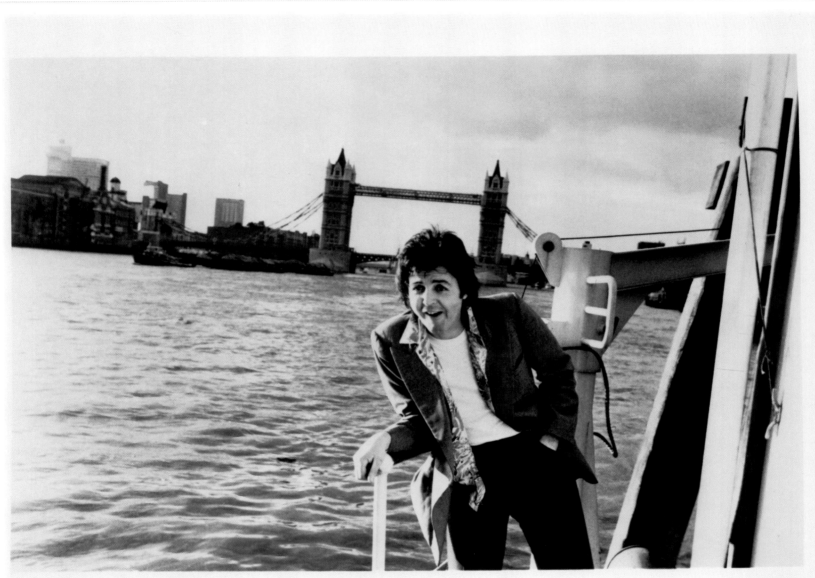

WINGS **PAUL McCARTNEY**

The Who's release of *Who Are You* was overshadowed by the untimely passing of drummer Keith Moon.

Billboard 200: *Who Are You* (#2)
Billboard Hot 100: "Who Are You" (#14)

WITH AN oeuvre comprising the rock opera *Tommy*, a live appearance at Woodstock and the epic albums *Live at Leeds*, *Who's Next* and *Quadrophenia*, the Who had cemented its status as one of rock's most influential bands by the mid-Seventies. At the end of 1976, however, the classic lineup consisting of lead singer Roger Daltrey, guitarist and singer Pete Townshend, bass guitarist John Entwistle and drummer Keith Moon semi-retired from giving live performances.

"I've always found touring hard emotionally—I don't like being away from home and family for long, and I don't really have the will to perform; I have to be goaded into it," Townshend said. "Every time I used to get on an airplane on the road, I'd spend the whole flight trying to write songs, because I knew as soon as we got back we'd be in the studio trying to make an album, and so on."

Who Are You was the Who's highest-charting album, and the title track became one of the band's biggest hits in the US, but the recording would be the English rock band's last to feature Moon. Three weeks following the album's release, after a party in London, the pioneering percussionist took an overdose of pills intended to combat alcohol withdrawal and died in his sleep at the age of 32.

Moon possessed an onstage wit and offstage dissoluteness that earned him a well-deserved reputation for rock 'n' roll misconduct that was never equaled. The remaining band members ultimately replaced him with Kenney Jones.

"On stage is where it counts now, where it's easy for us, because Keith lives on in the music," Daltrey said. "That's the most comfortable place for us. It's the days off that are hard." ∎

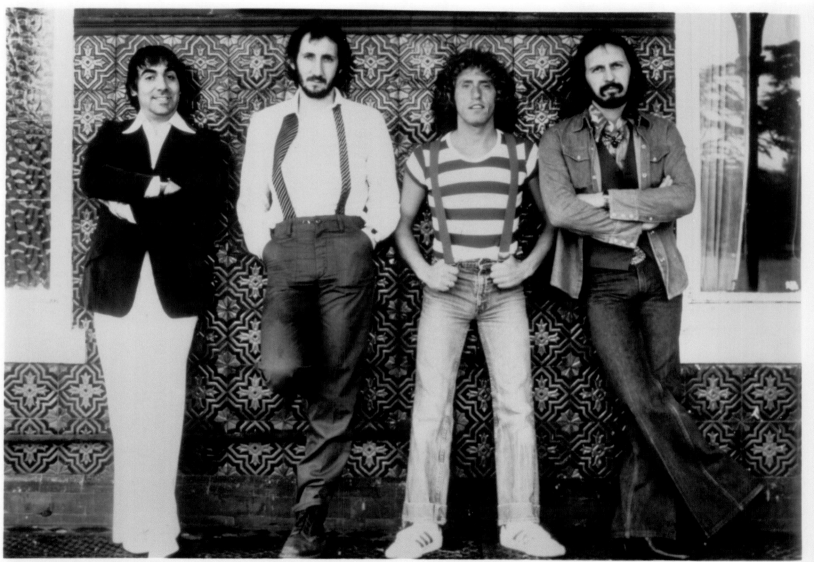

Keith Moon Pete Townshend Roger Daltrey John Entwistle

The Who

The Kinks' inspired single "A Rock'n'Roll Fantasy" was the group's most well-received song in years.

Billboard 200: *Misfits* (#40)
Billboard Hot 100: "A Rock 'n' Roll Fantasy" (#30)

ONE OF the few bands to stick out the "British Invasion" of the early Sixties, the Kinks had kept working away on the edges of the mainstream. The stock guitar riffs of "You Really Got Me" and "All Day and All of the Night" had endured since charting in 1964, and Ray Davies established himself as one of rock's most literate songwriters, a keen purveyor of social satire and topical wit.

But while contemporarites like the Who and the Rolling Stones had redefined aspects of rock culture, the Kinks spent a good portion of the Seventies releasing concept albums such as *Preservation Act 1* and *Preservation Act 2*, integrating theatrical sensibilities into their concerts.

"The amazing thing is that we took those shows on the road and sold out everywhere; the audiences loved them," leader Ray Davies said. "There's a market for that sort of thing. It's in me to do those types of albums."

In 1977, *Sleepwalker* signaled a shift toward a more rock-oriented style and began the band's commercial comeback in the US. Davies credited the success of *Misfits*, the following album, with "leaving those concept shows behind."

"It's strange, because a lot of the more established rock bands feel kind of alienated from the newer bands," he commented. "Even stranger is that the Kinks feel at home with it, because we started off with that very same raw sound. It's part and parcel of our music."

Many young groups would have taken a career as extended as the Kinks'—or a song as timeless as "A Rock 'n' Roll Fantasy."

"I think the secret is not to contrive it," Davies explained. "We possibly could have achieved more success if we'd have tried things more commercially feasible, but we wouldn't have stayed together for so long. In the end, if you do what feels right, you've got more chance of not sounding pretentious and not doing things that aren't cast for the band." ■

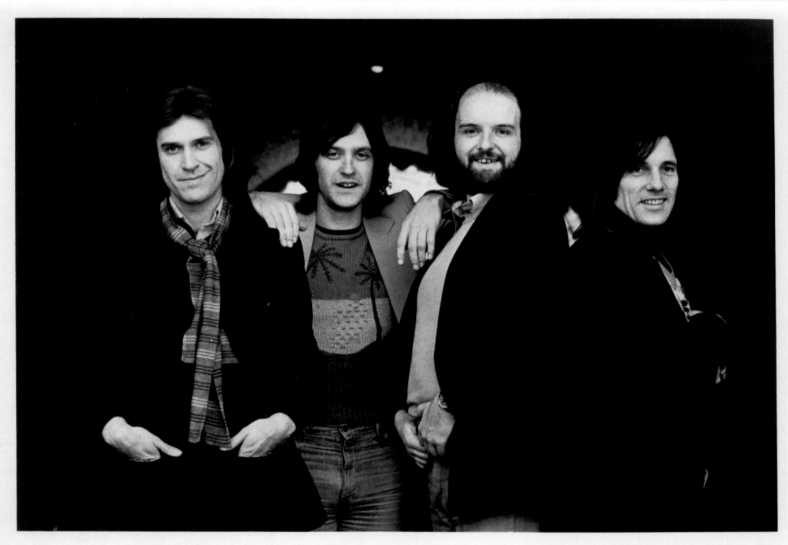

THE KINKS

Photo credit: David Gahr

JETHRO TULL
LIVE

BURSTING OUT

To observe its ten-year anniversary, Jethro Tull released *Bursting Out*, capturing a concert from Europe.

Billboard 200: *Bursting Out* (#21)

LED BY Ian Anderson, Jethro Tull had forged a signature progressive sound, the band's style shifting with the albums *Aqualung*, *Thick as a Brick* and *A Passion Play*—which incorporated elements of hard rock—to the folk roots of *Songs from the Wood*. In 1978, Tull released *Heavy Horses*, a hybrid of the band's rock dynamics and Anderson's English folk-derived production.

"We have that set of influences which are peculiarly British—Celtic, Gaelic and Anglo-Saxon in nature," Anderson said. "We've found the key is using them in an all-out rock context."

The record was supported with a major tour, which set the stage for *Bursting Out*, a live recording that captured Anderson as a one-of-a-kind frontman and flautist. It also buttressed his reputation as a strongly opinionated artist.

"We recorded in Switzerland, where the audiences are a little less excitable," Anderson conceded. "A polite and calm audience that doesn't get in the way of the music requires a bit more subtlety and room for expression, yet the crowds would always become excited by show's end. We arrived at a balance as opposed to an extrava-ganza that suggests every night on the road with Jethro Tull results in total hysteria. Most artists record a live album with the most outrageous audience reaction they can find. We don't mind showing that we work for it."

The live double album was a solid representation of the group's history, given the band's arena-headlining status.

"There's been a drop-off of older fans who have a commitment to home life, child-rearing and mortgages," Anderson mused. "I haven't received a satisfactory explanation for the increasing number of 14- and 15-year-old fans except that people tell me, 'Hey, Tull is a legend.' Well, they're right. To me, the Rolling Stones are a legend—even though I've never seen them, I know that if I do go, they won't disappoint me.

"For younger audiences, the same applies to Jethro Tull. They've heard about us in a subcultural way from older people and word-of-mouth, not by any inordinate amount of hype and publicity. Performing does keep you young—but it's easier for people who don't jump about or stand on one leg!" ■

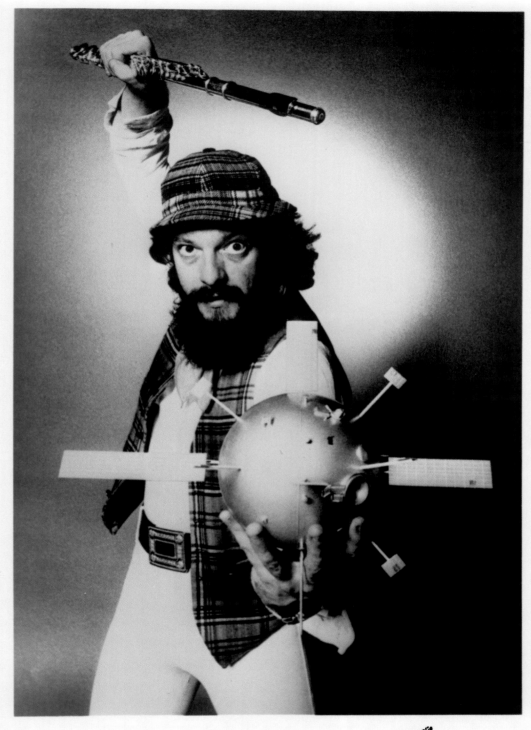

Ian Anderson **Jethro Tull** **Chrysalis**

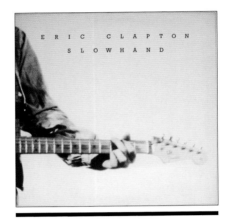

Eric Clapton's *Slowhand* begat the hits "Lay Down Sally," "Wonderful Tonight" and a version of "Cocaine."

Billboard 200: *Slowhand* (#2)
Billboard Hot 100: "Lay Down Sally" (#3);
"Wonderful Tonight" (#16)

ERIC CLAPTON'S place in history had been assured, having played with the Yardbirds, John Mayall & the Bluesbreakers, Cream, Blind Faith and Derek & the Dominos before his solo career began in the Seventies. Coming a few years into a comeback, *Slowhand* was a commercial and critical success. The stunning album included one of his biggest hits, the ballad "Wonderful Tonight." Girlfriend Pattie Boyd, the first wife of George Harrison, had moved in with the guitar hero, and he wrote the laid-back love song while waiting for her to get ready to attend a party.

"I remember telling her, 'Look, you look wonderful, okay? Please don't change again. We must go or we'll be late.' It was the classic domestic situation—I was ready and she wasn't," the guitarist and vocalist recalled. "I went back downstairs to my guitar, and the words of the song just came out very quickly. They were written in about ten minutes, and actually written in anger and frustration. I wasn't that enamored with it as a song. It was just a ditty, as far as I was concerned, that I could just have easily thrown away."

Manager Giorgio Gomelsky had given Clapton the sobriquet "Slowhand" back in 1964, while the guitarist was playing in English rock clubs with the Yardbirds. Whenever Clapton broke a string, he would stay on stage and replace it.

"The frenzied audiences would wait out the delay by breaking into a slow handclap, inspiring Giorgio to dream up the nickname of 'Slowhand,'" Clapton said. "Over the years the name had stuck, and was especially popular with the American band members (featured on *Slowhand*), maybe because it had a western ring to it." ■

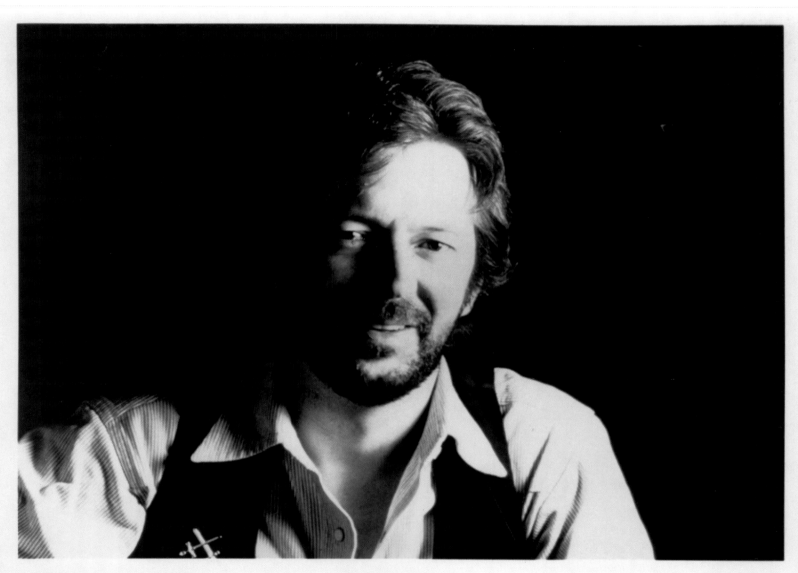

ERIC CLAPTON

Records, Inc.

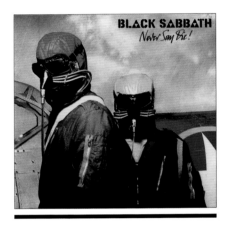

Billboard 200: *Never Say Die!* (#69)

Black Sabbath's *Never Say Die!* was attacked by critics, which didn't bother the famed British act a bit.

POSSIBLY THE most influential band in heavy metal history, Black Sabbath came from a working-class section of Birmingham, England. The group's dark music and doomsday image inspired a generation of teenagers around the world.

With guitarist Tony Iommi's ominous, menacing sound, bassist Geezer Butler's occult-influenced lyrics, Ozzy Osbourne's shrieking wails and drummer Bill Ward's lumbering beats, the members of Black Sabbath were masters of the monster riff, as the enduring popularity of "Paranoid," "Iron Man" and "War Pigs" attested.

The band built a reputation without the benefit of much radio airplay; the road was the group's salvation. A very visible minority of kids would run onstage to present the group with boa constrictors or carry upside-down crosses in hopes of getting the band members to join their coven.

"We've seen a lot of different styles and factions of music, and we've seen big holocaust bands come up and go down in the same year—and we're still plodding along," Osbourne said. "I've been performing for 10 years now and I don't know anything else. It keeps me thinking young, mixing with young people. I'm 30 years old, and I think, 'Thirty! I should be at home watching TV, eating popcorn every night.'"

Never Say Die! reflected the jazz and blues influences that the heavy metal masters had abandoned on their early albums. The title track and "Hard Road" cracked the Top 40 in the UK, the band's first singles to chart there since "Paranoid" in 1970.

"The title of the album is true to Black Sabbath," Osbourne said. "A lot of critics have put us down, but the main thing is that the kids still enjoy it. That fact alone assumes that we'll carry on forever."

However, *Never Say Die!* was the last studio album with Black Sabbath's original lineup. A decade of regular drug and alcohol use led to subpar performances and internal friction; the band dismissed Osbourne the following year. ■

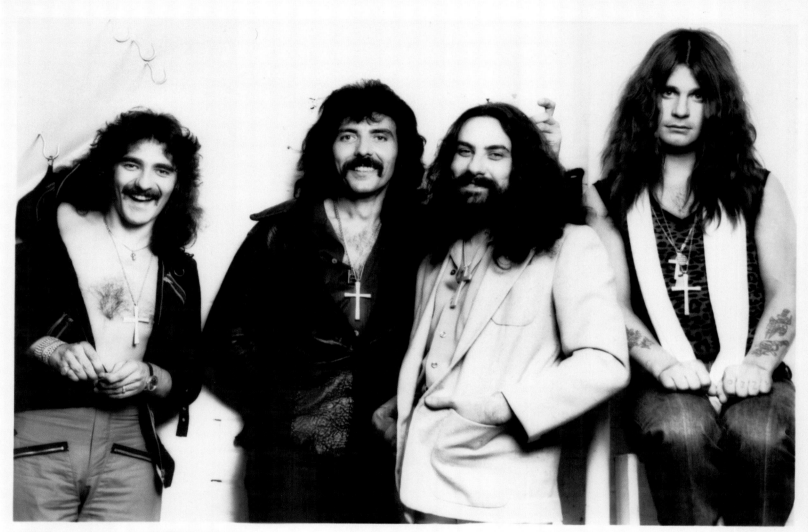

BLACK SABBATH

WARNER/REPRISE

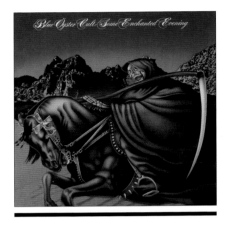

Some Enchanted Evening, **Blue Öyster Cult**'s live album, played a vital role for the hard-touring group.

FORMED IN Long Island, Blue Öyster Cult was hindered by an image problem on its early Seventies albums. Calculated to get attention, the group's hellfire and fascist vibe—black leather and paramilitary outfits, song titles such as "Dominance and Submission" and a red-and-black band ensign suggestive of the Third Reich flag—precluded its commercial success, defined by radio play and gold albums.

"We got a big laugh out of it, but it got to the point where we didn't want to hear about it anymore," lead guitarist Donald "Buck Dharma" Roeser reflected. "We're just the metal madmen of the East Coast. We combined off-the-wall lyrics with heavy off-the-wall music. We used to be praised for being a safe version of rabies or something. People were disappointed to find out that we are actually human beings."

A commercial breakthrough came in 1976 with the hit single "(Don't Fear) The Reaper."

"We became more melodic and less geometric and arbitrary," Roeser noted. "We used to write music structured in an almost mathematical way rather than an emotional way."

Blue Öyster Cult toured heavily, becoming one of the first acts to add lasers to its light show. Roeser presented a new tune, "Godzilla," that became a staple of live performances.

"It germinated in a hotel room in Dallas—I came up with the riff, and the only thing it reminded me of was Godzilla," Roeser laughed. "I've always been a big fan of his. I think the first Godzilla flick was the finest movie of that genre, even though they dubbed in Raymond Burr. It's funny, I never figured that out until three years ago."

Some Enchanted Evening, BÖC's second live album, recorded at various locations in the US and England, became the band's best-selling release. It included concert versions of "Godzilla" and "(Don't Fear) The Reaper," plus an epic version of "Astronomy" with a searing Roeser guitar solo.

"When the Cult began, we made a conscious effort to become a heavy band in the vein of the popular English bands of the time," drummer Albert Bouchard said. "But now we've cut down on the craziness. I guess people take our music seriously." ∎

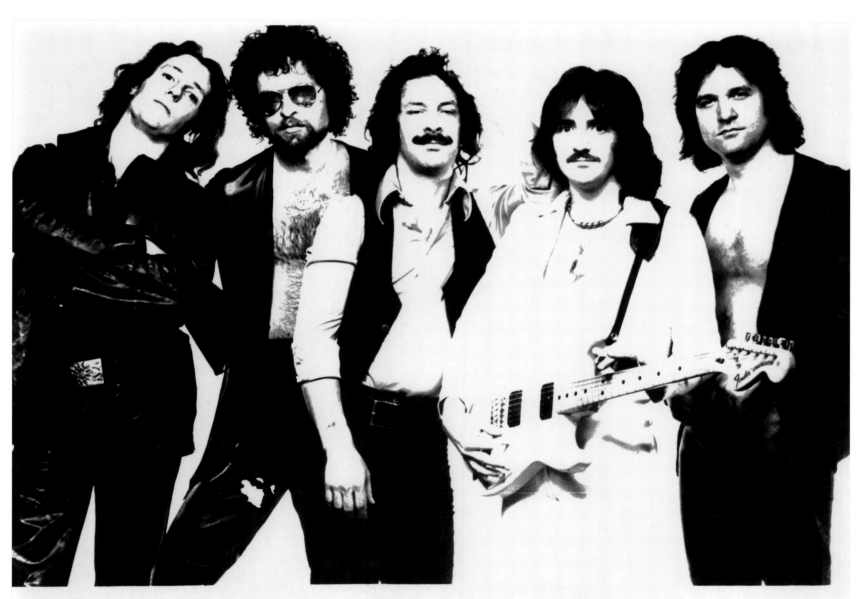

BLUE ÖYSTER CULT

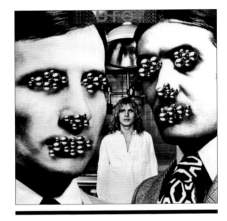

Billboard 200: *Obsession* (#41)

Even with the success of the *Obsession* album, guitarist Michael Schenker's rocky tenure in **UFO** ended.

THE BRITISH hard rock band UFO was notable for featuring former Scorpions member Michael Schenker starting in 1973. Only 18 at the time the band recruited him, the German lead guitarist was already a well-respected player.

Tensions began to grow between singer Phil Mogg and Schenker, who often walked off before and during shows. 1977's *Lights Out* was UFO's biggest critical and commercial success, yet Schenker disappeared abruptly after a show in London. His interest in religious cults prompted members of UFO to suspect Moonies—followers of the Reverend Sun Myung Moon's Unification Church—had abducted him. But three months later in Germany, a traffic cop stopped Schenker for speeding and recognized him as a missing person. He was suffering from nervous exhaustion after the group's long European tour, and he couldn't face the thought of the extensive American tour the band had set up, so he had taken it upon himself to "go missing."

"It was actually a moped that he got pinched on," Mogg said. "Michael doesn't speak an awful lot of English, and when he does he finds that he's misunderstood. And he doesn't particularly want to talk about his disappearance."

Many in the industry felt it was merely a publicity stunt. "I don't think we would have done a two-month tour without him if that was the case," Mogg insisted. "That's just basic logic. The point wasn't that if he didn't turn up within a certain period that we would have continued without him. We just wanted to know what had happened to him. We used to call him 'Jekyll and Hyde' anyway, so we just wanted to make sure he was all right. I think he was just completely fucked up, mentally and physically. He couldn't take anymore of whatever came down."

With Schenker returning to the fold and working his brand of fretboard sorcery on his iconic Gibson Flying V guitar, the band went back into the studio to record *Obsession*. But soon after a show in California in October 1978, Schenker unequivocally quit the band.

"Those black plastic pants he wore were mine," Mogg sneered. "I got them at the Sex shop in London before Malcolm McLaren (the store's owner and Sex Pistols manager) hit it big. Michael's not the only weird guy in this band, you know." ■

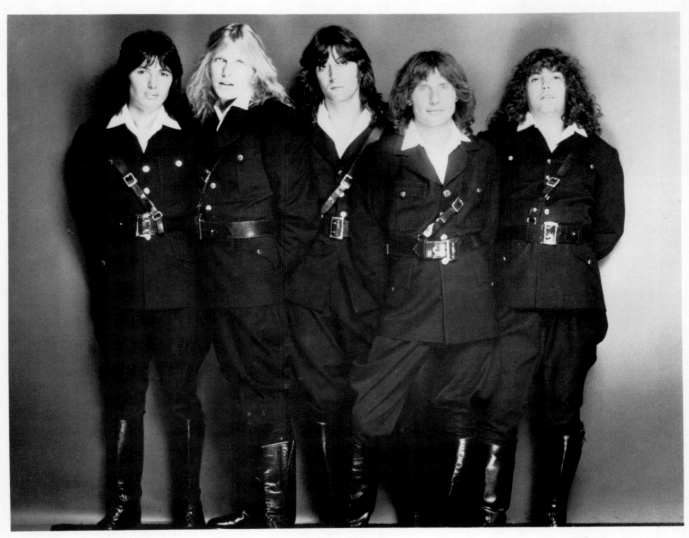

UFO

Chrysalis

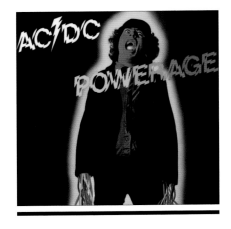

AC/DC, the Australian masters of hard rock, fired up the teen boys-will-be-boys hordes with *Powerage*.

FORMED IN 1974, AC/DC (the band took its name off the back of a vacuum cleaner because "it sounded powerful") offered high-volume escapism with the crunching riffs and rhythms of guitarists Angus and Malcolm Young and the lecherous sandpaper growl of singer Bon Scott.

"When we first came to America, the music of the day was soft, and the disco boom was just coming in—every radio station in the country, bar a few, was playing that," Angus Young recalled. "But there was a big difference between what people heard on the radio and what people went out at night to see. Whenever you walked into a club, all that appealed to people was lots of hard rock music. And that's all we ever liked to play."

Young was known as the leader of AC/DC's relentless instrumental attack as well as the guy who never took the macho image of heavy metal too seriously. He amused himself romping on stage in delinquent schoolboy garb, a trademark sweaty uniform of cap, blazer and short pants (a sartorial choice suggested by his sister). Early records such as *Dirty Deeds Done Dirt Cheap* and *'74 Jailbreak*

were produced by the famed team of Vanda & Young—Angus and Malcolm's older brother, George Young (formerly a member of the Sixties pop group the Easybeats, best known for the hit "Friday on My Mind"), and his partner, Harry Vanda.

"George was there from the very start; it was he who wanted to get me and Malcolm together in a band," Angus said. "Malcolm and I knew each other inside out. We could just glance at each other, and I would always know what chord he was going to hit, and he always knew how I was going to play off it. But it was more George's inspiration than ours. You could say he and Harry were members of the band, because they helped us in all areas. They had great ideas for studio stuff and our live shows. They always had that fun attitude with us."

Many considered 1978's *Powerage*, AC/DC's fourth internationally released studio album, the band's most underrated work; "Rock 'n' Roll Damnation" was issued as a single. *If You Want Blood You've Got It*, the group's first live album of rock 'n' roll party thunder, hit stores later that same year. ∎

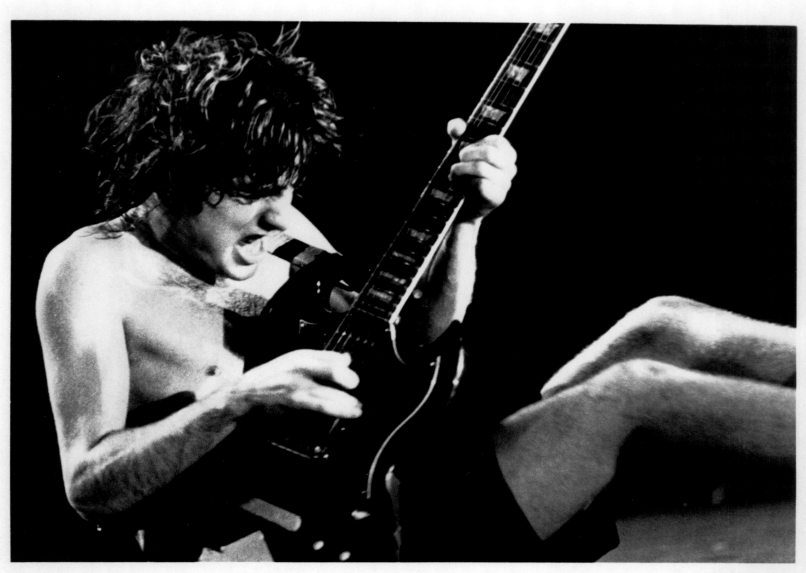

AC/DC ANGUS YOUNG

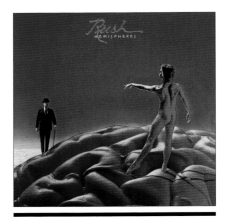

Rush's *Hemispheres* album silenced pundits who felt the group would never gain an ounce of credibility.

Billboard 200: *Hemispheres* (#47)

THE MEMBERS of Rush—bassist Geddy Lee, guitarist Alex Lifeson and drummer Neil Peart—had a number of strikes against them in the early Seventies. They were a Canadian band trying to crack the US market. They were a power trio, a musical configuration considered a leftover from the Sixties. They were dismissed as a ham-fisted, poorman's Led Zeppelin relying on arena-rock thud, and bassist Geddy Lee's high, nasal vocal style, an exaggerated hamster-on-helium shriek for attention, inspired a love/hate debate.

"I was brutalized fairly regularly in the early days in terms of my vocals," Lee said with a laugh. "The one that's stayed with me is 'the damned howling in Hades'—that's a favorite quote of mine. But it's a blessing to have the opportunity to make many records, that you have the ability to grow up in public."

Lee tamed his banshee vocals to a less-shrill register, and Rush gradually metamorphosed from its heavy metal genesis, proving its instrumental chops and incrementally refining its songwriting. The band made its first move toward respectability in 1976 with *2112*, a science-fiction concept album that showed the trio's determination to improve as players had paid off. Peart started writing lyrics based on compelling themes, and his interest in futuristic literature resulted in "Tears" on *2112*, a song inspired by Ayn Rand's novella *Anthem*.

"That was absolutely critical for us," Peart admitted. "Our first three albums had sold the same amount, and the business powers-that-be were convinced that was the end of us. We were insecure and had a lot of pressure to come down to earth and be calculated and commercial instead of pushing in ten different directions at once. But the result of that negativity was that we got angry—the album reflected our rebellion, our take-it-or-leave-it attitude."

A new set of listeners picked up on the album's sense of purpose and desperation, and *2112* became Rush's breakthrough release in the American market. The trio then expanded the progressive elements in its music with *Hemispheres*. The band's sixth studio album was loaded with Lee's dexterous bass playing, Lifeson's fiery, inventive guitar work, and Peart's extraordinarily precise drumming. Peart's lyrical abilities added an important element; he never underestimated the intelligence of the band's predominantly young audience. "Cygnus X-1 Book II: Hemispheres" occupied one side of the album. "Circumstances" and "The Trees," a pastoral about a conflict between maples and oaks in a forest, were two short tracks.

"It wasn't thought to be the way to become popular before we became successful, but I don't think people are stupid," Peart said of his cerebral approach. "When I write a song, it's something that has captured my imagination. I merely give other people the same amount of credit. I'm full of ideas. If it's a long one, we just go ahead and express it that way. We don't have any external limitations, and that's the key to our music." ∎

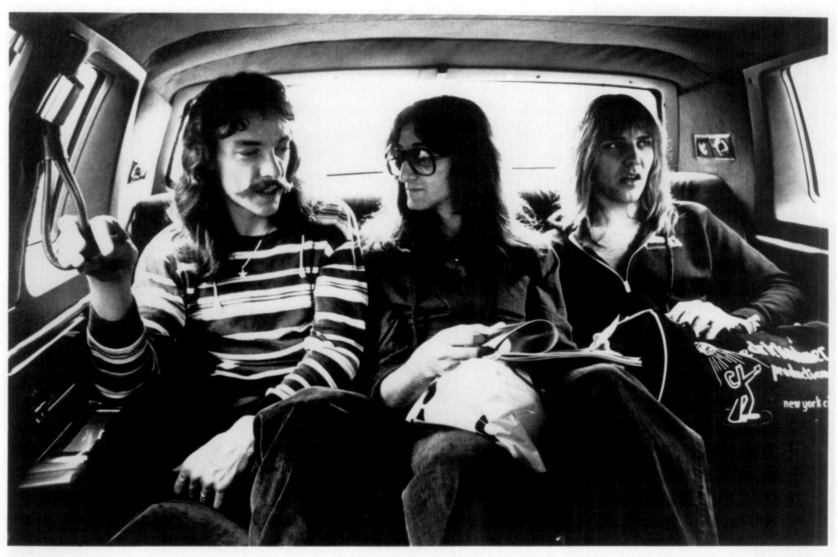

RUSH

Recording Exclusively For

A product of Phonogram, Inc.

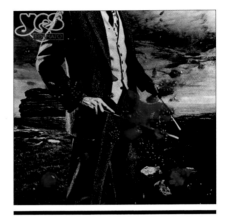

Billboard 200: *Tormato* (#10)

Criticized at the height of British punk as embodying the excesses of prog rock, Yes delivered *Tormato*.

IN 1968, musicians Jon Anderson and Chris Squire met in a London club and formed Yes, a band that built a reputation forging the progressive rock sound of the early Seventies. Members cycled through the lineup, but the essential Yes ingredients consisted of Steve Howe's blinding guitar work, the grandiose keyboard textures provided by Rick Wakeman, Anderson's airy vocals and the virtuoso rhythm section of Squire on bass and drummer Alan White on drums.

"When we stared out, heavy metal was very successful, with Black Sabbath and bands of that ilk," Squire said. "But Yes seemed to thrive on that environment—it seemed to make us stand out all the more."

Seeking to merge the intricacy of classical with the kick of rock 'n' roll, the band produced such songs as "Perpetual Change," "And You and I," "Starship Trooper" and "I've Seen All Good People"/"Your Move"—all of which went into rotation on FM radio. But rather than chasing pop hits, Yes pioneered concepts, intricate arrangements and classical references.

"We used to say that we 'de-commercialized' music—we took a pop song and made sure it wasn't too commercial," Howe said.

The grandeur of Yes' musical wizardry reached its zenith in 1972 with the band's fourth album, *Fragile*, which featured the single "Roundabout"; the reputation for arty eclecticism was reinforced by the four-sided *Tales from Topographic Oceans* (1973). The nadir of the band's excessive musical inclinations came with the release of five solo albums. By 1977, the off-the-beam instrumentalism that plagued Yes and other art rock bands coincided with—and many felt helped precipitate—the reactionary English punk rock movement.

Yes continued a movement towards shorter songs for *Tormato*. "Don't Kill the Whale" charted in the UK.

"We're split on doing types of material," White admitted. "I would love to do another *Topographic*, and Chris, for instance, is into the shorter songs. And who's to say we each won't change our minds?"

Yes supported the album with concerts performed "in the round." *Tormato* was the last album recorded with Anderson and Wakeman prior to their departures from the group. ∎

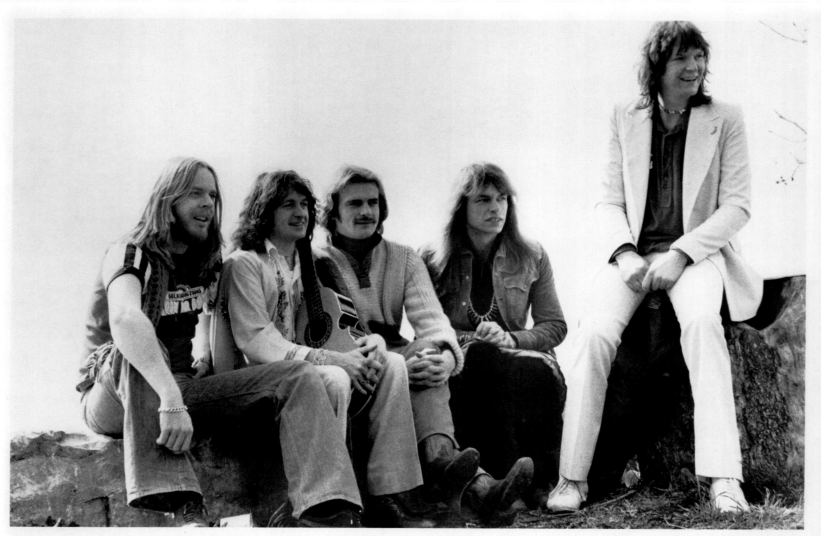

RICK WAKEMAN JON ANDERSON ALAN WHITE STEVE HOWE CHRIS SQUIRE

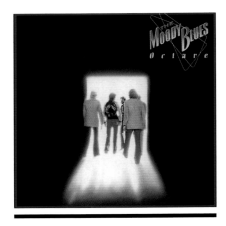

The Moody Blues let six years pass before following the best-selling *Seventh Sojourn* album with *Octave*.

Billboard 200: *Octave* (#13)
Billboard Hot 100: "Steppin' in a Slide Zone" (#39);
"Driftwood" (#59)

FORMED IN 1964, the Moody Blues were seen as a soulful British Invasion pop group—wearing matching blue-striped stage suits, the band hit the Top 10 a year later with "Go Now." Justin Hayward joined soon after as a songwriter, and in 1967, accompanied by members of the London Festival Orchestra, the band released *Days of Future Passed*, a teaming of contemporary melodies with symphonic sounds fueled by the splendor of "Nights in White Satin" and "Tuesday Afternoon." That enterprise propelled the Moody Blues' appeal to messianic proportions; such classic works as *In Search of the Lost Chord*, *On the Threshold of a Dream* and *A Question of Balance* established their "cosmic" brand of orchestral rock, with lush arrangements and thought-provoking lyrics. One factor in the band's success was the pioneering use of the Mellotron, a keyboard with string sounds that foreshadowed the synthesizer.

"Our music had an ethereal, idealistic quality to it—we were going to change the world," Hayward said. "When we first started having success, we asked the record company for every single musical instrument to be delivered in the studio. We'd invite people and throw parties, and we'd discover things about ourselves. You can't do that in any other medium. Everyone can play an instrument—you just have to find out which one it is.

"I enjoyed the late Sixties. We went through psychedelic and religious experiences, and it was a time of great discovery. But strange-ly enough, at the time of our greatest success in 1972, we were very unhappy people. We were letting our music do our talking for us. You won't find many articles about us back then that go into depth about us as people."

Rock's intellectual laureates slumped when they parted ways to embark on individual projects. Upon regrouping to record 1978's *Octave*, the group lost keyboardist Mike Pinder and longtime producer Tony Clarke, leaving four members—Hayward, bassist John Lodge, drummer Graeme Edge and flutist Ray Thomas; they eventually recruited former Yes keyboardist Patrick Moraz. The album produced "Steppin' in a Slide Zone," the first Moody Blues single to use synthesizers, giving the band an electronic rather than a symphonic sound.

"We've got to explore these things, we can't shut our minds," Edge said. "When the saxophone was invented so many years ago, people argued that it took away the contact between the musician and the instrument—it used mechanics, where previous to that it was all fingers-over-holes. But musicians will always utilize the technology of the day, be it a saxophone or the latest result of the microchip revolution."

Around this time, Hayward charted with the song "Forever Autumn," which he sang for the concept album *Jeff Wayne's Musical Version of the War of the Worlds*. "It's not actually Moody Blues," Edge said, "but it's such a lovely song—a signpost of his career." ■

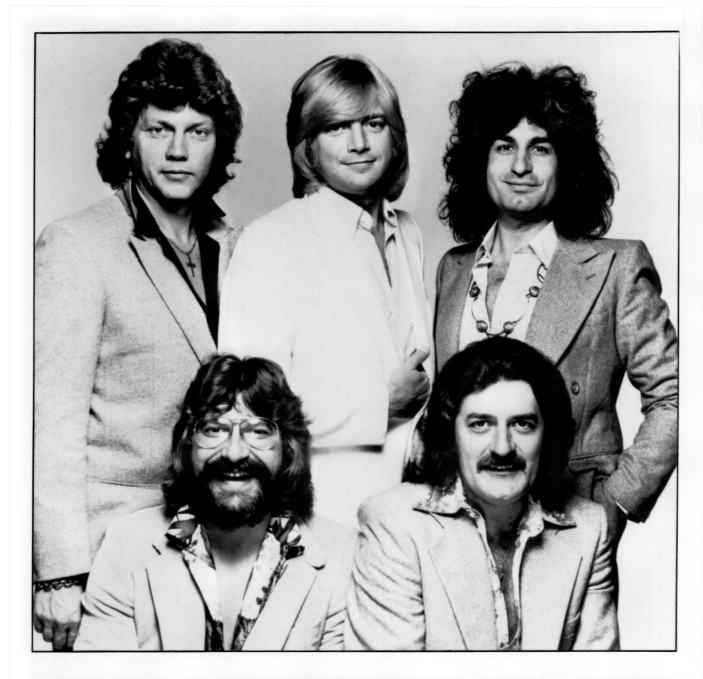

The Moody Blues American Tour 1978

**John Lodge, Justin Hayward, Patrick Moraz
Graeme Edge, Ray Thomas**

Recording as a trio, Genesis attained its first worldwide pop hit with the song "Follow You Follow Me."

Billboard 200: *...And Then There Were Three...* (#14)
Billboard Hot 100: "Follow You Follow Me" (#23)

HAVING BUILT a cult following in the early Seventies by virtue of melodic, epic songs and equally grand visual performances, the English progressive rock band Genesis was in a position for a commercial breakthrough—only to have lead singer Peter Gabriel leave the group in 1975.

"His leaving lightened up the band," bassist and guitarist Mike Rutherford said. "After all those years together, we had to work even harder to make up for Peter's departure. It made the four of us closer, really." Contrary to various reports, the band remained on friendly terms with Gabriel. "He avoided putting out a Genesis-type album," Rutherford noted.

Lead singer Phil Collins—the band's drummer prior to Gabriel's departure—guitarist Steve Hackett, keyboard artist Tony Banks and Rutherford proved that Genesis wasn't dependent on one person, as some had feared. On tour, drummer Chester Thompson accompanied the band, freeing Collins for his singing chores. Then Hackett left the band in 1977 to pursue a solo career.

The album *...And Then There Were Three...* marked a departure from most of Genesis' previous work. "Follow You Follow Me," was a shorter, concise song featuring a simple melody and a verse-chorus structure; the romantic lyrics were written by Rutherford. A hit single was a new experience for Genesis.

"I just want to expand our audience," Rutherford said. "We don't project any success, so we won't be disappointed. I just hope it turns some people on to our albums that haven't heard them. We've been stuck with this 'underground-progressive' tag for too long." ∎

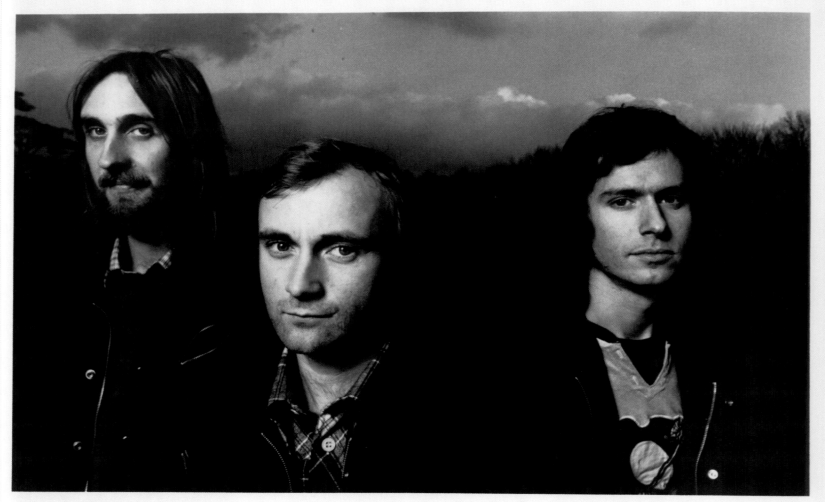

Michael Rutherford Phil Collins Tony Banks

GENESIS

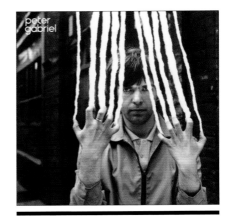

Billboard 200: *Peter Gabriel* (#45)

Produced by Robert Fripp, the second solo album from Peter Gabriel yielded a minor hit with "D.I.Y."

SINCE FIRST coming to attention as Genesis' eccentric frontman, Peter Gabriel had been one of art rock's most adventurous, intuitive thinkers. He would not title his first four solo albums, labeling them all *Peter Gabriel* using the same font, but featuring different cover art. His first solo album was referred to as "Car," in relation to its cover shot of him seated in a rain-soaked automobile. The second *Peter Gabriel* was called "Scratch," connecting to the image of Gabriel's clawed hands ripping giant white scratch-marks out of the cover.

"Other acts on each album very much try and present a brand-new face, a bit like marketing soap powders—new added ingredients, sparkling blue bits and all the rest," Gabriel said. "So I thought much more interesting for me would be just to keep exactly the same title, the same typeface, the same position, so the only way of telling the difference from the outside was by the difference in the picture, so it looks a bit like a songwriter's magazine that comes out once a year."

Working with Robert Fripp, the album was more outré than its predecessor. The song "D.I.Y." was an appeal for self-determination and to not fulfill expectations of social pressure.

"Rather than just change your attitude, change what you can do. In other words, one has responsibility for a lot more than most people are prepared to accept. I believe in small groups of people having a lot more control over themselves than they do at the present." ∎

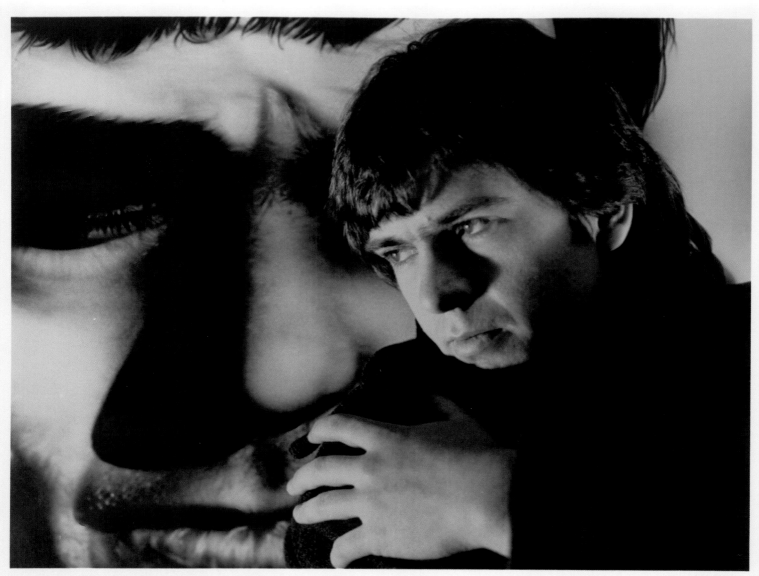

PETER GABRIEL

ATLANTIC

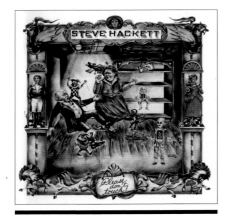

Fans called **Steve Hackett** crazy when he left Genesis to pursue his own interests on *Please Don't Touch*.

Billboard 200: *Please Don't Touch* (#103)

PIGEONHOLED AS a progressive rock group throughout its career, Genesis finally made a breakthrough with the *Wind and Wuthering* album and an American tour early in 1977. And then Steve Hackett, the band's versatile guitarist, abruptly quit. He was faced with the chore of finding audience acceptance on his own, but he felt his departure came at the right time for his own musical development.

"The idea of anonymity, of not having to stand behind a flag called Genesis or any band, is quite a nice thing," Hackett said. "It means you can hook up with whoever you like whenever you want in whatever part of the world you choose. You've also got the ability to work closely with those people; you form a band for a very short period of time. Provided those people are as happy as you are with what they did with you, it strikes me that you've got the best of both worlds."

Hackett celebrated his freedom by assembling stellar players for *Please Don't Touch*, his first post-Genesis album; Steve Walsh of Kansas and Richie Havens contributed vocals. What kept him on track for his studio work was his fascination with ESP and various forms of spiritualism, notably Macumba, a combination of voodoo and Catholicism practiced in South America.

"I've always liked the spookiness of some music, the feeling of something else in there," Hackett explained. "An Indian lady in Brazil told me that I was influenced by an entity that manifested itself with a harp. It might seem strange that it was a stringed instrument, but if you look back over the centuries, the harp used to be tuned much higher before the concert harp was developed. The Celtic harp sounds very much like a 12-string guitar, as a matter of fact. And when an English lady I came to for a reading said, 'You've got a harp standing next to you,' I was riveted for the entire session."

When Hackett said, "I want to bury Genesis," there was no malice involved; he was affirming his commitment to music that he felt only he was capable of producing.

"*Please Don't Touch* is the hardest thing I've ever done. It will probably be quite a while before I can even pick up a guitar again. But the harp entity demanded that I do this album. I said, 'Yeah, but I owe it to the band to stay with them.' But then I knew that I owed it to myself. I could feel it. And that's why it had to be done." ■

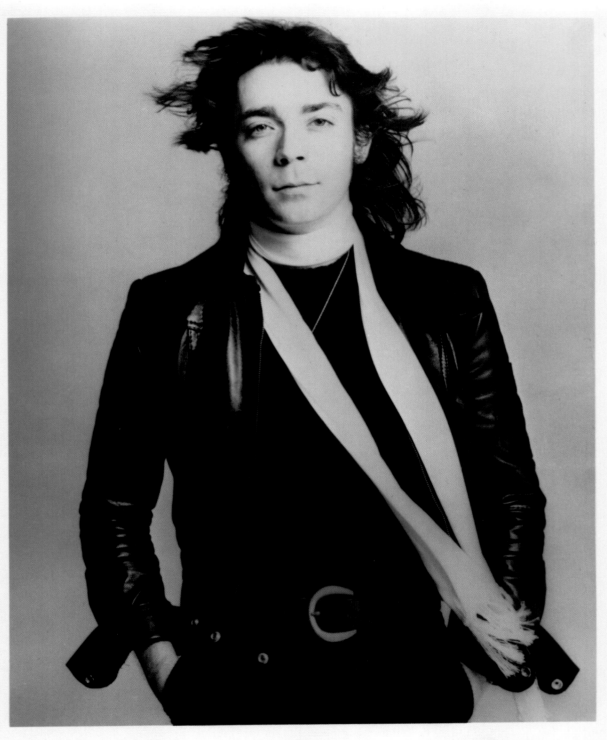

Steve Hackett

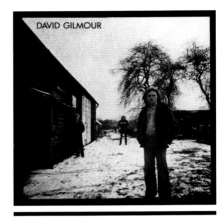

The first solo album by Pink Floyd guitarist **David Gilmour** stood out as one of the year's premier releases.

Billboard 200: *David Gilmour* (#29)

IN 1977, Pink Floyd reached a plateau that had taken the British band more than a decade to achieve. The album *Animals* met with commercial and critical success, and the accompanying tour packed stadiums and arenas across America and Europe. Having solidified its status as a bona fide supergroup, the band's members decided to take a year off from being Pink Floyd.

The first efforts of the hiatus came in the form of guitarist David Gilmour's solo album. Gilmour had perfected his linear guitar style in the progressive setting of Pink Floyd after replacing Syd Barrett in 1968. On *David Gilmour*, his guitar dominated the musical setting. Since the Floyd would often go several years between album releases, the band's zealous fans greeted any activity in the group's camp with fervent anticipation.

"I just made an album," Gilmour allowed. "I didn't think about it deeply; I wanted to record it quickly and get some spontaneity and life into the whole thing, to get it out of my hands before I changed my mind and started taking it back in and redoing it over and over again. It wasn't a matter of working outside of the framework rather than of not having to make compromises. It's just nice to get out of working in any group situation once in a while and be on your own—do it exactly the way you want to do it to please yourself, not to please three other people."

Roger Waters had assumed the mantle of lyricist for Pink Floyd, so Gilmour's album gave him the chance to extend certain concepts. Since *Dark Side of the Moon*, Pink Floyd had shifted from describing chemically induced fantasies to a less cosmic presentation of personal realities. Gilmour said his album "represents personal things to me, much more inward than the outward visions Pink Floyd albums have dealt with lately. That's just the way I write. I would find it very hard to write fictionalized stories."

Gilmour solicited the track "There's No Way Out of Here" from Ken Baker of Unicorn, a band he had worked with for two albums. Besides his output with Unicorn, Gilmour helped singer Kate Bush reach the top of the British charts with a No. 1 single, "Wuthering Heights." Pink Floyd had never searched out publicity, but Gilmour had built a reputation for stepping outside the Floyd's activities to oversee special projects.

"We only talk when we have something interesting to say," Gilmour said of his bandmates. "As for me, I'm just not as well-known on my own as the Pink Floyd is. I don't want the possibility of sitting around in a few months' time with a failed album thinking, 'Well, that *could* have done it…'" ∎

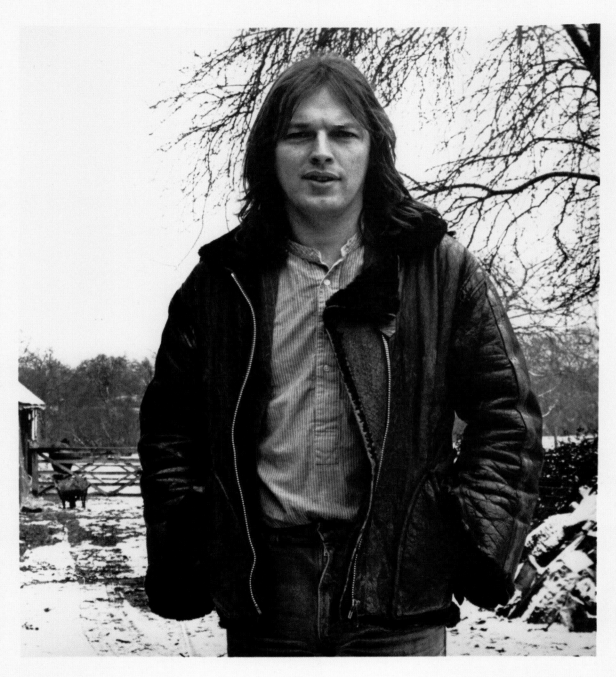

David Gilmour

7805

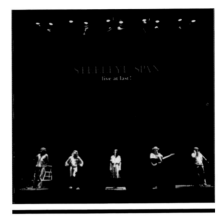

Following ten albums of English folk rock, Steeleye Span issued an aptly-titled concert set, *Live at Last*.

STEELEYE SPAN formed in 1969 with the desire to prove that traditional English folk songs, jigs and reels and electric instrumentation could be combined tastefully. Thanks to the UK hit single "All Around My Hat," the group became one of the British folk revival's best-known acts. After a period of "pure" folk music, Steeleye Span employed a full-time drummer. Some old-line fans found the results unnecessarily raucous. Nevertheless, the band persevered in that direction.

Through many personnel changes, the band had brushes with the commercial world. David Bowie played saxophone on an album, and the band opened for Jethro Tull on a US tour. At one point, the Steeleye show was more theatrics than music, as the members staged a mini-play. "I was singing six songs a night and changing costumes as many times," lead singer Maddy Prior said.

"Our academic source is old English folk music, and that's all," guitarist Tim Hart said. "It's all written down for us, and what we do with it is our business, since nobody knows how it was originally interpreted. The guitar wasn't around; it might have been whistles and fiddles. It was the instrument of the day, and that's what we're using. That's our music. It isn't part of the hamburger culture, or Chuck Berry. It's a part of us and England."

Live at Last, the first Steeleye Span album recorded outside the studio, was released at difficult time in the band's existence. Key members Bob Johnson and Peter Knight had departed; early member Martin Carthy rejoined on guitar. Most of the tracks were essentially new material, taking the band back to a more avowedly traditional approach without rock amplification.

Another factor might have limited Steeleye Span's American following. The band's name sounded a little too similar to another act, though Prior feigned naiveté about Steely Dan: "We really aren't doing the same sort of thing, of course." ■

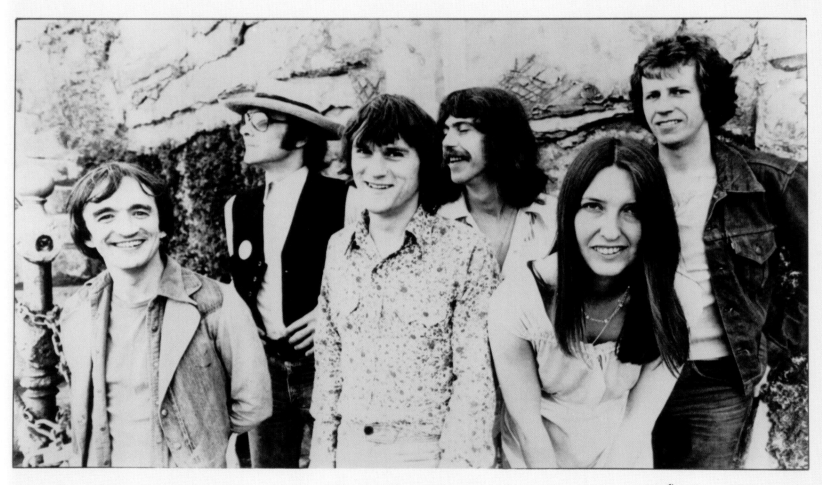

Steeleye Span

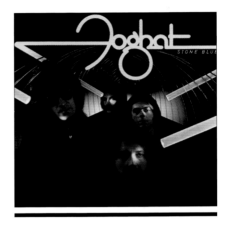

Billboard 200: *Stone Blue* (#25)
Billboard Hot 100: "Stone Blue" (#36)

In the wake of a best-selling live album, the title track to Foghat's *Stone Blue* cracked *Billboard*'s Top 40.

FORMED IN 1971 when guitarist Lonesome Dave Peverett, bassist Tony Stevens and drummer Roger Earl left England's Savoy Brown to team up with slide guitarist Rod Price, Foghat debuted with a self-titled album defined by a jolting cover of Willie Dixon's "I Just Want to Make Love to You" that scorched the radio airwaves. The four Englishmen stormed the States, playing to packed arenas and earning a reputation as a premier blues-based boogie squad.

"When we started out, we weren't seen as modish," Peverett said. "It was the era of Seals & Crofts and Carole King and James Taylor—pretty wimpy. We built our reputation playing in front of people."

An impressive recording legacy followed—the classics "Slow Ride," "Fool for the City" and "Drivin' Wheel." Avowed in America for its live prowess, Foghat curiously never made a dent in the Unit-ed Kingdom. "You've got to expect that," Peverett snickered. "We're good old boys."

The band finally moved to the colonies for good. "People say it was a tax dodge, but believe me, there were not taxes to dodge 'cause we weren't making anything when we did it," Earl explained.

Stevens left the band due to the never-ending tour schedule and was ultimately replaced by Craig MacGregor. *Foghat Live* attained the group's strongest sales figures, and the studio hit "Stone Blue" followed. Earl, who sported rock's most threatening mustache, re-stated Foghat's approach to music.

"The way we play has always been consistent with our basic rock format," he declared. "We're not going to wander off and become another Yes." ∎

LONESOME DAVE PEVERETT **ROGER EARL**

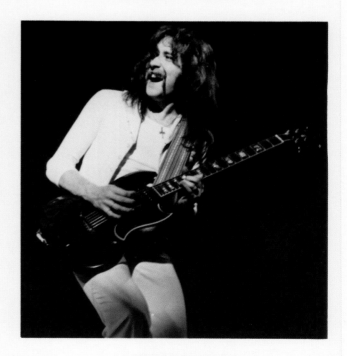

CRAIG MacGREGOR **ROD PRICE**

From the Inside, Alice Cooper's concept album, hatched the power ballad "How You Gonna See Me Now."

Billboard 200: *From the Inside* (#60)
Billboard Hot 100: "How You Gonna See Me Now" *(#12)*

ALICE COOPER'S outrageous career began in 1969 when the former Vincent Furnier led a band of weirdos in a new brand of crude, high-energy rock. He lunged out at America as the most perverse and subversive teen idol in the history of pop music—a dark-haired, spider-eyed, cross-dressing menace with a black sense of humor.

"We drove a stake through the heart of the love generation," Cooper crowed.

Hailing from Detroit, the original Alice Cooper band broke into the music mainstream, with the archetypal hard rock anthems "I'm Eighteen," "School's Out" and "No More Mr. Nice Guy" kicking off a string of raw, clever singles. But Cooper drew the most attention with his elaborate tours—like no other rocker before him, he brought show business to his craft.

Cooper's well-orchestrated spectacles established him as America's top box-office attraction, the first rock performer to employ multilevel sets and unusual stage props such as electric chairs, huge boa constrictors, gallows, chopped-up doll babies and fake blood. Cooper was considered "the godfather of shock rock," outraging parents and influencing a generation of fledgling bands. He began a solo career in 1975 with the success of the *Welcome to My Nightmare* project.

"Our shows were concerned with ultraviolence, but we never advocated it," Cooper insisted about his ghoulish demeanor. "It's so easy to fall into every rock 'n' roll trap there is. When you have a character as defined as Alice, you have to battle so that it's not such a cartoon, a parody of itself."

But Cooper was in dire need of help with his alcoholism. He had himself hospitalized in a sanitarium for treatment. Once sober, he used his experience as the inspiration for his semi-autobiographical *From the Inside*, an album he co-wrote with Bernie Taupin, the lyrical powerhouse behind Elton John's greatest hits. It spawned the hit tune "How You Gonna See Me Now."

"The only way to stay in the game during the dark age of disco was to do ballads," Cooper said. "And I accidentally wrote a good one." ■

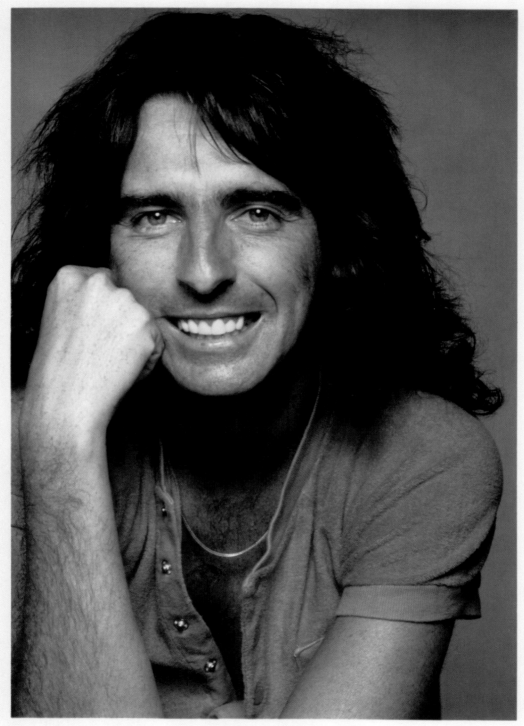

ALICE COOPER

WARNER / REPRISE

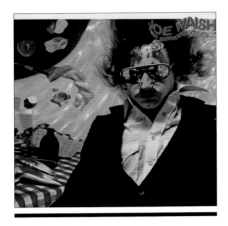

Eagles member Joe Walsh became a solo sensation with the riotous "Life's Been Good," his biggest hit.

Billboard 200: *But Seriously, Folks...* (#8)
Billboard Hot 100: "Life's Been Good" (#12)

THE JAMES Gang, Joe Walsh's first band, was a Cleveland power trio that showcased his blossoming writing and guitar-playing talent; "Funk #49" and "The Bomber" endured as hard rock landmarks. After leaving the group in 1971, Walsh relocated in Colorado, formed a band called Barnstorm and went on to score hit records of his own; appropriately, the first smash ever made at Caribou Ranch, the legendary recording complex outside of Boulder, was Walsh's "Rocky Mountain Way." The guitarist joined the Eagles in 1975, his boisterous playing the key to his membership. As the Eagles struggled to record their follow-up to *Hotel California*, Walsh reignited his solo career, recording *But Seriously, Folks...* over an 18-month period.

"I am definitely in the Eagles and I will continue to be—that's important to me," Walsh said. "Oh, don't mention my voice. It's bad enough being the fourth-best singer in the Eagles."

The lyrics to "Life's Been Good" reflected Walsh's tongue-in-cheek approach to the industry, a comedic depiction of the antics and excesses of the era's rock stars.

"That was a good joke. Everybody thinks this lifestyle we lead is so extravagant, and it ain't—it's a pain," the amiable Walsh said. "I tell you, I really felt humble when I did that song. I wanted it to be humorous. I wanted to present some of the ridiculous, non-musical things we get faced with in our crazy lifestyle. But I didn't want to come across as a jerk, you know? So I really didn't mean for that to be a single, but my record company thought it should be. I'm really amazed that it took off like it did. I didn't know if people would think it was funny, or if they'd think it was funny after hearing it three or four times. But I guess it's okay!"

Known as rock music's consummate cynic, Walsh built his reputation on hotel-room demolition and goofy wordplay. "I'm really honored that I've reached the public acceptance that I have," he said. "Man, I don't want to get a big head. I don't want to start believing it myself, you know? I'm just real grateful for the chance to do solo albums and be in the Eagles and make music…I'm still just a jerk! I'm a famous jerk—that's all that's changed." ■

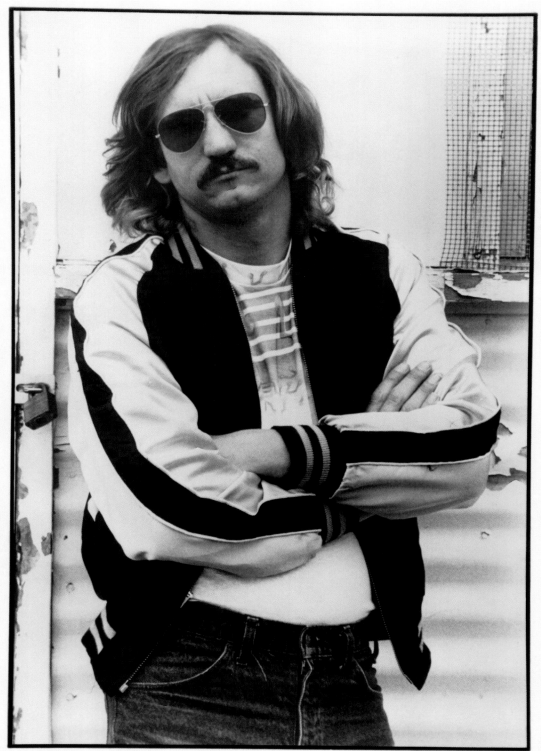

JOE WALSH

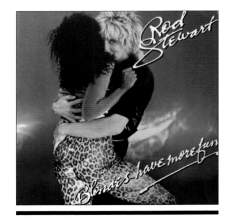

The disco trend was peaking when "Da Ya Think I'm Sexy" became one of Rod Stewart's knockout singles.

Billboard 200: *Blondes Have More Fun* (No. 1)
Billboard Hot 100: "Da Ya Think I'm Sexy?" (No. 1);
"Ain't Love a Bitch" (#22)

WITH HIS distinctively raspy voice, Rod Stewart had carved out a highly successful career as the lead singer of the Faces, one of rock music's most charismatic acts. When he decided to pursue his burgeoning solo career and the Faces broke up, he bore the brunt of criticism for catalyzing the split. And he didn't endear himself to old Faces fans or British patriots by moving from England to Los Angeles to be a star, his look evolving to include a glam element— dyed-blonde hair, makeup and foppish costumes. Whether he still had a rock 'n' roll soul was very much in question. Critics said he had squandered his talent and settled for sham stardom.

"How do you gauge success?" Stewart retorted. "I was very unpopular in the music press, but I was selling millions of records. I don't think I've ever lost any credibility as far as the music goes. I've never written anything for the Top 10 except, arguably, 'Da Ya Think I'm Sexy.'"

"Da Ya Think I'm Sexy"—the opening track on Stewart's album *Blondes Have More Fun*—became a No. 1 hit in the US and a num-ber of other countries.

"There were only three rock-disco hits—the Stones' 'Miss You,' Blondie's 'Heart of Glass' and mine," he said. "And we were the first ones to use electric guitars."

Stewart, who donated his royalties from "Da Ya Think I'm Sexy" to UNICEF, had his name splashed on the cover of every gossip magazine in the country.

"I can't tell you how many times I've read what I've bought or where I've been when it hasn't been anywhere near the truth," he said. "I think it's just that you get so big in a profession that people have to write negatively. They just don't like your success. When the Police dye their hair, it's okay; but when I do, I get crucified.

"Well, there was an embarrassing period with Britt Ekland. It was a case of being madly in love with a woman, doing everything she told me—and she totally ruined me. Thank goodness that's all done!" ∎

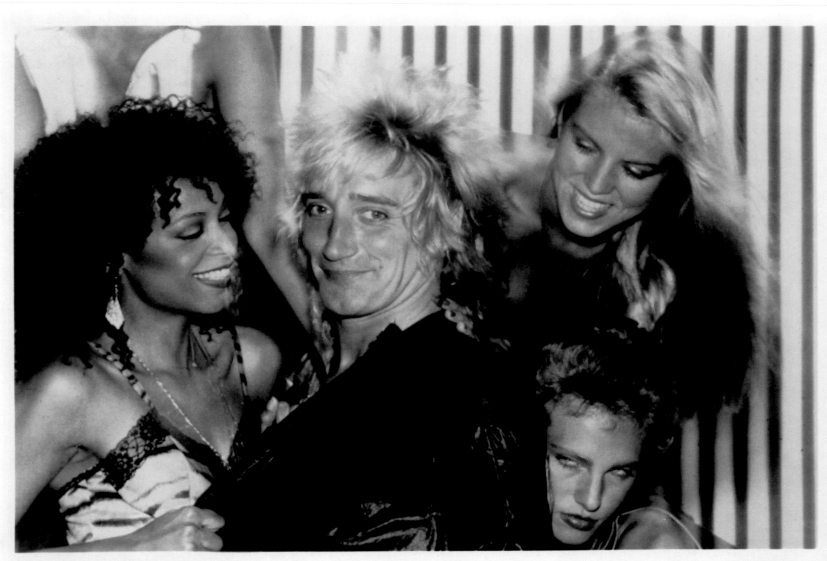

ROD STEWART

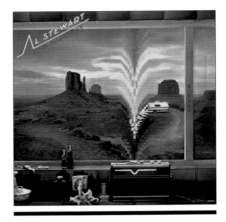

Billboard 200: *Time Passages* (#10)
Billboard Hot 100: "Time Passages" (#7);
"Song on the Radio" (#29)

Al Stewart's intriguing "Time Passages" spent a total of 10 weeks at No. 1 on the easy listening charts.

CONSIDERED THE "thinking man's rock star" by his devotees, British singer-songwriter Al Stewart had developed a profound brand of historical folk rock, writing epic songs based on such atypical subjects as literature, art, cinema and wine. That reputation took root in America with 1974's *Past, Present and Future*, a concept album about European history that featured "Roads to Moscow" and the epic "Nostradamus," which focused on the 16th-century seer's prophecies.

1976's "Year of the Cat," Stewart's commercial breakthrough, was less lyrically intricate than his typical compositions, and he admitted that the title track of the follow-up album, *Time Passages*—once again imbued with the crisp production of Alan Parsons—was written with the intent of having hit-single potential.

"It's just a case of the public latching on to a creamy saxophone riff," Stewart characteristically quipped.

Often played over the airwaves, "Time Passages" would eventually emerge as the No. 1 adult contemporary single of 1979, and "Song on the Radio" was a considerable hit, but Stewart then seemed to drop out of favor as quickly as he had been discovered.

"I wasn't a very good pop star," he reflected with characteristic candor. "It got to the point where we took around an army of technicians, started playing in huge theaters, hired a private plane—and we spent nearly all the money we had made on the big hits. I'm afraid to mix with people in the music industry, because all they do is tell each other Polish jokes, which bores the living daylights out of me. I don't think there's a single one of them I can sit down with and discuss Peter the Great." ∎

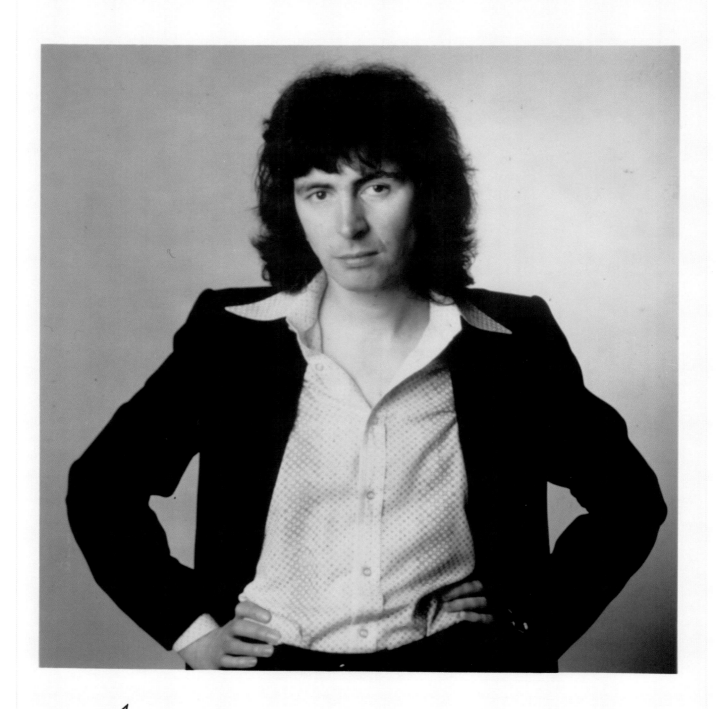

AL STEWART KINETIC

The debut album by **Dire Straits** bore "Sultans of Swing," a hit that cemented the band's status in the US.

Billboard 200: *Dire Straits* (#2)
Billboard Hot 100: "Sultans of Swing" (#4)

THE MAIN force behind Dire Straits, Mark Knopfler wrote and sang all the songs and played the guitar that provided the British band's signature sound. He also sent a demo tape containing the songs "Sultans of Swing," "Water of Love" and "Down to the Waterline" to DJ Charlie Gillett, who played the tape on his radio show on BBC Radio London. It led to Dire Straits' first recording contract.

"Sultans of Swing" was the first song to feature Knopfler's precise, emotive guitar style. The track appeared on the album *Dire Straits*, which broke into the top of the charts five months after its release in the United States. Knopfler's studied lack of image suggested a shy side to his personality.

"Mostly, I have to remind myself of what I am and what I do," he allowed. "Music's about many things, not just the ability to dazzle people with a million notes."

Dire Straits embarked on its first North American tour, and "Sultans of Swing" became a fixture in the band's live performances. One show left Bob Dylan so impressed that he invited Knopfler and drummer Pick Withers to play on his next album. Knopfler was unaware of the religious nature of the material that awaited him; *Slow Train Coming* was Dylan's first effort since converting to Christianity. ■

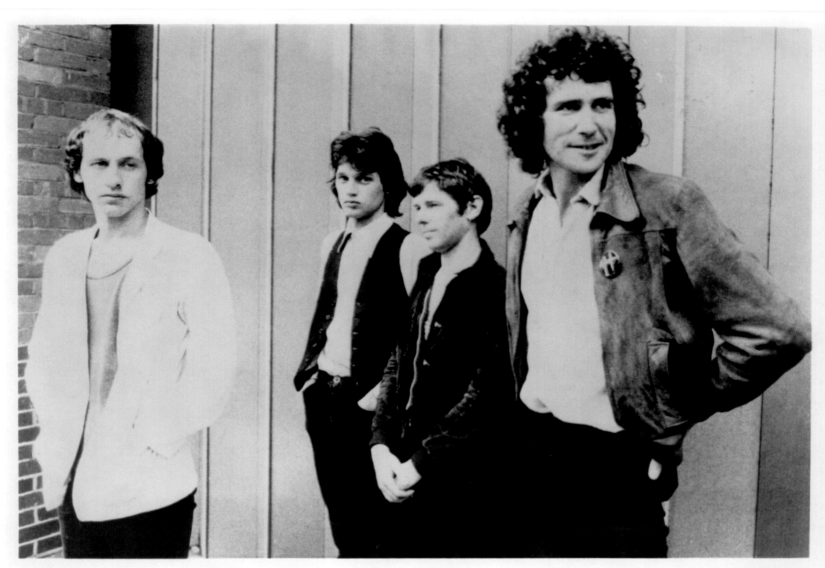

Dire Straits

WARNER / REPRISE

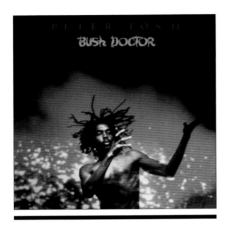

Billboard 200: *Bush Doctor* (#104)
Billboard Hot 100: "You Gotta Walk) Don't Look Back" (#81)

"(You Gotta Walk) Don't Look Back" certified Peter Tosh as one of reggae's best-known acts in America.

AS ONE of the original Wailers, along with Bob Marley and Bunny Livingston, Peter Tosh played a critical role in developing reggae music with his distinctive guitar work and the political and religious nature of his lyrics. The Wailers split in 1974, as reggae gained popularity in America. While Marley became known as the spearhead of the movement, Tosh remained closer to the Jamaican market and the ghetto-based grit of pure reggae. "Legalize It," his pro-marijuana anthem, was banned in Jamaica but became a hit anyway. *Legalize It* and *Equal Rights* matched the brilliance of Marley's more publicized work, but the albums lacked proper promotion in the US.

Tosh knew his music was "progressive," and he finally lucked into some benefactors—Mick Jagger and Keith Richards. The two Rolling Stones members were hardcore reggae fanatics; they signed Tosh to their Rolling Stones Records as the only act other than the label's chairmen of the board. Tosh admitted some reluctance about entering the American market in a big way, explaining his disdain for commerciality and the corruption of white people in general. He even denounced Marley as a "sell-out." As a Jamaican, Tosh's only interests were the Rastafari religion, potent marijuana—the "herb" had a sacred connotation for his people—and his music.

"I know the roots of reggae music and I know what it takes to make it be acceptable to universal people," Tosh said in his thick patois. "See, reggae is a music that goes through the ears and penetrate the mind. When you know how to construct the music that way with a scientific procedure, then you will get across to any kind of people no matter what race, color or creed."

Hanging out with the Stones mellowed Tosh's attitude slightly. Jagger and Richards served as executive producers for his album, *Bush Doctor*. The lead single, "(You Gotta Walk) Don't Look Back," was a vocal duet with Jagger, who showed up to perform it with Tosh on a *Saturday Night Live* appearance.

"Television, mon, is the one greatest thing the white man ever made," Tosh admitted. "Millions of people see that. You get across to more people in a shorter space of time." ■

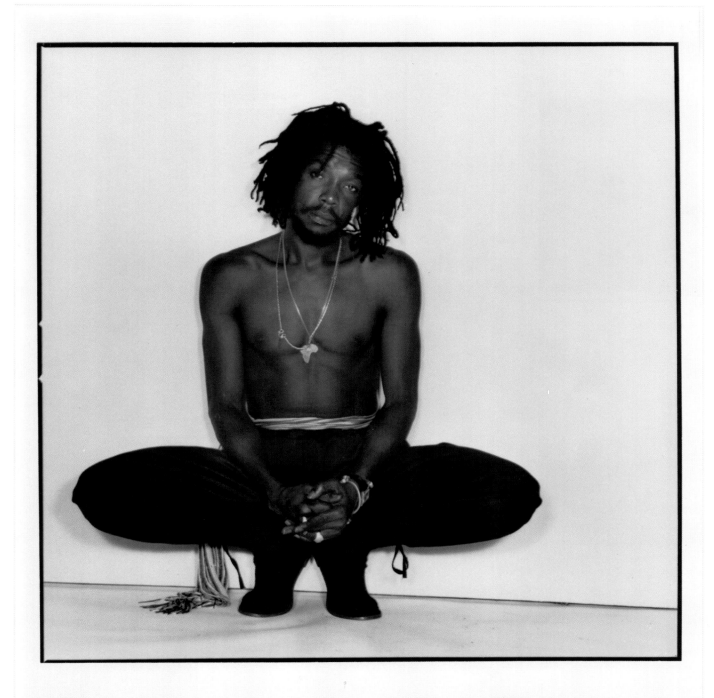

PETER TOSH

Rolling Stones Records distributed by Atlantic Records

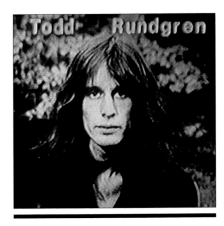

The entirety of his solo album *Hermit of Mink Hollow* was written and recorded by Todd Rundgren alone.

Billboard 200: *Hermit of Mink Hollow* (#36)
Billboard Hot 100: "Can We Still Be Friends" (#29)

THE SEVENTIES were a decade of multi-faceted artistry for Todd Rundgren, one of the first musicians to achieve prominence both as a multi-instrumentalist, singer and songwriter and as a record producer. He became a pop icon by tunesmithing the hits "Hello It's Me," "We Gotta Get You a Woman" and "I Saw the Light." As a producer, he guided such acts as Hall & Oates, the New York Dolls, Grand Funk Railroad and Meat Loaf to success.

Turning his back on simply attempting to make hit records, the "eccentric pop genius" delved into more experimental territory and progressive rock, trying something new with every album. On 1976's *Faithful*, he devoted one album side to near note-for-note replications of Sixties standards. Critics and music industry insiders revered Rundgren, but for all of his intriguing musical premises, the public still clamored for a return to his early melodic pop style.

"I've always had this thing about not taking orders," Rundgren said with a chuckle. "Even if I could perceive a consensus among my fans that would cause me to go in a certain direction simply to please them, there may be some natural contrariness in me that would cause me not to do so."

Rundgren had played all the instruments and sang all vocals on the first three sides of the 1972 double album *Something/Anything*, but *Hermit of Mink Hollow* was his first work to have no other musicians credited. The hit single "Can We Still Be Friends" was reminiscent of his straightforward pop ballads, telling the story of a failed relationship ending.

"Who knows how to choose a hit," he mused. "Is it consulting animal entrails or tea leaves?"

A techno-dabbler, Rundgren accompanied "Can We Still Be Friends" with an innovative self-produced music video. He also experimented with a quadraphonic sound system for his tour and organized the first interactive television concert, during which viewers at home could choose which songs would be played. ∎

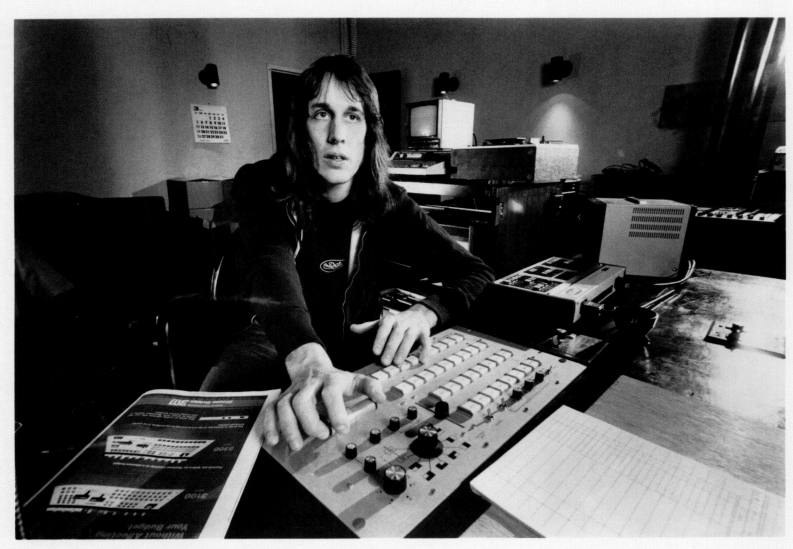

TODD RUNDGREN

On his debut album, Eddie Money came up a winner with "Baby Hold On" and "Two Tickets to Paradise."

Billboard 200: *Eddie Money* (#37)
Billboard Hot 100: "Baby Hold On" (#11);
"Two Tickets to Paradise" (#22); "You Really
Got a Hold on Me" (#72)

BORN EDDIE Mahoney, Eddie Money was a Brooklyn kid who played in garage bands and almost became a cop like his father and grandfather. But he quit the police academy and moved to the Bay Area, where he played in bands and was honing original compositions before Bill Graham made him the first signee to Wolfgang Productions.

"I'm American, I'm an ex-radical from the Sixties, and I'm broke. It's time for me as a capitalist to make some bread," Money offered in his best rapid-fire street talk. "I ain't got no light show, and I ain't got no smoke bombs. I just give 'em real rock 'n' roll. Graham might be the biggest rock impresario in the world, but all he gave me is a sign that lights up at the end of my live set that says 'Eddie Money.' It looks like 'Eat at Joe's.'"

The irrepressible Money established himself as a consummate record peddler, doing promotions and interviews prior to his live performances. His self-titled debut album charted with "Baby Hold On" and "Two Tickets to Paradise" getting tons of radio airplay.

"'Baby Hold On' and 'Two Tickets' are about my ex-old lady, who was a very rich sorority girl that left me for some doctor," Money explained. "At the time, I thought I was going to be a rock star, and I said, 'Hey, don't be thinking about what's not enough, just be thinking about what we've got.' I kind of represent American male inadequacy in a positive way. It's not like new wave, where 'I can't get a job, I wanna die…' No, that's not me. My thing is, 'Yeah, life stinks, but I've got two tickets to paradise...'

"I'm just a street kid who's always been into the art form of things. I feel real romantic, like I'm gonna die before I make it. I can't believe Graham's managing me, or CBS is recording me, or Premier Talent is booking me. I'm just waiting for it to turn into a pumpkin." ∎

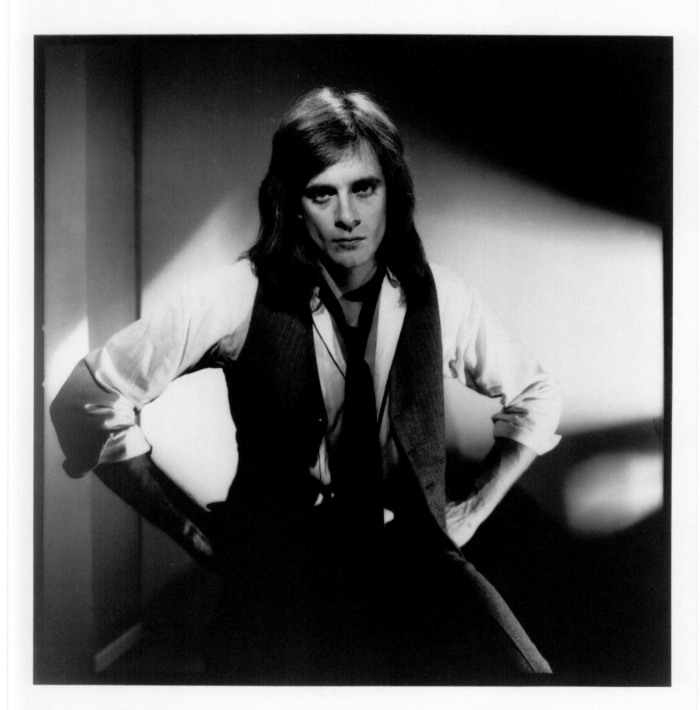

EDDIE MONEY

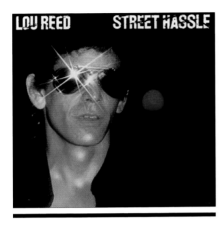

With the harsh grace of *Street Hassle*, Lou Reed renewed his music as a force not to be underestimated.

Billboard 200: *Street Hassle* (#89)

IN THE Sixties, Lou Reed made a splash as the leader of the Velvet Underground, an avant-garde group sponsored by Andy Warhol that also spawned John Cale and Nico. He wrote "Heroin," "Rock & Roll" and "Sweet Jane," and enthusiasts appreciated his riveting lyrical approach to life's darker side. After leaving the band in 1970, Reed started establishing himself as a solo artist, and with his signature song "Walk on the Wild Side" and the live album *Rock 'n' Roll Animal*, he was poised on the brink of mainstream stardom.

Reed's next move went down in record marketing history. Unhappy with his contract with RCA, in 1975 he released *Metal Machine Music*, a two-record set that consisted of nothing but unrelenting electronic noise.

"*Metal Machine Music* was one of my greatest artistic achievements," the defiant Reed insisted. "Someday people will look back on that album and realize how ahead of its time it was. I still play it all the time. I think of it as the Warhol Campbell's Soup Can of rock, y'know? Now I'm really getting into video. Whenever we arrive in a town, I set up all of my recorders and electronic games and monitors in my room, like a media center."

By 1978, Reed had signed with Arista, and *Street Hassle* renewed his enthusiasm for gadgetry. The album, which balanced between live and studio recordings, was the first commercially released rock album to employ binaural recording technology, using two microphones arranged with the intent to create a 3-D stereo sound sensation for the listener when played back through headphones.

"Basically, it's a way of getting more information on tape," Reed explained. "Binaural recordings reproduce sound placement just like it was performed live. We modified it into a stereo recording, so it's kind of unique."

Street Hassle's title track was divided into three distinct sections; the third, "Slipaway," contained a brief, spoken-word section by Bruce Springsteen that was not credited in the liner notes. Both *Street Hassle* and a live album, *Live: Take No Prisoners*, were released in the midst of the punk scene Reed had inspired.

"Are any of the new groups today just doing what ol' Lou was doing years ago? Well, yeah. But that's okay." ∎

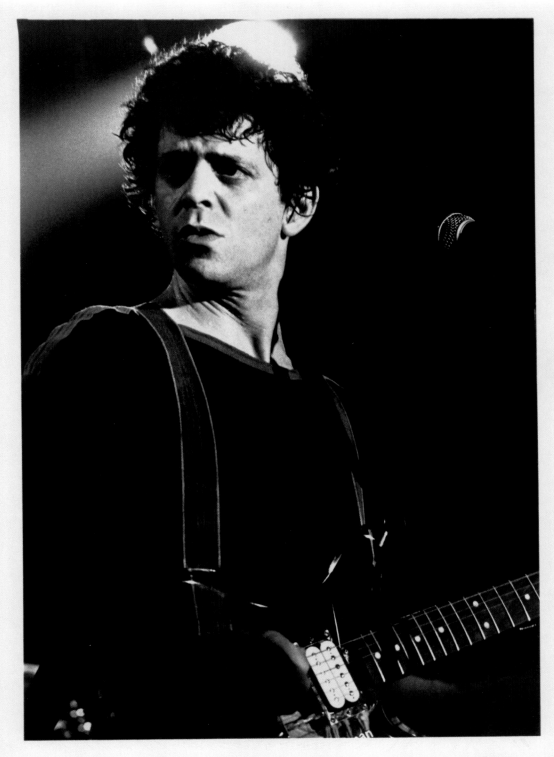

LOU REED

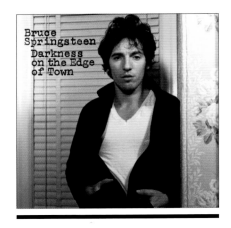

Billboard 200: *Darkness on the Edge of Town* (#5)
Billboard Hot 100: "Prove It All Night" (#33);
"Badlands" (#42)

Darkness on the Edge of Town noted Bruce Springsteen's increasing intellectual and political awareness.

ON HIS first three albums, Bruce Springsteen was known for raw, rapid-fire lyrics, outsized characters and long, multi-part musical compositions. He had found success with *Born to Run*, exploding into a wave of publicity—he appeared on the covers of both *Time* and *Newsweek* on the same week in October 1975.

Darkness on the Edge of Town marked the end of a three-year gap between albums brought on by contractual obligations and legal battling with his former manager. *Born to Run* had concerned the relationship between a boy and girl; *Darkness* found the boy alone. "Prove It All Night" and "Badlands" were sparer and more carefully drawn than his past songs.

"Yeah, I found I had invented a bunch of characters after I com-pleted *Born to Run*," Springsteen explained. "I decided that I had to follow up on the identities that I had given them, because they all represent an emotional side of me. So *Darkness* tried to resolve that—I was influenced by movies a lot at that time, so the record was paced like that, ending with the guy all alone dealing with his isolation."

Springsteen had seen *The Grapes of Wrath*, John Ford's great Forties film adaptation of John Steinbeck's novel about the displaced Okies of the Thirties who moved west to get work as migrant workers but found only oppression, disenchantment and death.

"I was sitting there thinking, 'Yeah, that's what I want to do,'" Springsteen reflected. "I want to do some work that gets into people's lives and means something, if I can." ∎

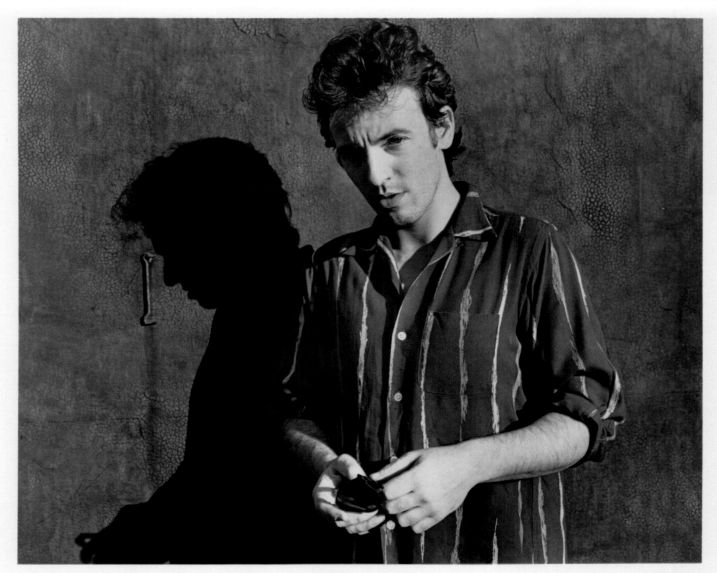

Bruce Springsteen

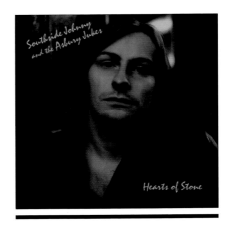

Billboard 200: *Hearts of Stone* (#112)

Southside Johnny & the Asbury Jukes' enlivening music distilled the vitality of classic rhythm & blues.

"SOUTHSIDE" JOHNNY Lyon sounded true to his background—a white man who grew up listening to the drama, emotion and humor of black music. His record collection was an astounding maze of vinyl dotted with names like the Flamingoes, the Cadillacs, the Valentines and more classic and obscure artists of the Fifties and Sixties.

"That's my inspiration. I want to do thousands and thousands of those songs," Lyon said. "What's happened is that people have lost sight of influences and roots. We blend rock 'n' roll and the R&B sound from the Fifties and the soul from the Sixties and what we hear today. When we do old songs, it's because we believe they're great songs. When you build on something that's gone before that really moves you, that's when you're going to move forward. And that's what our band is all about."

Some of Lyon's New Jersey friends, namely Bruce Springsteen and his guitarist "Miami Steve" Van Zandt, shared the same passion. Lyon played in bands around the Garden State until the time was right for the Asbury Jukes. He and Van Zandt kept the rhythm section from Lyon's old band and built from there.

Before the recording of the outfit's first album, *I Don't Want to Go Home*, Van Zandt left to work with Springsteen's E Street Band. "It was a good move for him," Lyons said with a grin. "Our future was uncertain, and Bruce's looked pretty good."

Van Zandt continued to spend all of his time off the road working as producer and songwriter for the Jukes, remaining an integral part of the group's concept. Van Zandt's songs were perfect vehicles for Southside Johnny's voice and the passionate, hard-driving backup provided by the Jukes. The first two albums featured guest vocals from Lee Dorsey, the Drifters, the Coasters and the Five Satins.

A breakthrough seemed imminent on the third album. Leaving guest appearances and any nostalgic trappings behind, the band wrote and recorded *Hearts of Stone* in collaboration with Van Zandt as well as Springsteen, who also donated two more songs—the title track and "Talk to Me," which was released as a single. But the tune didn't make the charts, and the album did not sell well enough for Epic Records to renew the Jukes' contract.

"Everybody always underestimates the American listening public, saying they won't like anything different from what they're used to," Lyon conceded. "I think they like anything that's sincere, and if there's one thing about our albums, we're really sincere about them. We try our best, and I think it comes across." ∎

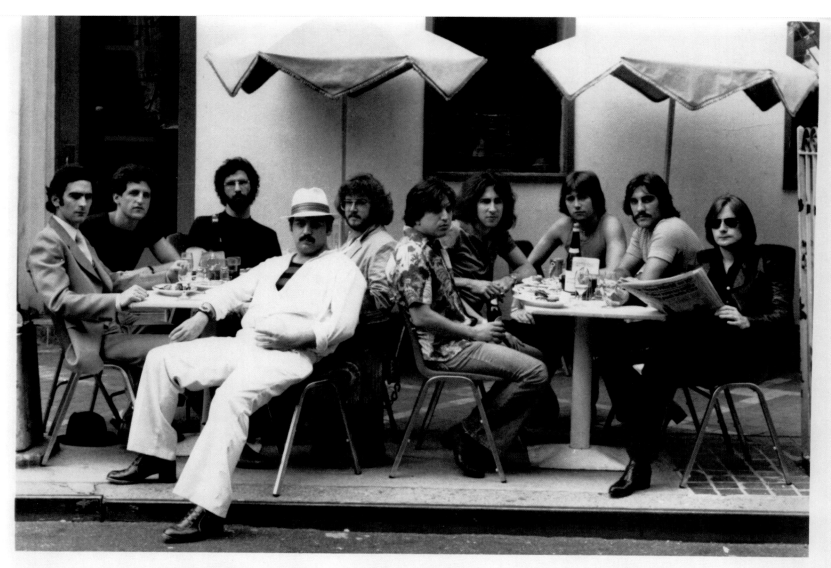

LEFT TO RIGHT· Ed Manion, Billy Rush, Alan Berger, La Bamba, Kevin Kavanaugh,
Rick Gazda, Stan Harrison, Steve Becker, Bob Muckin, Southside Johnny

SOUTHSIDE JOHNNY and the ASBURY JUKES

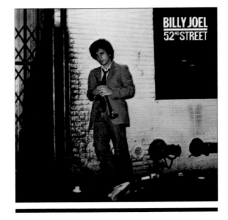

52nd Street, Billy Joel's first chart-topping record, won him two Grammys, including Album of the Year.

Billboard 200: *52nd Street* (No. 1)
Billboard Hot 100: "My Life" (#3); "Big Shot" (#14);
"Honesty" (#24)

AFTER A dozen years of pursuing a career in music, Billy Joel hired Phil Ramone as a producer and used his touring band in the studio. Suddenly the feisty singer-songwriter and pianist found himself at the summit of the pop heap with 1977's *The Stranger*. Four singles from the breakthrough album charted—"Just the Way You Are," "Only the Good Die Young," "Movin' Out (Anthony's Song)" and "She's Always a Woman"—and "Vienna," "Scenes from an Italian Restaurant" and the title track became some of his most celebrated compositions.

"I'm proud of it, but I didn't sit down and say, 'I'm gonna write four hits for this album.' I just wrote songs," Joel said. "I think touring had a lot to do with everything. We started doing larger halls, and the material went over great in concert and the album took off. I didn't want to do the big rooms 'cause I'd seen too many groups that couldn't pull it off. They go on automatic pilot and have to use schtick—lasers and smoke bombs and crab monsters. I didn't want to get into that. I've got an audience that listens."

With everyone paying attention, expectations ran high for Joel's next album, *52nd Street*.

"But one of the things we wanted philosophically was not to do *The Stranger* again, the way to play it safe— 'Scenes from a Polish Restaurant' or something."

Three songs contributed to the album's success—"My Life," "Big Shot" and "Honesty."

"'Big Shot' is me talking about myself. Not Billy Joel, but about anybody who's ever had a hangover. I have researched this song many times. I wake up—'What did I do last night?' 'You were a jerk...'"

"Honesty" led some critics to brand Joel a balladeer, a label he thought was unfair and insulting. He was seen in his publicity photo looking punkish in a leather jacket; onstage he still opted for a suit jacket and loosely knotted tie.

"It's a thank-you gesture toward the audience that paid for a show, but I still wear them with my sneakers and blue jeans," Joel said. "If I ever get to acting like one of those big prima-donna rock stars, just kick me. Whatever else, I'm in it for the music. What's going on now isn't my idea of success. Being able to make a living as a musician to begin with is a miracle. If you like it, that's success. If you think you're good at it, that's success. If you pay your bills and stay out of debt, that's success. Everything else is a numbers game. That's a manager's success, an agent's success. I'm gonna do this my whole life. I'm not gonna be a five-year burnout." ■

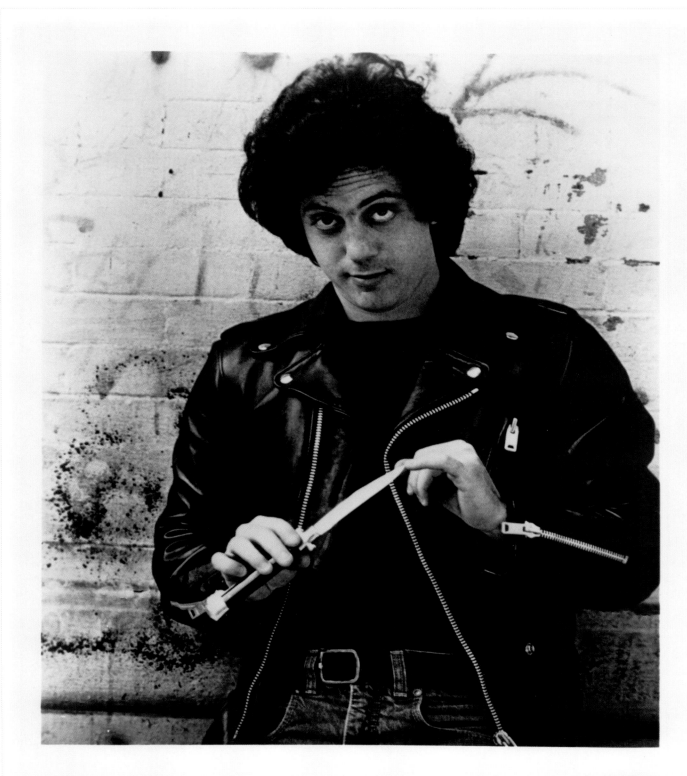

BILLY JOEL

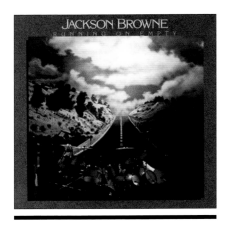

Billboard 200: *Running on Empty* (#3)
Billboard Hot 100: "Running on Empty" (#11);
"Stay"/"The Load-Out" (#20)

The title track and "The Load-Out"/"Stay" made *Running on Empty* Jackson Browne's greatest success.

OF ALL the singer-songwriters from the movement's Seventies heyday, Jackson Browne was the master of elevating the emotional landscape—in all its small, significant detail—along the hard road to romance. He became the eloquent, talented troubadour of choice for earnest college girls and the guys who wanted to impress them.

After his 1972 self-titled debut album produced a surprise hit with "Doctor My Eyes" (composed on a piano with a bad key that would flop twice, giving him its unusual beginning), Browne then engraved his niche in American rock music with the classic albums *For Everyman*, *Late for the Sky* and *The Pretender*. The Californian exposed aspects of his life that most people try to keep hidden.

"There was a point when things coalesced for me, when I wrote the songs for my first album," he recalled. "I heard about the death of a friend, and I sat down and wrote 'Song for Adam.' I didn't know him very well, but I recounted a brief friendship and his passing, from grace or fate. That was the beginning, to discuss something like suicide…it touches you somewhere deeper."

Breaking the usual conventions for a live album, Browne released *Running on Empty*, his innovative concept album about life on a cross-country tour—recorded onstage, backstage, in hotel rooms, even on the tour bus. "The Load-Out"/"Stay" was his sendoff to concert audiences and roadies. Accompanist David Lindley came through with a first-rate falsetto chorus of "Stay" to Browne's delight.

"He was supposed to do it just like we mapped it out, but when he actually did it, it blew us away," Browne said. "Some things surprise you when they work out better than they were planned." ■

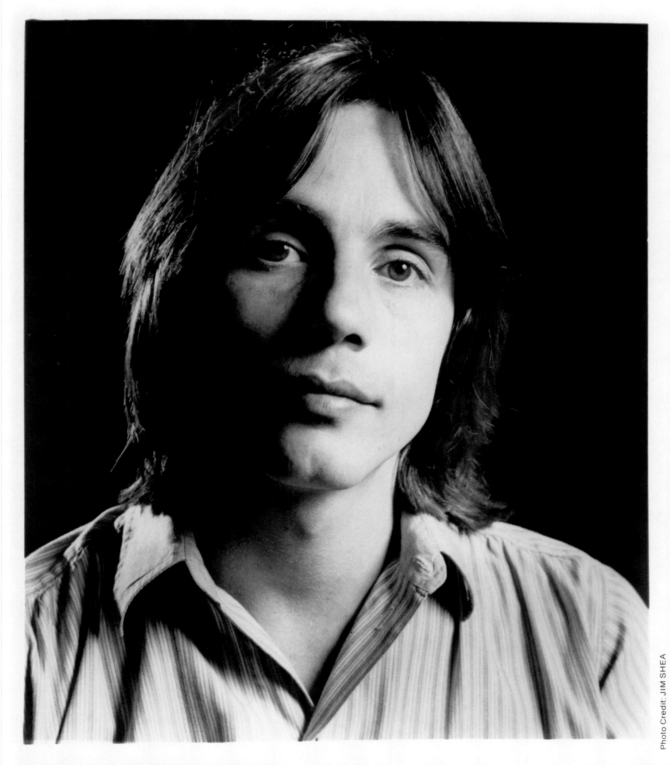

JACKSON BROWNE

One of Southern California's toughest, quirkiest figures, Warren Zevon issued the album *Excitable Boy*.

Billboard 200: *Excitable Boy* (#8)
Billboard Hot 100: "Werewolves of London" (#21)

WARREN ZEVON had spent the early part of his career absorbing classical influences, learning piano and then guitar, writing jingles and performing overseas. Jackson Browne had a hand in producing his first two major-label albums—a self-titled debut and *Excitable Boy*—but despite Browne's patronage, it was obvious that Zevon was more genuinely eccentric than his compadre and the other singer-songwriters of the era. Stretching the limits of pop craft, he seemed to draw his primary inspiration from Dashiell Hammett's cold-blooded prose and Ross Macdonald's tragic romanticism.

"I made a decision very early that the only way I could stay approximately sane was to work as a solo act," Zevon said. "Whether that's evolved out of a desire to be Bob Dylan or Dylan Thomas or just logic, that's how I've always felt. I've stuck with it many years, from circumstances which range from kids now banging on the glass to get into a show to making $3 a night singing at a bar in Spain. I've just wanted to be myself."

Zevon released *Excitable Boy* to critical acclaim and commercial attention. "Werewolves of London" was a relatively lighthearted version of Zevon's signature macabre outlook, and "Lawyers, Guns and Money," the fatalistic "Roland the Headless Thompson Gunner" and the title tune received heavy FM radio airplay. For his twisted humor and the violent self-destructiveness depicted in his songs—and with an album sporting a graphic of a gun lying on a dinner plate—the irrepressible wordsmith earned the moniker "the Sam Peckinpah of Rock." But Zevon was just as readily dubbed "F. Scott Fitzevon" for his legendary capacity for vodka ("It's my family fluid—we used to be the Zevotovskys") and erratic performances that undercut his artistry.

"I don't think you can make preferences between writing and performing. It implies that a human being can only have one interest," Zevon said. "When you write a song, you're essentially entertaining yourself. But then you want what entertains you to entertain other people; it's a whole other level of gratification. My physician has informed me, with a certain dim glimmer of glee in his eye, that I have ripped a ligament doing my John Travolta thing—I probably never should have gone to see *Saturday Night Fever* two weeks before the tour. I've been kinda overextending myself, but the rest of it is instinctual, just a combination of self-expression and totally irrational, berserk behavior." ■

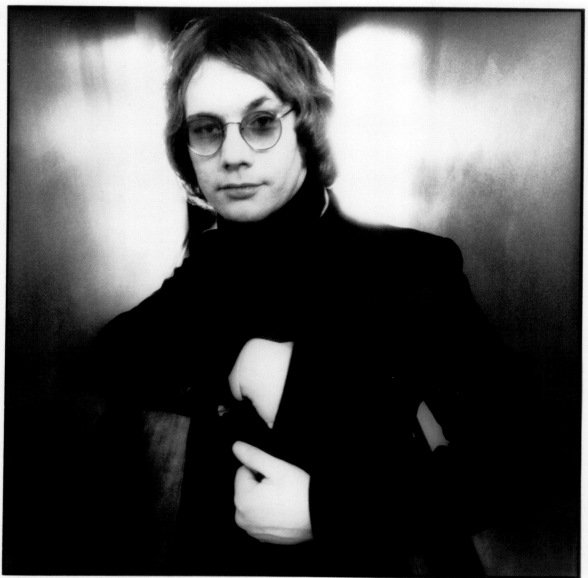

WARREN ZEVON

asylum

Randy Newman had never charted a single before, but his satirical "Short People" invited controversy.

Billboard 200: *Little Criminals* (#9)
Billboard Hot 100: "Short People" (#2)

ONE OF the most perceptive and subtly outrageous songsmiths of the rock era, Randy Newman was a complex, self-effacing man who had waited for years for listeners to come to terms with his uningratiating style. Known for his distinctive voice and mordant pop songs, Newman's wry, ambiguous manner had always set him apart from his peers. Born of a musical family (his uncles Alfred, Emil and Lionel Newman composed numerous Hollywood film scores), Newman was a successful professional arranger before embarking on a songwriting career.

On his own albums, Newman sang his half-bitter little oddities in a froggy mumble, but he complemented his barbed clichés and hilariously absurd presumptions with a sophisticated musicality. Newman's storytelling often featured quirky characters and cynical views, and his recordings included masterpieces of startling ambiguities and compassion that were unequalled in pop. Such classics as 1969's *Randy Newman* (a pioneering album featuring a large orchestra), 1972's *Sail Away* (a tour de force of social satire) and

1974's *Good Old Boys* (a series of thematically linked songs about the South) secured his reputation for pointed, oblique tunes.

"When a song works, the audience understands the character's point of view, and they don't mistake it for mine," Newman said.

Little Criminals contained the surprise smash "Short People," which became a subject of controversy. As with many of his songs, Newman wrote it from the perspective of a biased individual, a prejudiced attack on short people. Many listeners, including members from organizations supporting the rights of dwarfs, misunderstood it, wrongly assuming it reflected Newman's personal viewpoint. They mistook the satire on bigotry for bigotry itself, and, somewhat ironically, "Short People" became his biggest hit.

"A lot of my characters are insensitive. They don't know what they're saying, how they indict themselves," Newman mused. "I like the idea of the untrustworthy narrator. The people in my songs are generally exaggerations. What they say and think is colored by who they are." ∎

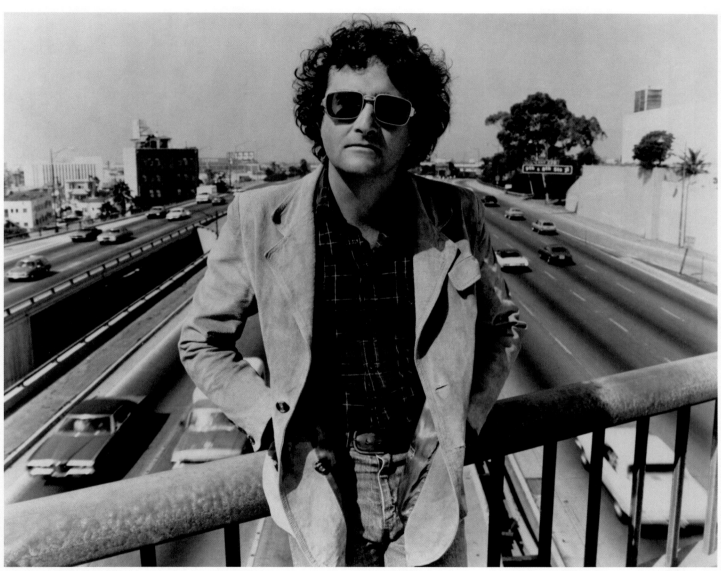

RANDY NEWMAN

WARNER BROS.

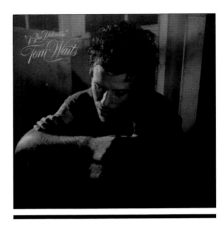

Billboard 200: *Blue Valentine* (#181)

Tom Waits, a lauded albeit unusual songwriter, revealed a significant musical shift with *Blue Valentine*.

BALLADEER TOM Waits was characteristically contemplative about growing up in Whittier, California.

"I've got a lot of preachers and teachers in my family," he said. "Had I chosen to be a minister, I would have had a lot more encouragement from most of them, I can guarantee you that. I was going left-of-center, the way they viewed it. I used to sleep out in the orange groves with the migrant workers, sit by the fire at night and listen to their stories and songs. My dad is from Texas, loved Woody Guthrie—one of the earliest songs I learned is 'So Long, It's Good to Know You.' My mom was in a little church singing group, real close harmonies like the Andrews Sisters, that was popular in those days. I remember the record collection at home as being Frank Sinatra, Belafonte—no blues."

Waits' career began when talent manager Herb Cohen discovered him at a "hoot night" at the Troubadour in West Hollywood. In 1973 he released his debut album, *Closing Time*, and he was soon designated the next big thing in the booming Southern California singer-songwriter movement occupied by Jackson Browne and the Eagles (who covered Waits' "Ol' 55" on their *On the Border* album). But Waits fought tenaciously to separate himself from convention, delivering detailed skid-row monologues and singing his songs in a bourbon-fed, cigarette-damaged voice.

"Sometimes it's good when people come in with a preconceived idea of what you're gonna be—you can surprise them," he said. "You wait a long time to make a record and you think that's a big deal. And you look around and you're one of a lot of people who've made records. So you take it to the next level."

For part of the Seventies, Waits resided at West Hollywood's fabled Tropicana Motel and forged a genteel neo-beatnik image, with a halo of smoke and three-day stubble ringing his low-slung cloth cap and pointed shoes. But he backed his persona with real musicianship, writing durable melodies and impressionistic lyrics. His fifth album, *Blue Valentine*, featured "Christmas Card from a Hooker in Minneapolis," "Romeo Is Bleeding" and "Kentucky Avenue." The woman pictured with him on the sleeve art was singer-songwriter Rickie Lee Jones, with whom he was having a relationship. ■

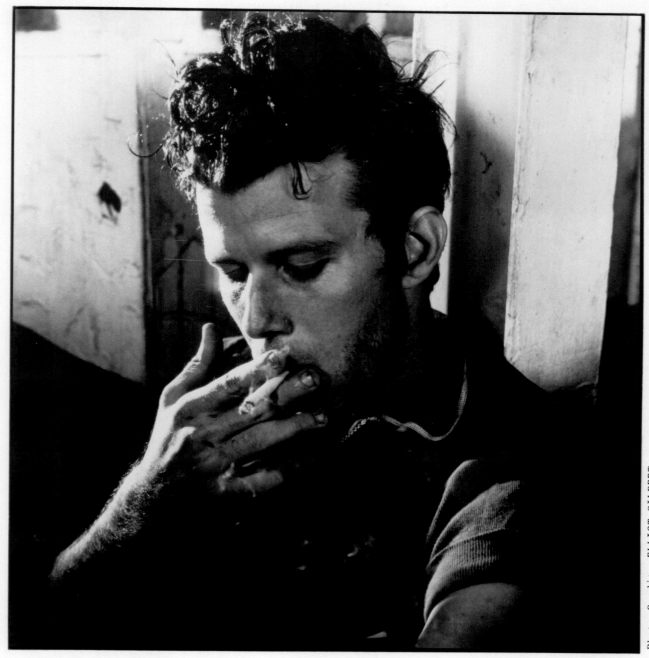

TOM WAITS

asylum

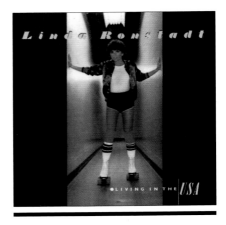

Billboard 200: *Living in the USA* (No. 1)
Billboard Hot 100: "Back in the U.S.A." (#16);
"Ooh Baby Baby" (#7); "Just One Look" (#44)

Linda Ronstadt remade the Motown standard "Ooh Baby Baby" and Chuck Berry's "Back in the U.S.A."

LINDA RONSTADT established her career at the forefront of California's emerging folk rock and country rock movements. With the release of the chart-topping albums *Heart Like a Wheel* and *Simple Dreams*, she became the first female "arena-class" rock star, a top-grossing concert artist. *Living in the USA* was her third No. 1 on *Billboard*'s album chart and the first album in history to ship double platinum (for two million copies).

By 1978, the attractive Ronstadt's image had become as famous as her music; she'd appeared multiple times on the covers of *Rolling Stone*, *Time* and *Newsweek*, referred to as the "Queen of Rock" and the "First Lady of Rock." *Living in the USA*'s cover photograph of Ronstadt in a satin exercise outfit increased the popularity of roller skating in the US.

But her impact on popular culture took its toll.

"I never go out that much—I have to find more private pathways," Ronstadt said. "I don't like people to know my business; it's not good for the music. What I do personally shouldn't interfere. I think people should be able to attach their own private dreams to whatever the songs are. If there's too much of what party you were at last night, it gets a little distracting.

"But people are curious, they want to know—and there's no way to avoid a little of that unless you want to be a mole." ∎

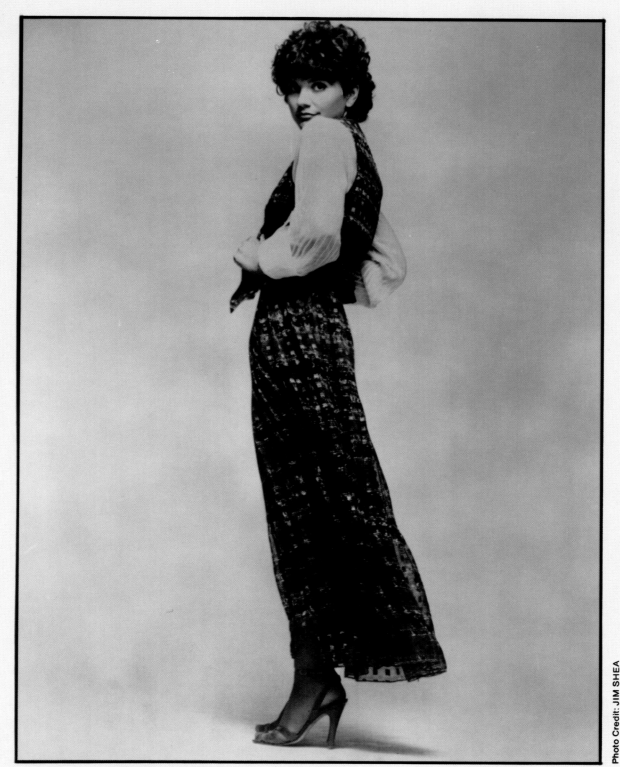

Photo Credit: JIM SHEA

LINDA RONSTADT

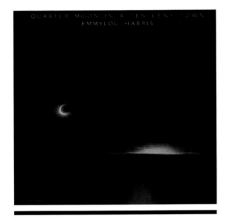

Quarter Moon in a Ten Cent Town took **Emmylou Harris'** vision of country music to a greater audience.

Billboard 200: *Quarter Moon in a Ten Cent Town* (#29)

EMMYLOU HARRIS first established herself adding heart-tugging harmonies to the "cosmic American music" of Georgia-bred Gram Parsons, a country-soul singer-songwriter who had been a member of the Byrds and Flying Burrito Brothers before releasing a pair of solo albums. Harris' clear soprano perfectly complemented Parsons' lived-in lead vocals.

Touring briefly with Parsons and the Fallen Angels in the winter of 1972 and the following spring, Harris came into prominence as a decorous honky-tonk angel. Parsons' fatal overdose in September 1973 fixed the 26-year-old musician as a legend. It also marked the end of Harris' apprenticeship, and the profound experience gave her a sense of purpose and mission.

Although she topped the country charts in America with ease, Harris' inability to break through to a contemporary audience was somewhat baffling—especially considering the enthusiasm of her European fan base.

"I had a following over in England and Europe before I did in the States; I feel kind of a commitment to folks over there," she admitted. "I didn't really get into country music until I met Gram Parsons. The whole thing he started when the popularity of the Flying Burrito Brothers made him quite a superstar in Holland and England. They were aware of me from my singing on his albums, so there's always been an interest in my music because of him."

The album *Quarter Moon in a Ten Cent Town* signaled a slight change in direction from Harris's previous three albums. Rather than mixing classic and contemporary, she recorded recent songs from a wide variety of writers. "Two More Bottles of Wine," penned by Delbert McClinton, became her third single to top the country singles charts. "To Daddy," written by Dolly Parton, went to #3.

Singers such as Parton and Linda Ronstadt had discovered how pop trappings could be applied to traditional country material and broaden their appeal. Harris had always worked with producer Brian Ahern, whom she married in 1977, and many of the same musicians. She interpreted her solidarity with Ahern and her Hot Band as a plus, not a limitation to artistic growth.

"They really know how to put across my music and my ideas—we complement each other very well," she insisted. "I haven't worked with anyone else, but I'm completely satisfied. Over here, I'm not like Dolly or Linda—my appeal seems limited to country audiences. But they've been extremely loyal, too." ■

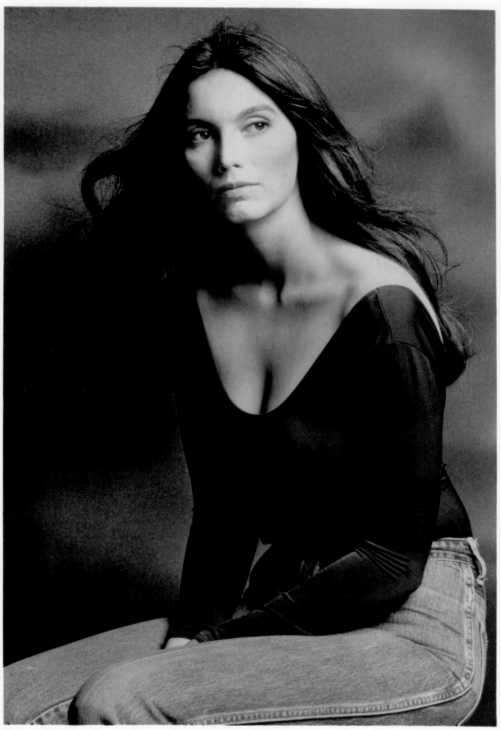

EMMYLOU HARRIS

WARNER / REPRISE

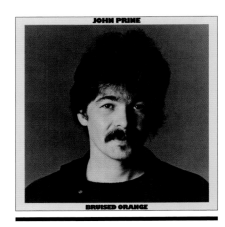

Billboard 200: Bruised Orange (#116)

John Prine managed another smart, artistic album with the expressive and articulate *Bruised Orange*.

JOHN PRINE came out of working-class Chicago in the early Seventies, a folk-based singer-songwriter who produced rewarding and interesting albums while confronting the label of "the new Dylan." He'd not only worked as a letter carrier for the post office but served in the Army, so his poignant, sentimental writing reflected a cutting cynicism.

"I wrote a good deal of my first album on my mail route," Prine said. "Once you're on the right street, it's like being in a big library without any books. Without bad weather or the occasional dog, it's mundane."

Through songs that were simultaneously detailed and funny, Prine forged a reputation as a respected songwriter and performer. The prime Prine included "Illegal Smile," "Sam Stone" (about the abuse of Vietnam vets), "Angel from Montgomery" (which was covered most famously by Bonnie Raitt) and the wry ballads "Dear Abby" and "Donald and Lydia."

After recording four critically acclaimed albums for Atlantic, Prine was principally regarded as a minor cult figure, and his disappointment was palpable. He then signed to Asylum Records and turned to his friend and fellow Chicago songwriter Steve Goodman to produce his fifth album. The release of *Bruised Orange*, perhaps his most intelligent, blue-collar work, was viewed as a creative high point, giving listeners songs such as "The Hobo Song," "Sabu Visits the Twin Cities Alone" and the title track.

"When I made *Bruised Orange*, they gave me crates of oranges as a promotional gimmick," Prine said. "So that's why I made the *Pink Cadillac* album, but I never did see a car—not even to pick me up at the airport." ∎

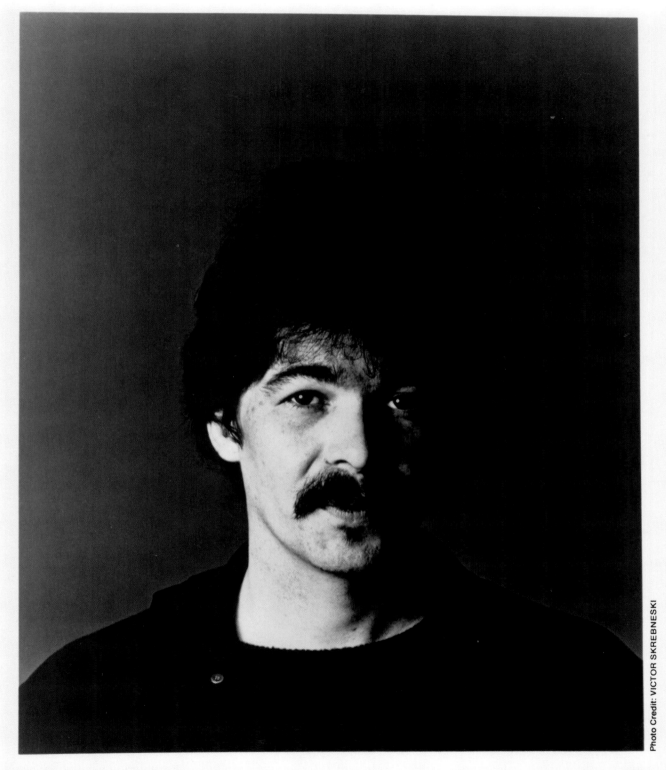

JOHN PRINE

asylum

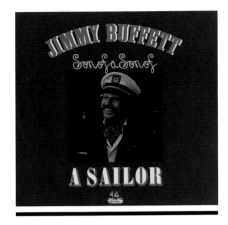

Jimmy Buffett played up his fondness for drunken wisdom with the hit single "Cheeseburger in Paradise."

Billboard 200: *Son of a Son of a Sailor* (#10)
Billboard Hot 100: "Cheeseburger in Paradise" (#32);
"Livingston Saturday Night" (#52); "Mañana" (#84)

JIMMY BUFFETT'S music was his vehicle to express humorous lyrics and a celebration of the hedonistic lifestyle. From a base of hardcore fans that enjoyed his friendly outlaw image, his following swelled gradually to reach major proportions. Together with the Coral Reefer Band, he recorded *Changes in Latitude*, a million-selling album, and the whimsy of the breakthrough hit "Margaritaville"—a perfect example of his charming brand of let's-go-down-to-the-Caribbean escapism—shot him into the national spotlight.

"I worked by myself for a long, long time just doing clubs and getting by," Buffett reflected. "When I first started the band, we were broke all the time. There's just a big step that everyone takes where you find out what you want to do, so we wanted to work incessantly. The way I do records is that I try to do all of my homework ahead of time and be just as prepared as I can be. Every album has been done within six weeks."

Son of a Son of a Sailor continued in the laid-back vein Buffett had established over the years. "Cheeseburger in Paradise" became one of his signature songs and a concert favorite. Buffett was still a performing animal first and foremost, and *You Had to Be There*, a double-live album, was released at the time "Cheeseburger in Paradise" was at its peak in popularity.

"I always thought that I didn't want to play big halls, but when it's my crowd, I don't lose as much intimacy as I thought I would," Buffett said. "I do a half-hour acoustic set in the show and it works as well in front of 12,000 people as it does for 3,000. I wouldn't ever forgive myself if I didn't go take a shot. I look at my crowds and see such a chronological cross-section of people from 16 to 60 out there. I like that. If I'm still having fun in ten years, I'd still like to be doing it." ∎

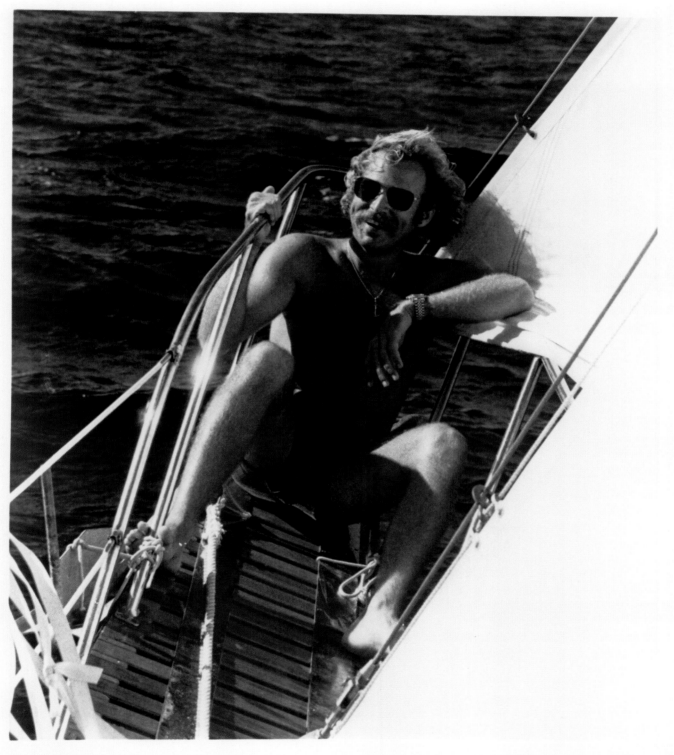

JIMMY BUFFETT

FRONT LINE
MANAGEMENT COMPANY, INC.
9128 SUNSET BOULEVARD, LOS ANGELES, CALIFORNIA 90069, (213) 278-0211

RECORDS

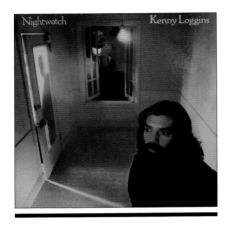

Kenny Loggins' *Nightwatch* included the hit "Whenever I Call You 'Friend,'" a pairing with Stevie Nicks.

Billboard 200: *Nightwatch* (#7)
Billboard Hot 100: "Whenever I Call You 'Friend'" (#5)

FROM HIS early days as one-half of Loggins & Messina, Kenny Loggins had been one of pop music's top singer-songwriters. "Danny's Song," "House at Pooh Corner" and "Your Mama Don't Dance" were among the well-known hits the duo created before amicably parting to pursue solo careers.

"Jimmy Messina's influence was very strong in the group, especially the country aspect of it," Loggins said. "He's a Texas boy, and his Telecaster sound was very identifiable. For some reason, I got very heavily into writing ballads, while Jimmy had the uptempo things."

Embarking on his own, Loggins enlisted Bob James, the noted jazz-rooted pianist, as a producer. "I didn't want to sound like Loggins & Messina without Messina," he explained. "I wanted to make a clean break. I reasoned that Loggins & Messina was a guitar-oriented band—all of our songs were written for and arranged on guitars. If I brought in a guy like Bob, whose expertise is on piano, I could compose on guitar for him to interpret on piano. That way the players heard the songs with a fresh sound without basing them on my past."

Loggins collaborated with many people lyrically and musically on his albums. He co-wrote "Whenever I Call You 'Friend'" with singer-songwriter Melissa Manchester, but the vocal trade-off between him and Stevie Nicks of Fleetwood Mac propelled the song into the Top 10.

"Stevie and I had been talking about singing a duet for quite a while," Loggins related. "It was a melody that I brought home off the road with me, and Melissa helped me finish the lyric on it. It was a difficult decision to make—I felt very strongly that this was the tune for Stevie and me, and no matter who I had written it with, I had to structure it for Stevie's voice."

Loggins & Messina had a reputation for being an exciting live act, and Loggins carried on that concept. "I feel the same kind of audience now—basically college-aged, mostly girls," he admitted. "There's a lot of country out there. At this point, I'm so tired. I don't want to be overly dramatic, but anybody who has been touring too long starts writing songs about how fucked up it is on the road. And I hate those songs." ■

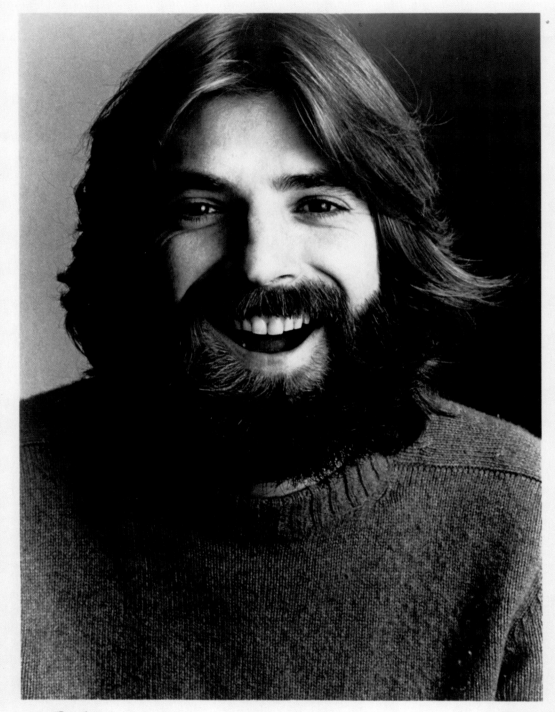

Kenny Loggins

COLUMBIA

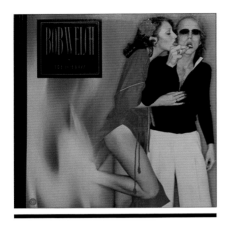

The positive response to Bob Welch's *French Kiss* album renewed interest in his Fleetwood Mac output.

Billboard 200: *French Kiss* (#12)
Billboard Hot 100: "Sentimental Lady" (#8);
"Ebony Eyes" (#14); "Hot Love, Cold World" (#31)

BEFORE THE addition of Stevie Nicks and Lindsey Buckingham propelled Fleetwood Mac into superstardom, Bob Welch was a creative force in the band. Welch, who sang, composed and played guitar for the Mac on five albums, was the man behind standards such as "Sentimental Lady" and "Hypnotized." He endured a dark chapter in the band's history when a former manager put a bogus Fleetwood Mac on the road in 1974.

"There was a lot of pressure building up because of the lawsuit that followed," Welch said. "It was real nerve-wracking, since we were rapidly running out of money, the record company was upset, and we were spending all of our time in lawyers' offices. It got a little hairy. We finally moved to Los Angeles, made the *Heroes Are Hard to Find* album, and did a three-month tour. After all of that, I was completely burned out. I didn't have another song left to write for a while, and I just told the band that I had come to the end of the line. In hindsight, it was the only thing I could have done."

Welch formed the rock trio Paris, which put out two records and then disbanded. The release of Welch's first solo album, *French Kiss*, focused attention on his reworked version of his signature song, "Sentimental Lady," which first appeared on Fleetwood Mac's *Bare Trees*. It reunited Welch with his ex-cohorts Mick Fleetwood and Christine McVie, with Lindsey Buckingham lending a production, vocal and guitar assist.

"I already had the album done, but I decided to go in and cut tracks with them to use in place of some others," Welch revealed. "But we didn't have time—just to get 'Sentimental Lady,' I had to follow the band up to Toronto and then return to Los Angeles to mix it."

Although Welch insisted he never planned on a solo career, "Sentimental Lady" created quite a stir, and the second and third singles released from *French Kiss*—"Ebony Eyes" and "Hot Love, Cold World"—also reached the charts.

"As long as I've started this and made the statement, I'm not going to jump back into a band," Welch said. "My career has taken some weird turns, but this feels awfully good." ∎

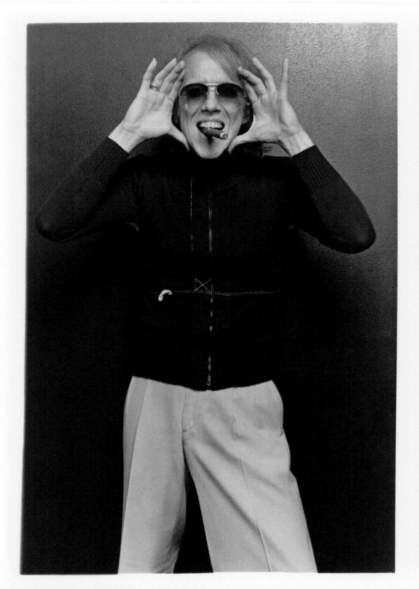
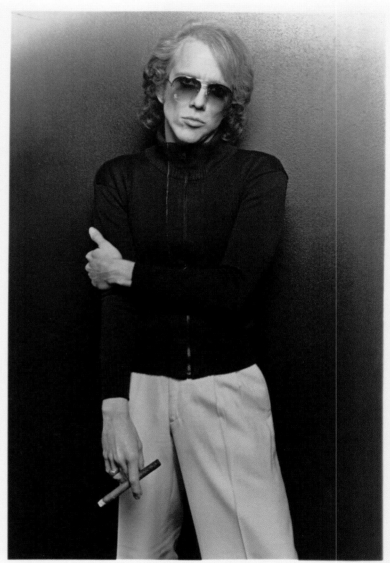

BOB WELCH

Photo: Olivier Ferrand

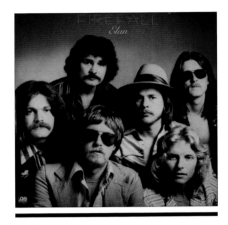

Billboard 200: *Élan* (#27)
Billboard Hot 100: "Strange Way" (#11)

Firefall's commercial hot streak continued with the hit "Strange Way" and a platinum album for *Élan*.

FOUNDED IN Boulder, Colorado, in the summer of 1974, Firefall began as a collaboration between singer-songwriter Rick Roberts and guitarist Jock Bartley. The group's soft rock blend of country and pop reached a commercial peak with "Livin' Ain't Livin'," "Cinderella," "Just Remember I Love You" and the band's biggest smash, "You Are the Woman."

Élan was Firefall's third album. As with its predecessor, *Luna Sea*, the band discarded certain tracks and added new ones at the last minute. Mick Fleetwood of Fleetwood Mac, who managed Firefall for four days before amicably annulling the contract ("too much going on" was the excuse), convinced the group to go back into the studio.

"On *Luna Sea*, the record company wasn't totally satisfied. On *Élan*, it was dissatisfaction on the band's part," Roberts said. "Mick told us straight out that we should work on it some more. We all made up our minds with various degrees of swiftness that maybe it was a good idea. I must say I was the last one. But it was a godsend. It's a much stronger album for it."

Firefall added strings to the hit "Strange Way," and recorded four new songs. There was broad populist acceptance for a rock 'n' roll band that avoided the trappings of glitter or heavy metal flash in favor of acoustic guitars, mellow pop melodies and vocal harmonies. However, Firefall's success with softer ballads stereotyped the group.

"Someone along the chain of consumption—be it in merchandising, radio or the actual listening audience—preferred that we be a ballad band," Roberts said. "In the short run, the 'Colorado sound' was a good marketing tool. In the long run, musical styles and fads come and go. When the Colorado sound became passé, it was an albatross. It wasn't really accurate. I thought of us being in the same category as the Eagles, in terms of our sound being rock with a lyrical and melodic content." ■

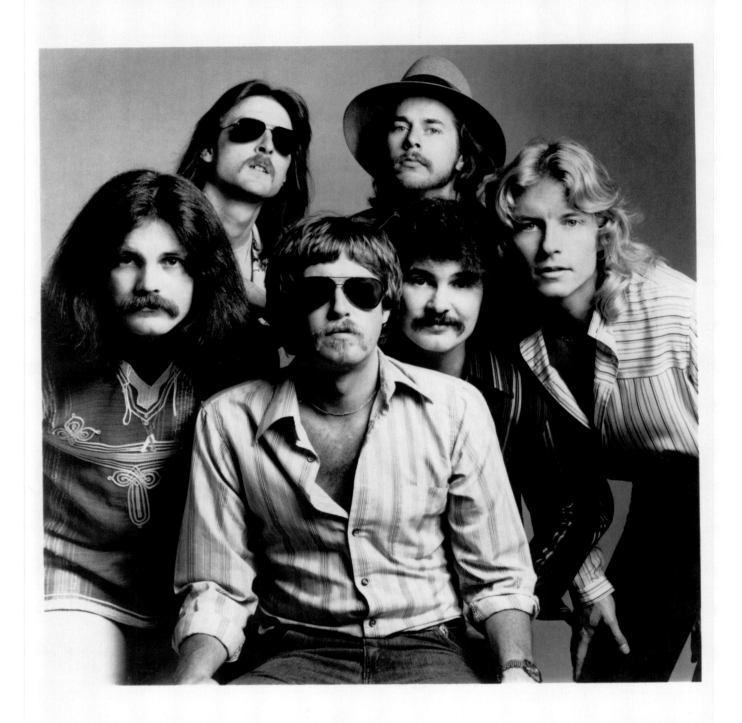

FIREFALL

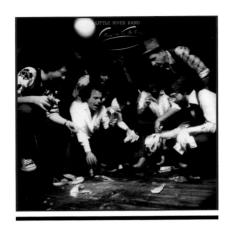

Thanks to "Reminiscing" and "Lady," Little River Band's *Sleeper Catcher* earned platinum certification.

Billboard 200: *Sleeper Catcher* (#16)
Billboard Hot 100: "Reminiscing" (#3); "Lady" (#10)

LITTLE RIVER Band was the biggest thing to hit Australia since boomerangs. Formed in Melbourne in 1975, the band had become an airwave staple Down Under with nifty tunes such as "Help Is on Its Way" and "Happy Anniversary." Well-crafted melodic ballads highlighted the band's knack for precise instrumentation and exquisite harmonies.

"We get the best of everything down there," lead guitarist David Briggs explained of the band's influences. "We grew up hearing the best of the English scene of the Sixties and the best of the American scene of the Seventies. We've absorbed all of that, and that's what you're hearing in the band."

"Reminiscing," written by guitarist Graeham Goble, was Little River Band's greatest success in the United States, accumulating millions of plays on radio. "We're not an image band," Briggs said of how he and his mates were viewed in Australia. "People don't know our faces, generally. We've never pushed The Look. It's always been The Music. That's just the way the band operates."

Goble, lead singer Glenn Shorrock, guitarist Beeb Birtles and Briggs wrote most of the group's material.

"We've never had to sit down and figure out what kind of songs we need for an album," Shorrock said. "Maybe we should, but with three or four songwriting inputs, we simply have never been at a loss for different kinds of songs. Everyone in the group has proven themselves capable of writing hit material." ∎

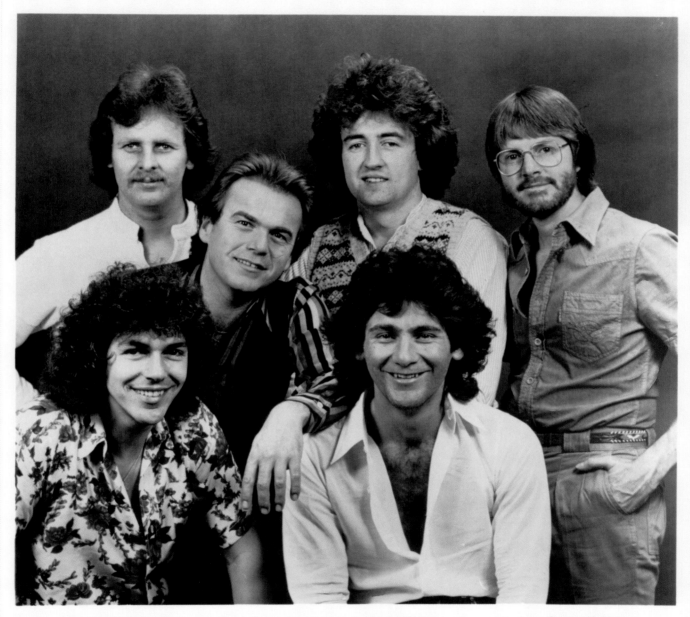

David Briggs Glenn Shorrock George McArdle Graham Goble

Beeb Birtles Derek Pellicci

LITTLE RIVER BAND

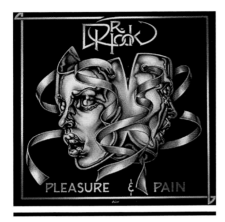

Billboard 200: *Pleasure & Pain* (#66)
Billboard Hot 100: "Sharing the Night Together" (#6);
"When You're in Love with a Beautiful Woman" (#6)

Pop, easy listening and country music outlets all played Dr. Hook's hits from the *Pleasure & Pain* album.

DR. HOOK never floated along with the trends in the Seventies, and the result was a unique niche. They managed to succeed with everything from country-flavored acoustic ballads ("A Little Bit More") to novelty songs ("The Cover of the Rolling Stone").

"We've always been a little out of step," singer Dennis Locorriere laughed. "We're from New Jersey, and when we moved to San Francisco, the first thing we were handed was the Grateful Dead's phone number—we passed. When we went to Nashville, we didn't join the scene, we already had our own little family—we were just moving and putting the tents up somewhere else. In the mid-Seventies, when everyone was kicking ass, we went bankrupt—people said, 'How'd that happen? You've had quite a few hits.'"

Dr. Hook would make jaws drop for their demented stage hijinks, which ranged from bizarre repartee to imitating the opening act. College kids, couples, cowboys and bikers could all manage to have a good time at a Dr. Hook show.

"Everything is tongue-in-cheek," Locorriere explained. "When we first started playing clubs, we always kept it real loose, and it's still like that—we feel that's what sets us apart from everybody else. There are guitars and vocalists, but we've always put our personalities up front as much as the music."

The band's *Pleasure & Pain album* featured two Top 10 hits, "Sharing the Night Together" and the disco-influenced soft rock of "When You're in Love with a Beautiful Woman." But it was Dr. Hook's live antics that kept audiences engaged.

"I believe the only thing that's kept us together—and popular—is that there's a certain honesty about what we do that people feel. At this late date, I know they don't feel that we're doing it for the bucks. Well, they might, because we shift gears all the time—when we put out 'Beautiful Woman,' they went 'Aw, they went disco' like I was off in a corner sporting a three-piece white suit or something. But we do what we want to do. We always say, if you're gonna go down, man, you might as well go down in flames. It's better to commit suicide than get murdered!" ■

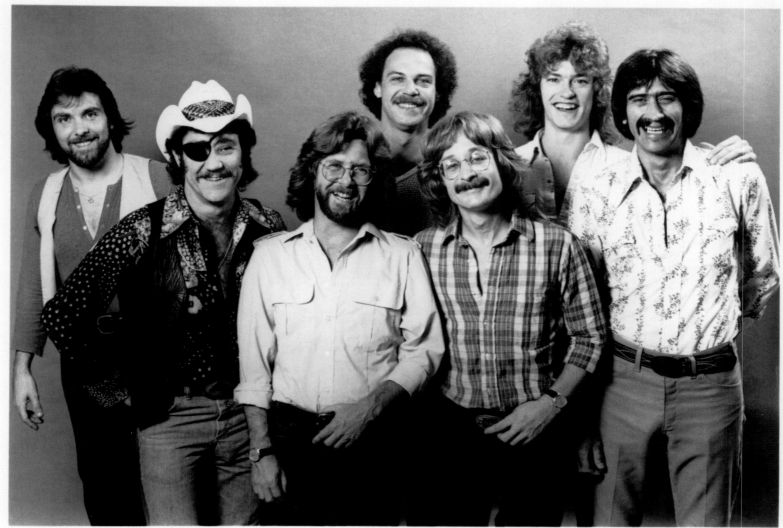

Dennis Locorriere Ray Sawyer Jance Garfat John Wolters Rik Elswit Bob "Willard" Henke Bill Francis

DR. HOOK

Photo: Jim McCrary

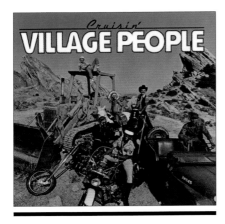

Village People followed up the mainstream attention for "Macho Man" with the iconic smash "Y.M.C.A."

Billboard 200: *Cruisin'* (#3)
Billboard Hot 100: "Y.M.C.A." (#2)

A PRODUCER of disco records, Jacques Morali created the Village People with male American stereotypes in mind, recruiting six actors, singers and dancers to make a readily identifiable image three-dimensional—the cowboy, the American Indian, the cop, the construction worker, the G.I. and the biker. "Y.M.C.A." became popular at parties, sporting events, weddings and other functions. The group dance, invented to fit the song, involved moving arms to form the letters Y-M-C-A as they were sung in the chorus; it originated on Dick Clark's influential television show.

"He said, 'The YMCA is threatening to sue (over trademark infringement), but I'll take care of all financial responsibility should they touch you—I've got a battery of lawyers," said Felipe Rose, who danced in the Indian costume. "It gave our movement a signature piece." The organization ultimately settled out of court with songwriters Morali and singer-actor Victor Willis, who portrayed the policeman.

Disco was liberating dance music for gays, people of color, blue-collar whites and jaded celebrities. The campy performers convinced Morali they could sell the music onstage, and the Village People became the first disco group to break open the arena-sized concert market.

"That we don't happen to play instruments has very little to do with our musicianship," "Cowboy" Randy Jones said. "We do things that we wouldn't be able to do if we had guitars strapped around our necks. We're a very visual act, which has to be done if dance music is to be performed live."

Did the Village People spend time as each other's characters? "There's no cross-dressing allowed in the group," Rose laughed. ■

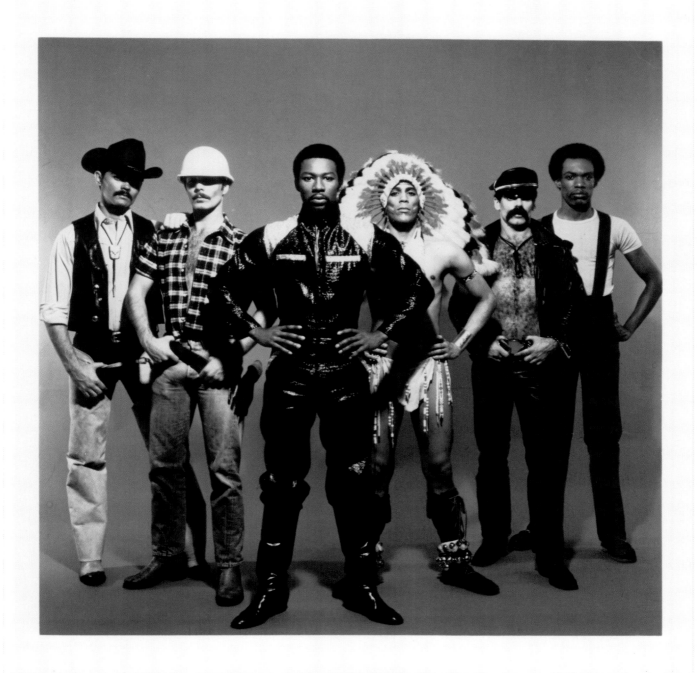

VILLAGE PEOPLE

CAN'T **STOP** PRODUCTION INC.
65 EAST 55TH
NEW YORK, NEW YORK 10022
(212) 751-6177
688-6470

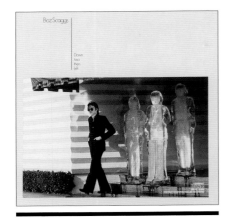

Boz Scaggs' shimmering, alluring R&B-flavored pop was in evidence on the album *Down Two Then Left*.

Billboard 200: *Down Two Then Left* (#11)
Billboard Hot 100: "Hard Times" (#58);
"Hollywood" (#49)

WILLIAM ROYCE Scaggs (high school friends dubbed him Boz) got his start in Texas as the singer and rhythm guitarist in the Steve Miller Band. In 1967, he migrated with Miller to the Bay Area, playing hard blues. Over the next decade, Scaggs developed into one of the smoothest white soul singers around. In 1976, using session musicians who would later form Toto, his milestone *Silk Degrees* album went multi-platinum and made him an international star. "Lowdown," "Lido Shuffle" and "We're All Alone" were detailed and alluring bits of songcraft.

"It was an organic process," Scaggs said. "At the time, I wasn't thinking, 'Well, let's try to blend in some urban soul with some southern blues sensibilities.' Those guys I worked with were listening to the same part of the radio dial that I was, the soul side—they were turned on by the Isley Brothers, the Philadelphia stuff. They were trained musicians, but I personally was learning. As that black music became more sophisticated, so did mine. I guess that was the part

that most people see as innovative, but everybody from the Young Rascals and the Beatles and the Rolling Stones has been doing the same thing all along. We just happened to be borrowing from a more immediate source."

A world tour followed, then Scaggs released his follow-up album, *Down Two Then Left*. Two singles from the album charted, with "Hollywood" peaking at #49. *Down Two Then Left* was certified platinum but didn't sell as well as *Silk Degrees*. The thoughtful crooner remained cool and sophisticated.

"If there's some style, something that characterizes the way that I appear to other people, I'd say it's from living up to what my parents expected of me," Scaggs said. "My father was a very elegant, careful, cultured man, a gentleman's gentleman. He was a hard taskmaster, and a great example. The values he gave me, just making sure that there were certain things in place in the upbringing of his children, had to do with the way I live my life." ■

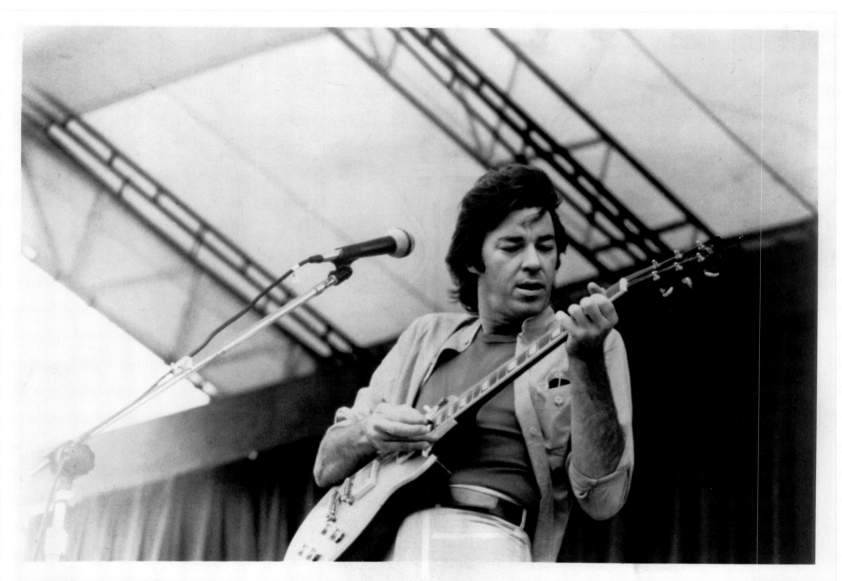

BOZ SCAGGS

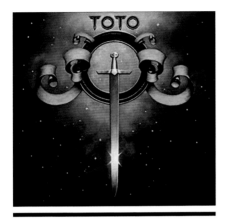

As Toto, the most sought-after West Coast session players transitioned into a band with "Hold the Line."

Billboard 200: *Toto* (#9)
Billboard Hot 100: "Hold the Line" (#5); "I'll Supply
the Love" (#45); "Georgy Porgy" (#48)

AFTER PLAYING in the same band with guitarist Steve Lukather and keyboardist David Paich since they attended Grant High School in Los Angeles, brothers Steve and Jeff Porcaro made their marks as studio musicians playing with such notables as Steely Dan and Boz Scaggs. But making their own music had always been a priority. In 1978, together with vocalist Bobby Kimball and bassist David Hungate, the group recorded and released its first album, the self-titled *Toto*. It spawned three hit singles—"Hold the Line," "I'll Supply the Love" and the silky funk of "Georgy Porgy." Toto quickly gained a following, but critics dismissed the songs as formulaic rock—all chops and no brains.

That reaction produced a slightly defensive attitude from the band.

"We're real sensitive to criticism," Jeff Porcaro said. "I was 23 years old and being called a studio musician. That made me mad—I was in a band. We were put down as a bunch of studio guys getting together to make an album. That was ridiculous. All of us except Bobby have been in the same band since we were teenagers, and even when we went our separate ways for a while to get gigs, we always knew we'd put a band together."

Despite the impressive singles, Toto didn't impart a perceptible image to fans.

"We have international appeal, and that's what we wanted," Porcaro insisted. "Over in Europe and Japan, you're appreciated strictly by your music, not by how you look and stuff." ■

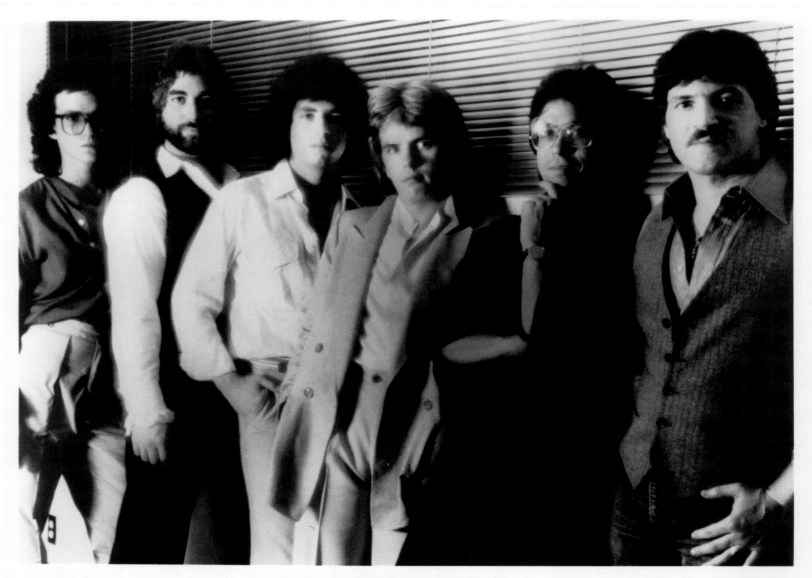

The FITZGERALD HARTLEY Co

TOTO

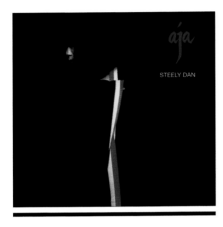

"Peg," "Josie" and "Deacon Blues" clinched Steely Dan's standing as one of rock's most influential acts.

Billboard 200: *Aja* (#3)
Billboard Hot 100: "Peg" (#11);
"Deacon Blues" (#19); "Josie" (#26)

BEGINNING AS a polished six-piece band on 1972's *Can't Buy a Thrill*, Steely Dan showcased the dual songwriting talents of co-founders Donald Fagen and Walter Becker. After three albums, the act had become the exclusive province of the duo, who avoided the grind of touring to concentrate on a studio-based configuration. In a fussy quest for inspired instrumentation, they regularly brought in dozens of top session players and jazz luminaries to try out multiple tracks and takes.

"That was the problem when we didn't have a regular band—we didn't get to work longer in rehearsal," Fagen said. "We basically had to experiment a lot and try different musicians in the studio."

"It was a confusing moment in musical history, too, because of disco," Becker added. "There was this desire to get these inhumanly perfect tracks, but we wanted them with all kinds of fancy playing on these elaborate charts that we'd written."

Steely Dan's lustrous, noirish sound—sleek horn charts, master-fully tight grooves and Fagen's sardonic sneer—defied all conventions. *Aja* was the band's most widely admired album, buffed to a high gloss by longtime producer Gary Katz and a skilled team of engineers. The credits listed nearly 40 musicians. An audiophile masterpiece, *Aja* went on to win a Grammy award and became Steely Dan's first platinum record. During the sessions for *Aja*, Steely Dan recorded "FM (No Static at All)," the title song to the 1978 film *FM*; it was a hit while the movie failed at the box office.

"Growing up when we did in the Fifties and Sixties, we couldn't hear much jazz in live situations because we were too young—we were very focused on the idea that recordings are the real text of the art form," Becker said. "So we had a relatively enjoyable and satisfying job of being songwriters and recording artists on the one hand, versus a frustrating, exhausting, trying, intermittently unrewarding job of touring in a rock 'n' roll band on the other. We just decided to do what we could do." ∎

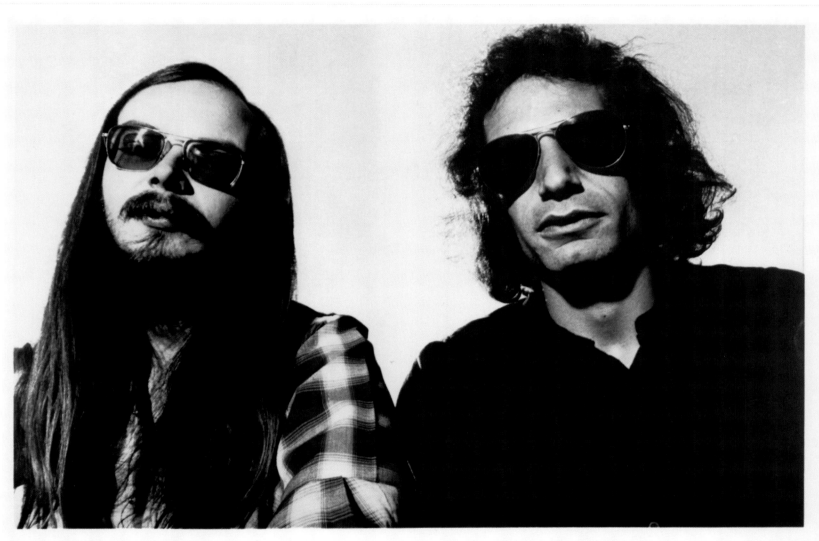

FRONT LINE
MANAGEMENT COMPANY, INC.
SUITE 307, 8380 MELROSE AVENUE,
LOS ANGELES, CALIFORNIA 90069
(213) 658-6600.

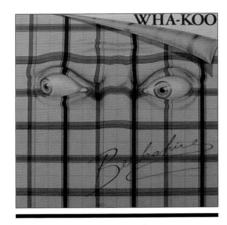

Wha-Koo made inroads in international markets, but the band never gained traction in its own country.

WHA-KOO FORMED under the direction of singer-guitarist Denny Douma, who penned most of the group's material and surrounded himself with a talented entourage of musicians, including David Palmer, a vocalist on Steely Dan's first album *Can't Buy a Thrill*.

Wha-Koo cultivated a reputation as a front-runner in the Los Angeles rock scene. The band's second album, *Berkshire*, was co-produced by Grammy Award-winner Ken Caillat, best known for engineering the Fleetwood Mac album *Rumours*. But the hassles of recording *Berkshire* ended up being an ordeal for everyone involved.

"We spent three and a half months and $200,000 making the record, and I could never do anything like that again," Palmer said. "If you want to make art, that's fine, but if it's art at that cost, then it's simply not worth it to me."

The result of the tensions led to a radical change in the Wha-Koo lineup; the Palmer-Douma team disintegrated and Palmer emerged as the group's leader. Hot on the heels of *Berkshire*'s release, Palmer fronted a touring group that included less than half of the recording personnel.

"I've given up predicting anything, but it would be nice to think that we could make a splash just by virtue of having a repertoire of good songs," Palmer said.

The everchanging situation hindered the group's chances for fame. A beautifully crafted single, "(You're Such a) Fabulous Dancer," was a Top 10 hit in Australia, but the shining effort failed to connect with the American record market. Wha-Koo wound up a negligible star in the musical galaxy. ■

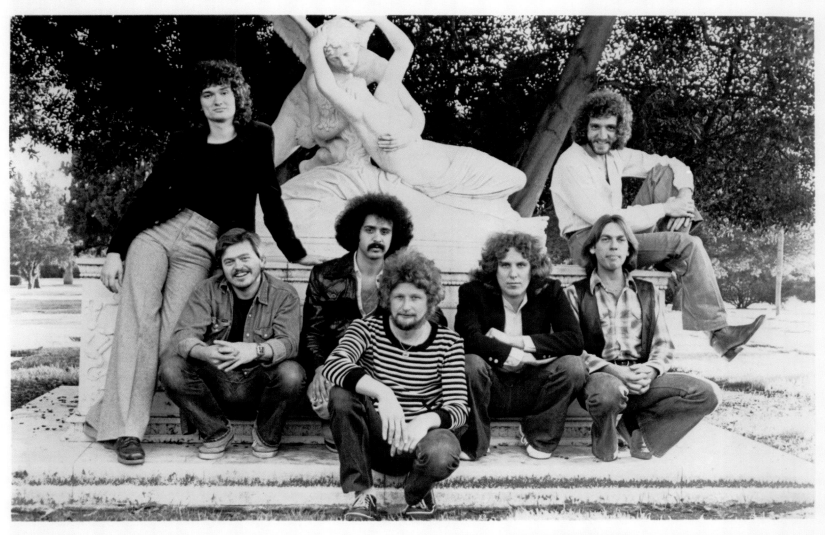

WHA-KOO

FERRIS ASHLEY MANAGEMENT
9744 Wilshire Blvd.
Suite 208
Beverly Hills, Calif. 90212
(213) 278-0891

Waiting for Columbus reaffirmed Little Feat's chops and summed up the members' slow-building career.

Billboard 200: *Waiting for Columbus* (#18)

WITH EXTREMELY inventive but largely ignored music, Little Feat had built a fanatical cult following. The landmark albums *Sailin' Shoes* and *Dixie Chicken* yielded outstanding reviews but little commercial success, and while *The Last Record Album* in 1975 gave the Feat its first hint of chart action, the quirky California group was never fully appreciated for its supple multi-rhythms and melodic interplay, a rich gumbo of blues rock, jazz fusion, New Orleans R&B, country and acoustic music. The group was funky but loose and unpredictable, factors that lent a terrific sense of spontaneity to its performances.

But the band hardly ever went out on the road. Alcohol played games with founder Lowell George's well-being, forcing the rest of Little Feat into a more democratic process that led to shifts in musical direction. Things picked up on the basis of *Waiting for Columbus*, a two-record live set showcasing George's slide guitar mastery, the tasty keyboard work of Bill Payne, an insanely tight rhythm section and the band's most memorable songs, such as "Willin'" and "Dixie Chicken."

George, Payne explained, was starting to assert himself again. "Lowell is much more a part of the group than he has been in years. It's something that I've been waiting for, for a long time." He ascribed George's reticence to step out in the last few years "to health problems, and maybe the band not having the type of success it should. Lowell moves in mysterious ways."

Waiting for Columbus became the band's highest-charting album. Payne, a studio ace who played on albums by the Doobie Brothers, Bob Seger, Burton Cummings and others, joined all of Little Feat's members for the most extensive touring they'd ever done.

"We've always moved pretty slowly on things," Payne admitted. "Shoot, I couldn't have done half the session work I've done if this band was working the way it was supposed to, the way it is now. But I think it's happened all at the right time. I don't think it could have happened any quicker." ∎

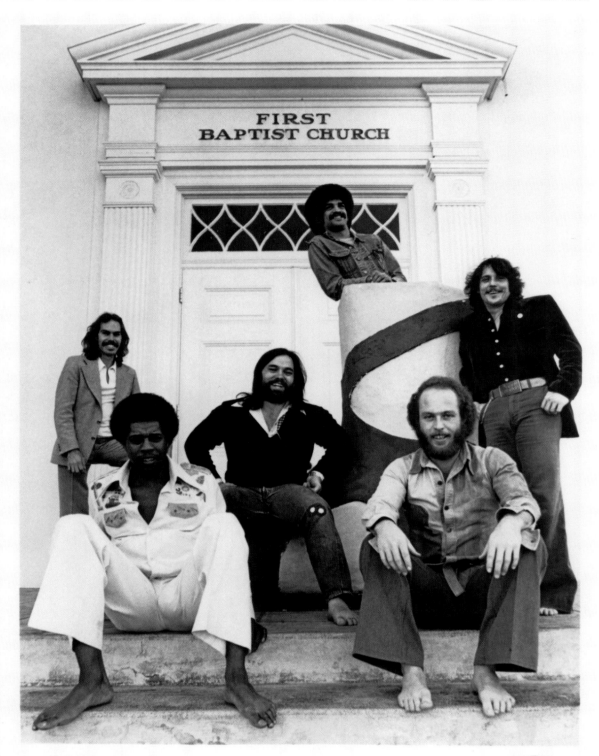

LITTLE FEAT

WARNER BROS.

Philadelphia's Daryl Hall & John Oates released *Along the Red Ledge* and continued their pop success.

Billboard 200: *Along the Red Ledge* (#27)
Billboard Hot 100: "It's a Laugh" (#20);
"I Don't Wanna Lose You" (#42)

DARYL HALL & John Oates had met trying to crack Philadelphia's black music scene in the Sixties. By the mid-Seventies, the twosome had alternated among folk, soul, rock and pop sounds on the hits "Sara Smile," "She's Gone" and "Rich Girl." But by the time they released *Along the Red Ledge* in 1978, the popularity of disco music was dominating radio airplay.

"We've had the most hit success with a kind of Philadelphia R&B rock style, but we have all different kinds of music to put out there, and it's a real challenge for us to put them all on one album," Hall said. "We had been relying too much on studio musicians over the years, and there was too much difference between what we did live and what we were doing on the records. I was trying to find a way to close the gap and make the songs closer to the way I thought they should sound. So we got a band and new producer that didn't have any preconceived notions about us."

Guitarist Caleb Quaye, drummer Roger Pope and bassist Kenny Passarelli were a working unit with Elton John at one time, while David Kent (synthesizer) and Charlie DeChant (saxophone) were hold-overs from Hall & Oates' last touring group. *Along the Red Ledge* showcased the diverse talents of the two singer-songwriters. "It's a Laugh" featured a passionate edge in Hall's voice that separated it from standard radio fare. One of Gene Page's patented string arrangements helped "I Don't Wanna Lose You" bounce along in Philly-style soul fashion.

"We can't help being that way," Hall mused. "There are certain elements that hold it together—the vocal styles and, more than anything, the point of view. The consciousness behind the songs is the unifying factor. We've tried to do a lot of things; we've written on some strange subjects and people don't really understand them. Their emotions are geared toward relating strongly to 'soap opera-ish' things. So we take relationships between people in general and use them as being symbolic of larger things. We've always fought people who tend to disregard or ignore something that doesn't fit into a pattern, saying, 'Well, they're blue-eyed soul.' But we've never fit into a pattern. It's finally getting so obvious that people can't ignore it anymore." ∎

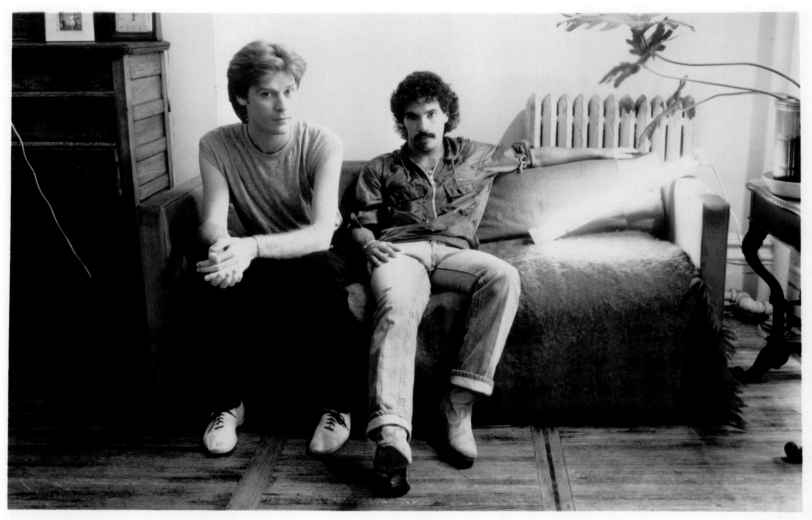

**DARYL JOHN
HALL OATES**

RCA Records and Tapes

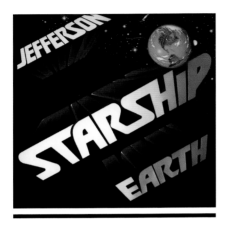

Jefferson Starship took off again with the achievement of the *Earth* album and the tune "Count on Me."

Billboard 200: *Earth* (#5)
Billboard Hot 100: "Count on Me" (#8);
"Runaway" (#12); "Crazy Feelin'" (#54)

PAUL KANTNER was the talented guitarist for Jefferson Airplane, San Francisco's most significant band, when "White Rabbit" and "Somebody to Love" charted in the Sixties. He first used the Jefferson Starship name for *Blows Against the Empire,* a science-fiction song suite recorded with the Airplane's Grace Slick and well-known guests David Crosby, Graham Nash and Jerry Garcia. The album, a chronicle of the hijacking of Earth's first interstellar spacecraft by a group of dissident scientists and rock musicians, earned a nomination from science-fiction writing's prestigious Hugo Awards.

As the original Airplane members dispersed in the Seventies, the Kantner/Slick songwriting axis decided to tour in 1974 and the Jefferson Starship name stuck. When it experienced a Top 10 hit with singer Marty Balin's "Miracles," the act that had once exhorted followers to "feed your head" was then expected to churn out easy-listening material. Kantner shrugged it off, maintaining the same insouciance that was just as fashionable early in the group's career.

"Most everything we do is a matter of good timing," he explained.

"We do real terrible when we try to plan things out. I have a hard time planning for next week."

Earth continued Jefferson Starship's success, wavering between a high-energy and mellow style; the single "Count on Me" was in lighter mode. The album marked the end of the initial Jefferson Starship lineup. After the band's notorious 1978 European concerts, where Slick missed shows and gave substandard performances, she and Balin bailed on the group, and drummer John Barbata's car accident further depleted the ranks.

Kantner and guitar whiz Craig Chaquico, an original Starship member who had been in his mid-teens when he was recruited by Kantner, then linked up with singer Mickey Thomas (known for his vocal on Elvin Bishop's "Fooled Around and Fell in Love") and drummer Anysley Dunbar, who felt creatively constrained as a member of Journey.

"I guess the Starship is kinda like a lumpy bed," Kantner said. "You move around until it feels right." ■

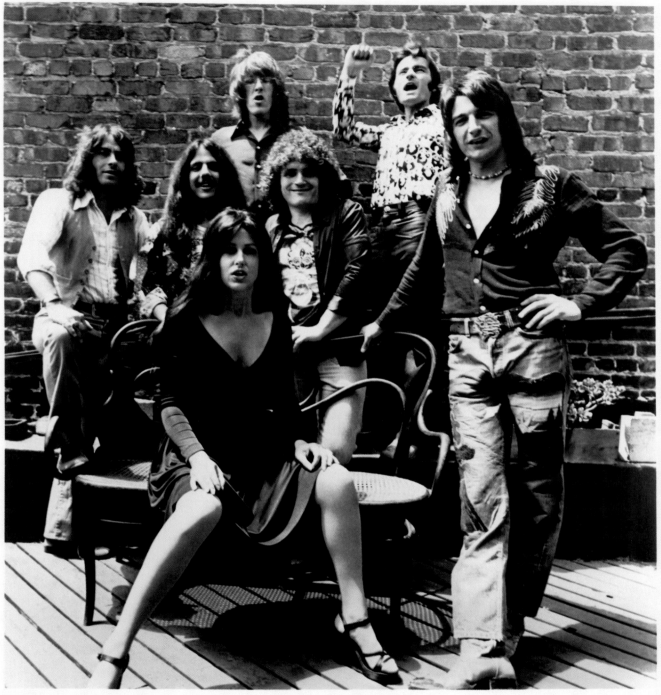

Paul Kantner Marty Balin

Pete Sears Craig Chaquico David Freiberg

Grace Slick John Barbata

JEFFERSON STARSHIP

RECORDS

Manufactured and Distributed by **RCA** Records

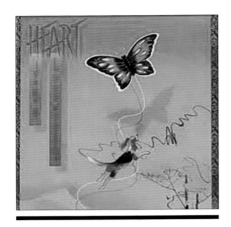

Heart found immediate success delivering tomboy rock and acoustic serenades with the same aplomb.

Billboard 200: *Dog & Butterfly* (#17)
Billboard Hot 100: "Straight On" (#15);
"Dog & Butterfly" (#34)

IN 1976, rock music's leading new act was Heart. Lead singer Ann and guitarist Nancy Wilson, two sisters from the Northwest, drew inspiration from hard rock and heavy metal as well as folk music with *Dreamboat Annie*, a debut album on Mushroom Records, a small independent label. It spawned two smash singles, "Crazy on You" and "Magic Man," and Heart became one of the year's platinum wonders.

Then Heart started to record its second album, to be called *Magazine*. The band recorded four basic tracks with mock vocals and no overdubbing before leaving on a European tour. During the absence, the group's producer left the staff of Mushroom, which took the cuts, added a reject from *Dreamboat Annie* and some live cuts from a radio station broadcast, and made an "album."

"Those vocals were a great embarrassment to me," Ann Wilson said. "I mean, I was just fooling around, I wasn't even paying attention. It was pretty hard for us to think of that product going out."

In the meantime, Heart signed a contract with CBS subsidiary Portrait Records and released *Little Queen* in 1977 (which featured the smash "Barracuda"). Mushroom came up with a court injunction barring the band from recording, so the group had to rush the sessions to beat the decision. A Seattle court forced Mushroom to allow Heart to remix the live tracks and record new vocals for *Magazine*, and the album was re-released in 1978, joining the rest of the Heart catalog in the million-selling category.

"Our last two albums have been really off-balance because of this hostile legal deal," Ann Wilson said. "Either we were too pressured for time and couldn't do what we wanted, as in *Little Queen*, or somebody tried to release a bunch of half-finished stuff, as in *Magazine*."

Heart then put the finishing touches on its fourth album, *Dog & Butterfly*. The Top 20 rocker "Straight On" incorporated a funky bass line, and the gentle title track pulled heavily from the group's folk music influences.

"It's pretty schizo compared to the last stuff," Wilson said. "More importantly, this album was made under the proper circumstances. It's pretty new for us!" ■

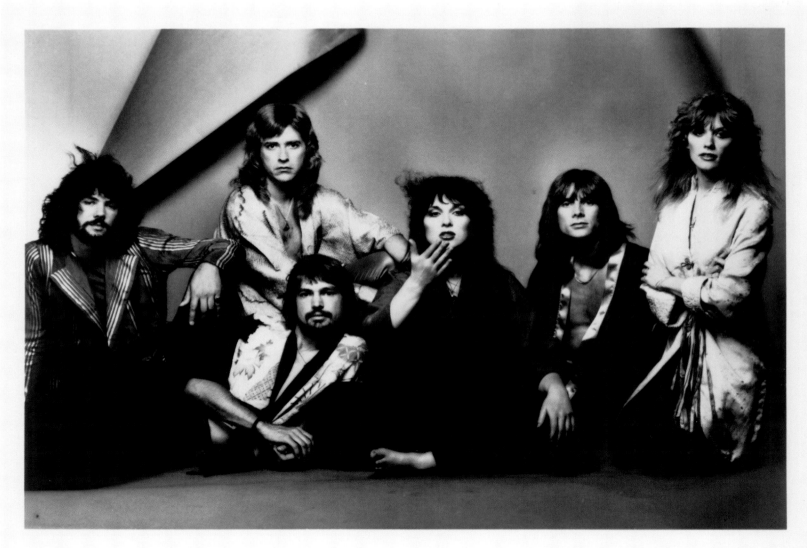

HEART

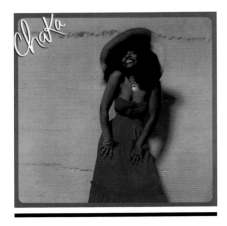

Established in the group Rufus, Chaka Khan debuted as a solo act with the smash "I'm Every Woman."

Billboard 200: *Chaka* (#12)
Billboard Hot 100: "I'm Every Woman" (#21)

HAILED AS one of popular music's most free-spirited divas, Chaka Khan enjoyed a reputation as a world-class vocalist and performer, due in no small part to her alternately wild and sultry voice and her equally passionate party-down persona. She developed her craft during a stint with Rufus, a rock 'n' soul band that had evolved out of the Chicago area's American Breed (which had a hit in 1967 with "Bend Me, Shape Me"). Rufus racked up a string of hits, including the Grammy-winning "Tell Me Something Good" in 1974.

Khan's increasing popularity prompted ABC Records to start calling the group Rufus featuring Chaka Khan. Khan (her spiritual name, "Chaka," apparently meant "fire, war, red—it seems more like me than my real name, Yvette," she explained) and the Rufus members recorded *Street Player*, the band's third album to top *Billboard*'s R&B Albums chart.

Still a part of Rufus, Khan signed a solo deal and had a hit with her debut later in 1978. *Chaka* sold more than *Street Player*, thanks to the anthemic single "I'm Every Woman." Rumors ensued that she was leaving Rufus for good.

"There's no way I'd ever leave Rufus," she explained. "We're a family, and our separate projects are merely an extension of us."

Khan participated in another album and tour with Rufus, but after fulfilling her contract with the band, she was free to leave. Despite reports of acrimony, Khan insisted the separation was amicable.

"I wanted to sing songs that the group didn't have to decide on democratically," she said. "We were intensely in love with each other, but it was inevitable that we would split up. Any time you get six different personalities together, there's going to be bickering, but we weren't mad at each other." ■

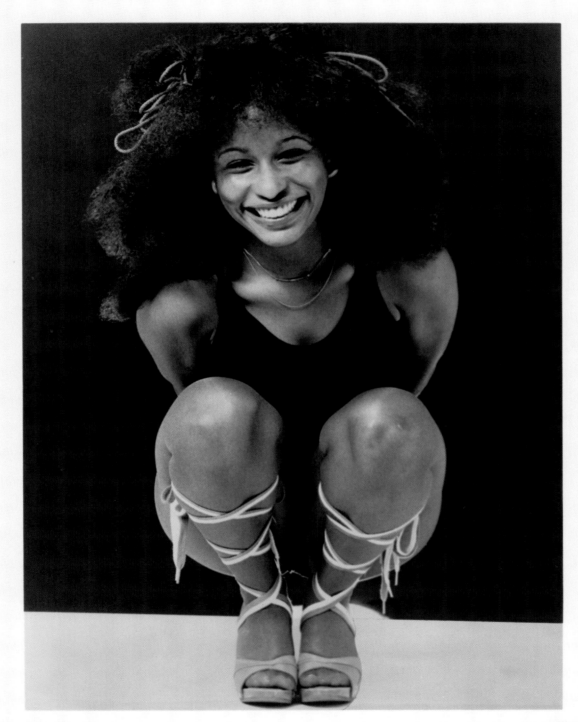

Chaka Khan

WARNER / REPRISE

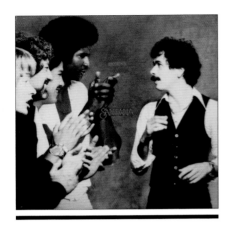

Inner Secrets served as a musical departure for Santana, a move toward a more traditional rock sound.

Billboard 200: *Inner Secrets* (#27)
Billboard Hot 100: "Well All Right" (#69); "Stormy" (#32); "One Chain (Don't Make No Prison)" (#59)

IN SAN Francisco in the mid-Sixties, guitarist Carlos Santana formed the band Santana, a melting pot of black, white and Latino musicians. Santana set the crowd ablaze at 1969's groundbreaking Woodstock festival, and during the halcyon days of "Evil Ways" and "Black Magic Woman," both hits in 1970, the act's exotic mix of Latin rhythms and rock music made its way onto radio playlists and millions of stereos.

The years following the band's first success found the soft-spoken Santana in a state of perpetual transformation. The musician moved from one style to the next, exploring spirituality with guru Sri Chinmoy (who inspired him to take the name "Devadip") and fusing jazz forays into his arty albums with John McLaughlin and Alice Coltrane.

"I've learned a lot from so many people," Santana said. "A lot of bands—the Who, the Rolling Stones—stay together because they need to stay together. But I could never go the distance with any individual for too long unless we had the same vision and commitment. If the music that wants to come out lends itself to certain instruments or musicians, then I have to find them. To stay with the same band for the sake of convenience would be poison to me."

The album *Inner Secrets* included "Well All Right" (a cover of a Buddy Holly song), "Stormy" (a remake of the Classics IV's 1968 hit), and "One Chain (Don't Make No Prison)," which the Four Tops had recorded in 1974. The ethnic influences that made the band's earliest material so special leaned more toward a commercially appealing sound for rock radio, featuring Santana's unmistakable guitar work.

"I don't like to sing," he noted. "I get an opportunity to sing through my guitar." ■

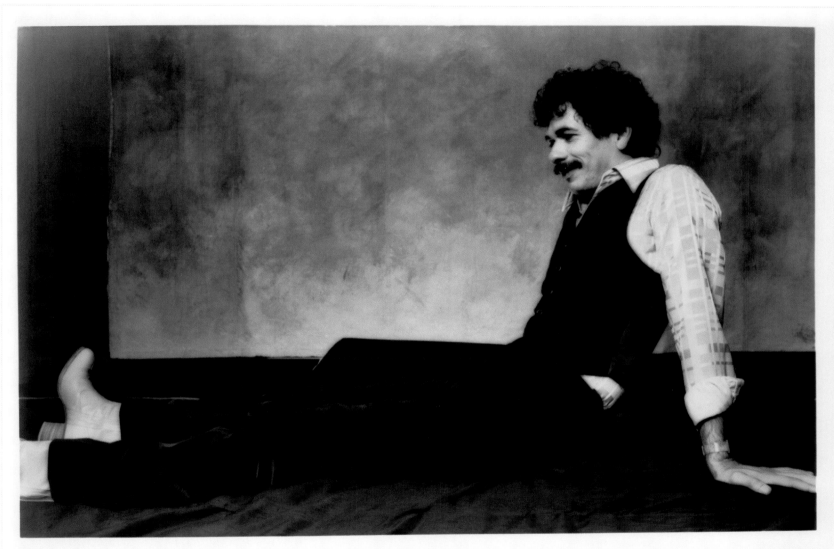

DEVADIP CARLOS SANTANA

Columbia

7810

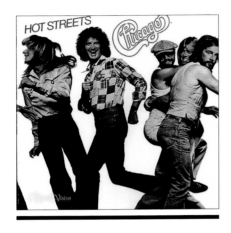

Hot Streets and the hits "Alive Again" and "No Tell Lover" marked the beginning of a new era for **Chicago**.

Billboard 200: *Hot Streets* (#12)
Billboard Hot 100: "Alive Again" (#14); "No Tell Lover" (#14); "Gone Long Gone" (#73)

EVER SINCE 1969's *Chicago Transit Authority*, a debut album that effectively synthesized jazz, rock and blasts of brass, Chicago reigned as a veteran album-oriented act that still enjoyed Top 40 success. Through nine studio albums, Chicago had avoided any major personnel changes. Musically and personally, the band was like a family.

"Fans always say, 'I grew up with your music.' To which I always reply, 'So did I.' We were very much young boys when we started the band," keyboardist Robert Lamm said.

But everything changed in 1978. The year began with a split from producer James William Guercio; Chicago had recorded its last five studio albums at Guercio's Caribou Ranch in Colorado. Then, in January, guitarist, vocalist and founding member Terry Kath died from an accidental, self-inflicted wound from one of his guns, which he thought was unloaded. His death left the other members of the band devastated, and they considered breaking up.

"That was unexpected," trumpeter Lee Loughnane said. "Somehow we survived that."

Phil Ramone was called upon to produce *Hot Streets*, the band's tenth release; Donnie Dacus replaced Kath on the studio effort. All Chicago albums had come to be identified merely by Roman numerals, but the group broke with tradition by giving the album a title, rather than a number. The energetic "Alive Again" brought Chicago a hit single.

Lamm described the band's long-term appeal as "the most successful experiment in group therapy ever to go down in history. Chicago is the only experience I've ever known, so it's hard to be objective, but this is an extraordinary combination of individuals. We've weathered some difficult times and made it look easy. And that's a gift." ∎

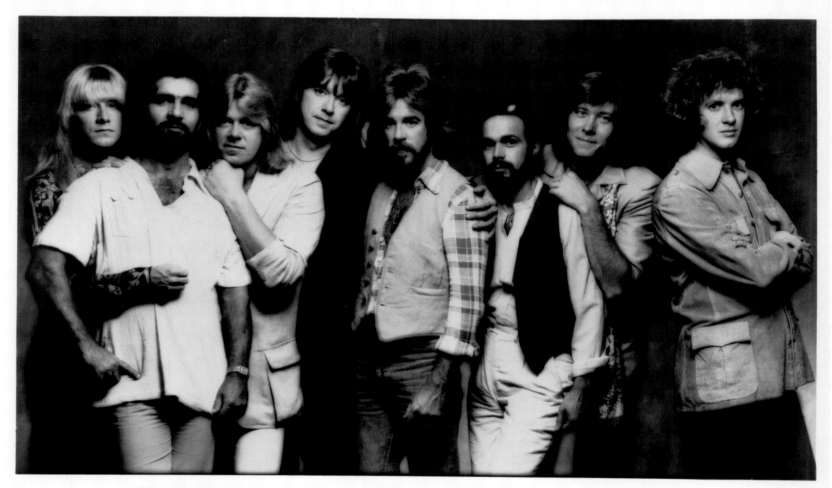

Management: Wald/Nanas Associates, 9356 Santa Monica Boulevard, Beverly Hills, California 90210 Telephone (213) 273-2192

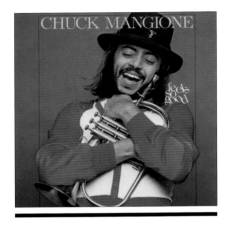

As industry awards piled up, Chuck Mangione's *Feels So Good* album sold more than two million copies.

Billboard 200: *Feels So Good* (#2)
Billboard Hot 100: "Feels So Good" (#4)

CHUCK MANGIONE was a popular concert and recording act throughout the Seventies; his composition "Chase the Clouds Away" provided background music during ABC's telecast of the 1976 Summer Olympics in Montreal. *Feels So Good* gave "the sincere little man with the flugelhorn" the status of the premier instrumentalist in the world of jazz and pop, his music acting as a jazz primer for many of his newer listeners.

"It's a result of a whole lot of hard work on our part and a determination to take the music to as many people as possible," Mangione said of his notoriety. "A lot of people think we are a relatively new group that began with *Feels So Good*. But the people who were there in 1970 are still there. It's a collective audience that I'm very proud of."

As a composer, Mangione turned out a varied and significant amount of music—soundtracks (his composition for the 1978 film *The Children of Sanchez* starring Anthony Quinn won him his second Grammy), orchestral pieces and the recorded and touring work with his quartet.

"I've been thrilled that our music and instrumental music in general has been meeting with more commercial acceptance," Mangione said. "I think people like to use their imagination. In radio and television, there's a tendency to believe that unless someone is speaking or singing or dictating, they can't command attention. But unlike almost any other musical art form, instrumental music allows a listener to draw his own conclusions and feelings. That's a freeing situation for the mind and spirit." ■

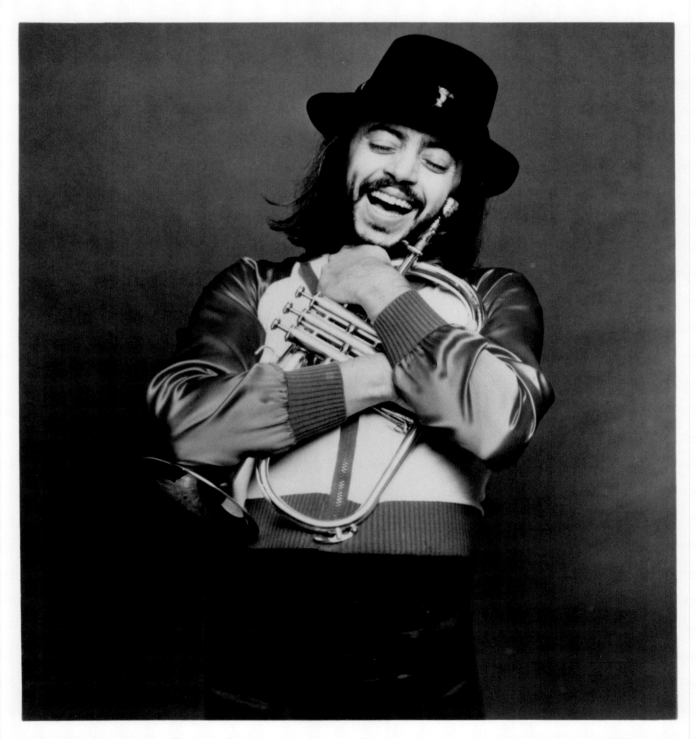

CHUCK MANGIONE

Billboard 200: *Herb Alpert/Hugh Masekela* (#65)

The alliance of Herb Alpert & Hugh Masekela resulted in a record made during a period of deep creativity.

AFTER A string of hits in the Sixties with the Tijuana Brass, Herb Alpert enjoyed a successful solo career. The talented trumpeter was also a recording industry executive, whose A&M Records was the largest independently owned record label in the world.

In 1976, while producing a record for South African singer Letta Mbulu, Alpert had become fascinated with that country's music. The vice-chairman found the work of fellow trumpeter Hugh Masekela so inspiring that he put off a great percentage of his business and production work to concentrate on a collaboration with him.

"I got an idea to fuse South African ideas with West Indian and Brazilian and some Tijuana bebop—just brew all of those elements together," Alpert said. "I was calling a friend one morning and Hugh happened to answer the phone. I told him what I was up to and the idea intrigued him. He came by that afternoon and I played him some tapes, and while we were talking, I just flashed on the idea of us play-ing together. We had no formal agreement; we just gathered songs to see what it sounded like and if we could have some fun doing it. Every step along the way, things just fell into place. We recorded the album in three consecutive nights."

The album's rousing, disco-fied version of the oft-recorded South-ern Rhodesian classic "Skokiaan" made the R&B charts, and the two trumpeters found their groove on the road, playing with their nine-piece band. A collaborative live album, *Main Event Live*, was released later that year.

"We don't have marathon battles," Masekela said. "We didn't reach our musical compatibility through teaching so much as playing through osmosis. Herb taught me the economical approach to the horn, the value of blending together. We're not really out to prove virtuosity. He plays more notes than before and I play less—a very happy medium." ∎

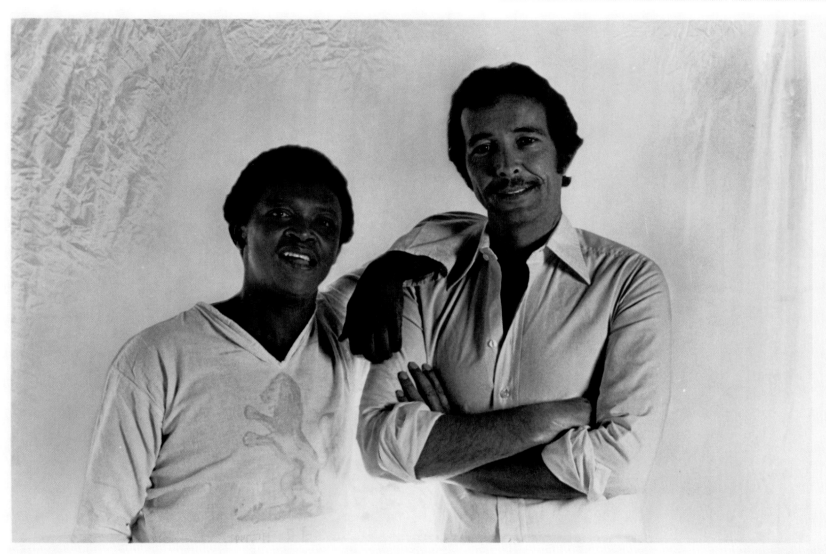

HERB ALPERT • HUGH MASEKELA

ROGERS & COWAN, INC.
Public Relations
9665 Wilshire Blvd., Suite 200
Beverly Hills, Calif. 90212
(213) 275-4581

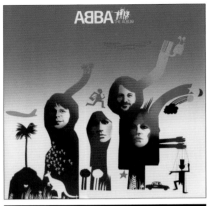

Billboard 200: *ABBA: The Album* (#14)
Billboard Hot 100: "The Name of the Game" (#12);
"Take a Chance on Me" (#3)

ABBA: The Album was the fifth release by the supergroup **ABBA**, Sweden's most identifiable pop export.

CLEAN, WHOLESOME and happy, ABBA was one of the world's most commercially successful bands. The two married couples that comprised ABBA (Agnetha and Björn, Benny and Anni-Frid) took their time cracking the American market, where hit singles—"Waterloo," "S.O.S." and "Dancing Queen"—were their calling card.

"We decided very early on that we could not spend as much time in America as they wanted us to," Björn said. "Everyone else, the Fleetwood Macs and others, were touring four, five months a year. We said, 'We can't do that. We have kids. We have a life. We'd rather write songs than tour.'"

ABBA: The Album coincided with the debut of *ABBA: The Movie*, and "Take a Chance on Me" and "The Name of the Game" emerged as two of the group's best-loved songs.

"But even if we sold millions and millions of records, we were not appreciated as craftsmen or artists," Björn said. "We were very European in comparison with other groups that had made it big in America. We were considered lightweight—pop was not the 'in' thing."

Respect did come, as every record was a well-honed piece of commercial pop, making use of irresistible hooks, impeccable production and perfect harmonies.

"We would try to change up to another key all the time, and Frida (the brunette) had to really work to sing with Agnetha (the blond)—she's a mezzo, and Agnetha is a true soprano. But that was very much the secret to that metallic, shimmering sound. I can hear it a mile away, because together they sound different than anyone else in the business." ∎

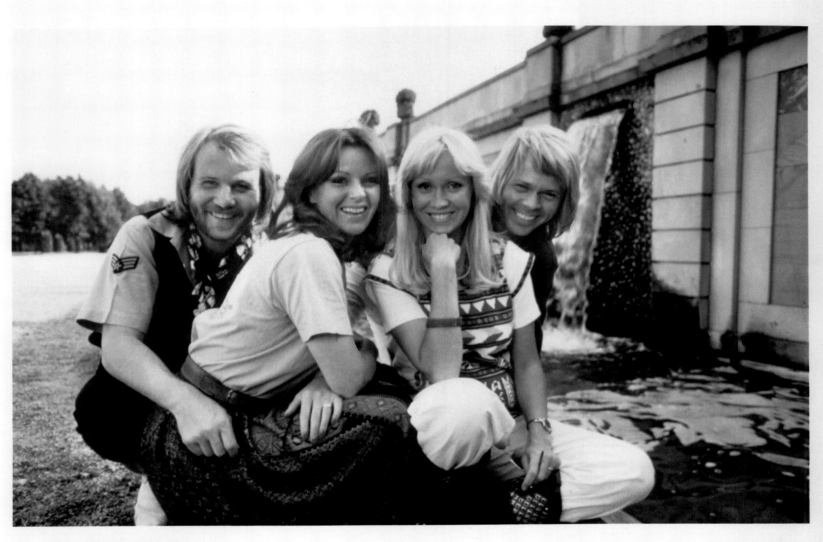

ABBA®

Earth, Wind & Fire inspired listeners with a cover of the Beatles' classic "Got to Get You into My Life."

Billboard 200: *The Best of Earth, Wind & Fire, Vol. 1* (#6)
Billboard Hot 100: "Got to Get You into My Life" (#9); "September" (#8)

EARTH, WIND & Fire started racking up Top 40 hits in 1974, and "Shining Star" and "Sing a Song" ranked as some of the most joyous moments in the music world. The colorful, imaginative multi-platinum group played exuberant dance tunes that combined showmanship—legendary stage performances with elaborate costumes and stage effects—with life-affirming, often metaphysical lyrics wrapped around an exciting jazz-funk rhythm. The two principals were leader Maurice White and Philip Bailey, the vocalist with the soaring falsetto.

"Those messages of love and brotherhood and respect were relevant when we first wrote them," Bailey said. "It made us proud that we chose to set a standard for ourselves."

Earth, Wind & Fire's *All 'n All* emerged as the best-selling R&B release of 1978, featuring the songs "I'll Write a Song For You," "Serpentine Fire," "Love's Holiday" and the pop hit "Fantasy." The album won a Grammy Award for Best R&B Vocal Performance by a Duo, Group or Chorus, and "Runnin'" picked up another Grammy for Best R&B Instrumental.

Earth, Wind & Fire won a third Grammy Award for a rendition of the Beatles' "Got to Get You into My Life," which the band performed in the ill-fated film *Sgt. Pepper's Lonely Hearts Club Band*. The movie was a commercial failure, but the song was the biggest triumph from its soundtrack.

"We were on a deadline," Bailey divulged. "We were writing the arrangement while we were on the road, and we rehearsed it in another city on the way to Colorado, then had a concert in Denver the next night. Then we went to a little studio in Boulder and did the track. When we started reworking the original, I was wondering if the whole treatment was going to be too different from the Beatles song. But it ended up being a major smash."

Earth, Wind & Fire released the song as a single and it reached the Top 10 on the pop chart. The band included it and "September," which also became a charting hit, on the album *The Best of Earth, Wind & Fire, Vol. 1*. ■

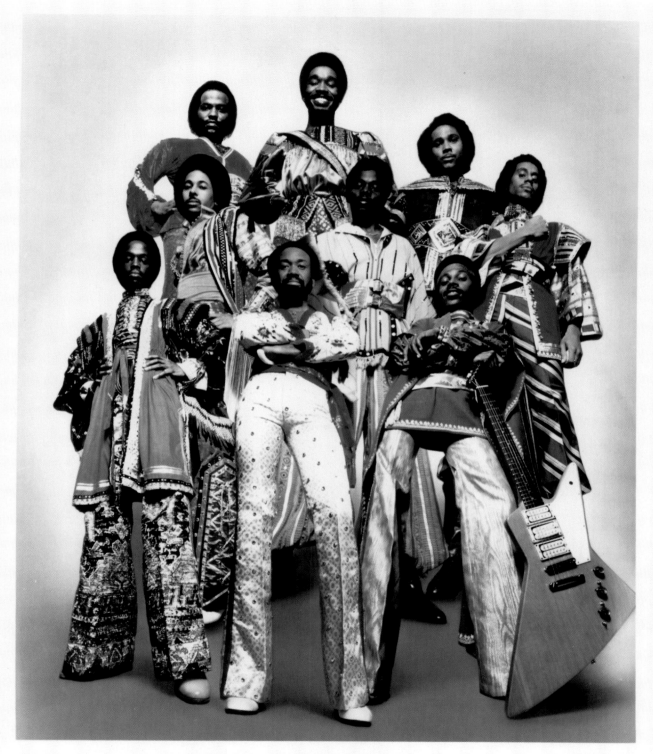

 EARTH, WIND & FIRE

THE ORIGINAL MOVIE SOUND TRACK
SATURDAY NIGHT FEVER

The three **Bee Gees** singles from *Saturday Night Fever* launched the disco era's most popular period.

Billboard 200: *Saturday Night Fever* (No. 1)
Billboard Hot 100: "How Deep is Your Love" (No. 1); "Stayin' Alive" (No. 1); "Night Fever" (No. 1)

BY THE mid-Seventies, the sweet harmonies and melodic might that marked the Bee Gees' late Sixties work ("New York Mining Disaster 1941," "Massachusetts," "I've Gotta Get a Message to You," "How Can You Mend a Broken Heart" and "Run to Me") had shifted to such funky pieces as "Jive Talkin'" and "You Should Be Dancing," setting them up for the seismic impact of *Saturday Night Fever*.

The soundtrack for the film, composed and performed primarily by the Bee Gees, stayed atop the album charts for 24 straight weeks from January to July 1978, and three songs reached No. 1 on the *Billboard* charts. With falsetto vocals and irresistible rhythms, the trio seduced mid-America into dance music and became one of disco's most resonant symbols.

"We were always into R&B. We never even thought about disco—for us, disco was KC & the Sunshine Band and Donna Summer and Village People, these long, extended records that people danced to, big party music," Maurice, one of the three brothers Gibb, explained. "None of *Fever* was written for a disco movie. We didn't even know it was about disco, actually. We thought it was about a guy who won a dance competition in the clubs in Brooklyn. The story didn't really knock us off our feet. But nobody knew what it was going to do!"

What it did was firmly identify the Bee Gees with the days of white suits, blow-dried hair, platform shoes, medallions and mirror balls.

"America tends to hang on to images. We were 'just a disco band,' but people forget we had three platinum albums before *Fever*, so we weren't worried about it as a career move," Gibb said. "It's got a life of its own now—'Stayin' Alive' is the national anthem of the Seventies." ■

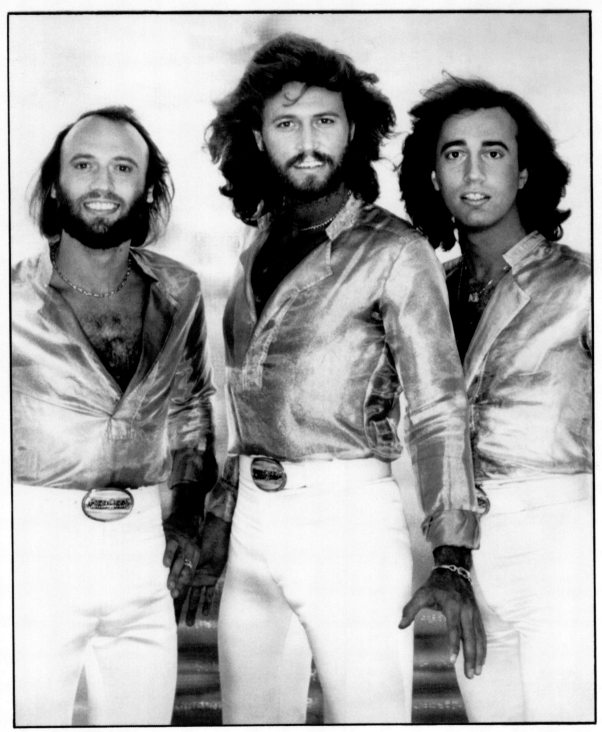

Records, Inc.

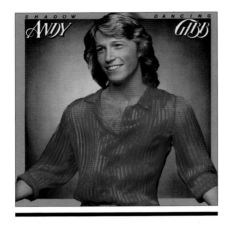

Billboard 200: *Shadow Dancing* (#7)
Billboard Hot 100: "Shadow Dancing" (No. 1); "An Everlasting Love" (#5); "(Our Love) Don't Throw It All Away" (#9)

The single "Shadow Dancing" by Andy Gibb achieved the honor of being *Billboard*'s No. 1 song of 1978.

ANDY GIBB'S famous siblings, the Bee Gees (Barry, Maurice and Robin Gibb), provided expert guidance for his entrance into the entertainment business. They manufactured several hits for their baby brother during the time that their contributions to the *Saturday Night Fever* soundtrack were dominating the world charts.

"I'm making music of now and it's what is selling now," Gibb allowed. "I know I've been very lucky. Obviously my biggest help of all—I mean obviously and I admit that—is my brothers. I basically became an extension of the Bee Gees by dint of their writing and production. Since I grew up with them, I've always been amazed by what they do. They are simply the most special, talented people I've ever known."

The *Shadow Dancing* album became another million-seller, and with the title track, Gibb became the first male solo artist to have three consecutive No. 1 singles on the *Billboard* Hot 100, continuing the momentum of his successes "I Just Want to Be Your Everything" and "(Love Is) Thicker Than Water."

But Gibb's fame was brief due to depression and drug addiction. Only 20 years old when *Shadow Dancing* came out, he died just five days after turning 30. ■

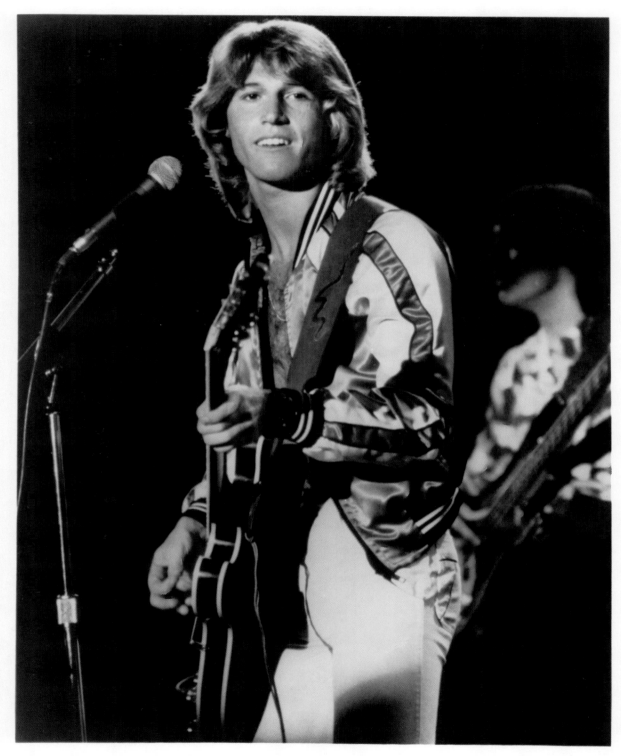

ANDY GIBB

RSO
Records, Inc.

Reaching his career peak, Kenny Rogers recorded "The Gambler" and rose on charts around the world.

Billboard 200: *The Gambler* (#12)
Billboard Hot 100: "The Gambler" (#16);
"She Believes in Me" (#5)

IN 1967, Kenny Rogers left the New Christy Minstrels, a folk singing troupe, and formed his own band, the First Edition, which went on to chalk up a string of hits including "Just Dropped In (To See What Condition My Condition Was In)," "But You Know I Love You" and "Ruby, Don't Take Your Love to Town."

"We were four members of the New Christy Minstrels who just sang background in the middle of the group, and they wouldn't let us record on their sessions," Rogers remembered. "We were going nowhere. One of the guys' mother was a secretary for the biggest honcho in the record business, Jimmy Bowen. The old story is, the mother said, 'Hey my son's putting a band together,' and he said, 'Well, bring them over, we'll do an album.' And that's exactly what happened. We left on a Saturday night from Las Vegas. Monday morning, we were in the recording studio in Los Angeles."

When the First Edition disbanded in 1976, Rogers launched his solo career after having a revelation during a Nashville country music festival.

"A guy came up onstage and said, 'Ladies and gentlemen, here's a hit from 1956—"Crazy Mama"!' The place went crazy. I said to myself, 'A hit from 1956 and they still remember it? That's where I want to be, right here with these people!' I was raised with country music, I feel comfortable with it. I'm in an unusual category. I was in jazz for nine years, folk music for two. I'm basically a country singer who's had a lot of other influences."

Rogers entered the country market in 1977 with his crossover hit "Lucille"; he then teamed up with close friend Dottie West for a duet album, *Every Time Two Fools Collide*. The title track, which hit No. 1 on the country chart, and "Anyone Who Isn't Me Tonight" established them as a popular male-female pairing in country music.

Songwriter Don Schlitz had penned the "The Gambler," but other musicians' versions didn't catch on until Rogers finally broke the song loose. His interpretation became a No. 1 country hit and made its way to the pop charts at a time when country songs rarely crossed over, as did "She Believes in Me," the follow-up single. "The Gambler" won Rogers the Grammy award for Best Male Country Vocal Performance. ■

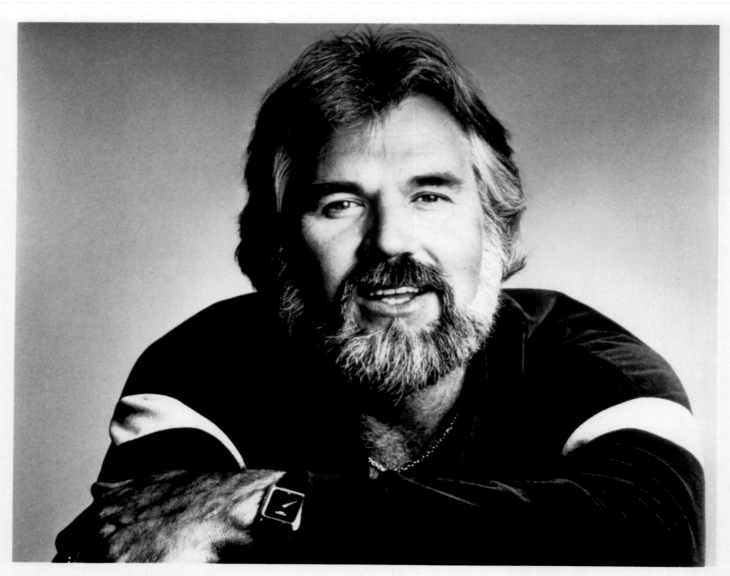

KENNY ROGERS

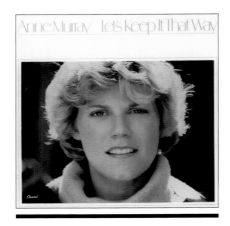

"You Needed Me" emerged as Anne Murray's biggest hit, a No. 1 single that revitalized her stellar career.

Billboard 200: *Let's Keep It That Way* (#12)
Billboard Hot 100: "You Needed Me" (No. 1)

BEGINNING WITH her signature song "Snowbird" in 1970, Anne Murray topped the pop, adult contemporary and country charts with a string of hits. After her 1974 remake of the Beatles' "You Won't See Me," the Canadian singer endured several years of declining chart popularity before the success of "You Needed Me," which won her the Grammy Award for Best Female Pop Vocal Performance.

Murray commanded a loyal following that not only bought her records but followed her television appearances on variety shows and holiday specials. If the decorated Canuck chanteuse seemed confident in front of a camera, there was a good reason.

"I'm comfortable working in the television medium because that's where I started," she explained. "Most musicians get their start working in clubs, but I sang on a Canadian variety show for four years. I began my career by lip-synching, because the equipment was too antiquated to record the music live. I did it twice a week, and by the time we finished I was a pro. Now, I defy anybody to tell whether I'm really singing or not."

The difference between making albums and taping for TV was not that great, she insisted.

"I'm involved in every phase of both, and contrary to popular belief, network executives aren't narrow-minded monsters. We both want the same thing, and we all pool our expertise. Television is a bit more confining than live concerts, though. It's not quite as loose—I can't do the same things I generally do to get an audience involved." ■

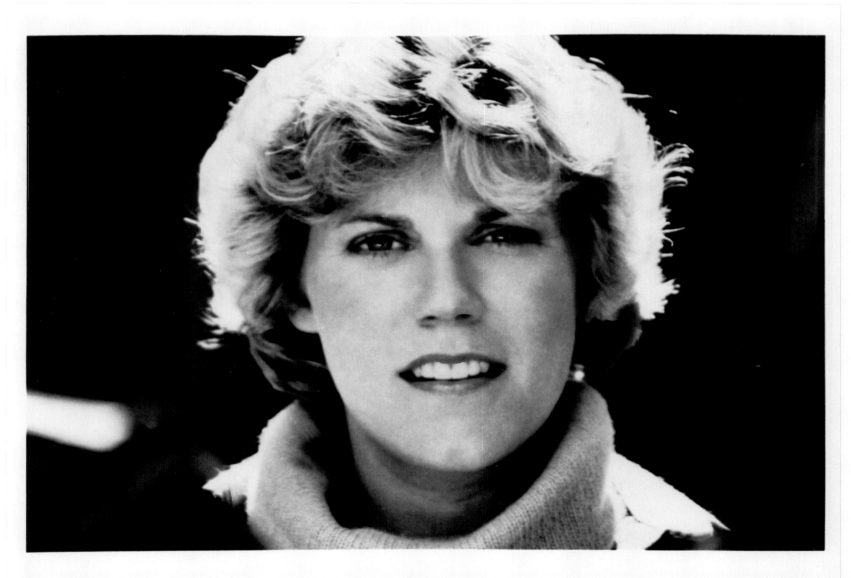

ANNE MURRAY

Barry Manilow's "Copacabana (At the Copa)" earned the pop icon one of his greatest international hits.

Billboard 200: *Even Now* (#3)
Billboard Hot 100: "Can't Smile Without You" (#3);
"Even Now" (#19); "Copacabana (At the Copa)" (#8);
"Somewhere in the Night" (#9)

BROOKLYN-BORN Barry Manilow began his musical career in the Sixties as a commercial jingle writer. In the early Seventies he worked as Bette Midler's pianist and arranger in New York nightclubs and bathhouses before he became the first artist to sign with Clive Davis' Arista Records. Manilow earned instant notoriety in 1974 with the No. 1 "Mandy," followed by such chart-toppers as "I Write the Songs," "Looks Like We Made It" and "Can't Smile Without You."

The performer with the pastel suits and rooster coif gained a reputation as the housewife's favorite, but in terms of critical respect, he came up empty. The shameless melodrama of his big-ballad style — suspended chords, swelling key changes, dramatic climaxes and sentimental love-lost lyrics — earned him millions of loyal fans who didn't give a flying fig what anyone else had to say about him.

"I'm trying to write standards, songs that will be around for a while," Manilow said. "And it's tough reaching for the big brass ring each time, but that entails writing songs that lend themselves to those big sweeping arrangements. I've gone on record as calling my music 'permanent wave,' because good love songs won't ever go out of style. I really can't think of anyone else that's doing it, you know?"

But his treacly tunes inspired rock-minded pop critics to invent insults for him — "the singer that taste forgot," the terminally un-hip "king of kitsch."

"They couldn't have been more insulting and demeaning to me," Manilow said. "They seemed to save up their best barbs for me. I'd come to town and they'd say, 'Oh, boy, we can use this one.'"

Nevertheless, *Even Now* spun off four hit singles — the title track, "Can't Smile Without You," "Copacabana (At the Copa)" and "Somewhere in the Night." "Copacabana" scored Manilow's first Grammy award for Pop Male Vocalist. For a time, fame turned him into a class-A jerk.

"When that success hit, I was unprepared for it," he admitted. "I turned into a brat, treating people badly. It was all based on insecurity and fear. I was miserable, but there's a part you don't want to pull out of. It's very glamorous being talked about — *'He's in a bad mood today!'* Look at a guy like Elvis Presley. He knew what was going on, and he loved it. I was there, man, I understand it, but it doesn't work." ■

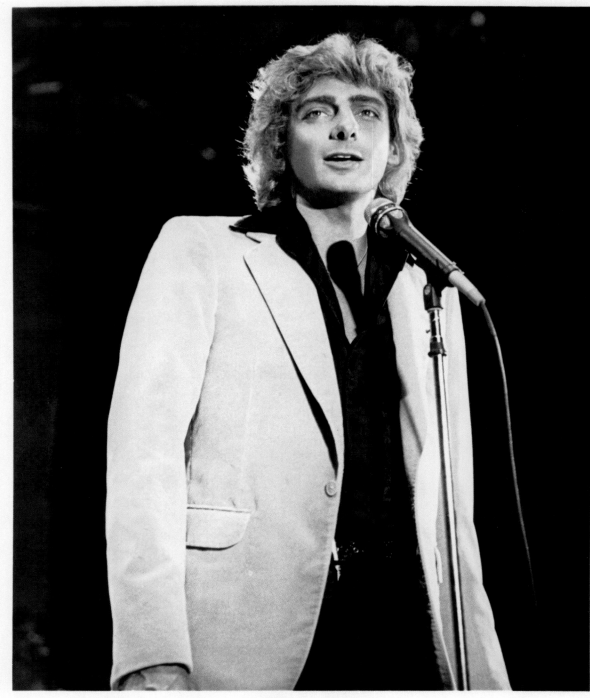

BARRY MANILOW

Personal Management:
MILES LOURIE
314 West 71st Street
New York, N. Y. 10023
(212)595-4330

Personal Agent:
ICM
International Creative Management
40 West 57th Street
New York, N. Y. 10019
(212)556-5600

Press Representatives:
SOLTERS & ROSKIN, INC.
62 West 45th Street, N.Y.C.
9255 Sunset Blvd., L.A.
(212)843-3500/(213)278-5692

Steve Martin acquired celebrity from the comedy album *A Wild and Crazy Guy* and his "King Tut" parody.

Billboard 200: *A Wild and Crazy Guy* (#2)
Billboard Hot 100: "King Tut" (#17)

BY 1978, Steve Martin was the most successful concert draw in the history of stand-up, earning the level of commercial success usually reserved for rock stars. He recorded the first half of *A Wild and Crazy Guy* in front of a small audience at the Boarding House, a nightclub in San Francisco where he'd taped his previous album, *Let's Get Small*. The second side was recorded at Colorado's Red Rocks Amphitheatre in front of more than 9,000 roaring fans.

A Wild and Crazy Guy reached #2 on *Billboard*'s album chart. It was eventually certified double platinum and won the Grammy Award in 1979 for Best Comedy Album. Martin appeared on the cover of *Rolling Stone* and *Newsweek*.

With the "Treasures of Tutankhamun" traveling exhibit attracting approximately eight million visitors during its seven-city US tour, Martin released the single "King Tut." Performed by Martin with the Toot Uncommons (actually members of the Nitty Gritty Dirt Band),

"King Tut" paid homage to Egyptian pharaoh Tutankhamun, the boy king who "gave his life for tourism." The hit single sold more than a million copies, many of them resulting from Martin's guest presentation on *Saturday Night Live*, the successful late-night television variety show.

"The record sales and the appearances on *SNL* compounded the size of the live audience," according to Martin. "My recollection of the general period is precise, but my memory of specific shows is faint. Every place was the same—I stood onstage, blinded by lights, looking into blackness. The nuances of stand-up still thrilled me, but nuance was difficult when you were a white dot in a basketball arena."

Within three years, Martin had quit stand-up and dedicated himself to acting, writing movies, plays and books. And to music—he had included banjo playing in his comedy routines from the beginning. ■

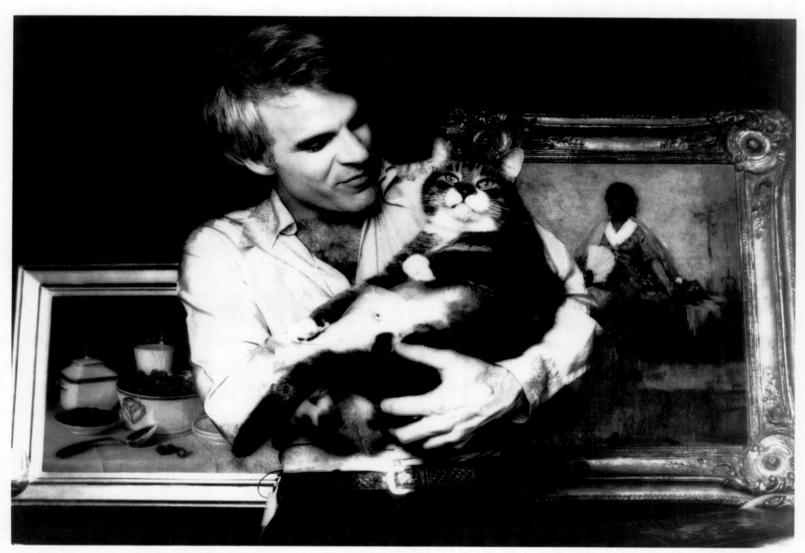

STEVE MARTIN

WARNER/REPRISE

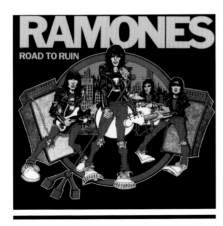

Ramones' road-weary ode "I Wanna Be Sedated" would become one of the band's best-known songs.

Billboard 200: *Road to Ruin* (#103)

THE RAMONES seemed to be the perfect antidote to rock's worst excesses. Formed in 1974, the Queens, N.Y., quartet looked like juvenile delinquents in leather, torn jeans and sneakers. Their fresh and funny three-chord style codified the American punk rock movement with stripped-down pop hooks about cretins and absurdist takes on teen angst. Mixing their love of early Sixties pop tunes, punk attitude and irresistibly inane lyrics, they repeatedly delivered a consistent cartoon vision—odes to being young, stupid and brain-damaged.

Often cited as the first group to define the punk sound, the influential band never achieved the commercial success suggested by its pioneering status. Even with songs such as "Do You Wanna Dance" and "Rockaway Beach," *Rocket to Russia* never got off the launching pad, sales-wise.

"We're proud, like we know that we kicked off the whole punk scene," singer Joey Ramone said. "What bugs me is people that come out that sound like a 20th generation of somebody else. Like the Cars kinda used us as a basic, and the singer is like Bryan Ferry, and they sound a little like Boston or somethin'…they're not doing anything that much different than what we're doing except they're very commercialized." He paused. "And, of course, their records are doing fantastic."

The fourth studio album by the Ramones was the first to feature new drummer Marky Ramone. He replaced founding member Tommy Ramone, who stayed to co-produce the album under his birth name of Erdelyi with Ed Stasium. In an attempt to get the band more airplay, *Road to Ruin* incorporated guitar solos, ballads, acoustic guitars and the first two Ramones songs to run longer than three minutes. The album also included fan favorite "I Wanna Be Sedated" and a cover of the Searchers' "Needles and Pins." Still, the change in form didn't gain mainstream acceptance.

"I don't care anymore if we have a hit," Johnny Ramone stated. "We're popular enough to satisfy me. Any more success would probably just be a pain in the ass. I'll be content if we can just hang on for a few more albums and quit when it stops being fun." ■

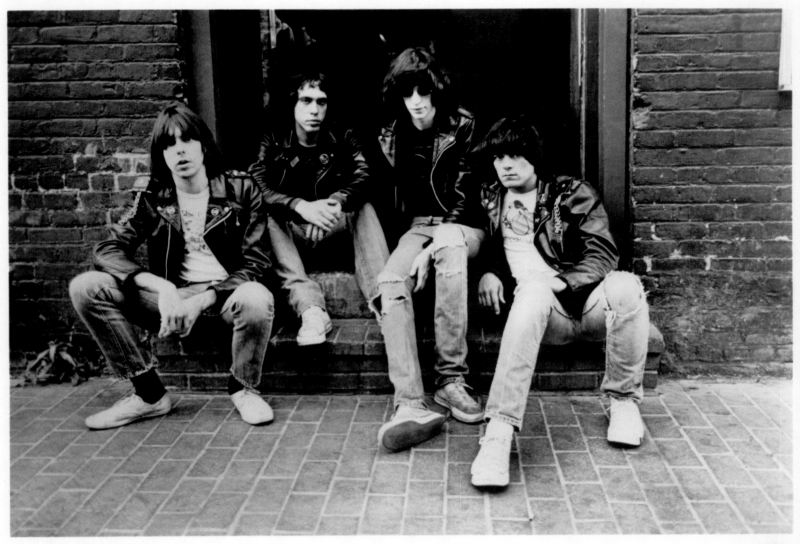

RAMONES Johnny Marky Joey Dee Dee

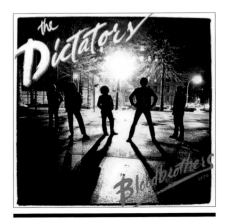

The Dictators, energized by the developing punk scene, found their own musicality on *Bloodbrothers*.

THE DICTATORS formed in New York City circa 1973 when Andy Shernoff quit editing his irreverent fanzine, *Teenage Wasteland Gazette*, and recruited Ross "The Boss" Friedman and Scott "Top Ten" Kempner as guitarists. Richard Blum was then transformed from an equipment-mangling roadie into the group's secret weapon—vocalist Handsome Dick Manitoba, "the Handsomest Man in Rock 'n' Roll."

Having made numerous industry contacts in his writing days, Shernoff landed the Dictators a recording contract with Blue Öyster Cult's producers. *Go Girl Crazy!*, the Dictators' 1975 album, provided a blueprint for American punk rock. With ahead-of-their-time enthusiasm for all-star wrestling, White Castle hamburgers and television references, it made them living legends among those who understood the joke.

Unfortunately, the hilarity was lost on radio programmers and the band's record company.

"It was the output from five teenagers who had never really paid dues in the rock business, and six months after they had decided to form a band, were thrown in the studio and given money to make a record," Manitoba lamented. "The craziness and energy that came out of that was unique. There was no limit. That's why that album will always be a classic."

Frustrated by the lack of sales, the Dictators broke up for a few months but reconvened and resurfaced with *Manifest Destiny* in 1977. *Bloodbrothers*, the group's third album, was the first to spotlight Manitoba as the vocalist on all the songs. The opening track, "Faster and Louder," featured an uncredited guest appearance by Bruce Springsteen. Critics and fans embraced the band as proto-punk godfathers.

"The Dictators had a punky attitude when it wasn't popular," Shernoff said. "There were no freaked-out kids, there were no Ramones, there were no bands catering to that audience. Punk rock is not a form of music; it's kind of a backlash, a return to where the rock 'n' roller is again getting into the role of the car thief, the juvenile delinquent, as when rock 'n' roll first started. Elvis Presley was just another sorry social misfit, and everybody in rock 'n' roll at the time was a social misfit. Since then, things have become respectable, so grandmother can listen to Peter Frampton.

"We had to prove that we're a traditional rock 'n' roll band." ■

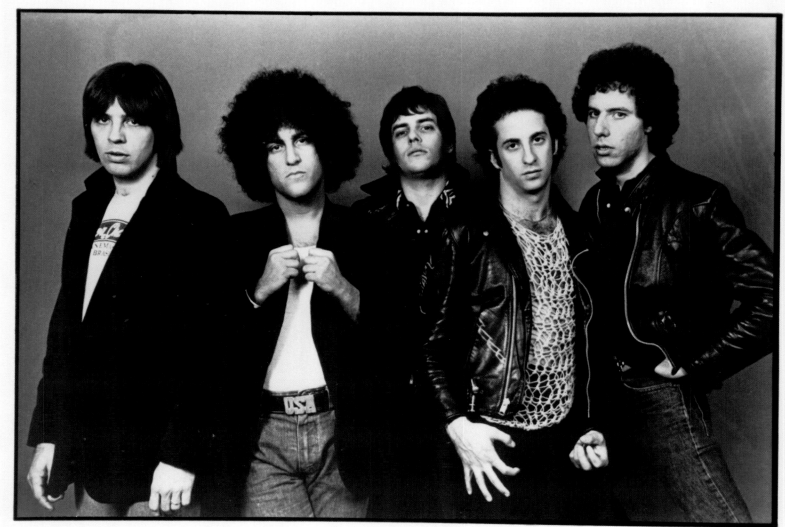

RICHIE TEETER HANDSOME DICK MANITOBA ROSS THE BOSS TOP TEN ADNY SHERNOFF

THE DICTATORS

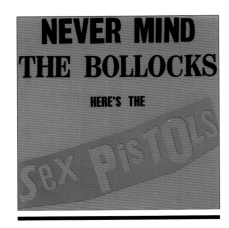

Sex Pistols' riotous *Never Mind the Bollocks, Here's the Sex Pistols* was punk's greatest recorded event.

Billboard 200: *Never Mind the Bollocks, Here's the Sex Pistols* (#106)

FRUSTRATED BY stifling nostalgia, high unemployment and repressive political leadership, English youth ignited a revolution in the mid-Seventies that would change the rules of rock music forever. The punk rock movement—an explosion of raw, untutored sounds, riotous concerts and outrageous behavior drenched with sex and violence—would have at its red-hot center the Sex Pistols, led by star hellion Johnny Rotten.

Four directionless young men who ran with manager Malcolm McLaren's philosophy of "If you're willing to offend, notoriety is easy," the Sex Pistols erupted out of London with the song "God Save the Queen." Their ravings and antics affronted everyone from members of Parliament to the rock establishment they sought to unseat. The band released only one album in its short life span, but the effect of *Never Mind the Bollocks, Here's the Sex Pistols* was electrifying.

Focused through Rotten's scabrous vocals and the relentless blitzkrieg of sound crafted by guitarist Steve Jones, the record's ele-

ments—nihilistic politics, punk musical values, willful vulgarity—were so crudely evocative that they stopped a new generation cold. Nothing had ever sounded quite like Rotten's feral parting shot in the stunning single "Anarchy in the U.K.": "I wanna get pissed/Des-*tr-oy*!"

"The Sex Pistols stood for a lot in their time," Jones said. "I knew two or three chords when we started. I guess that's what made it sound so…unusual."

In January 1978, the Sex Pistols came to the US for a 12-day tour, mostly of cities in the Deep South—and they imploded. They sought to raze the music industry, but they couldn't help but despise themselves when they became successful. The punk scene flew off the tracks and slid into facile nihilism, but the media romanticized and embalmed the Pistols' "no future" estrangement.

"That's romance, and that don't exist in the real world," Rotten spat out. "The Pistols never ended properly, it just kind of fizzled. So there's always going to be a dot-dot-dot." ■

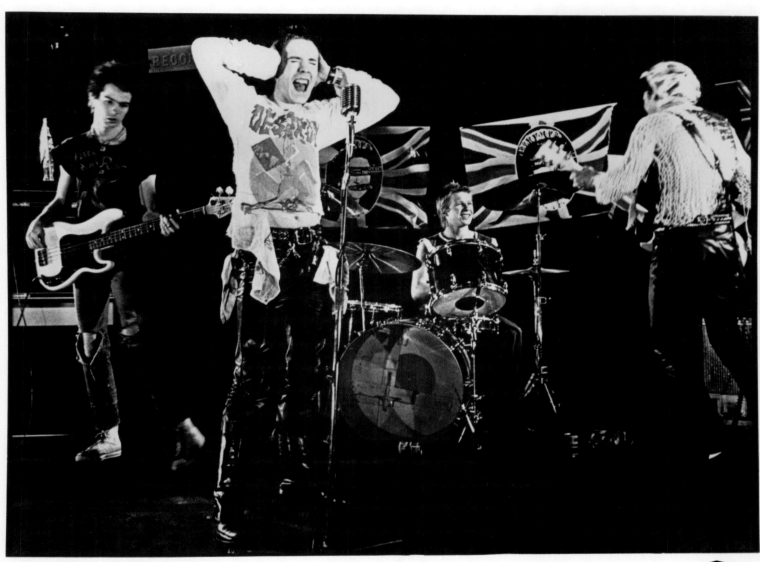

SeX PiSTOLs

WARNER / REPRISE

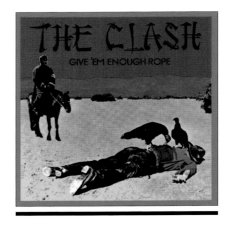

Billboard 200: *Give 'Em Enough Rope* (#128)

The Clash's second album, *Give 'Em Enough Rope*, was the English punk band's first release in the US.

THE CLASH achieved commercial success in the United Kingdom with the release of its self-titled debut album in 1977. Along with the Sex Pistols, the London-based group became frontmen for the punk rock movement in England, where urban revolution appeared more urgent and less frightening than it did to the stoned teens of America.

"When the Sex Pistols came on the scene in London, I knew that I had to change, to do something different," singer-guitarist Joe Strummer said. "It was early spring of 1976 and it was a really good feeling—a lot of people running around in the streets, a bit of cool weather, a lot of new fashion ideas, a lot of fanzines springing up. Everybody was in a higher pitch—it was a good time. But part of the heady days was that people just jumped up to do something without thinking too much of the future. A lot of groups were put together over the weekend and were crashing about by the next week. We weren't sure we'd last."

The Clash, one of the finest punk records of the period, wasn't released in the United States because of its extremely primitive sound quality. Before the Clash began recording its second album, CBS requested that the band adopt a cleaner sound than its predecessor in order to reach American audiences. Sandy Pearlman, known for his work with Blue Öyster Cult, was hired to produce *Give 'Em Enough Rope*, which preceded the US version of *The Clash*.

"You know, the Pistols said it all in one go—*Never Mind the Bollocks*. There was never a need for another Sex Pistols album after that," Strummer said. "Ours was the same—we spent a year making our first record and we really didn't want to make another one right away. We were pushed into it by the industry—you're a group, so you put out records. Something normal, they hope."

Although some complained about its relatively mainstream production style, *Give 'Em Enough Rope* received largely positive reviews. "Tommy Gun" rose to the highest chart position for a Clash single to date in the UK, but America remained unreceptive. Radio airplay was non-existent, and the average kid still formed images of safety-pinned weirdos when hearing the word "punk."

"We took a long time making the record," guitarist Mick Jones confided. "It was the transition from being total amateurs to sounding really good. There was quite a constant battle with Sandy. But it worked out because we had to have a look and see what it was like (in the US) before we came over to play. It was cool that we had time to make plans—you know, it's like we're Nazi spies or something. I don't know what's wrong with the people over here. All the kids seem to be walking around in a daze, the same songs are on the radio and they're all really shitty. We want to wake them up a bit, but it's probably gonna take some time." ■

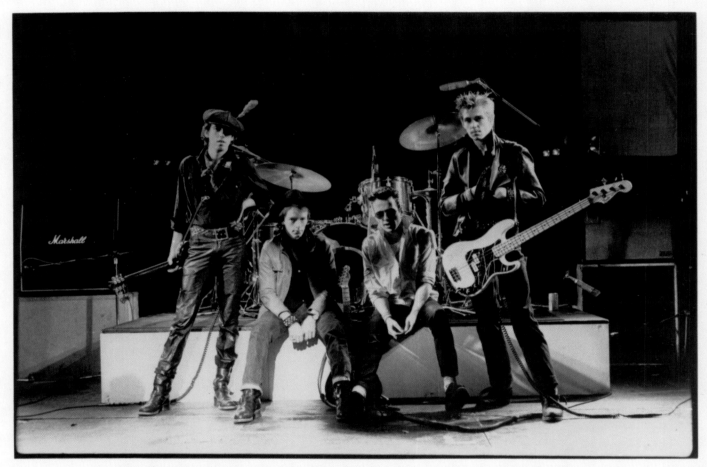

Mick Jones, Nicky "Topper" Headon, Joe Strummer, Paul Simonon

The Clash

Epic

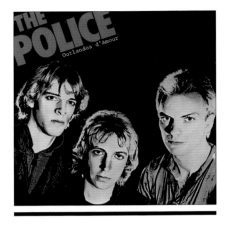

The Police's stunning "Roxanne" was characterized by insistent rhythms and Sting's plaintive vocal.

Billboard 200: *Outlandos d'Amour* (#23)
Billboard Hot 100: "Roxanne" (#32)

INSPIRED BY the punk boom in England, drummer Stewart Copeland, guitarist Andy Summers and bassist-songwriter Sting teamed up as the Police and transcended the faddish "new wave" label.

"We've been influential from the beginning," Sting admitted. "When we started, we didn't ask our label for a million dollars, we gave them a record and asked them to sell it. It's an enviable position."

"Part of our general policy right from the inception of the band has been to retain our autonomy and control as many aspects of our career as we can," Summers added. "It seems simple, but we've done exactly what we intended. You have to get past the trends and fashions and thing-of-the-week status and go for longevity. You can only do that by developing your own sound and showing some spark of originality."

Given Sting's building reputation as an intense, charismatic performer and the progressive musical backgrounds of Copeland and Summers, the Police's well-crafted approach soon made them one of rock's biggest outfits. The intriguing aspect of the peroxided trio's successful sound was the sensual shadings of the reggae music that had gained a foothold in Britain, incorporated into a rock context on "Can't Stand Losing You," "So Lonely" and, of course, "Roxanne," the heavily played give-it-up-for-me ode to a prostitute. Sting, who claimed Bob Marley as a major influence, had his own theory as to why his group was the only reggae on US airwaves.

"The prime reason is that we're a white group. I don't think a black Jamaican group stands much chance. That's not a perspective on America, that's just the way things are. Secondly, I think we're quite good at it—'*Just because we de wrong color, mon...*' It's similar to what happened with rhythm and blues in the Sixties. The Rolling Stones came out and played old R&B that was largely unheard of in the States." ■

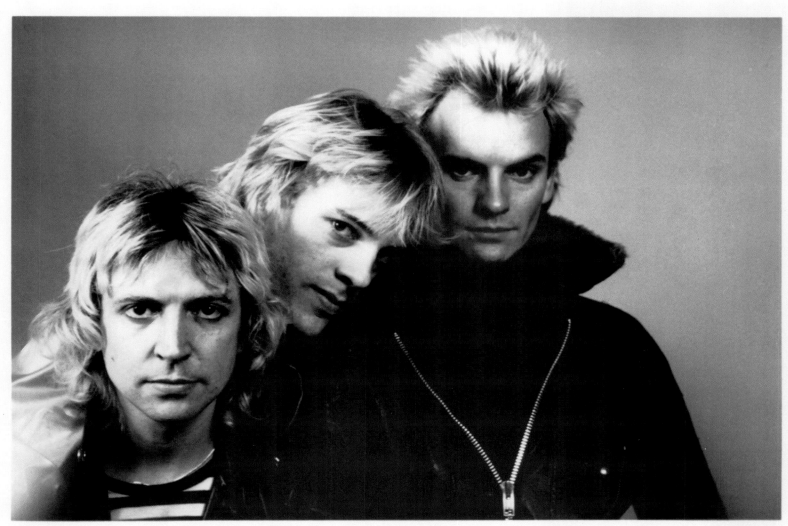

POLICE

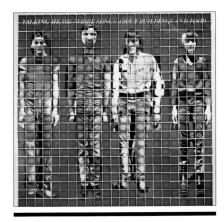

Billboard 200: *More Songs About Buildings and Food* (#29)
Billboard Hot 100: "Take Me to the River" (#26)

New wave band Talking Heads dented radio playlists with a version of Al Green's "Take Me to the River."

THE NEW York underground scene served as a spawning ground for numerous new groups in the Seventies. While much of America was encouraged to headbang to the Ramones and their minimalist ilk, Talking Heads eked out a loyal, intelligent following. The former art-school students refused to be categorized, combining their deadpan expressions, short hair, rhythmic twists and songs without solos into an idiosyncratic style.

"Our music was a little more oddball and wacky in the beginning," soft-spoken writer-guitarist David Byrne allowed. "At first, people said we were intellectual and only smarties would like us, but then all these kids came and liked us and proved they were wrong."

Talking Heads' second album, *More Songs About Buildings and Food*, was the first produced by collaborator Brian Eno. Described as a "non-musician's musician" early on in his career—he was the wizard who made early Roxy Music recordings dynamic with his in-ventive use of synthesizers and tapes—Eno's avant-garde approach perfectly complemented the band's music, and they began to explore an increasingly diverse range of musical directions.

"We have similar concepts about music, and that's why we get along," Byrne said. "I'm not well-trained musically, either. I never went to music school, and I can't read music. I still have to have some of the chords I come up with explained to me."

More Songs About Buildings and Food was a Top 30 album, and Talking Heads found the elusive hit recording on commercial radio—a cover of Al Green's "Take Me to the River," a song that the band had done live to enthusiastic response. Byrne thought the song was too "sluggish" to become an airplay staple.

"I'm sort of proud, because I think some of the stuff we do is pretty weird," he allowed. "It's very nice we can get on the radio, because we've never done anything with the radio in mind." ∎

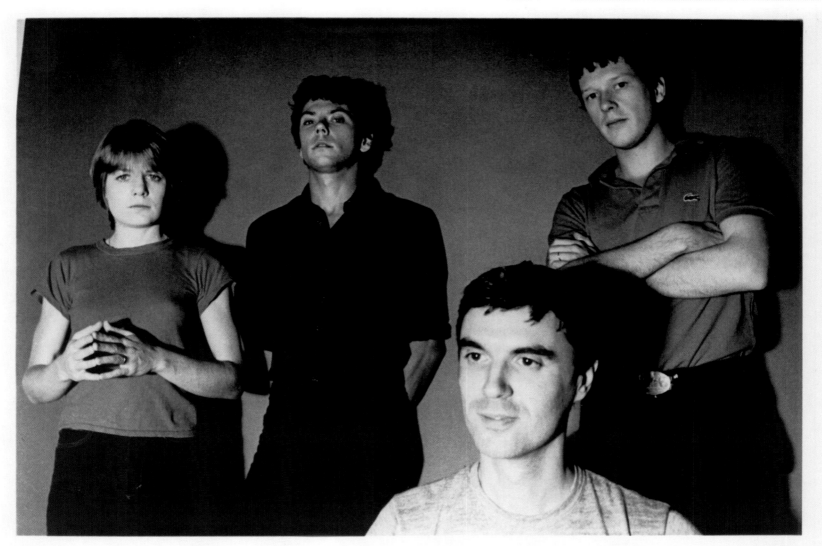

TALKING HEADS

Tina Weymouth Jerry Harrison David Byrne Chris Frantz

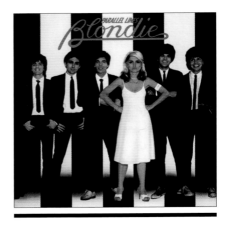

Early New York punk pioneers **Blondie** finally commanded a large listening audience with "Heart of Glass."

Billboard 200: *Parallel Lines* (#6)
Billboard Hot 100: "Heart of Glass" (No. 1);
"One Way or Another" (#24)

DEBBIE HARRY'S chilly beauty was central to the Blondie mystique when the band emerged from the New York club scene. Harry was the queen of CBGB's, a hole-in-the-wall on the Bowery and the place for aspiring bands to play. Fronting Blondie, her demeanor was less aggressive as the act matured.

"I don't like bumping into guitarists anymore," Harry said. "It's no more than that. It hurts!"

Blondie had been seen as "Debbie Harry's group" because of her glamorous aura; a "Blondie is a Group" button campaign proclaimed her role as a band entity rather than the star. Blondie released the singles "Denis," a remake of Randi & the Rainbows' early Sixties hit, and "(I'm Always Touched by Your) Presence, Dear"—both of which made the band famous overseas and neither of which became a hit at home.

"I thought that 'Presence, Dear' might do well in America—it has

a country, Eagles flavor to it," guitarist Chris Stein mused. "We have a lot of excuses for what happened over here. There's so much resistance to anything that radio stations think is like punk rock or new wave. It's so crazy because it's so meaningless. The scene is long gone—and good songs should make it anyway."

Blondie worked with producer Mike Chapman on new music, and his flair for carefully crafted pop rock songwriting helped make the band's third album, *Parallel Lines*, an international success. Still, none of the first three singles—"Picture This," "I'm Gonna Love You Too" and "Hanging on the Telephone"—charted in the US. When the band was surely resigned to not having hit records in America, the fourth, the danceable "Heart of Glass," hit the No. 1 spot. Some critics condemned Blondie for "selling out" by doing disco, but the song's smash status solved part of the band's ongoing identity crisis. ■

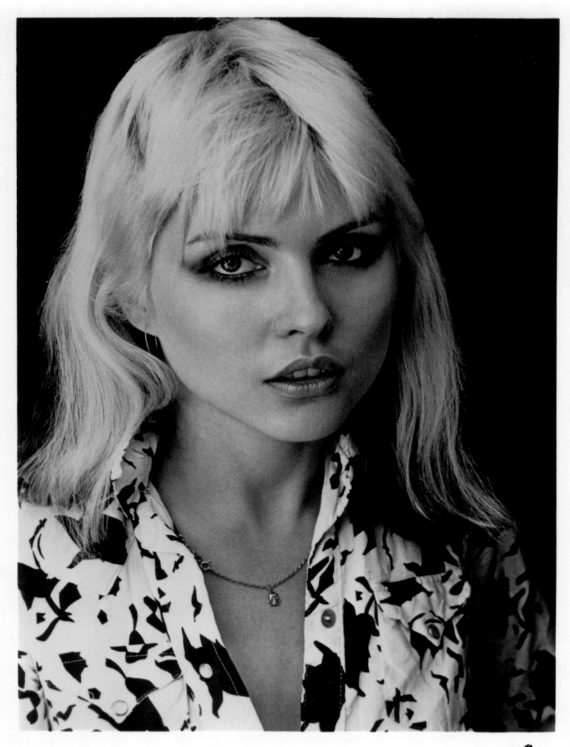

Deborah Harry of Blondie

Chrysalis ™

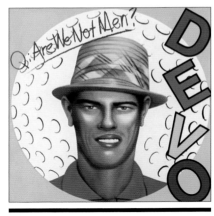

Billboard 200: Q: Are We Not Men? A: We Are Devo! (#78)

From Akron, Ohio, Devo came into prominence with the innovative *Q: Are We Not Men? A: We Are Devo!*

DEVO'S ORIGINS stemmed directly from the members sitting around their apartments, giving "art-raps" and creating their cynically offbeat view of advancing technology's dehumanizing effects. The group devised a dizzying array of components for their act—electronic pop music, absurdly provocative philosophy and highly developed media wizardry. The members mixed in surreal videos and costumes to propagate the mythology; singer Mark Mothersbaugh donned a baby mask as Booji Boy, a symbol of infantile regression.

"Devo is short for the theory of 'devolution,'" Mothersbaugh said. "The state of technology and civilization is in a downward spiral. Rather than evolution, we see devolution going on."

It was a chore for Devo to get a recording contract, but Warner Bros. Records backed the robotic group to the hilt for its debut album release, produced by Brian Eno. *Q: Are We Not Men? A: We Are Devo!* introduced people to "the sound of things falling apart," thanks to the bizarre but catchy brand of techno rock—the anthemic "Jocko Homo" (which introduced the call-and-response album title), "Come Back Jonee," "Mongoloid" and a spastic remake of the Rolling Stones' classic "(I Can't Get No) Satisfaction."

"We are convinced that mankind is in a post-human state," bassist Jerry Casale said. "As Devo, we try to act as a release of sorts—a steam valve for corporate society." ■

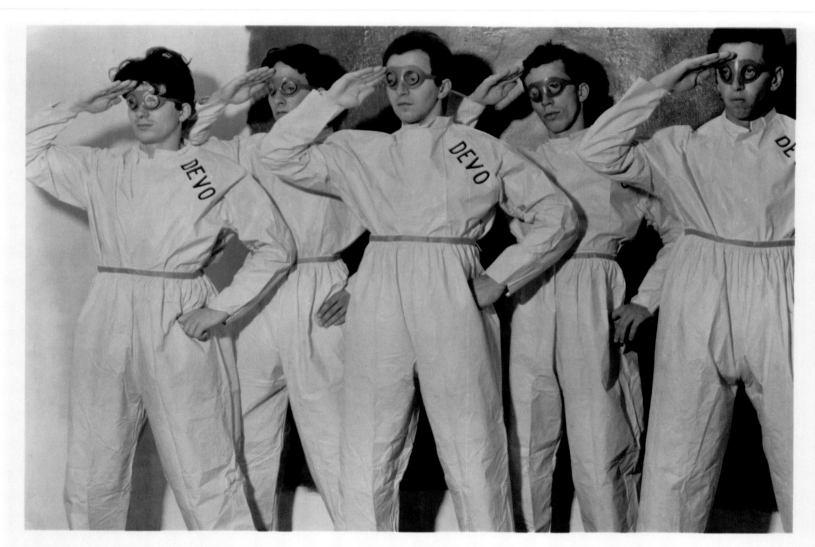

DEVO

WARNER/REPRISE

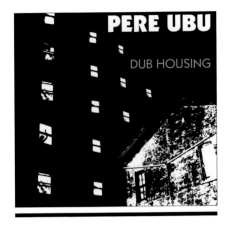

The influential **Pere Ubu** sprang from Cleveland, mixing an original, bizarre brew of folk-blues-jazz rock.

WHILE THE musicianship was often powerful and polished, Pere Ubu singer David Thomas' blasts of animal noises contorted into human warbling were the band's most noticeable sonic trademark.

"I was a journalist, I had strong opinions and I got tired of inflicting them on bands," he recalled. "I picked up the guitar and after three days my fingers hurt. So I sang. I was terrible for three years—I'm still tone-deaf. But necessity being the mother of invention, I sorted out a way to sing that people are able to take, yet delivers the emotions I want to deliver. By trial and error, I figured out how to get around inability."

Pere Ubu was hailed as a high point of cultural synthesis in rock, and the group was actually signed to a major label, Chrysalis, for *Dub Housing*, its second studio album.

"There was a brief period, about six months, where nobody knew what was going to happen in music, what was going to be commercial," Thomas said. "A big record company took us on during that period, and after that, they knew it wasn't us. But it was too late. We never set out to do experimental music. We never said, 'This is weird, this breaks new ground.' We just set out to make music that fulfilled the potential to communicate complex emotions." ■

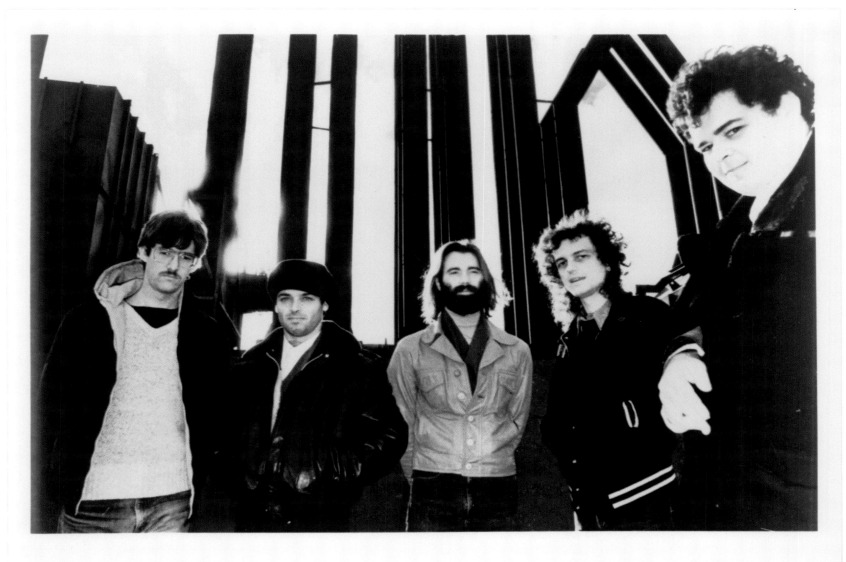

Pere Ubu

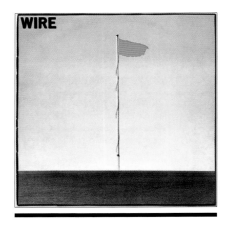

Contrary to the working-class snarl of British punk, Wire offered a deliberately experimental approach.

WHEREAS LONDON'S other exports (the Sex Pistols, the Damned, the Clash) viewed punk as a means to get back to rock's roots, Wire's brief, fractured songs and minimalist sonic quality cut the music to its nerve.

"It's difficult not to sound arrogant," guitarist-vocalist Colin Newman said. "But *Pink Flag* was one of the few Brit 'new wave'—God, I hate that term—items to get national distribution in the US. Wire's stripped-down minimalism appealed to a new generation of young musicians who, in fact, had much more entrenched 'muso' attitudes to rail against than their UK counterparts. So it happened that Wire, rather than the Pistols, became the drug of choice for the newly evolving hardcore bands."

Comprised of art-school students, the band members' collective and individual blurring of art, music and performance left a lasting impression on such descendants as R.E.M. and the Minutemen.

"In so many ways, *Pink Flag* occupies a niche in the US musical consciousness that it doesn't have in the UK, as a kind of blueprint for terseness. Each generation of young bands and their friends want to reject the inevitable lapses into dull formalism which US culture is famed worldwide for producing. They check out the blueprint and find something they can use. Either that, or they are all on drugs and hypnotized!" ■

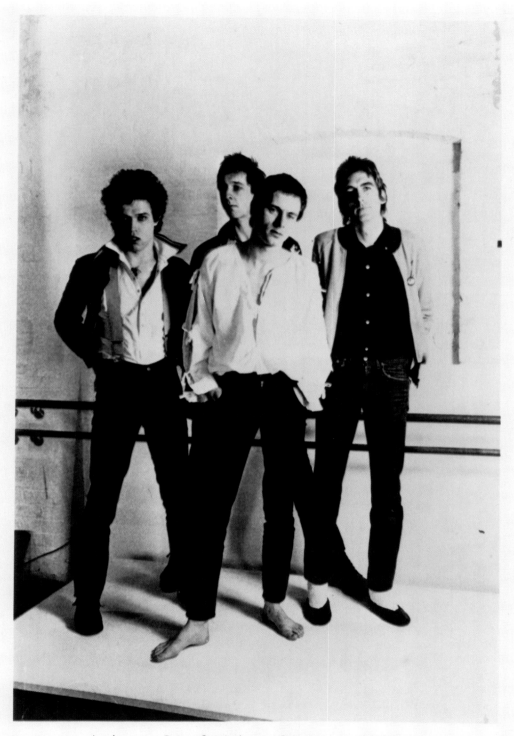

Lewis Robert Gotobed Colin B.C. Gilbert

WIRE

Generation X, an English pop-punk band from London, launched the phenomenon that was Billy Idol.

NO YOUNG English act had transcended punk categorization to do well in the American market, but with an accessible sound and image—notably vocalist Billy Idol's attractive looks and immanent conceit—Generation X had the potential to achieve commercial success. *Generation X*, the group's debut album, steered clear of the societal nihilism and militant politics of the punk movement, and Idol went on a promotional visit to the US to articulate the status of the English scene.

"English bands aren't just singing about how much they hate the government. American people just picked up on that side of it," Idol said. "The biggest risk is getting in a group in the first place, saying, 'I'm gonna do it, and fuck everything else,' because you get people saying 'You're a jerk, you can't sing.' Then you go and do it and you prove it to them. That's the whole point of this new music."

Idol cited the maturity of Patti Smith as an example of an artist growing into other musical roles.

"In the beginning, there was a huge rush of groups that wanted to get out and play because that feeling of pent-up frustration was inside us. Everybody did it openly, almost without thinking, because they didn't care. But we realized that we were denying a lot of other emotions, other ways of singing and playing songs which weren't coming out on records. Now groups have gotten over the anger, the first frustrated pleas, and are consolidating the way they feel. Everyone says the music's dead, but the groups that have hung in, like the Clash, are going to put out the best records ever made in the next year or so. We're people singing about real things, and perhaps that will get across to the people in the States. The audience needs as much time as the groups to suss it out. It isn't a rush job. We aren't a pack of cigarettes to be drawn off the market if we don't make it in six months."

Generation X wasn't out to destroy the old-timers as punk rock acts had people believing.

"We've never denied our influences, because I want to be a part of the history of rock 'n' roll," Idol insisted. "People like Peter Townshend, Ray Davies, Keith Richards and Lou Reed made me love rock 'n' roll, made me want to be in a group. If people say they hate the old groups, it's because the old groups have stopped singing songs the audience can feel part of. That was good, because it made us do it ourselves and not rely on an older culture. Now there's a Seventies culture, and we're going to make it ours." ■

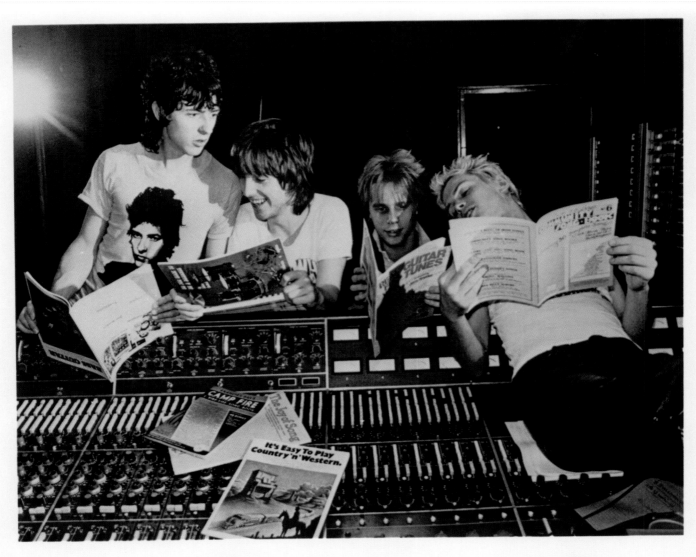

Generation X

Chrysalis ™

After the demise of the New York Dolls, David Johansen returned to recording with a self-titled album.

NOBODY WAS ready for the New York Dolls in the early Seventies. Playing loud, sloppy rock 'n' roll with their glitter, makeup and androgynous appeal, the frail New Yorkers opened up a whole new realm of pretentions. David Johansen was the group's bratty frontman.

"Back then it was all so innocent—there'd be a place to play, there'd be a crowd, so we'd do a concert," Johansen recounted. "Our records are considered classic, but the looseness of the recording sessions was responsible for that."

Eventually, the Dolls failed in their bid for rock stardom and split up after garnering a heap of media attention. Although the band never met with any degree of commercial success, it planted the seeds of what became the punk and new wave scene.

"We weren't ahead of our time," Johansen insisted. "Someone had to break down the barriers and show kids that you didn't have to be commercial, that you could just go out and do what you felt. We gave a lot of New York bands the chance to get out and play. It just got to a point where it was limiting each one of us into a role that we were finished with. It came down to whether we were gonna make a third album or not. We decided not to. You get weary after touring for three years. You want to go home and see your mother."

Johansen survived a bout with demon alcohol and kept in shape with a band featuring old Dolls cohort Sylvain Sylvain on guitar. When the singer decided the time was right to launch his solo career, *David Johansen*, which contained the powerful "Funky but Chic," showed he hadn't lost his swagger or street smarts. The album gave him immediate standing as an elder statesman of punk.

"It don't grate on me—I'm kinda proud of it," he said. "I'm really flattered when kids include me in those categories. Every town has pockets of real aware music fans. I'm glad they're still with me, because the music has come a long way." ■

David Johansen

7803

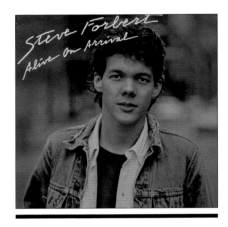

Billboard 200: *Alive on Arrival* (#82)

Singer-songwriter **Steve Forbert** embarked on a recording career with *Alive on Arrival* and won rave reviews.

AT THE age of 21, Steve Forbert quit his job as a truck driver in his hometown of Meridian, Mississippi, and moved to New York. There, he performed for spare change in Grand Central Station.

"I just felt it was the thing to do," Forbert said. "It was the only alternative for me. I wanted to do the whole thing, to make records and take my songs out to people—trying to be heard and make my own contribution."

Forbert eventually became a regular on the live music circuit, particularly at CBGB's, the New York club that was the breeding ground for innumerable punk bands and notorious audiences. The driving rhythms and sheer energy of his folk rock-styled songs helped compensate for his lack of volume.

"It wasn't as strange as you might think," Forbert reflected. "I had been reading about the place and groups like Television and Talking Heads. I liked that stuff, and I still do."

Forbert preferred to talk about himself through his music rather than in conversation. On his first album, *Alive on Arrival*, he struck his acoustic guitar aggressively, took fervent blasts on harmonica and sang in a hoarse almost-whisper. He soon found himself falsely labeled "the new Bob Dylan."

"That does get to be a bit of a drag sometimes," Forbert said. "I'm just trying to do what I think is right at any certain time." ∎

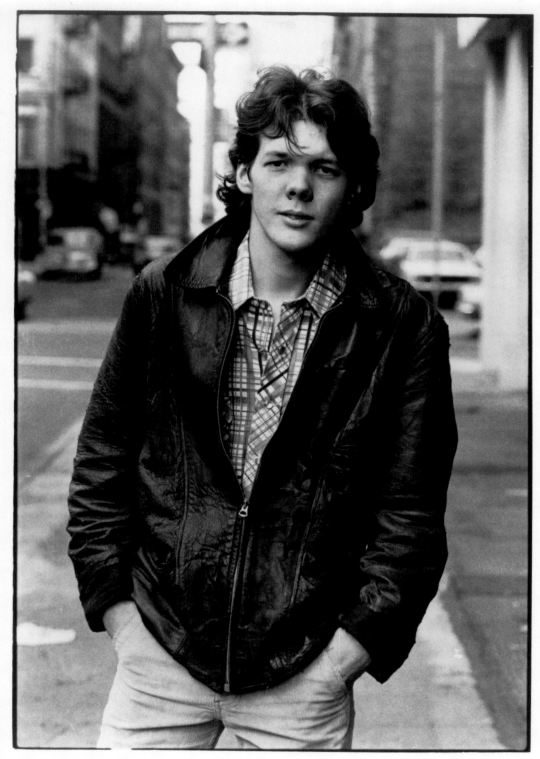

STEVE FORBERT

PHOTO:
DAVID GAHR 7807

Epic

NEMPEROR
RECORDS

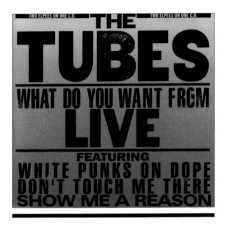

The Tubes sought to match their manic stage show with a recorded option, *What Do You Want from Live*.

Billboard 200: *What Do You Want from Live* (#82)

NEITHER A punk nor a glitter band, the Tubes were a bunch of gifted humorists trying to make it as a rock troupe. Satire wasn't the easiest tool to wield in the world of rock music, and the Tubes used it more like a club on tunes like "Don't Touch Me There" and "White Punks on Dope"—both parodies of rock 'n' roll lifestyles and celebrities.

The band's stage show involved conveyor belts and ramps, S&M regalia, and risqué choreography and costuming (one-legged ballerinas, human Quaaludes and dancing gorillas). Female vocalist Re Styles was tied between two video monitors to sing "Mondo Bondage"; lead singer Fee Waybill was beaten with giant cigarettes during "Smoke (La Vie en Fumér)."

Founded in San Francisco—"a wonderfully degenerate, diseased scene," per Waybill—the Tubes had yet to break big in the US market.

"There are not enough promoters with enough nerve to book us," he said "We've been thinking of calling it quits in the US because it's so fucked. We'll just go to foreign countries. We're big stars in England—where it's terrible! It's got the worst air, the worst water, the worst food, the worst anything you want to name. It is the pits. Every single person in the whole country smokes cigarettes, and they all have brown teeth and rotted-out gums. Everything is black from coal—the buildings are black, the streets are black, the signs are black. After you go there for two months, you're wishing for anything USA."

The release of *What Do You Want from Live*, recorded during a tour of the UK, marked the best representation of the band to that point. Waybill's musical superhero characters included Quay Lewd, "the ultimate rock star" with his three-foot-high platform shoes and Q-shaped guitar, and Johnny Bugger & the Dirt Boxes, a punk parody that the Tubes anticipated when people still thought Sex Pistols were bought at an adult toy store.

When asked what would happen if the live album stiffed, Waybill revealed, "We're gonna try recording in garbage cans. It all comes out the same anyway. We figure if we start in the garbage can, it won't have so far to go before it winds up there." ■

Bag-O-Bucks
112 Steuart · San Francisco
(415) 495-3141

A&M
RECORDS

Printed in U.S.A.

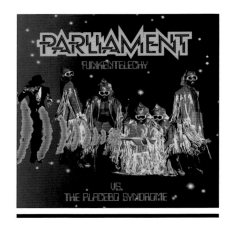

With the dizzying funk jam "Flash Light," **Parliament**, led by George Clinton, got a million-selling single.

Billboard 200: *Funkentelechy Vs. the Placebo Syndrome* (#13)
Billboard Hot 100: "Flash Light" (#16)

GEORGE CLINTON founded funk. In the Seventies, he ruled the Parliament-Funkadelic empire, a rotating roster of nearly 40 musicians, and his records with the two groups and various in-house projects (Bootsy's Rubber Band, the Brides of Funkenstein, the Horny Horns, Parlet) threw down an edict: "Free your mind, and your ass will follow."

The musical touches were wild, deep soul rhythms, screaming metal guitars and choral harmonies. And the shows were elaborate. "Dr. Funkenstein" and his entourage would descend to the stage in a full-size spaceship, clad in futuristic leather suits, goggle-style shades, jewel-encrusted boots and big hair.

"We tried to be spectacular," Clinton explained. "We told Kiss where to get their costumes at! Musically, we started out with pretentious shit, mixing boring psychedelia and corny horns. But then the stuff got good!"

Funkentelechy Vs. the Placebo Syndrome was a loose concept album warning the listener of falling into the "Placebo Syndrome," which Clinton identified as consumerism, and listening to disco music, which he saw as a simplification of funk music in an attempt to gain commercial success. It spawned "Flash Light," released in January 1978, which became the first No. 1 R&B hit by any of the P-Funk groups. The single spent four months on the pop charts, and *Funkentelechy Vs. the Placebo Syndrome* became Parliament's second platinum album. ■

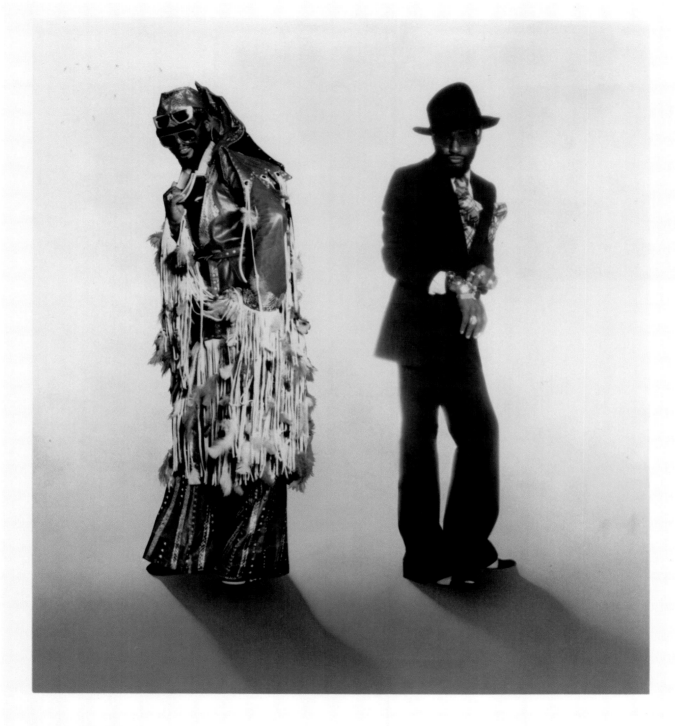

 GEORGE CLINTON

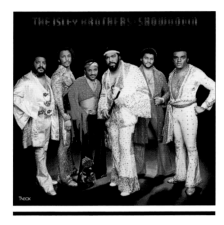

The Isley Brothers kept the funk in the family, generating the No. 1 R&B hit "Take Me to the Next Phase."

Billboard 200: *Showdown* (#4)

THE ISLEY Brothers started as a vocal trio from Cincinnati.

"Our father had a dream of having four sons who would be the next Mills Brothers, so the first four sons—Kelly, Rudolph, Ronald and Vernon—sang as a quartet," bassist Marvin Isley said. "But around the time my brother Ernie and I were born, Vernon died. So Kelly, Rudolph and Ronald went to New York in 1958 and played a few clubs. Dad died that same year, and the following year, the Isley Brothers had their first hit with 'Shout!' I was six at the time."

"Shout!" put the Isleys on the musical map, and the whole family moved to New Jersey to be nearer to the New York music scene. The Isley Brothers signed with Motown in 1966 and hit the charts with "This Old Heart of Mine (Is Weak for You)." By 1969, 16-year-old Marvin Isley was itching to play with his three older brothers, as were brother Ernie and brother-in-law Chris Jasper. "It's Your Thing" was the first release on the group's own T-Neck Records, which made the Isleys one of the first black groups to opt for creative control of its music.

"When the younger Isleys started playing their own instruments, we became a band rather than a group," Marvin noted. "It made us different from the Temptations or the Four Tops."

The younger brothers helped their older brothers incorporate elements of rock and funk-oriented material music as well as pop balladry. Ernie Isley had played the drums for many years with his siblings, but he got a bug about playing the guitar. The recorded result of Ernie's switch of instruments was *3 + 3*, a landmark album featuring the Top 10 smash "That Lady" that firmly established the Isley Brothers as a self-contained musical band. They recorded more top-selling albums in the Seventies; *The Heat Is On* featured the hit single "Fight the Power" and became their first LP to reach No. 1 on the pop albums chart.

The Isleys celebrated a 20th anniversary in 1978 with *Showdown*. While "Take Me to the Next Phase" sounded like a live recording, it was actually a studio recording with audience overdubs; group members provided additional crowd noises. A No. 1 R&B hit, it never managed to cross over to the pop chart. ∎

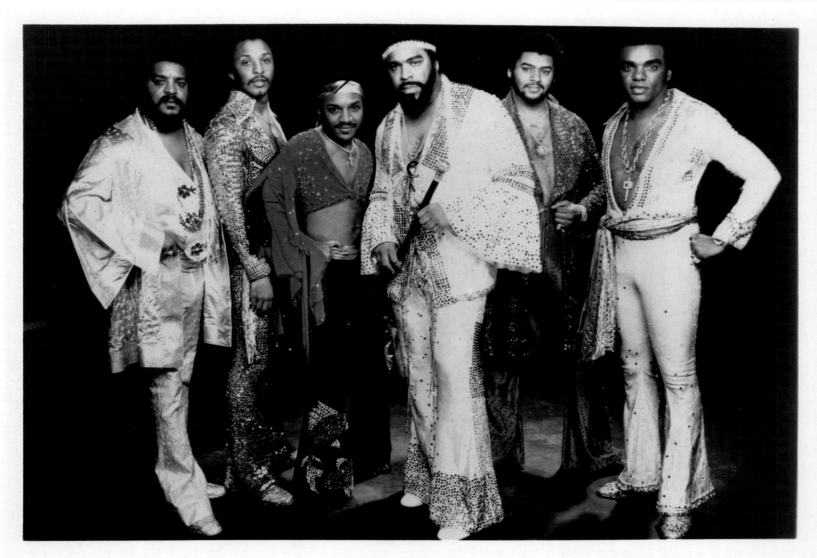

TNECK **The Isley Brothers** Epic

7803

A live take of "On Broadway" propelled George Benson's *Weekend in L.A.* album to platinum certification.

Billboard 200: *Weekend in L.A.* (#5)
Billboard Hot 100: "On Broadway" (#7)

GEORGE BENSON was well-versed on the twists and turns a musician's career could take. Beginning his professional career as a little-known jazz guitarist, he had recorded 12 albums as an instrumentalist before singing lead vocal on the 1976 pop smash "This Masquerade." The track won a Grammy Award for Record of the Year, and the album *Breezin'* hit No. 1 on the *Billboard* album chart.

Benson was then heralded as much for his melodic, velvety vocals as for his dexterous and inventive guitar-playing. Once hailed as "the natural successor to Wes Montgomery" before his commercial success overshadowed his early contribution to jazz, Benson cited the guitar great—who'd become his friend and mentor before he died in 1968 at the age of 45—as his greatest inspiration.

"He was an incredible individual," Benson said. "His guitar playing was just a reflection of what he was really like—a gracious, beautiful thinker who always looked for the good in people."

Benson's live take of "On Broadway," from the 1978 release *Weekend in L.A.*, recorded live at the Roxy Theatre in West Hollywood, hit #2 on *Billboard*'s soul chart and had substantial adult contemporary and smooth jazz radio airplay from that point on. It also won a Grammy for Best Male R&B Vocal Performance.

The impact gave Benson the freedom to pursue his goal of creating a smaller, more comfortable guitar that would withstand the volume levels of concert situations and retain a clear and clean sound. The introduction of the Ibanez George Benson GB-10 guitar model, which Benson used in all live performances and studio recordings, received a resounding acceptance in the marketplace.

"Many young guitarists told me that they could not get into the jazz feeling and sensitivity with the playing restrictions of the traditional jazz guitar with all its bulk and feedback," Benson stressed. "This is the guitar I've had in my head for a long time." ∎

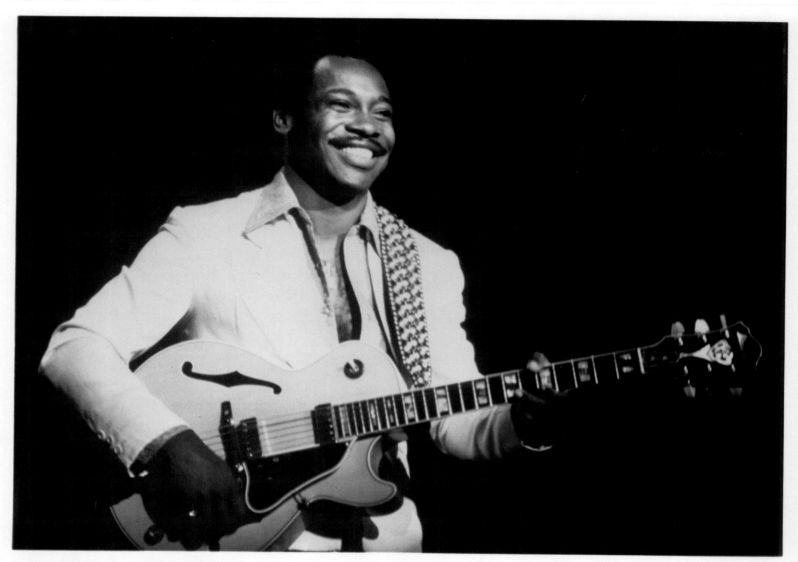

GEORGE BENSON

Billboard 200: *Cosmic Messenger* (#36)

Jean-Luc Ponty, a renowned figure in America's jazz rock movement, found himself riding the pop charts.

BEFORE JEAN-LUC Ponty's career, the violin was typecast as a classical music instrument, its presence in rock circles considered an eccentricity (Papa John Creach's tenure with Jefferson Airplane) or an affectation (the touring orchestras of the Eagles and Emerson, Lake & Palmer). And in the world of jazz, violin masters were few and far between.

But with his revolutionary style, the French artist defined the art of jazz rock violin in the early Seventies. Playing his Barcus-Berry electric violin, he contributed his talent to such well-known acts as the Mahavishnu Orchestra and the Mothers of Invention.

"It was an acoustic instrument with electronics put into it, much like the old jazz guitars," he explained. "The pickups captured the vibrations from the wooden body. Violins have a life of their own. The more you play them, the better the sound becomes, because the vibrations work into the wood. The violin's sound is expressive—it takes the place of vocals in my music."

"The founding father of fusion" had reached No. 1 on the *Billboard* Jazz Albums chart with *Enigmatic Ocean*; in 1978, *Cosmic Messenger* reached #2 and also cracked the pop Top 40.

"I've been accused of my albums all sounding the same. That's outrageous to me," Ponty said. "People who enjoy what I'm doing find something different with each release. It's important to keep a consistency of concept, but I don't like to rehash what I've done before. I get bored." ∎

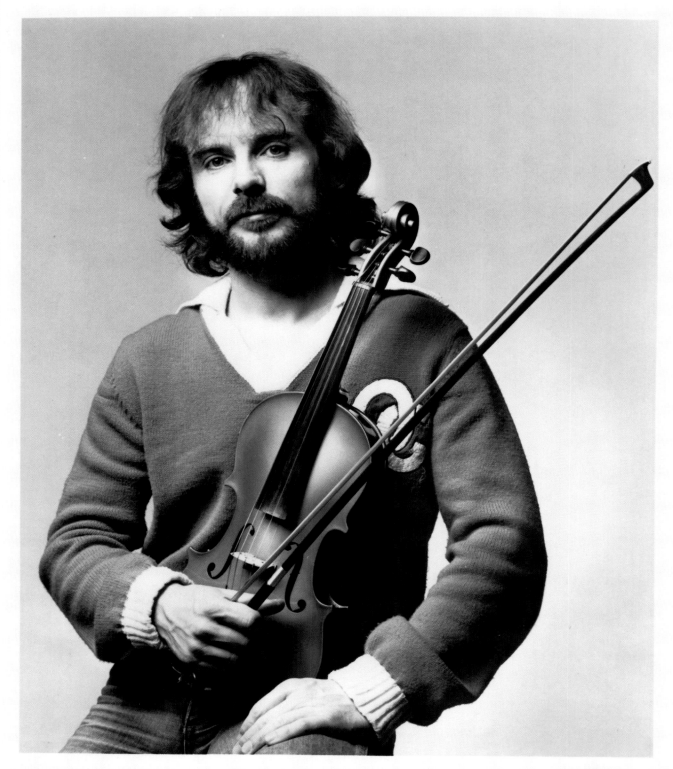

JEAN-LUC PONTY

ATLANTIC

Pioneering electronic music act Tangerine Dream put out *Cyclone*, its first album to accentuate vocals.

AN INTEREST in keyboards and electronic effects shaped German musician Edgar Froese's decision to form Tangerine Dream in the late Sixties.

"I wanted to start something where the music was totally improvisational," Froese noted. "The early Pink Floyd music interested me a lot, but I also liked the San Francisco bands who would just come out and play what they felt like."

Tangerine Dream—which in its most notable configuration consisted of Froese, Christopher Franke and Peter Baumann—based its sound on those dictums, attempting to create a central mood and then extemporizing from it. Free-form electronic jams characterized the trio's first four albums. Bringing the music to the stage, the three instrumentalists sat imperturbably behind their electronics array for three-hour concerts, with an elaborate laser and light show accompanying the musical barrage.

After years of cult status, Tangerine Dream composed its first soundtrack album, for the William Friedkin film *Sorcerer*, and shifted toward structured compositions on the album *Stratosfear*.

"We cut down some of the improvisation, composing certain parts of the music before recording them," Froese said. "We had something to base our concerts around, and there was more contemporary instrumentation."

After Peter Baumann embarked on a solo career in 1977, the nucleus of Froese and Christopher Franke recorded *Cyclone*. Unlike the other albums in Tangerine Dream's canon, which had been entirely instrumental, *Cyclone* featured proper vocals. The mystical lyrics and incorporation of woodwinds made the music a little less otherworldly, and fans denigrated *Cyclone* for not achieving a meditative state.

"I still like to think our music has a very visual appeal," Froese reflected. "People listen to our music and they can watch a movie in their own head at the same time." ■

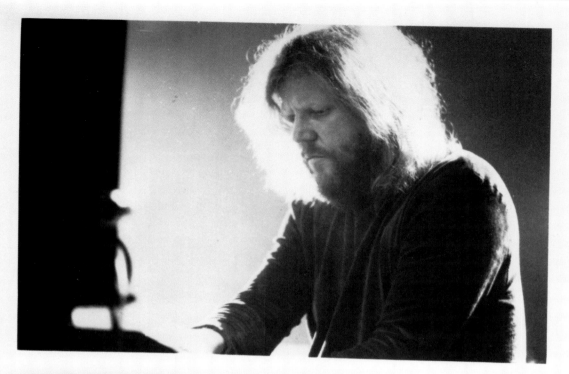

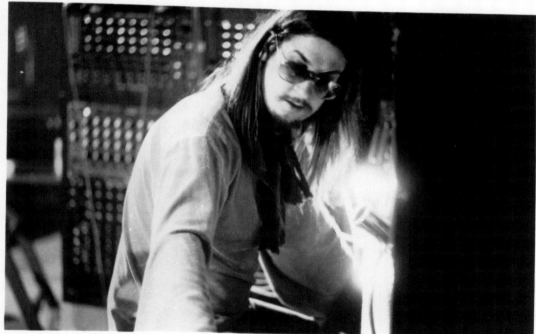

Tangerine Dream

Edgar Froese (top) and Christoph Franke

RECORDS

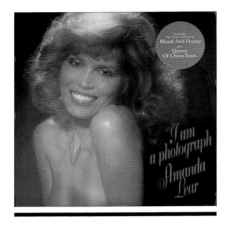

Amanda Lear's *I Am a Photograph* led to the come-hither singer being crowned as Europe's disco queen.

BY BEING seen with Andy Warhol, Salvador Dali, various Beatles, Stones and other jet-setters, Amanda Lear first gained notoriety in the Sixties. She posed on the cover of Roxy Music's album *For Your Pleasure* in 1973, but it was David Bowie who started Lear on a musical career, paying for six months of singing lessons. When emcee Wolfman Jack couldn't make it over to London for the taping of Bowie's *Midnight Special* TV show in 1974, she made her debut as "Wolfwoman Jack."

"I was to be seen as a 'transsexual transvestite from Transylvania,' a Dracula-type with blond hair and a deep, husky voice because I might be a man," Lear explained. "It was all a gimmick, but then Bowie split from his management and I had to start from scratch."

Lear peddled a demo of Elvis Presley's "Trouble" around London. "The idea was that I'd be a rock star in black leather and stiletto heels, very aggressive. But no companies were into it. They said, 'No, thank you, we like Olivia Newton-John.'"

Finally, a German record company signed Lear because she was "tall and blond and nasty and everything they'd been waiting for since the war. If Marlene Dietrich came back today, she'd do disco. It's tough to make people listen to you, so I remembered what I learned from David Bowie—make the singer interesting, not just the song."

Using the "Wolfwoman" image as a base, Lear became a smash in Germany, France and Italy, where she had three hits, all on her debut album, *I Am a Photograph*—"Blood and Honey," "Tomorrow" and "Queen of China-Town." Lear attributed the music's success to the lyrical content; the promotion involved lots of topless photographs of her.

"When you're 17, you want sex and you like comic strips, and that's how I write my songs—as sexy comic strips," she said. "I was the first white disco queen in a kingdom ruled by sexy blacks with sequins and wigs. European kids fell in love with me and started buying posters and t-shirts. Over in America, you've got your Farrah Fonzie-Whatsit, and that's what I was for them."

America wouldn't catch on, but in mainland Europe and Scandinavia, Lear was a million-album-selling disco queen.

"The reason I say that I'm the best is that the others are so bad. I mean, 'Love-to-love-you-baby-love-to-love-you-baby' 52 times with a few orgasms in-between is pretty inarticulate. Just because it's danceable doesn't mean it has to be stupid." ■

Amanda Lear

Chrysalis ™

The *Grease* soundtrack sent "You're the One That I Want," a duet for the film's stars **John Travolta & Olivia Newton-John**, to No. 1 in the US and the UK.

Billboard 200: *Grease* (No. 1)
Billboard Hot 100: "Grease" (No. 1); "You're the One
That I Want" (No. 1); "Summer Nights" (#5); "Hopelessly
Devoted to You" (#3); "Greased Lightnin'" (#47)

The soundtrack to the disco musical *Thank God It's Friday* featured **Donna Summer** performing "Last Dance," which won the Academy Award for Best Song.

Billboard 200: *Thank God It's Friday* (#10)
Billboard Hot 100: "Thank God It's Friday" (#22);
"Last Dance" (#3)

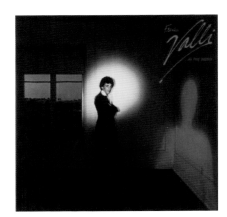

Sung by **Frankie Valli** and written by Barry Gibb of the Bee Gees, the title song for the movie adaptation of *Grease* was a new addition to the production.

Billboard 200: *Frankie Valli...Is the Word* (#150)
Billboard Hot 100: "Grease" (No. 1)

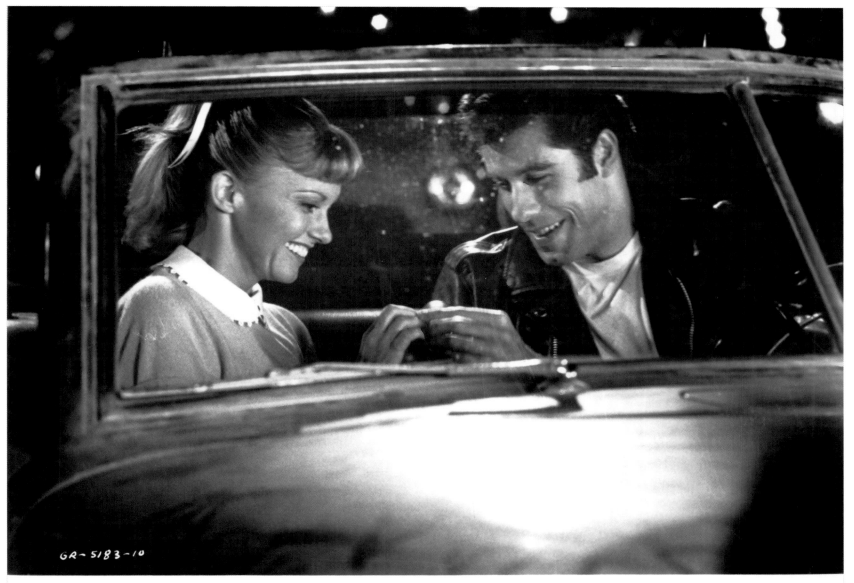

GR-5183-10

"GREASE"

In Color Panavision® A Paramount Picture

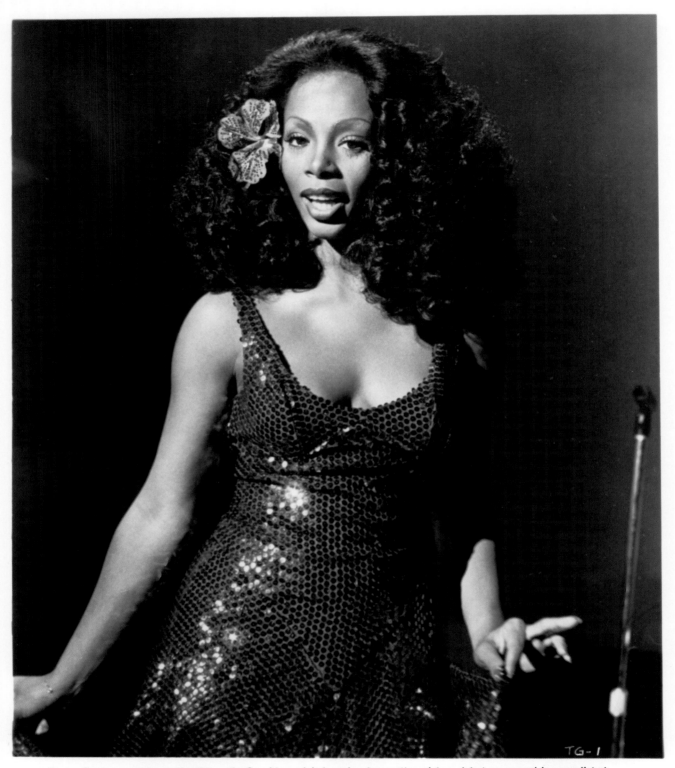

Donna Summer gold record artist on the Casablanca label, makes her motion picture debut as an aspiring vocalist at a far-out Los Angeles disco in "Thank God It's Friday," a contemporary comedy with music also featuring the top hit recording group, The Commodores. The Motown — Casablanca FilmWorks Production is a Columbia Pictures release.

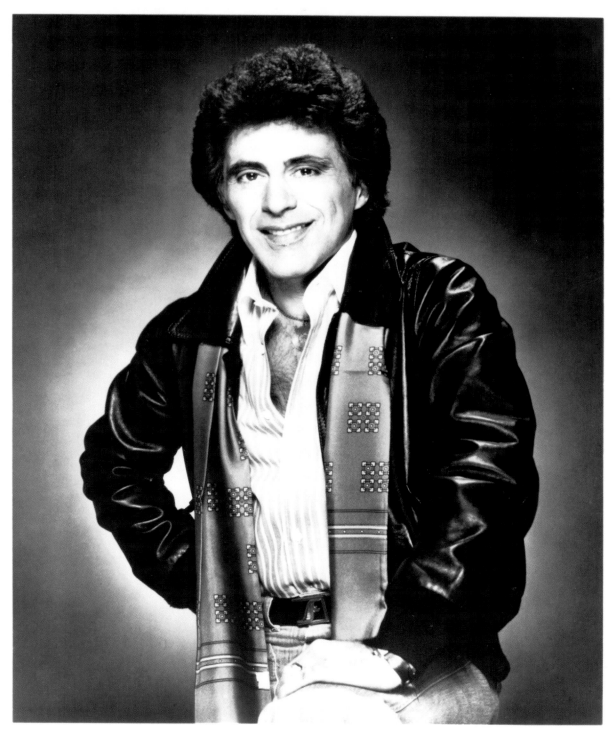

FRANKIE VALLI

CURB
RECORDS

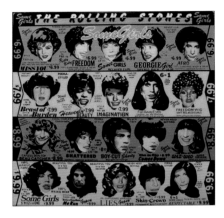

The Rolling Stones seemed obsolete by the mid-Seventies, but the album *Some Girls*, featuring the No. 1 hit "Miss You," represented a brilliant return to form.

Billboard 200: *Some Girls* (No. 1)
Billboard Hot 100: "Miss You" (No. 1);
"Beast of Burden" (#8); "Shattered" (#31)

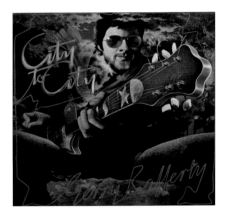

Ex-Stealers Wheel co-leader Gerry Rafferty's *City to City* included "Baker Street," defined by a distinctive saxophone solo played by Raphael Ravenscroft.

Billboard 200: *City to City* (No. 1)
Billboard Hot 100: "Baker Street" (#2);
"Right Down the Line" (#12); "Home and Dry" (#28)

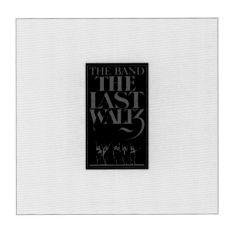

The Band's farewell concert on Thanksgiving Day 1976 yielded *The Last Waltz*, Martin Scorsese's documentary of the performance and a three-LP soundtrack.

Billboard 200: *The Last Waltz* (#16)

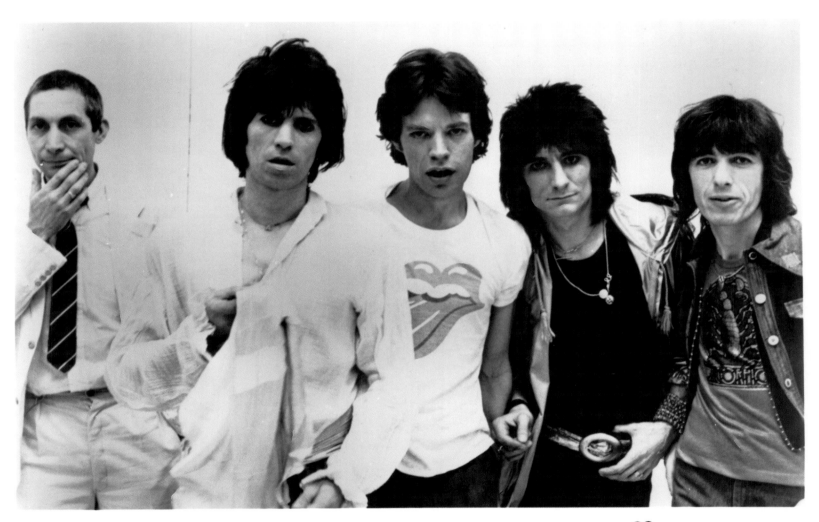

Rolling Stones

Rolling Stones Records distributed by Atlantic Records

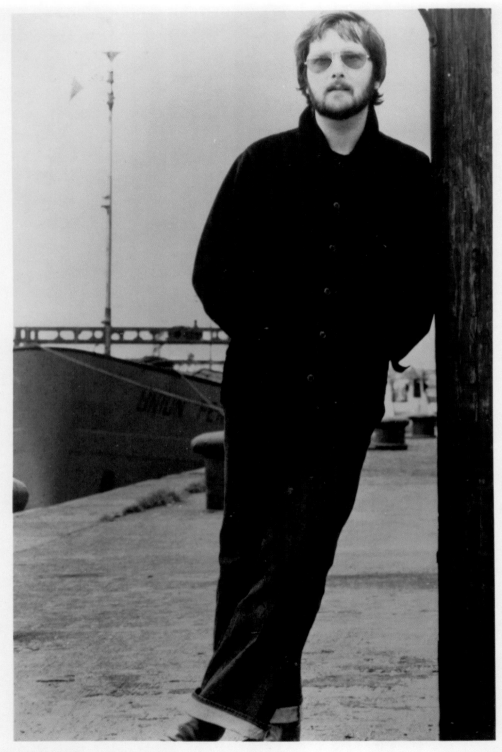

GERRY RAFFERTY

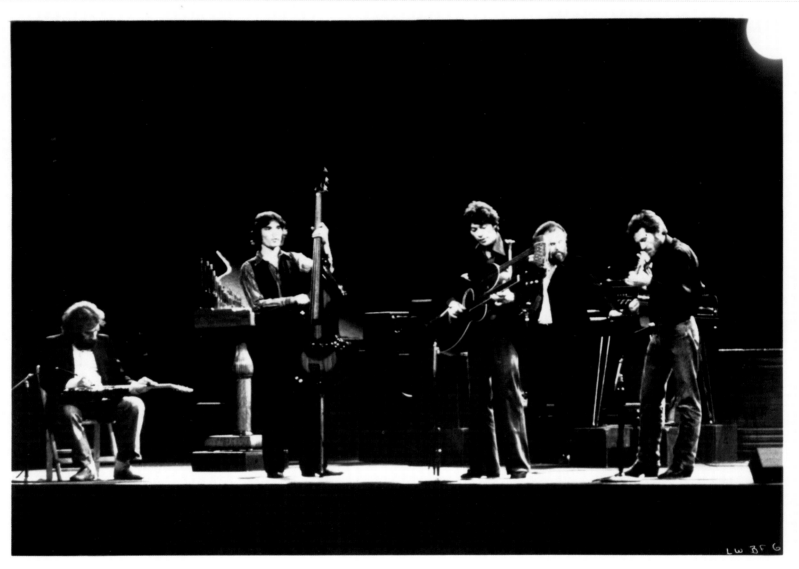

 THE BAND: Richard Manuel, Rick Danko, Robbie Robertson, Garth Hudson and Levon Helm on stage at The Last Waltz.

WARNER/REPRISE

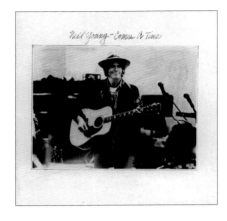

Comes a Time by **Neil Young** marked a return to the accessible country folk sound he'd achieved on *Harvest*, the best-selling album in the US in 1972.

Billboard 200: *Comes a Time* (#7)
Billboard Hot 100: "Four Strong Winds" (#61)

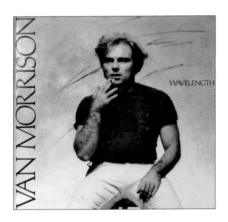

The title track from Irish singer-songwriter **Van Morrison**'s *Wavelength*, a modest hit, used synthesizers to simulate the sounds of shortwave radio stations.

Billboard 200: *Wavelength* (#28)
Billboard Hot 100: "Wavelength" (#42)

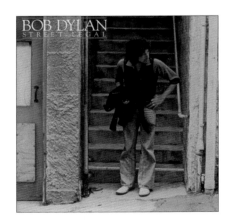

Employing an eight-piece band with a horn section and female trio of backup singers, **Bob Dylan** formulated a polished pop rock sound on *Street-Legal*.

Billboard 200: *Street-Legal* (#11)

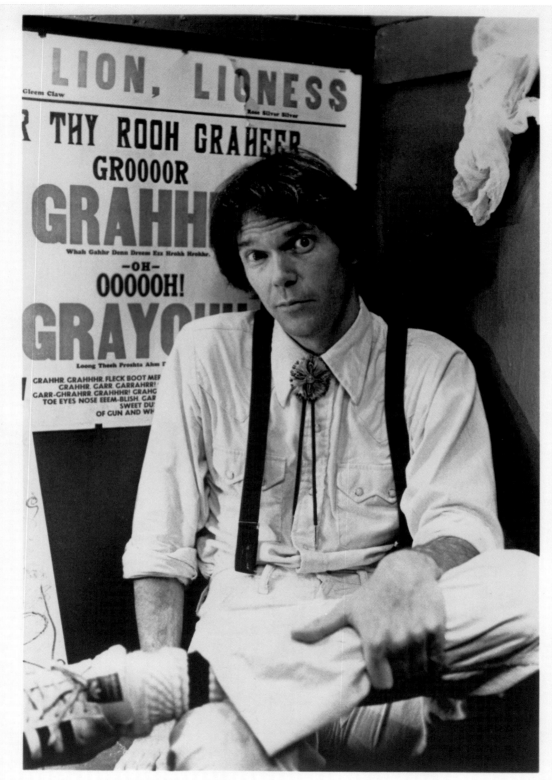

NEIL YOUNG

WARNER/REPRISE

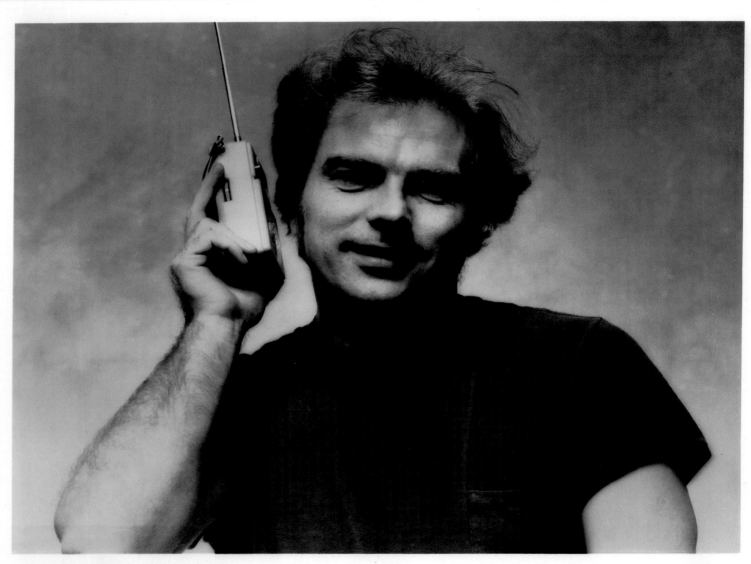

VAN MORRISON

WARNER / REPRISE

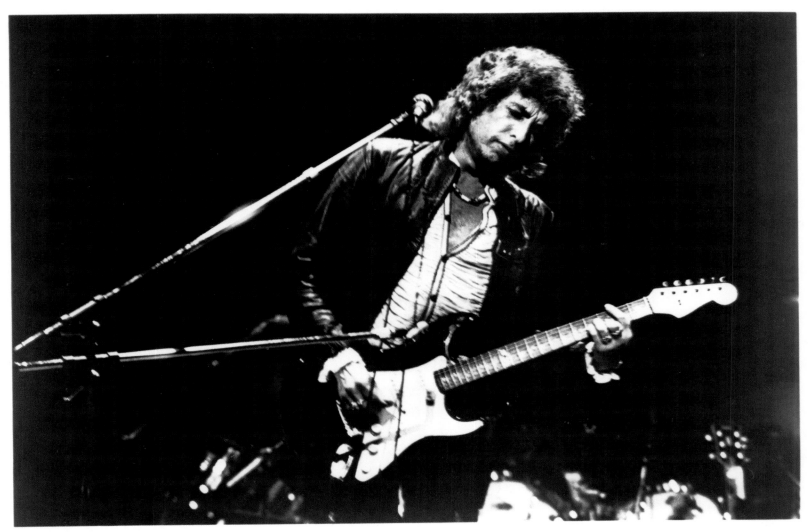

BOB DYLAN

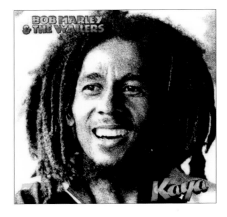

Bob Marley & the Wailers recorded *Kaya* and the song "Is This Love" in England, where the reggae ambassador spent two years in self-imposed exile.

Billboard 200: *Kaya* (#50)

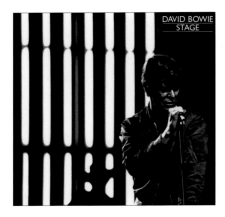

Compelling recordings from David Bowie's 1978 tour, which brought the music of his "Berlin phase" to the world, made up *Stage*, a live double album.

Billboard 200: *Stage* (#44)

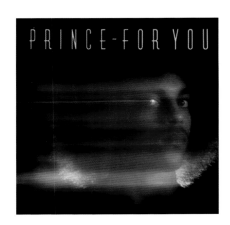

Inking a major record deal at age 18, Prince released *For You*, a debut album with the tagline "produced, arranged, composed and performed by Prince."

Billboard 200: *For You* (#163)
Billboard Hot 100: "Soft and Wet" (#92)

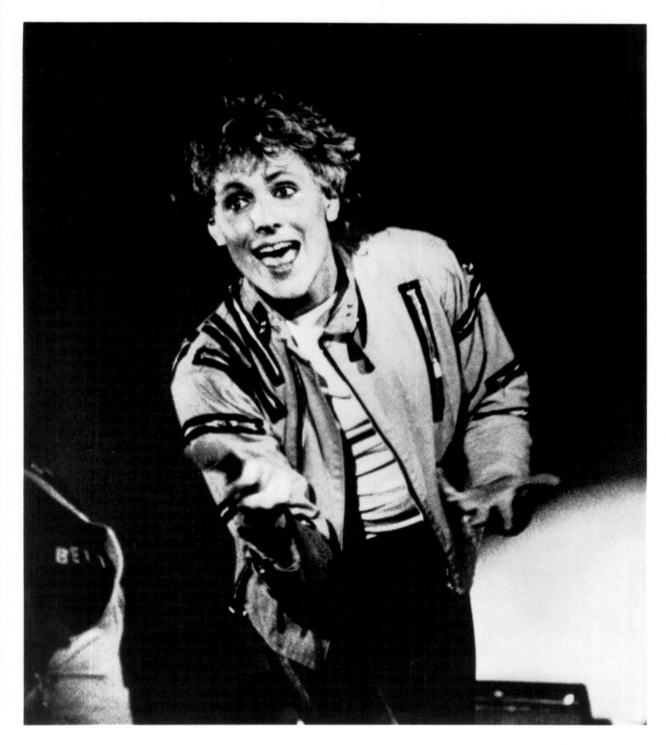

PLASTIC BERTRAND

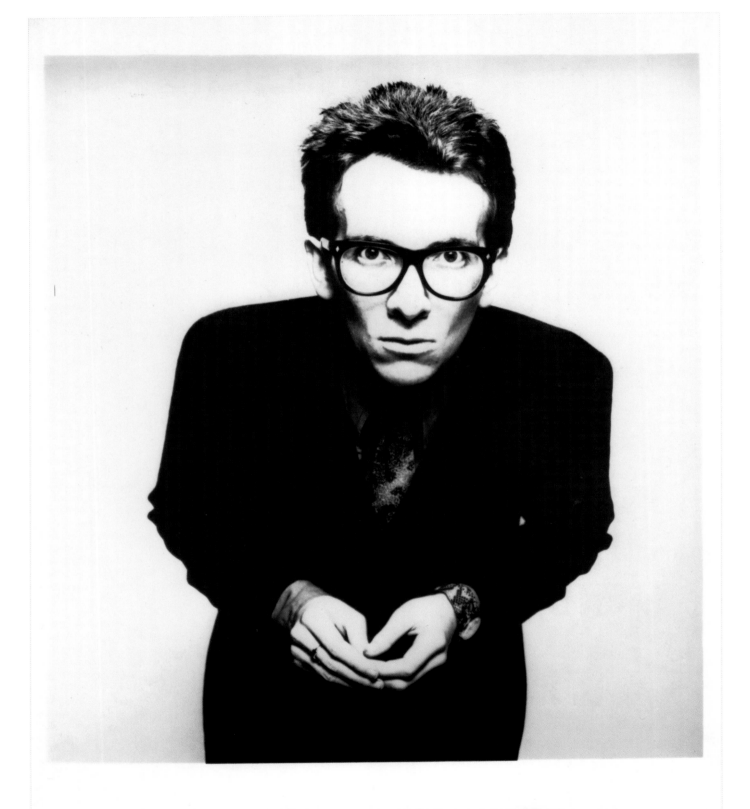

Elvis Costello

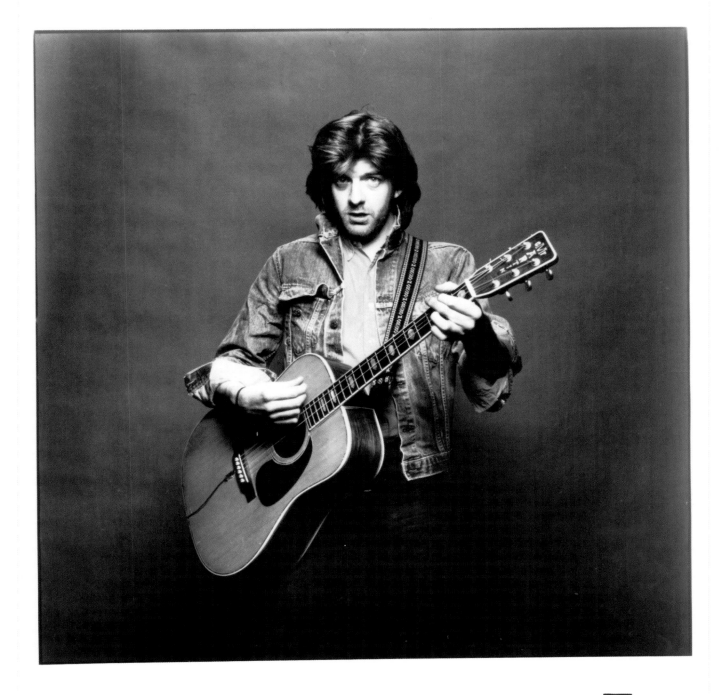

NICK LOWE

7802

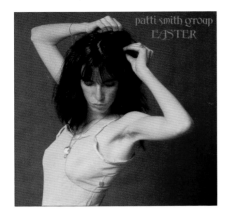

New York City "punk poet laureate" Patti Smith imbued lust, grief and apprehension into the hit "Because the Night," co-written with Bruce Springsteen.

Billboard 200: *Easter* (#20)
Billboard Hot 100: "Because the Night" (#13)

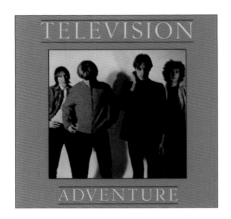

An innovative act on the New York art-punk scene, Television followed up its debut album with the softer *Adventure* in April 1978—only to break up in July.

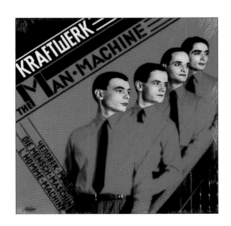

The Man-Machine by the groundbreaking German quartet Kraftwerk incorporated more danceable rhythms, setting the tone for high-art electronic pop.

Billboard 200: *The Man-Machine* (#130)

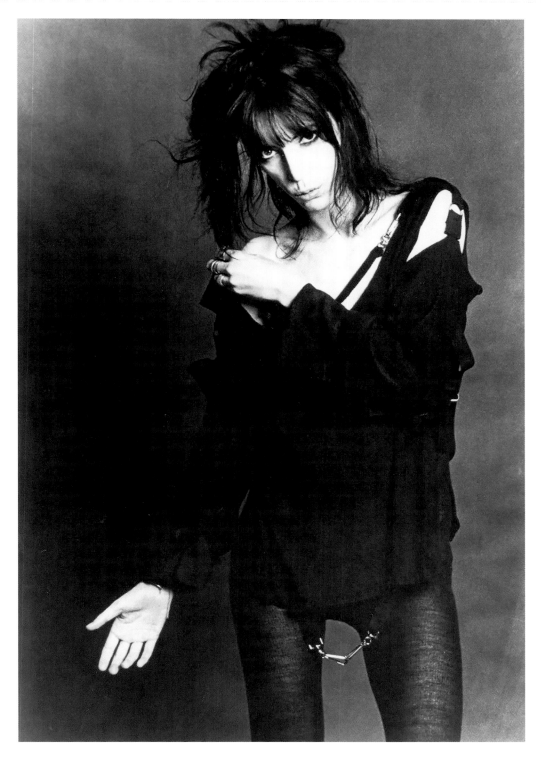

Contact: Ina Lea Meilbach
888 Seventh Avenue
New York, New York 10019
(212) 765-4936

patti smith

ARISTA ™ RECORDS

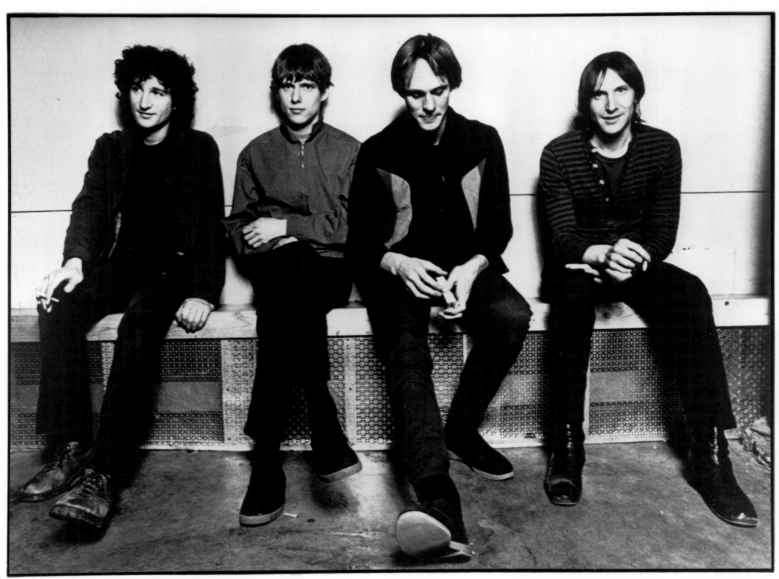

TELEVISION

elektra

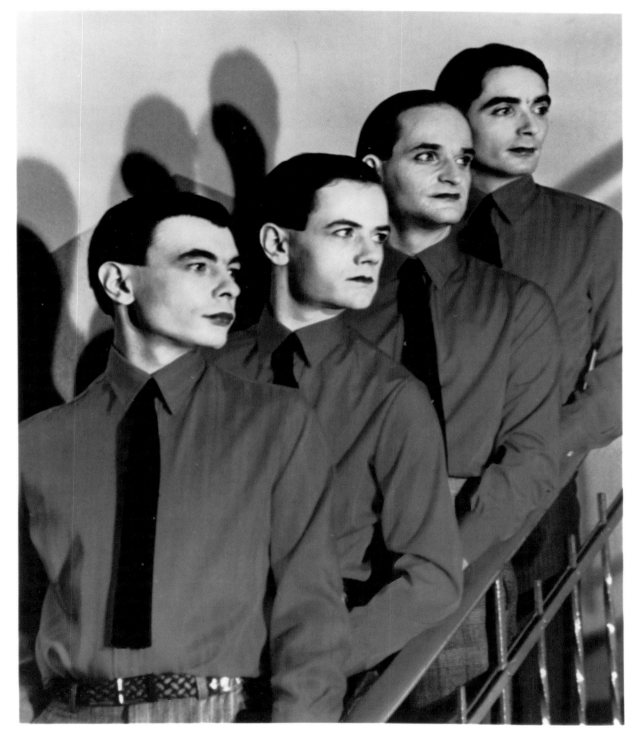

Karl Bartos Ralf Hutter Florian Schneider Wolfgang Flur

KRAFTWERK

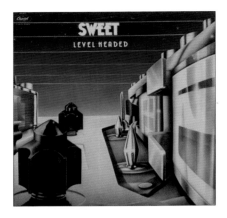

Straying from early glam-pop records for a more mature take, "Love Is Like Oxygen" was Sweet's final Top 10 hit and the last to feature its classic lineup.

Billboard 200: *Level Headed* (#52)
Billboard Hot 100: "Love Is Like Oxygen" (#8);
"California Nights" (#76)

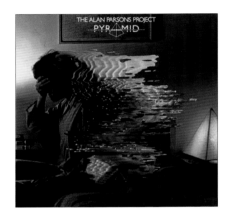

The Alan Parsons Project, conceived by the titular engineer-producer with songwriter Eric Woofson, recorded *Pyramid* with a rotating cast of session musicians.

Billboard 200: *Pyramid* (#26)
Billboard Hot 100: "What Goes Up" (#87)

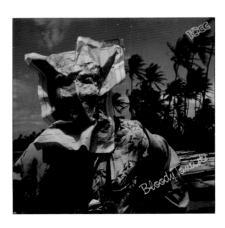

Written by founding members Eric Stewart and Graham Gouldman, the pop reggae effort "Dreadlock Holiday" continued the chart run of art rockers 10cc.

Billboard 200: *Bloody Tourists* (#69)
Billboard Hot 100: "Dreadlock Holiday" (#44);
"For You and I" (#85)

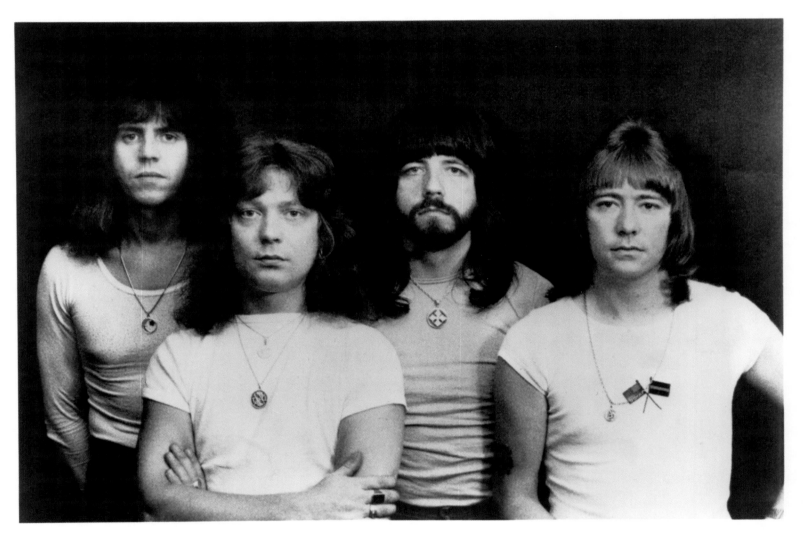

Mick Tucker Steve Priest Andy Scott Brian Connolly

SWEET

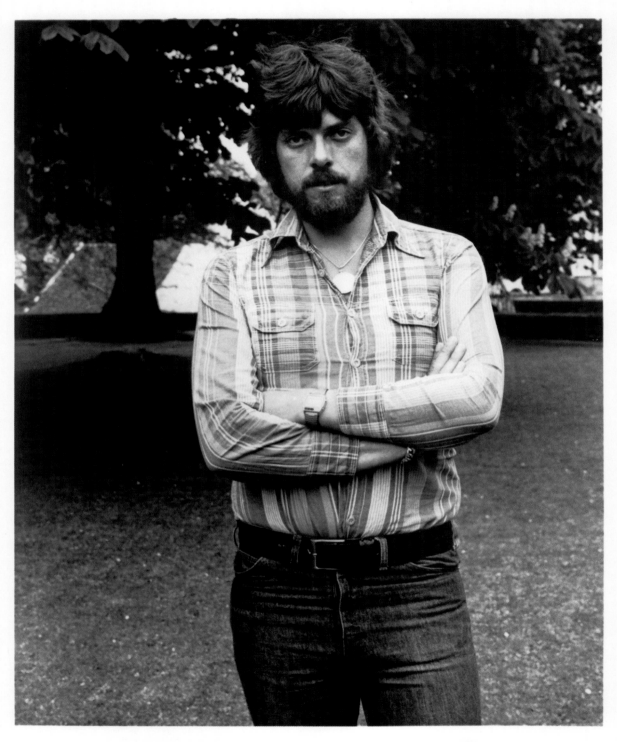

ALAN PARSONS
ALAN PARSONS PROJECT

ARISTA RECORDS

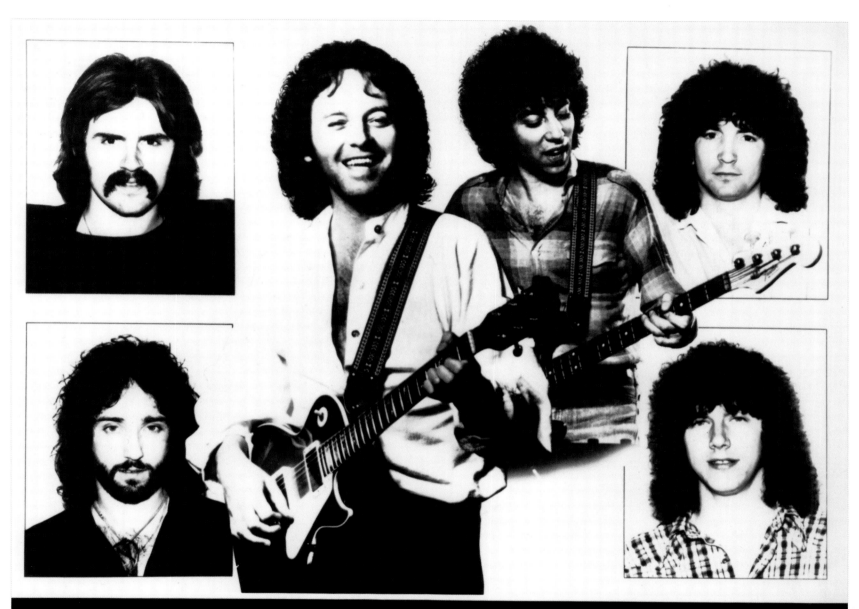

10cc
On Polydor Records

polydor

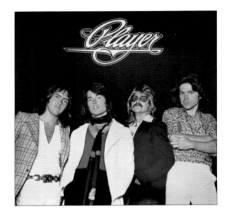

The soft rock outfit **Player** made its mark with the No. 1 single "Baby Come Back," which lodged itself in the *Billboard* Hot 100 for a total of 32 weeks.

Billboard 200: *Player* (#26)
Billboard Hot 100: "Baby Come Back" (No. 1);
"This Time I'm in It for Love" (#10)

Driven by the hit "Love Will Find a Way," **Pablo Cruise**'s *Worlds Away* charted higher than any other of the Northern California pop rock quartet's albums.

Billboard 200: *Worlds Away* (#6)
Billboard Hot 100: "Love Will Find a Way" (#6);
"Don't Want to Live Without It" (#21);
"I Go to Rio" (#46)

Ambrosia had a major-league pop breakthrough with the smash "How Much I Feel," featured on the California-based group's third album, *Life Beyond L.A.*

Billboard 200: *Life Beyond L.A.* (#19)
Billboard Hot 100: "How Much I Feel" (#3)

JOHN FRIESEN RONN MOSS PETER BECKETT J. C. CROWLEY

Records, Inc.

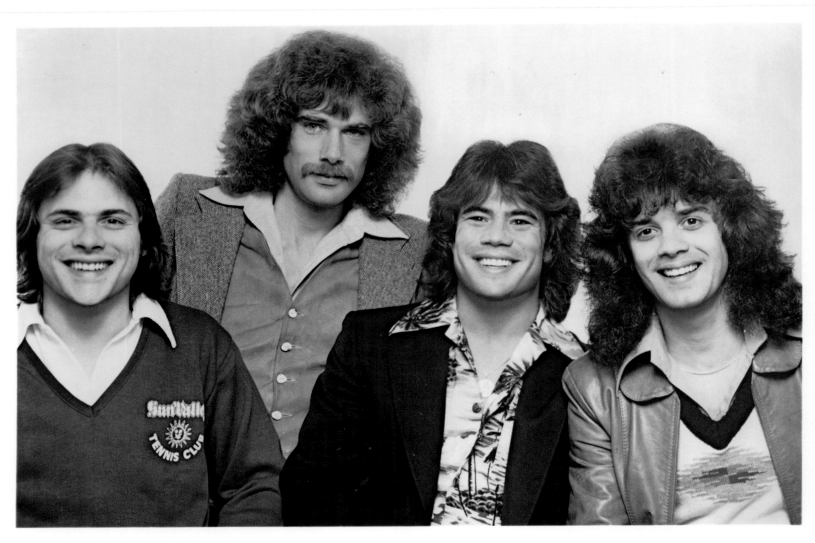

BOB M BROWN MANAGER
P.O. BOX 779
MILL VALLEY CALIFORNIA 94941
(415) 332-4243

L to R: STEVE PRICE
DAVE JENKINS
CORY LERIOS
BRUCE DAY

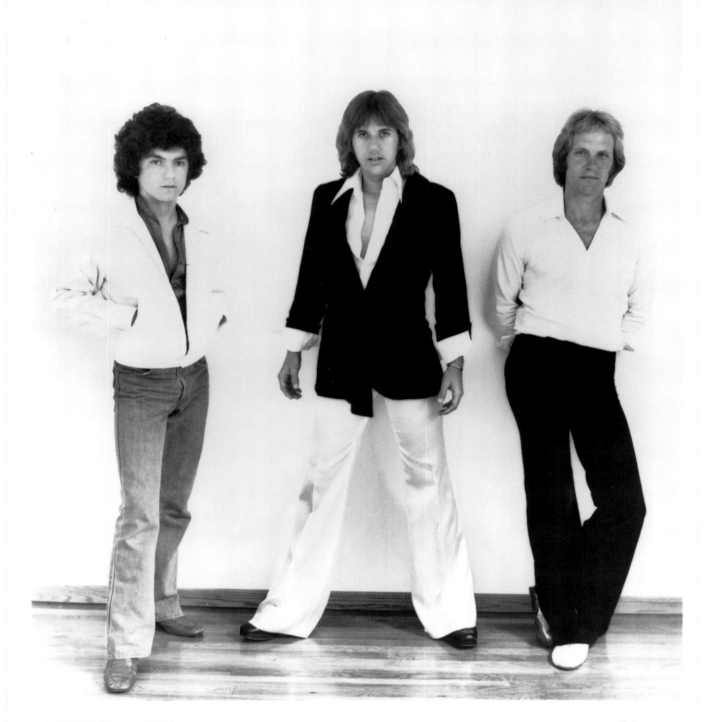

AMBROSIA

JOE PUERTA, DAVID PACK, BURLEIGH DRUMMOND

WARNER/REPRISE

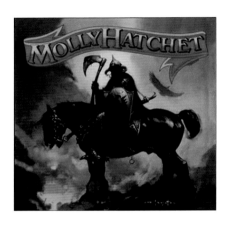

Point of Know Return by **Kansas** was acclaimed for the title track and "Dust in the Wind," one of the first acoustic tracks by the progressive rock band.

Billboard 200: *Point of Know Return* (#4)
Billboard Hot 100: "Point of Know Return" (#28);
"Dust in the Wind" (#6); "Portrait (He Knew)" (#64)

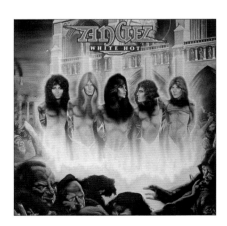

Releasing a self-titled first album including "Dreams I'll Never See," Jacksonville's **Molly Hatchet** quickly caught the attention of southern rock devotees.

Billboard 200: *Molly Hatchet* (#64)

Reviled by rock critics and extolled by its fans, the band **Angel** dressed in all-white, a glam image putting across a calculated flip side to labelmate Kiss.

Billboard 200: *White Hot* (#55)
Billboard Hot 100: "Ain't Gonna Eat My Heart
Out Anymore" (#44)

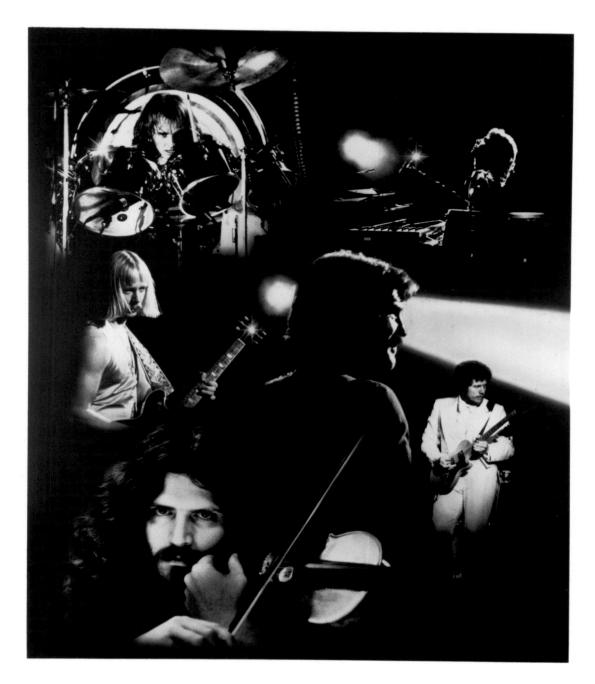

PERSONAL
REPRESENTATION
BNB

KIRSHNER

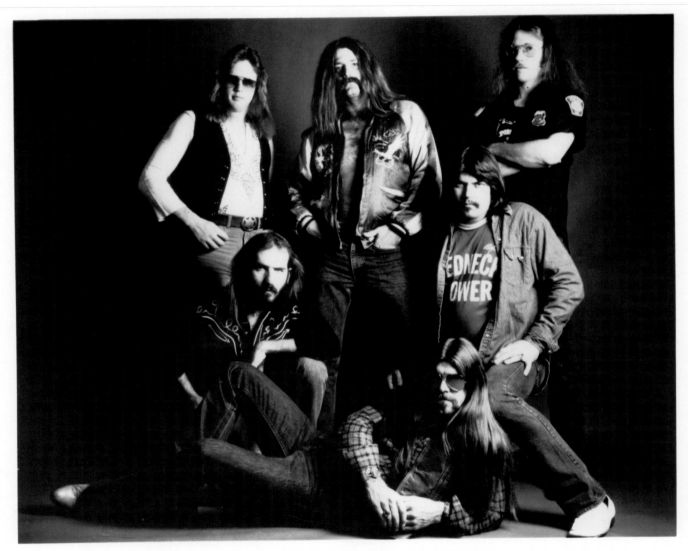

MOLLY HATCHET

TOP Bruce Crump, Duane Roland, Steve Holland

BOTTOM Banner Thomas, Dave Hlubek, Danny Joe Brown

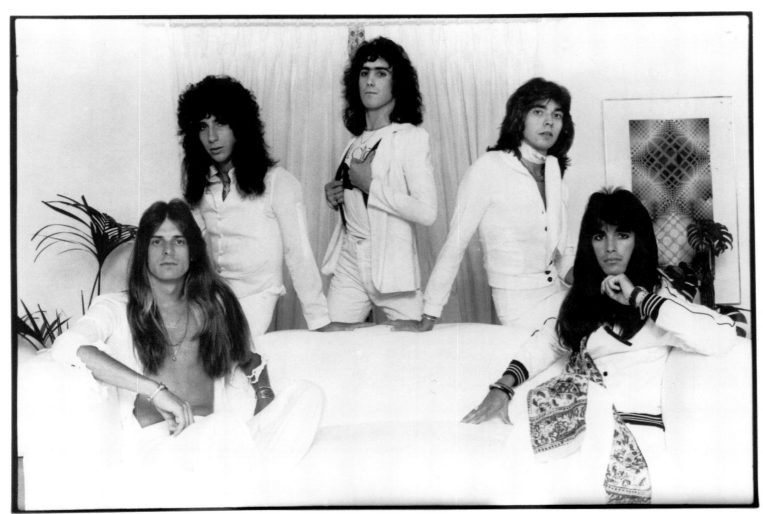

ANGEL

Casablanca
Record and FilmWorks ©

ORGANIZATION, INC.

Management
8899 Beverly Boulevard, Suite 906
Los Angeles, California 90048

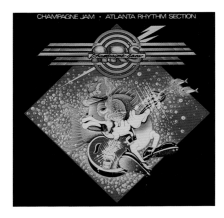

Atlanta Rhythm Section went up against the southern boogie band stereotype, releasing *Champagne Jam* and the radio-friendly "Imaginary Lover."

Billboard 200: *Champagne Jam* (#7)
Billboard Hot 100: "Imaginary Lover" (#7);
"I'm Not Gonna Let It Bother Me Tonight" (#14);
"Champagne Jam" (#43)

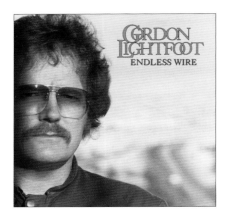

Featuring an updated rendition of "The Circle Is Small," Gordon Lightfoot's *Endless Wire* confirmed the Canadian singer-songwriter as a folk rock legend.

Billboard 200: *Endless Wire* (#22)
Billboard Hot 100: "The Circle Is Small (I Can See It in Your Eyes)" (#33)

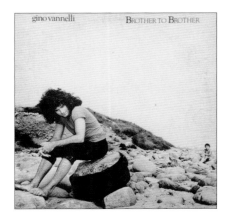

Perceived as a schlocky Adonis, Canadian singer-songwriter Gino Vannelli scored a Top 10 hit with "I Just Wanna Stop," crooning about romantic agony.

Billboard 200: *Brother to Brother* (#13)
Billboard Hot 100: "I Just Wanna Stop" (#4);
"Wheels of Life" (#78)

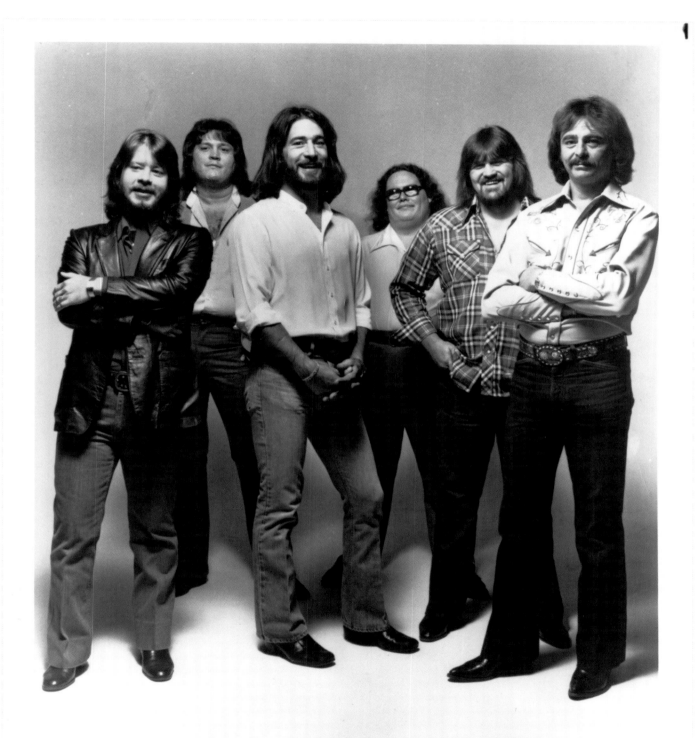

ATLANTA RHYTHM SECTION

GORDON LIGHTFOOT

WARNER / REPRISE

GINO VANNELLI

DIRECTION:
BILL JOHNSTON
DAVID BENDETT
(213) 278-5657

A&M
RECORDS

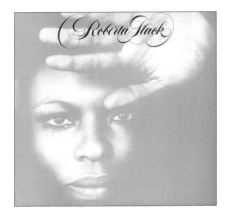

"The Closer I Get to You," performed by Roberta Flack as a warm twosome with fellow soul musician Donny Hathaway, developed into her biggest success.

Billboard 200: *Blue Lights in the Basement* (#8)
Billboard Hot 100: "The Closer I Get to You" (#2)

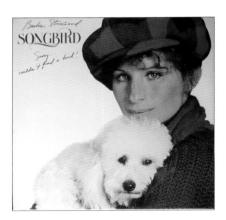

Songbird by Barbra Streisand introduced her solo version of "You Don't Bring Me Flowers," which she would eventually also record with Neil Diamond.

Billboard 200: *Songbird* (#12)
Billboard Hot 100: "Songbird" (#25)

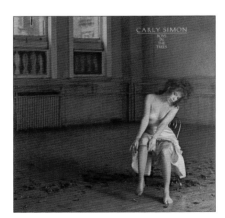

Boys in the Trees put Carly Simon's career back on track with the Top 40 hits "You Belong to Me" and "Devoted to You," a duet with husband James Taylor.

Billboard 200: *Boys in the Trees* (#10)
Billboard Hot 100: "You Belong to Me" (#6);
"Devoted to You" (#36)

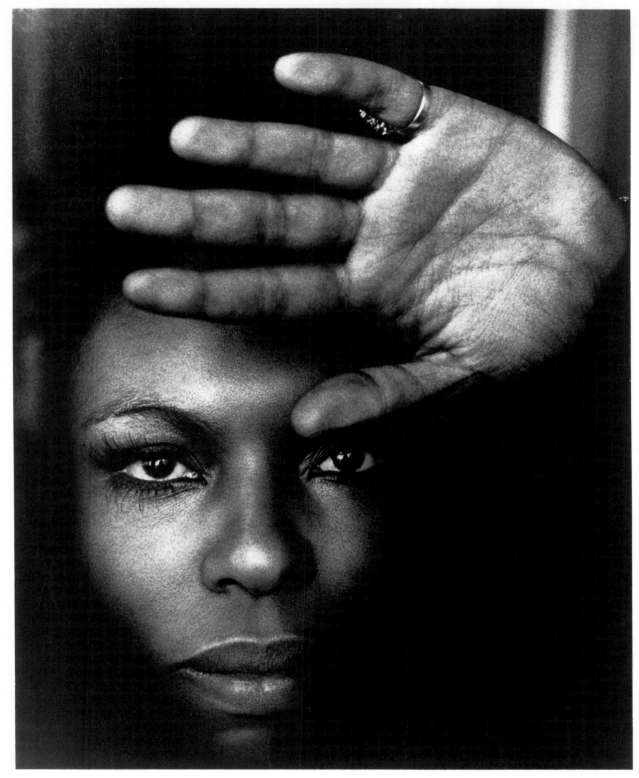

Roberta Flack

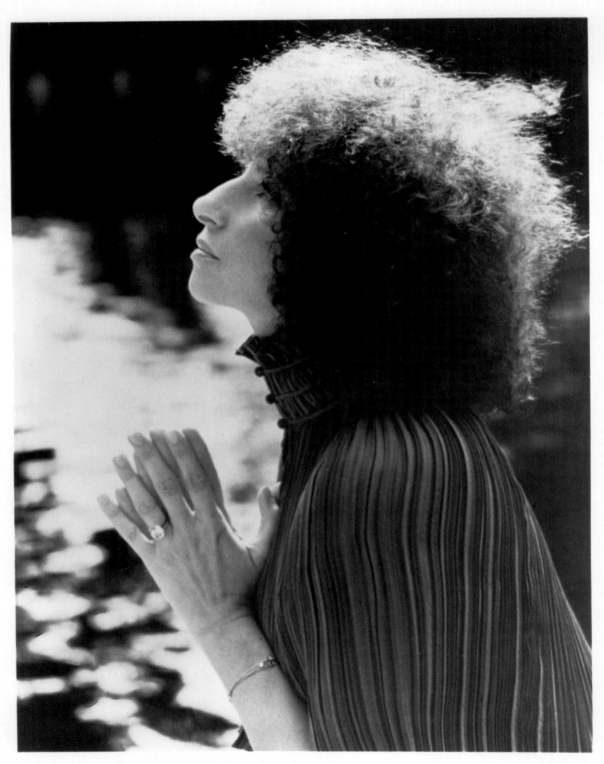

BARBRA STREISAND

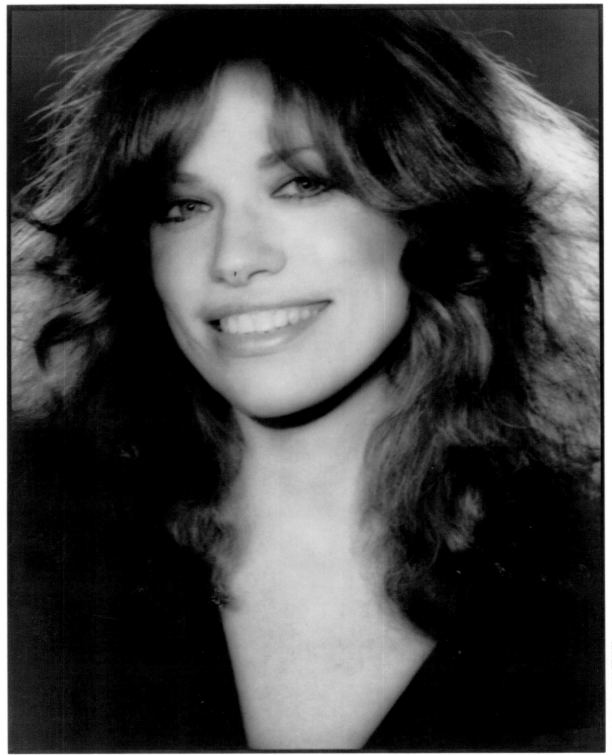

CARLY SIMON

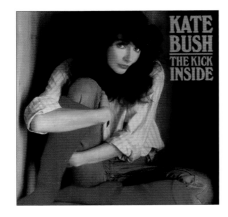

At age 19, English singer-songwriter Kate Bush topped the UK singles chart with "Wuthering Heights," based on the Emily Brontë novel of the same name.

Billboard Hot 100: "The Man with the Child in His Eyes" (#85)

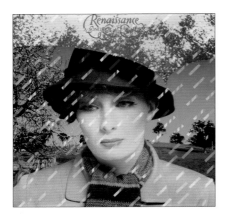

Renaissance, a classically based progressive rock band known for lead singer Annie Haslam's operatic range, scored a UK hit single with "Northern Lights."

Billboard 200: *A Song for All Seasons* (#58)

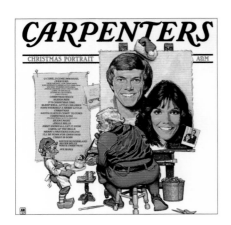

Carpenters' brand of melodic pop—and the brother-sister team's wholesome and clean-cut image—was featured on the seasonal *Christmas Portrait*.

Billboard 200: *Christmas Portrait* (#145)

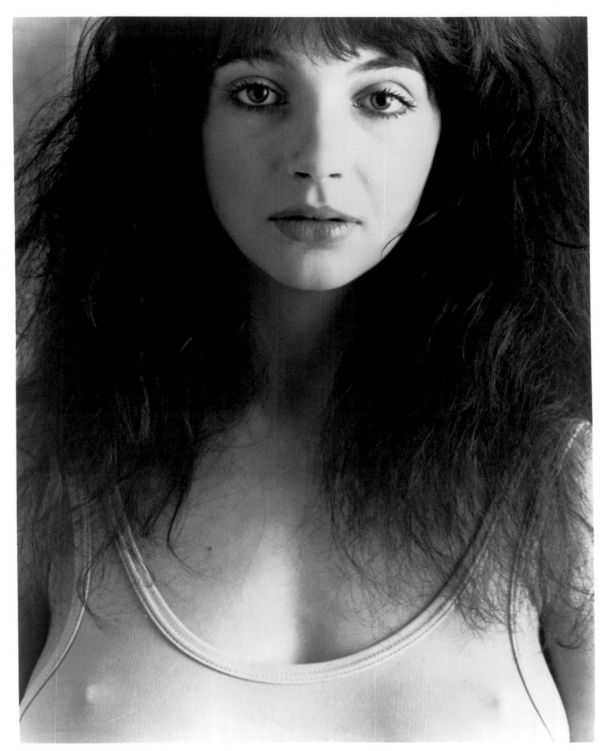

KATE BUSH

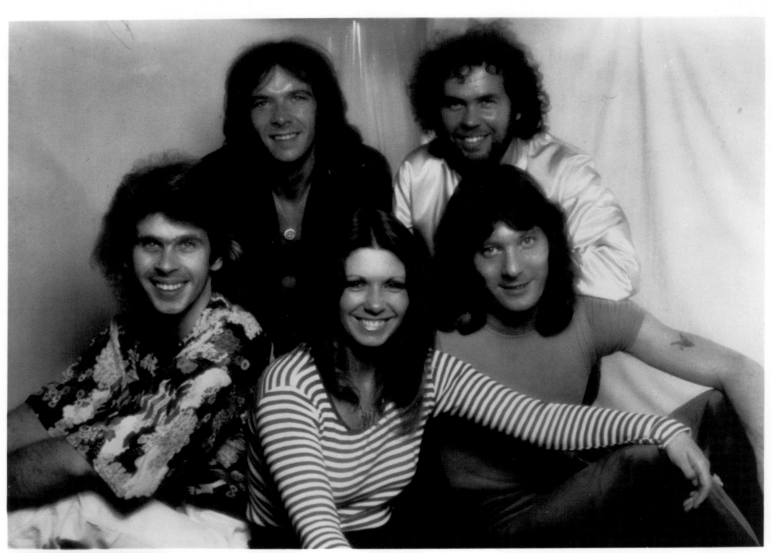

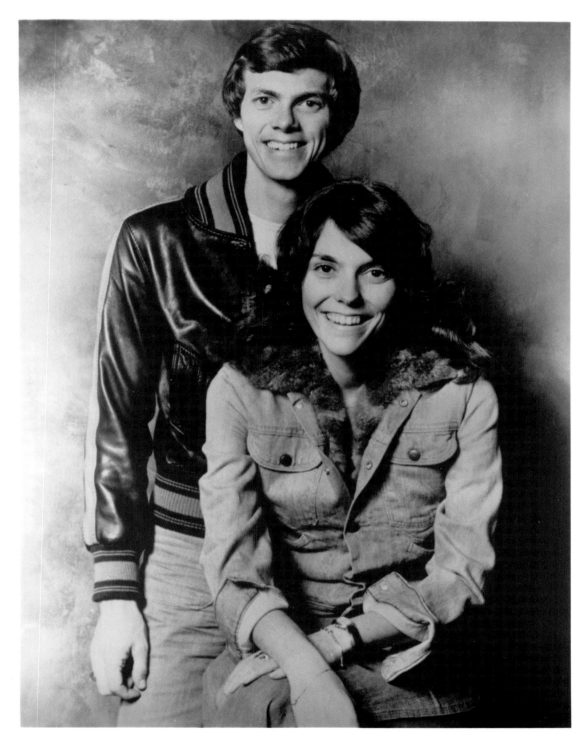

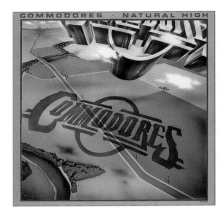

With Lionel Richie as the co-lead singer, the funk band **Commodores** reached No. 1 on the pop, soul and easy listening charts with "Three Times a Lady."

Billboard 200: *Natural High* (#3)
Billboard Hot 100: "Three Times a Lady" (No. 1);
"Flying High" (#38)

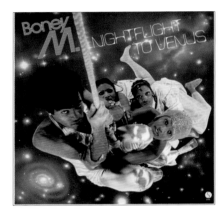

Nightflight to Venus by the German-based disco band **Boney M.** included "Rivers of Babylon," a huge success in Europe and most other parts of the world.

Billboard 200: *Nightflight to Venus* (#134)
Billboard Hot 100: "Rivers of Babylon" (#30)

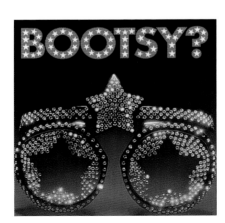

Parliament-Funkadelic bassist **Bootsy Collins** formed Bootsy's Rubber Band, and the unit's *Bootsy? Player of the Year* spawned the No. 1 R&B hit "Bootzilla."

Billboard 200: *Bootsy? Player of the Year* (#16)

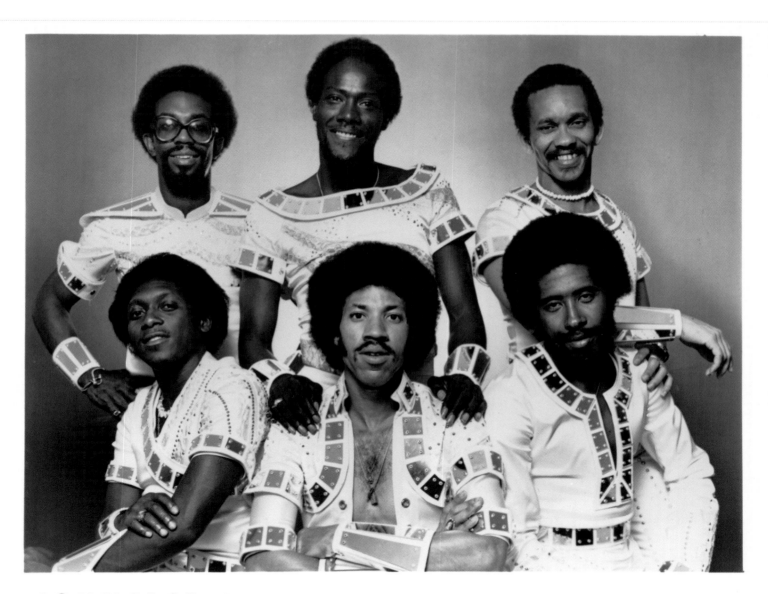

COMMODORES

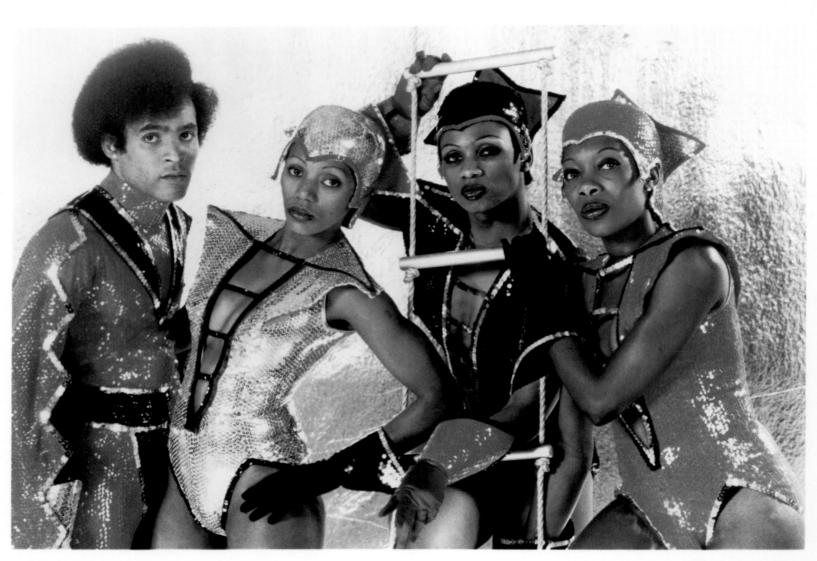

Boney M.

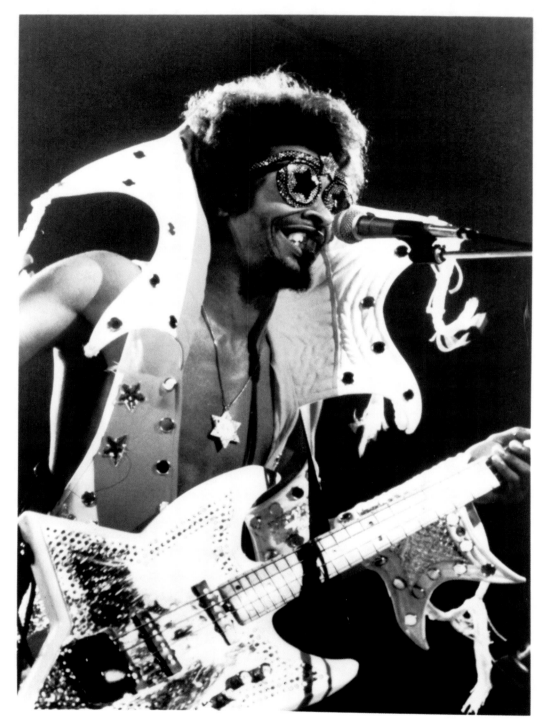

BOOTSY COLLINS
BOOTSY'S RUBBER BAND

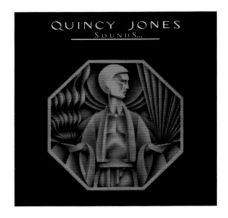

Quincy Jones worked on "Stuff Like That" with Ashford & Simpson, Chaka Khan and studio musicians to turn the track into a No. 1 single on the R&B chart.

Billboard 200: *Sounds...And Stuff Like That!!* (#15)
Billboard Hot 100: "Stuff Like That" (#21)

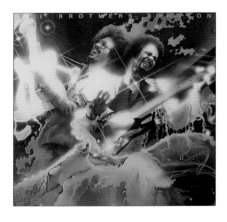

The Brothers Johnson topped the R&B albums chart with *Blam!*, produced by Quincy Jones and featuring the blazing dance single "Ain't We Funkin' Now."

Billboard 200: *Blam!* (#7)

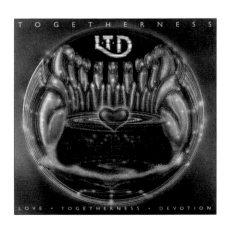

Jeffrey Osborne led **L.T.D.** through the sleek No. 1 R&B hit "Holding On (When Love Is Gone)," released from the soul group's fifth album, *Togetherness.*

Billboard 200: *Togetherness* (#18)
Billboard Hot 100: "Holding On (When Love Is Gone)" (#49)

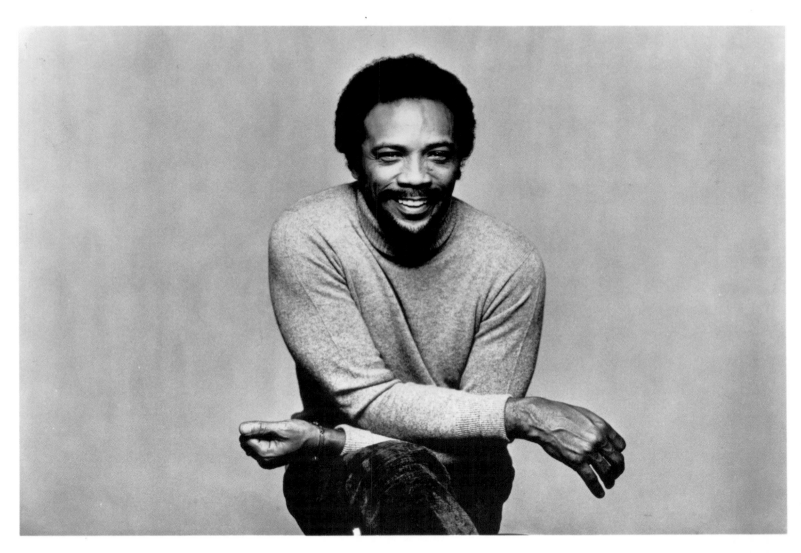

QUINCY JONES

QUINCY JONES PRODUCTIONS

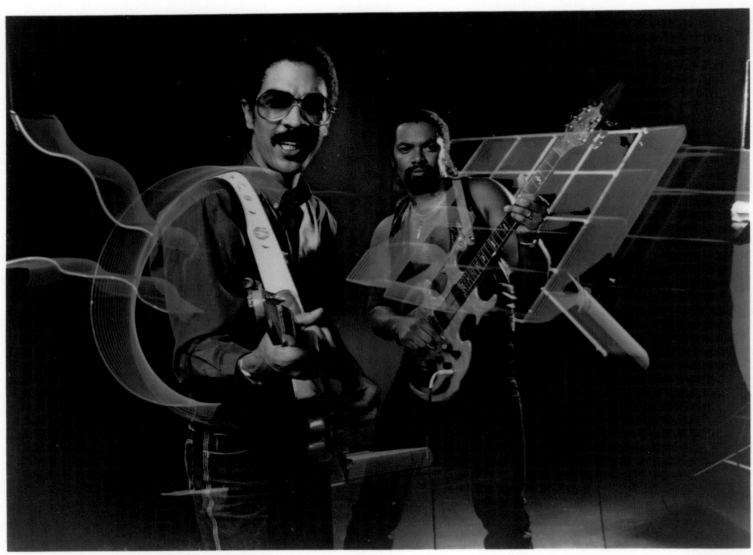

THE BROTHERS JOHNSON
QUINCY JONES PRODUCTIONS

A&M RECORDS

Printed in U.S.A.

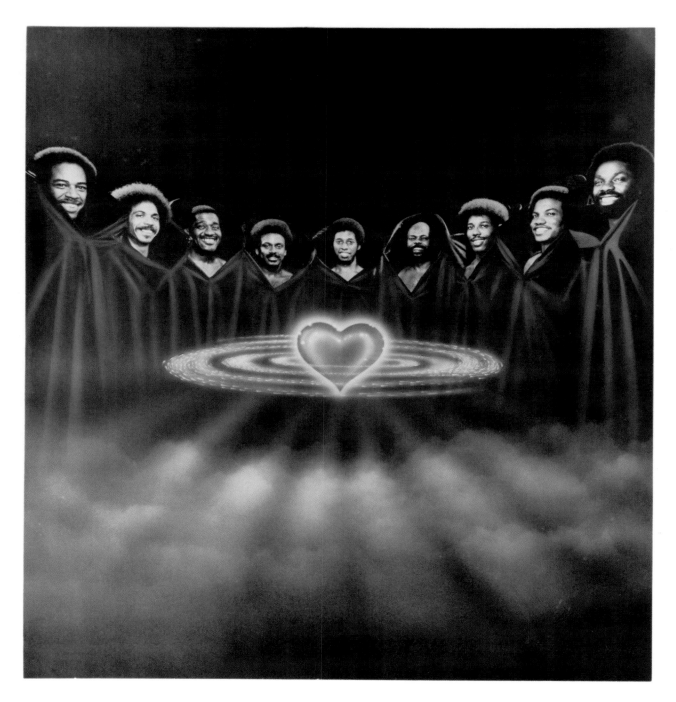

MANAGEMENT

THE TENTMAKERS CORPORATION

L.T.D.

A&M
RECORDS

Printed in U.S.A.

An R&B group conceived by singer-songwriter and session guitarist Ray Parker Jr., **Raydio** scored its first worldwide hit with the cautionary "Jack and Jill."

Billboard 200: *Raydio* (#27)
Billboard Hot 100: "Jack and Jill" (#8)

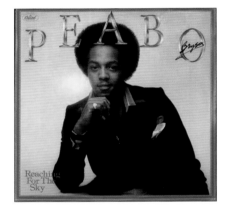

Peabo Bryson debuted on a major label with *Reaching for the Sky*, and the ballads "Feel the Fire" and the title track became two of his most revered hits.

Billboard 200: *Reaching for the Sky* (#49)

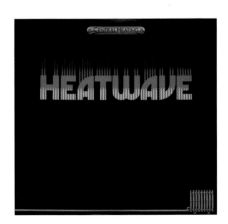

Written by band member Rod Temperton, **Heatwave**'s sophisticated "The Groove Line" highlighted the British funk group's sophomore album, *Central Heating*.

Billboard 200: *Central Heating* (#10)
Billboard Hot 100: "The Groove Line" (#7)

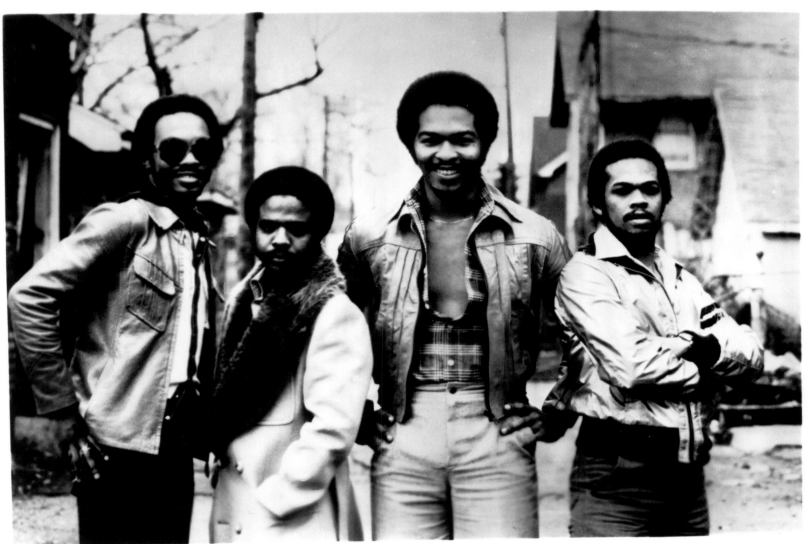

Vincent Bonham **Jerry Knight** **Ray Parker, Jr.** **Arnell Carmichael**

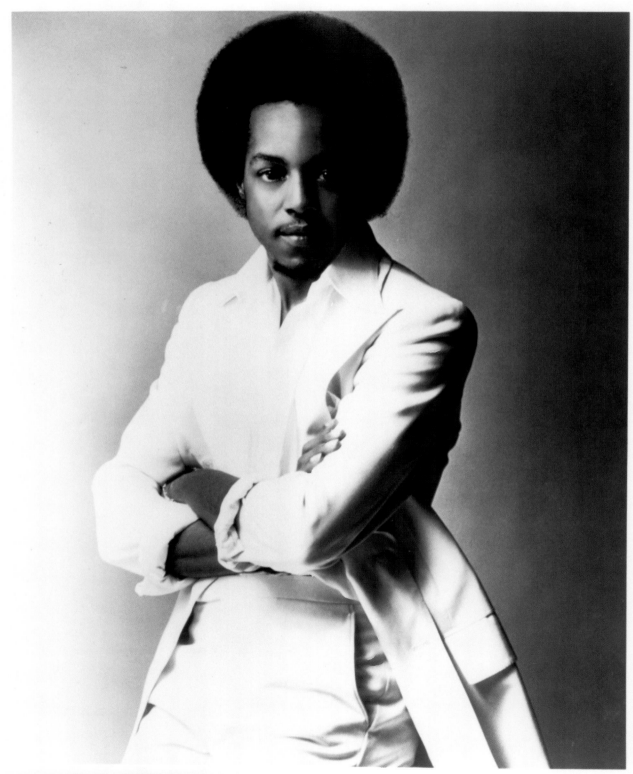

PEABO BRYSON

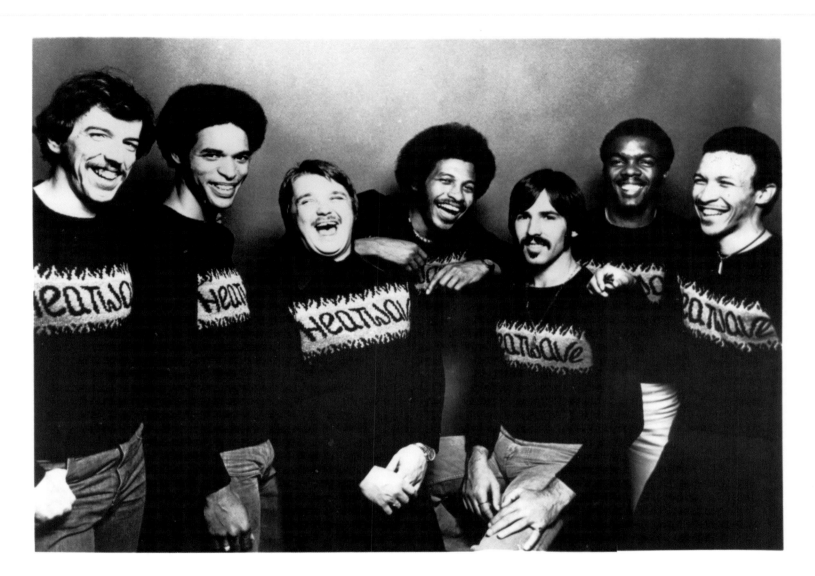

HEATWAVE

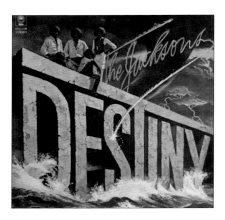

Chic, a collaboration between guitarist Nile Rodgers and bassist Bernard Edwards, reached No. 1 on the charts with the iconic disco track "Le Freak."

Billboard 200: *C'est Chic* (#4)
Billboard Hot 100: "Le Freak" (No. 1);
"I Want Your Love" (#7)

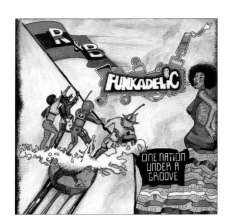

The Jacksons shaped the album *Destiny* and the hit "Shake Your Body (Down to the Ground)" after being allowed complete creative control for the first time.

Billboard 200: *Destiny* (#11)
Billboard Hot 100: "Blame It on the Boogie" (#54);
"Shake Your Body (Down to the Ground)" (#7)

Pursuing a heavier, psychedelic funk rock sound relative to its sister act Parliament, Funkadelic released the influential album *One Nation Under a Groove*.

Billboard 200: *One Nation Under a Groove* (#16)
Billboard Hot 100: "One Nation Under a Groove" (#28)

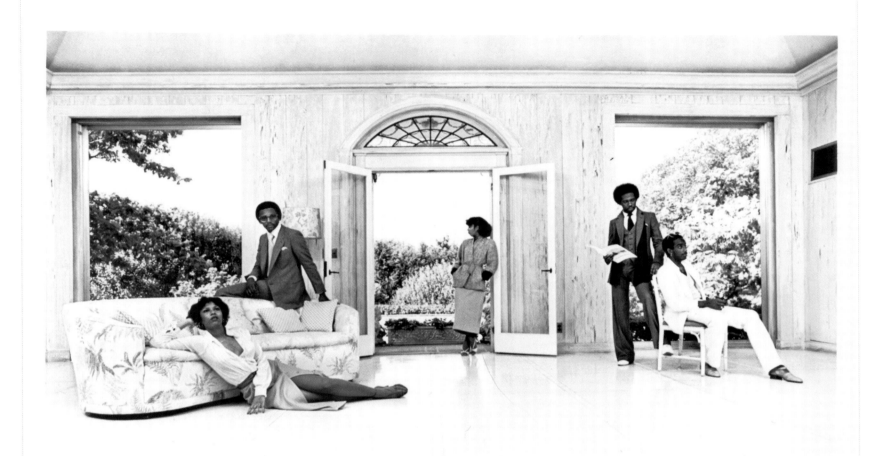

Direction: The Chic Organization Ltd.
110 E. 59th Street
New York, N.Y 10022
(212) 935-3333

CHIC

ATLANTIC

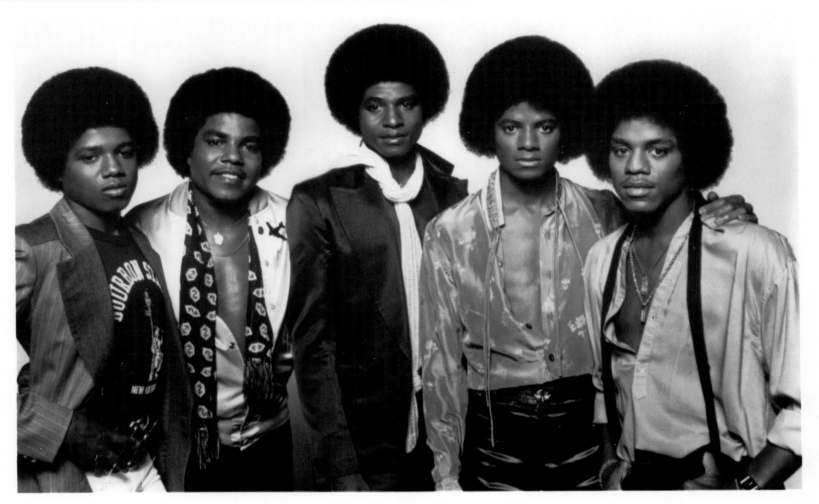

randy tito jackie michael marlon

Epic

7810

The Jacksons

Weisner/DeMann/Jackson Entertainment, Inc.
9200 Sunset Blvd, Penthouse-15, Los Angeles, CA 90069, (213) 550-8200

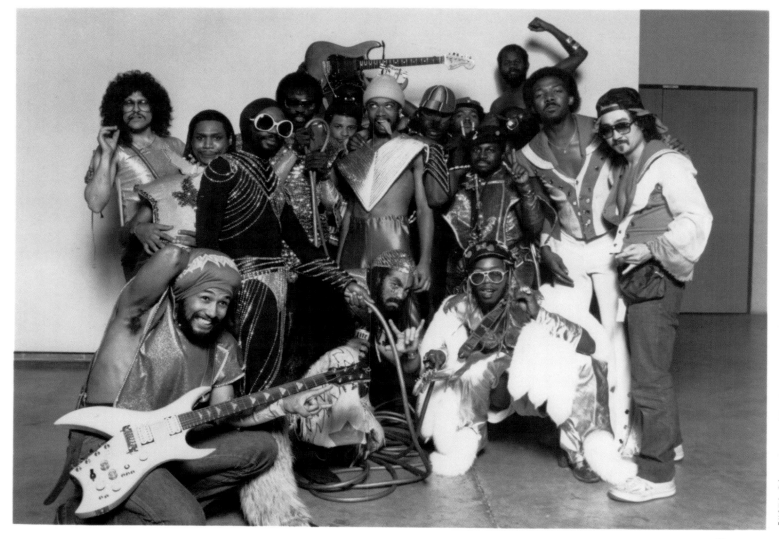

FUNKADELIC

WARNER BROS.

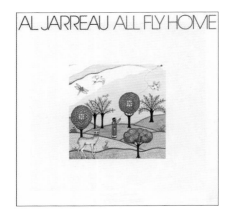

Mixing a wide range of cover songs and tunes that he wrote or co-wrote, jazz singer Al Jarreau won his second Grammy Award with his album *All Fly Home*.

Billboard 200: *All Fly Home* (#78)

After three years of acoustic playing with his group Shakti, John McLaughin returned to a popular jazz rock strain with *Johnny McLaughlin: Electric Guitarist*.

Billboard 200: *Electric Guitarist* (#105)

With *Rainbow Seeker*, his third solo album, Crusaders keyboard player Joe Sample distinguished himself as an inventive creator of light jazz funk grooves.

Billboard 200: *Rainbow Seeker* (#62)

AL JARREAU

WARNER / REPRISE

JOHN McLAUGHLIN

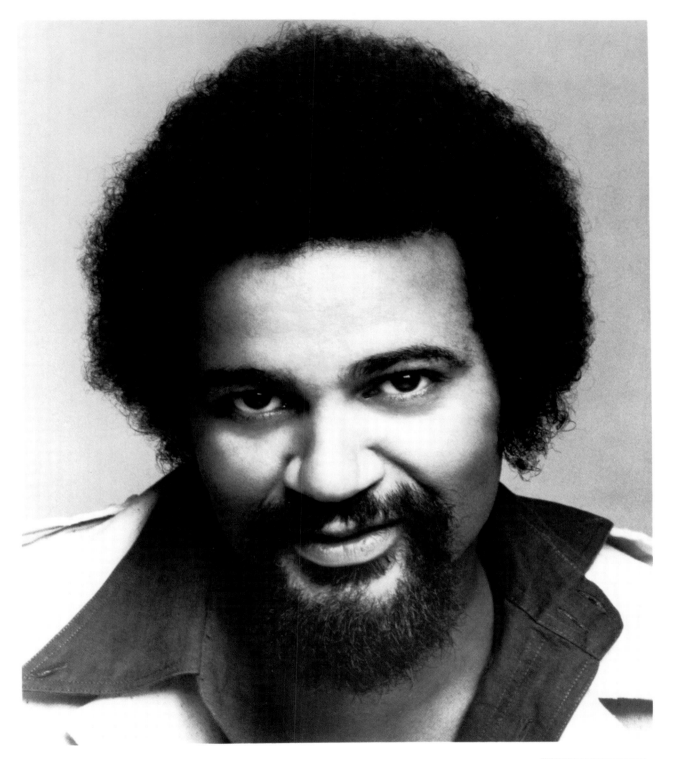

JOE SAMPLE

Nick Gilder left the Vancouver glam rock band Sweeney Todd and subsequently had a No. 1 hit in both the US and Canada with "Hot Child in the City."

Billboard 200: *City Nights* (#33)
Billboard Hot 100: "Hot Child in the City" (No. 1);
"Here Comes the Night" (#44)

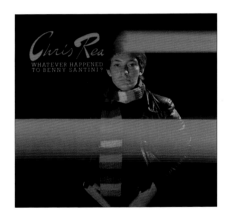

British singer-songwriter **Chris Rea** became known in America for "Fool (If You Think It's Over)," meriting him a Grammy nomination for Best New Artist.

Billboard 200: *Whatever Happened to Benny Santini?* (#49)
Billboard Hot 100: "Fool (If You Think It's Over)" (#12);
"Whatever Happened to Benny Santini?" (#71)

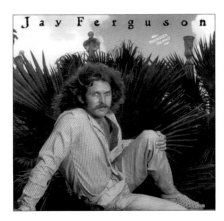

Jay Ferguson, known for his work with Spirit and Jo Jo Gunne, scored a Top 10 hit with the song "Thunder Island," featuring Joe Walsh on slide guitar.

Billboard 200: *Thunder Island* (#72)
Billboard Hot 100: "Thunder Island" (#9)

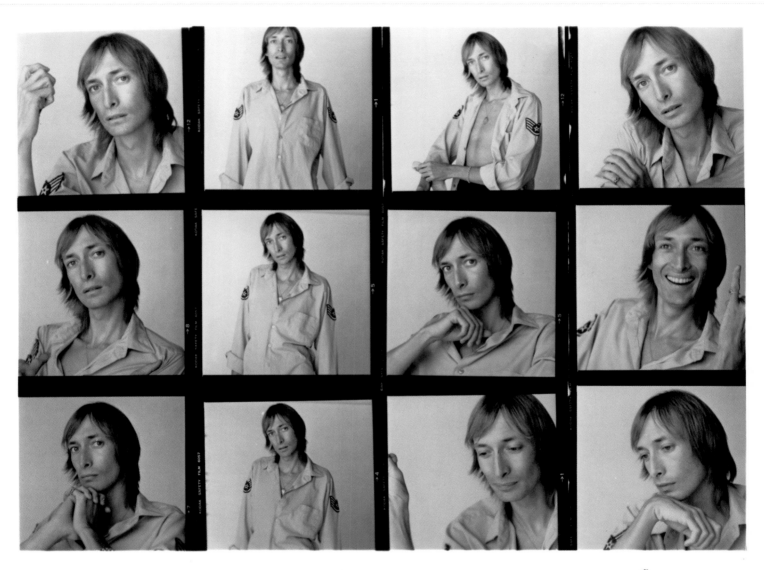

Nick Gilder

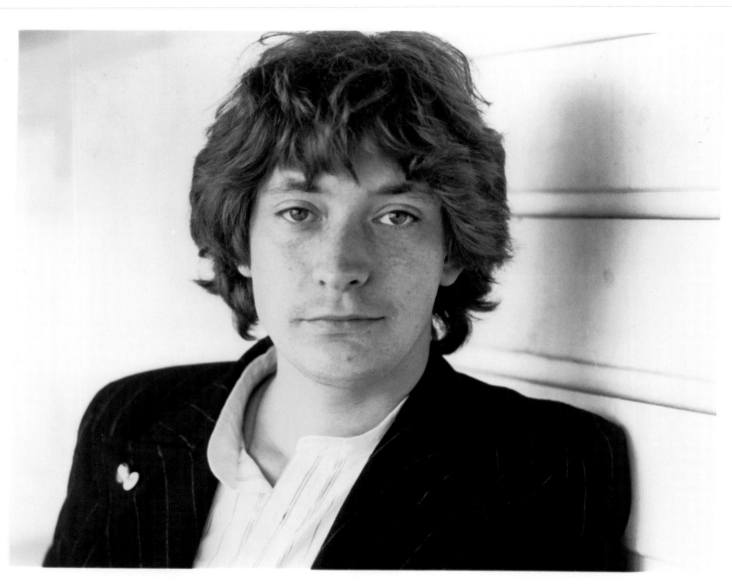

MAGNET

Chris Rea

UA

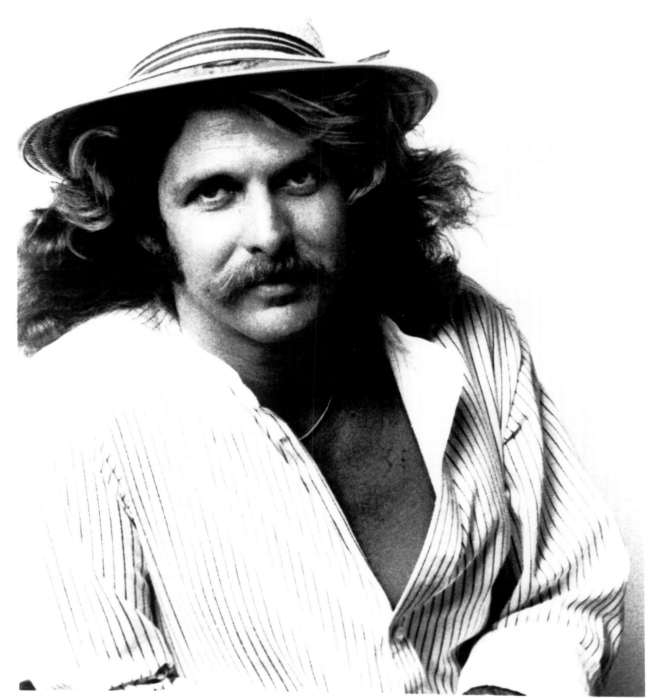

JAY FERGUSON

asylum

From the album *Longer Fuse*, Canadian singer-songwriter Dan Hill scored a massive global smash with the sentimental ballad "Sometimes When We Touch."

Billboard 200: *Longer Fuse* (#21)
Billboard Hot 100: "Sometimes When We Touch" (#3)

Paul Davis' "I Go Crazy," a track from his album *Singer of Songs - Teller of Tales*, slowly scaled the pop singles chart, taking seven months to peak.

Billboard 200: *Singer of Songs - Teller of Tales* (#82)
Billboard Hot 100: "I Go Crazy" (#7); "Darlin'" (#51);
"Sweet Life" (#17)

Walter Egan's hit single "Magnet and Steel" found him joining forces with Fleetwood Mac's Lindsey Buckingham (co-producer) and Stevie Nicks (vocals).

Billboard 200: *Not Shy* (#44)
Billboard Hot 100: "Magnet and Steel" (#8);
"Hot Summer Nights" (#55)

DAN HiLL

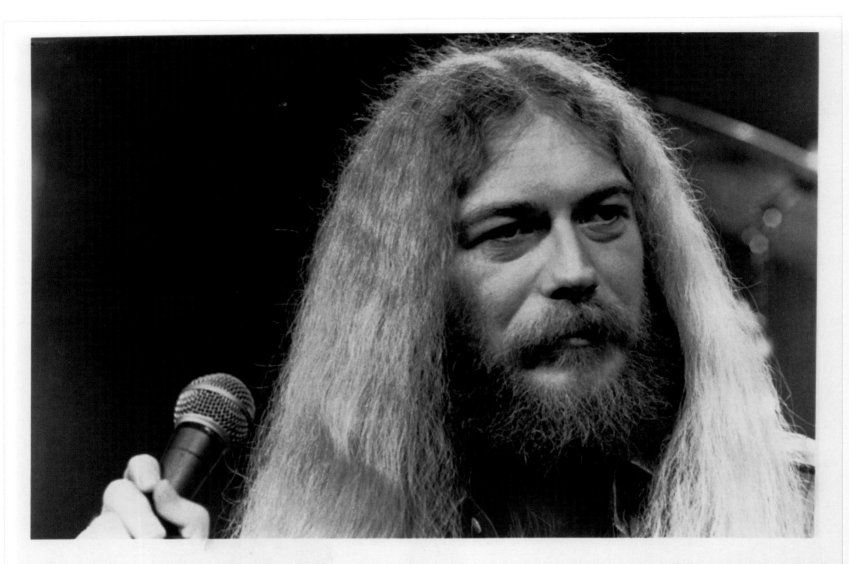

Paul Davis

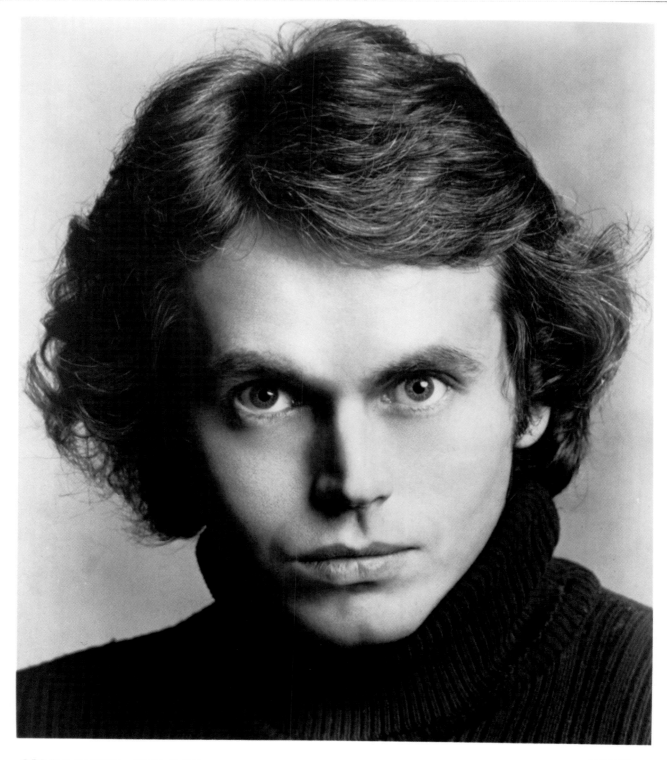

WALTER EGAN

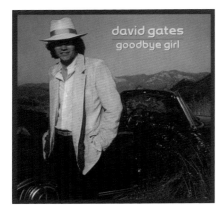

David Gates, known as the frontman and lead singer of Bread, released "Goodbye Girl," which served as the theme song to the movie of the same name.

Billboard 200: *Goodbye Girl* (#165)
Billboard Hot 100: "Goodbye Girl" (#15); "Took the Last Train" (#30)

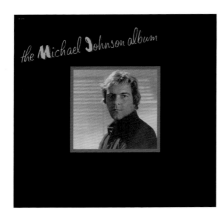

Singer-songwriter and guitarist Michael Johnson scored his first hit record with the soft rock single "Bluer Than Blue," a showcase for his mellifluous voice.

Billboard 200: *The Michael Johnson Album* (#81)
Billboard Hot 100: "Bluer Than Blue" (#12); "Almost Like Being in Love" (#32)

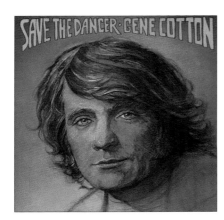

Several recordings into his career as a folk pop singer and songwriter, Gene Cotton achieved his biggest hit with the lilting "Before My Heart Finds Out."

Billboard Hot 100: "Before My Heart Finds Out" (#23); "You're A Part of Me" (#36); "Like a Sunday in Salem (The Amos & Andy Song)" (#40)

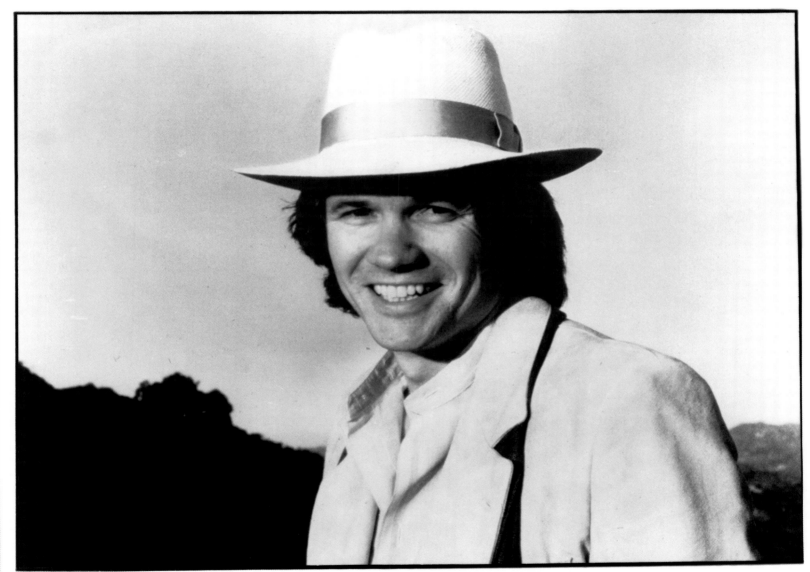

DAVID GATES

elektra

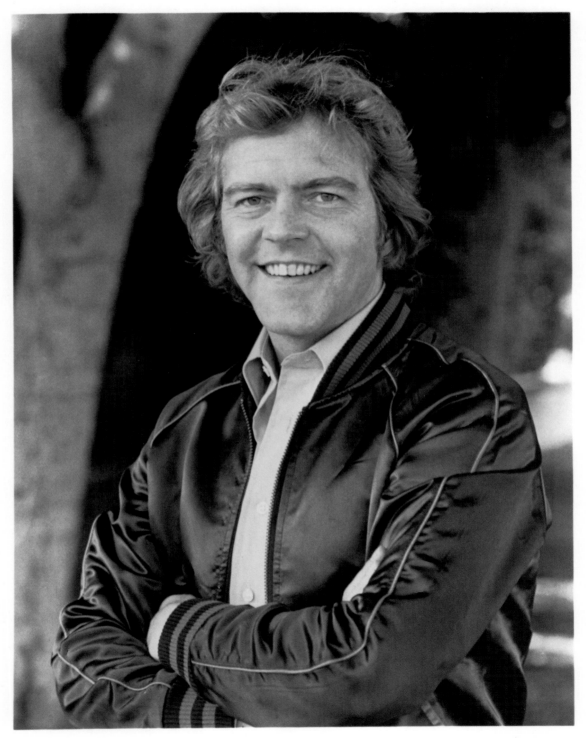

MICHAEL JOHNSON

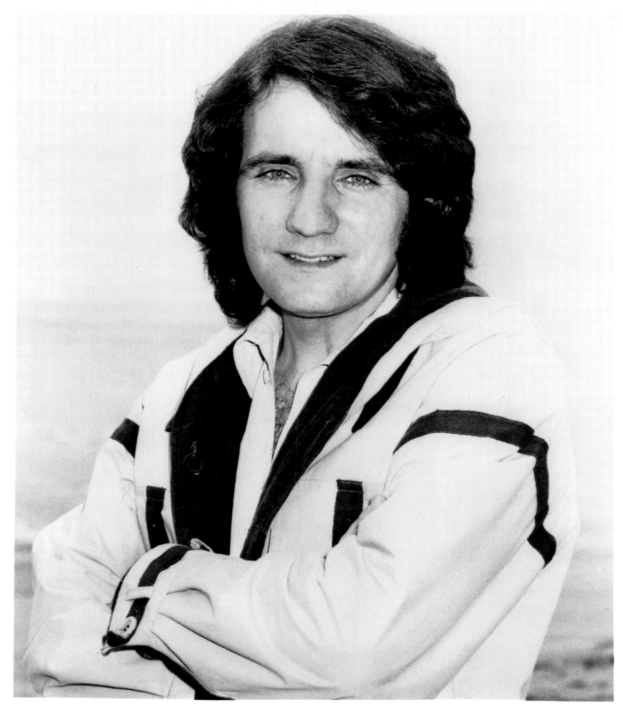

Personal Management:
New Direction
(213) 550-7205

GENE COTTON

ARIOLA
RECORDS
America

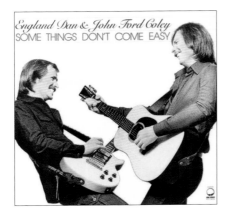

England Dan & John Ford Coley's rendition of the ballad "We'll Never Have to Say Goodbye Again" spent six weeks at No. 1 on the easy listening charts.

Billboard 200: *Some Things Don't Come Easy* (#61)
Billboard Hot 100: "We'll Never Have to Say Goodbye Again" (#9); "You Can't Dance" (#49)

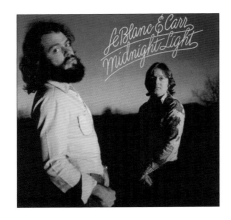

Musician and songwriter Lenny LeBlanc hooked up with producer and studio guitarist Pete Carr to form LeBlanc & Carr, creators of the Top 20 hit "Falling."

Billboard 200: *Midnight Light* (#145)
Billboard Hot 100: "Something About You" (#48); "Falling" (#13); "Midnight Light" (#91)

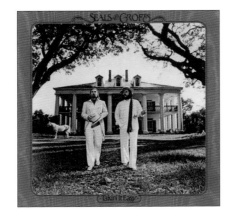

Known for "Summer Breeze," "Diamond Girl" and "Get Closer," the soft rock team of Seals & Crofts picked up their final hit record with "You're the Love."

Billboard 200: *Takin' It Easy* (#78)
Billboard Hot 100: "You're the Love" (#18); "Takin' It Easy" (#79)

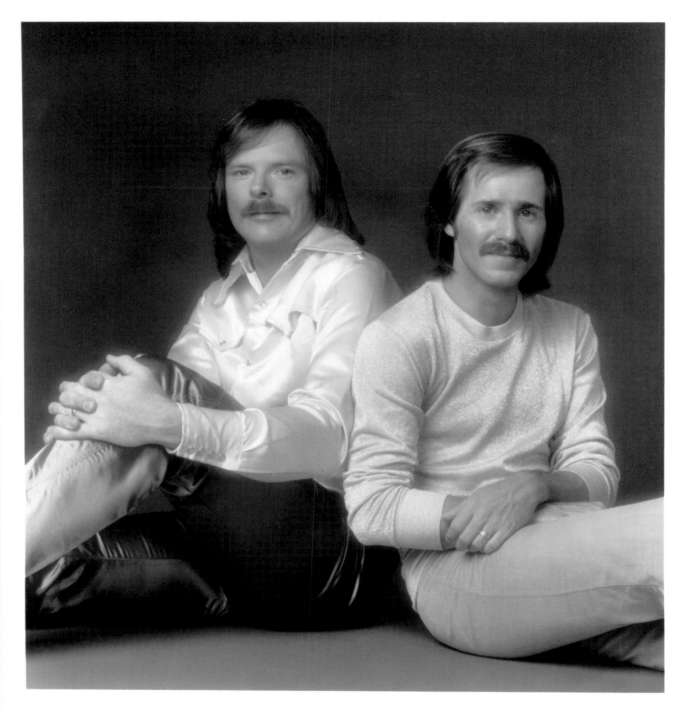

ENGLAND DAN & JOHN FORD COLEY

BIG TREE
RECORDS
Distributed by Atlantic Records

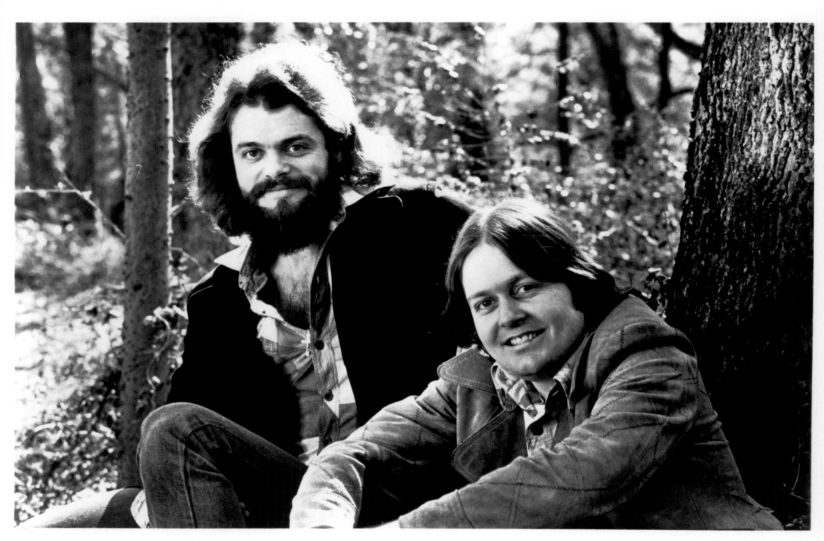

LENNY LeBLANC & PETE CARR

BIG TREE
RECORDS
Distributed by Atlantic Records

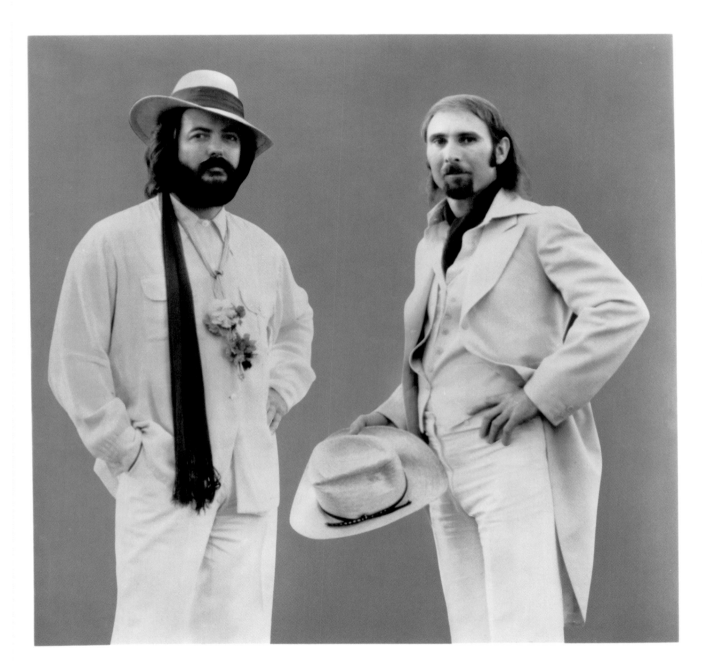

SEALS & CROFTS

WARNER / REPRISE

Singer **Natalie Cole** issued *Natalie Live!*, a double album capturing her concerts and a powerful rendering of the Beatles' "Lucy in the Sky with Diamonds."

Billboard 200: *Natalie Live!* (#31)

Rita Coolidge's greatest success on the charts came with *Anytime...Anywhere* and a cover of Jackie Wilson's "(Your Love Has Lifted Me) Higher and Higher."

Billboard 200: *Anytime...Anywhere* (#6)
Billboard Hot 100: "(Your Love Has Lifted Me) Higher and Higher" (#2); "We're All Alone" (#7); "The Way You Do the Things You Do" (#20)

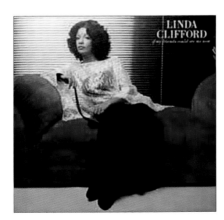

Singer **Linda Clifford** scored a hit in the dance clubs and on the disco charts with her version of the classic show tune "If My Friends Could See Me Now."

Billboard 200: *If My Friends Could See Me Now* (#22)
Billboard Hot 100: "Runaway Love" (#76); "If My Friends Could See Me Now" (#54)

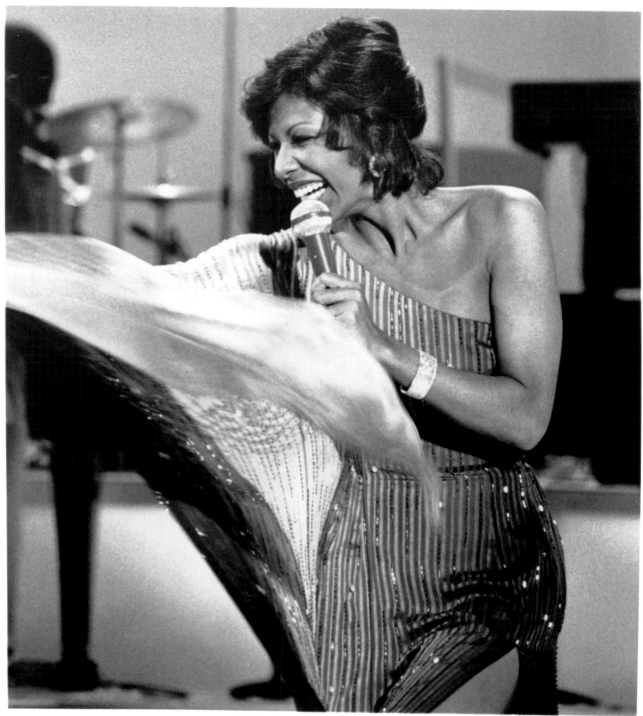

Natalie *Live!*

Photo by Tony Esparza

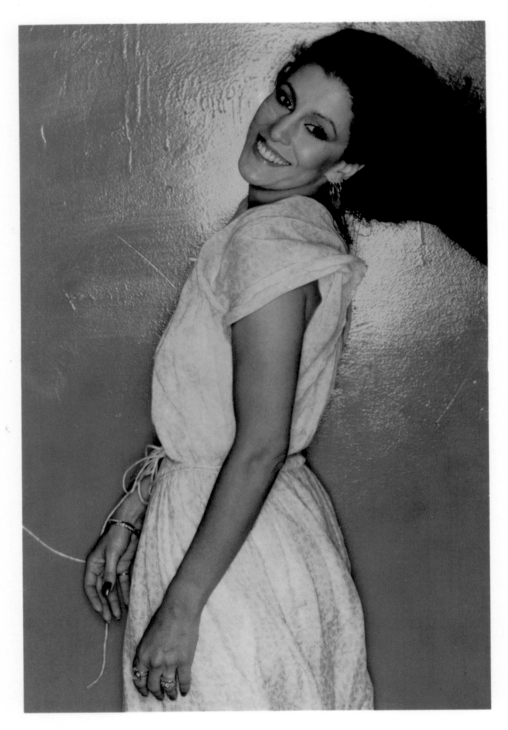

RITA COOLIDGE

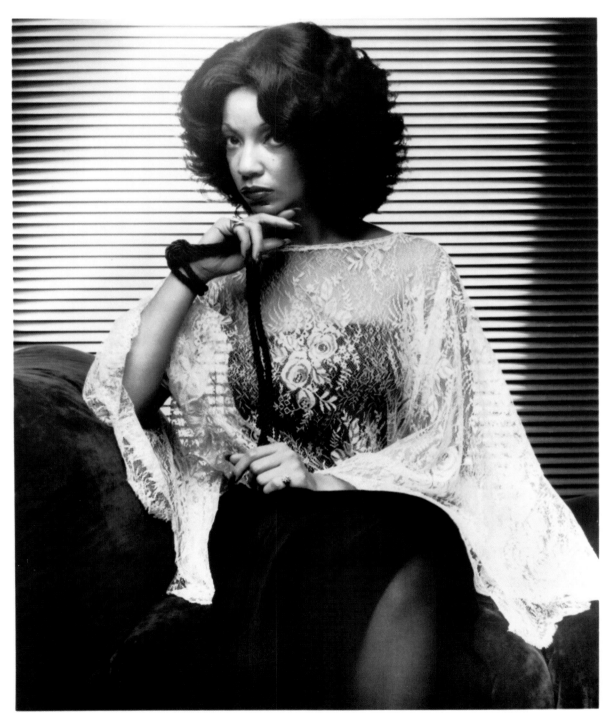

LINDA CLIFFORD

RECORDS

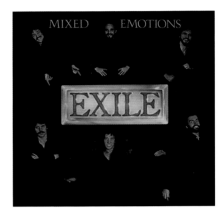

The group **Exile** catapulted to the peak of pop success with the mega-hit "Kiss You All Over," which held down the top spot on the charts for four weeks.

Billboard 200: *Mixed Emotions* (#14)
Billboard Hot 100: "Kiss You All Over" (No. 1);
"You Thrill Me" (#40)

Willie Nelson released *Stardust*, an album of pop standards that industry observers predicted would ruin his "outlaw" standing but instead went platinum.

Billboard 200: *Stardust* (#30)
Billboard Hot 100: "Georgia on My Mind" (#84)

At the pinnacle of his "outlaw country" success, **Waylon Jennings**' "I've Always Been Crazy" occupied the top spot on the country chart for three weeks.

Billboard 200: *I've Always Been Crazy* (#48)

EXILE

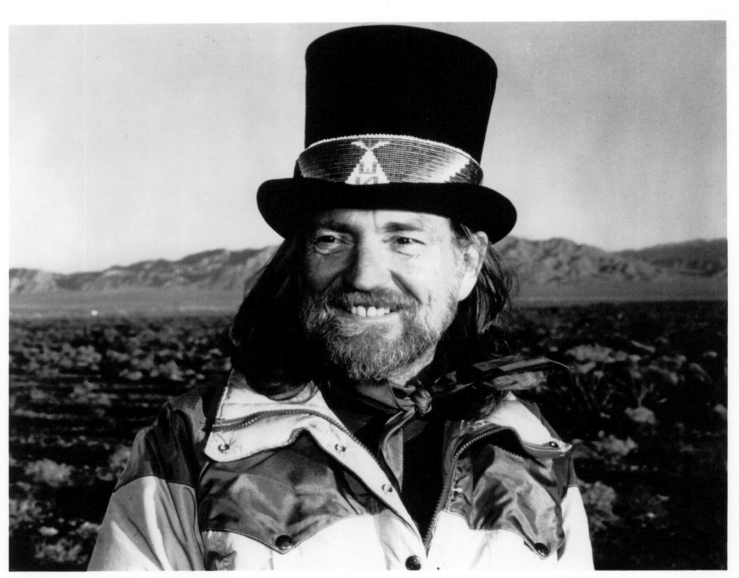

WILLIE NELSON

COLUMBIA

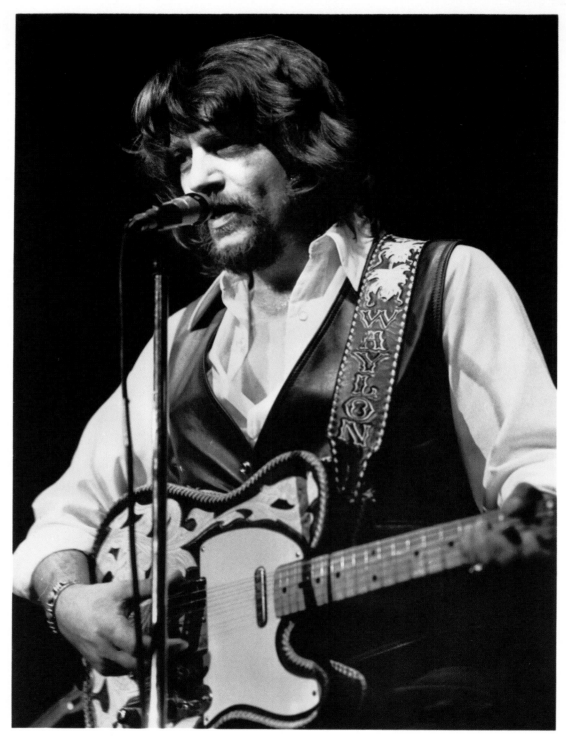

JENNINGS

Exclusively on RCA

RCA Records and Tapes

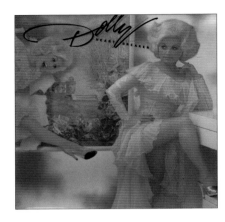

Heartbreaker heightened **Dolly Parton**'s visibility outside the confines of country music, as "Baby I'm Burning" became a surprise hit on the disco charts.

Billboard 200: *Heartbreaker* (#27)
Billboard Hot 100: "Heartbreaker" (#37);
"Baby I'm Burning" (#25)

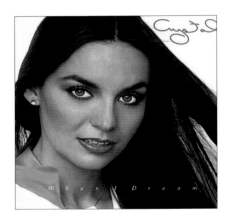

Following the crossover allure of "Don't It Make My Brown Eyes Blue," **Crystal Gayle** had another charting country and pop hit with "Talking in Your Sleep."

Billboard 200: *When I Dream* (#52)
Billboard Hot 100: "Talking in Your Sleep" (#18);
"When I Dream" (#84)

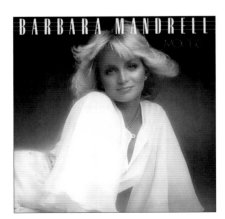

Barbara Mandrell's *Moods* spawned two country chart-toppers with "Sleeping Single in a Double Bed" and "(If Loving You Is Wrong) I Don't Want to Be Right."

Billboard 200: *Moods* (#132)
Billboard Hot 100: "(If Loving You Is Wrong) I Don't
Want to Be Right" (#31)

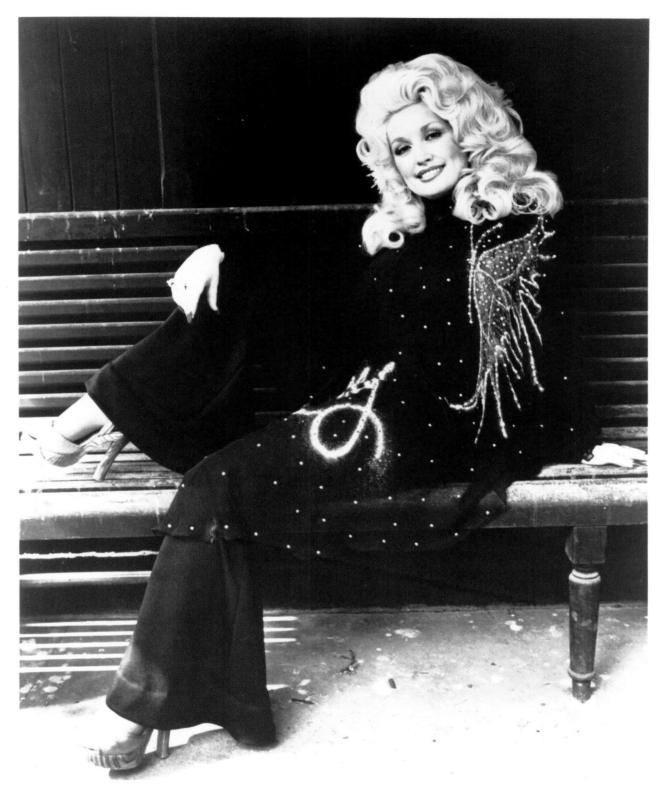

DOLLY PARTON
Exclusively on RCA

RC**A** Records and Tapes

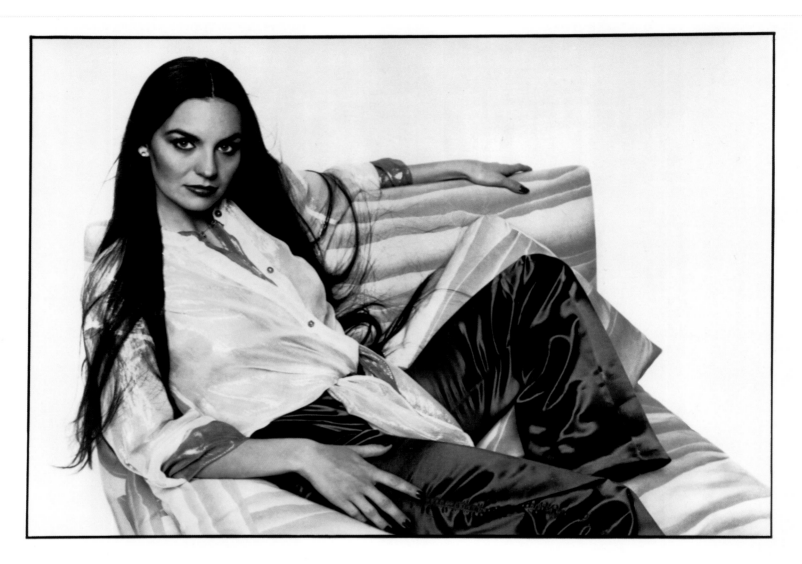

CRYSTAL GAYLE

THE SHEFRIN COMPANY
Public Relations

UNITED ARTISTS RECORDS

WILLIAM MORRIS
AGENCY, INC.

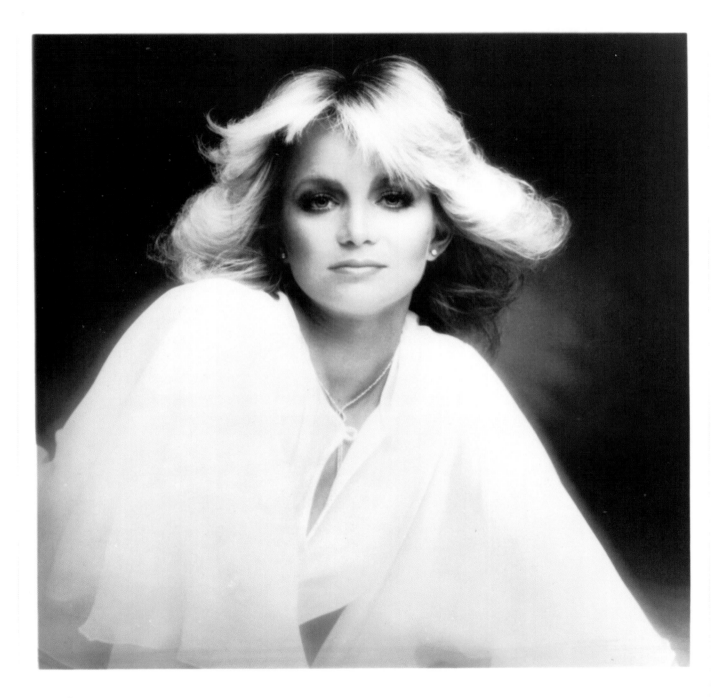

 BARBARA MANDRELL

Irby Mandrell
Personal Manager
P.O. Box 23110
Nashville, TN. 37202

615/244-7530

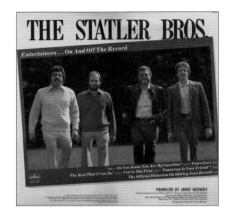

The Statler Brothers, who started out in 1964 as the backup voices for Johnny Cash, earned their first country No. 1 for "Do You Know You Are My Sunshine."

Billboard 200: *Entertainers...On and Off the Record* (#155)

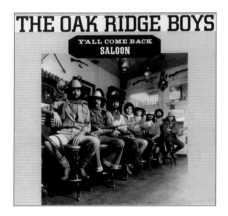

The Oak Ridge Boys fully converted from gospel with *Y'all Come Back Saloon,* and "I'll Be True to You" gave the vocal quartet its initial No. 1 country track.

Billboard 200: *Y'all Come Back Saloon* (#120)

A springboard to a recording career after success as a songwriter, **Eddie Rabbitt**'s album *Variations* included the country hit "You Don't Love Me Anymore."

Billboard 200: *Variations* (#143)
Billboard Hot 100: "You Don't Love Me Anymore" (#53)

THE STATLER BROTHERS

 THE OAK RIDGE BOYS

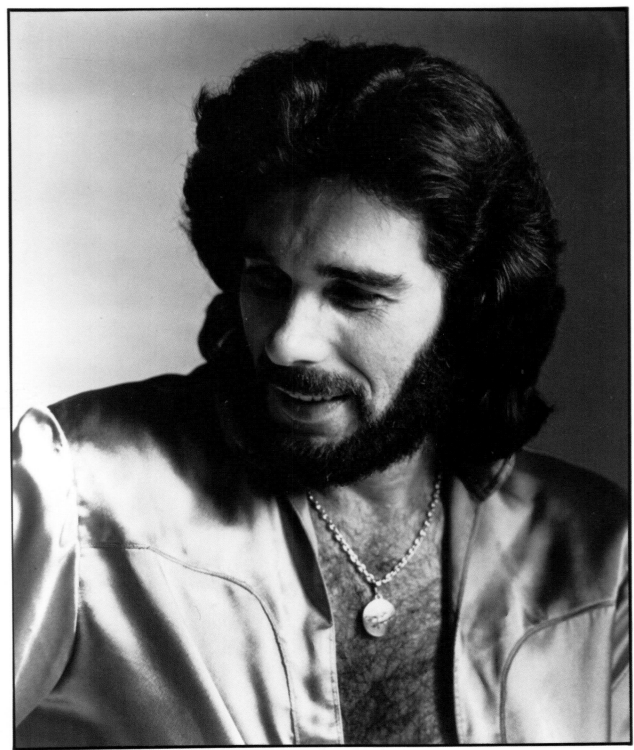

EDDIE RABBITT

elektra

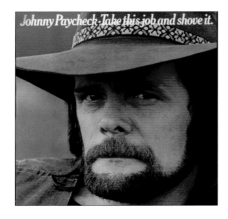

Inflating his outlaw country perspective, Johnny Paycheck recorded the blue-collar anthem "Take This Job and Shove It" for his only No. 1 country hit.

Billboard 200: *Take This Job and Shove It* (#72)

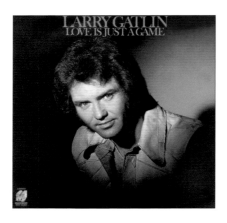

Country singer and writer Larry Gatlin continued his solo success, getting his first chart-topper under his belt with "I Just Wish You Were Someone I Love."

Billboard 200: *Love Is Just a Game* (#175)

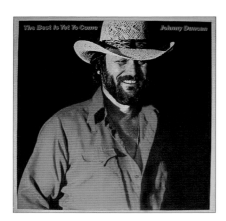

Aided by his smooth baritone, popular country singer Johnny Duncan continued his string of hits with "She Can Put Her Shoes Under My Bed (Anytime)."

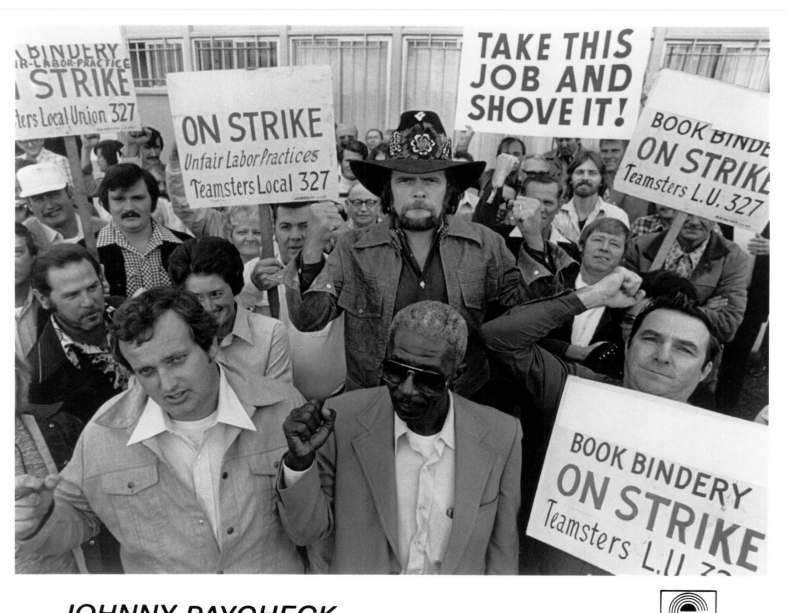

JOHNNY PAYCHECK

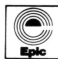
Epic

LARRY GATLIN

BOOKING AGENCY: REPRESENTED BY

apa
AGENCY FOR THE PERFORMING ARTS, INC.
120 WEST 57th STREET, NEW YORK, NEW YORK 10019

212/582-1500 213/273-0744

MONUMENT

Marketed by Phonogram, Inc.

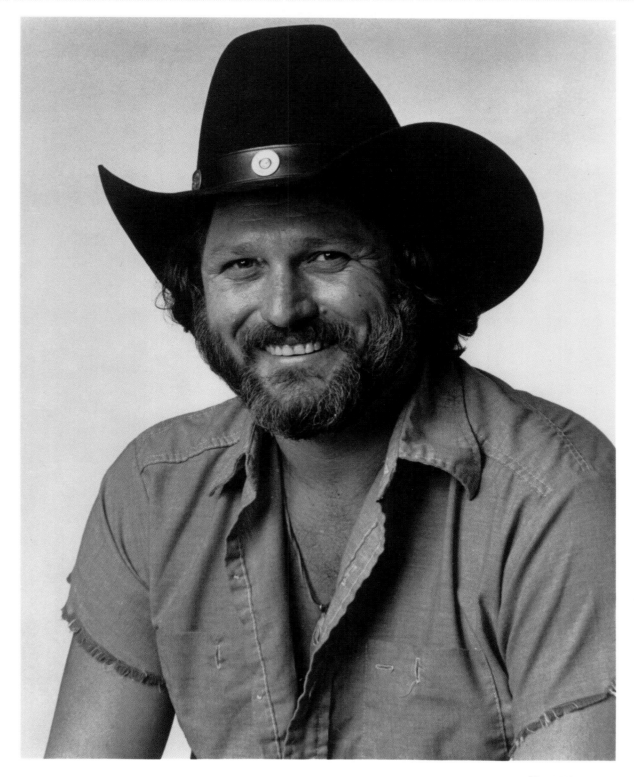

JOHNNY DUNCAN

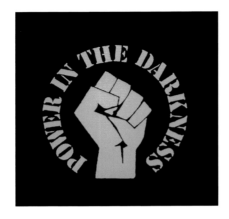

The Tom Robinson Band's blatantly political "Glad to be Gay," a confrontational and militant song, instantly became Britain's unofficial national gay anthem.

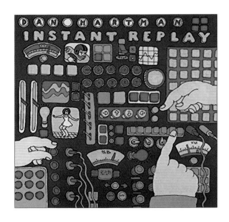

The versatile Dan Hartman, who got his start with the Edgar Winter Group, adapted to disco days by penning the No. 1 dance chart smash "Instant Replay."

Billboard 200: *Instant Replay* (#80)
Billboard Hot 100: "Instant Replay" (#29);
"This Is It" (#91)

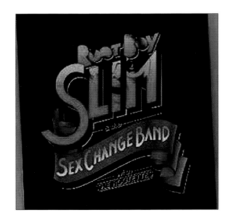

Offering a gleefully repulsive outlook on life, Root Boy Slim and his Sex Change Band opened their album with the landmark party tune "Boogie 'Til You Puke."

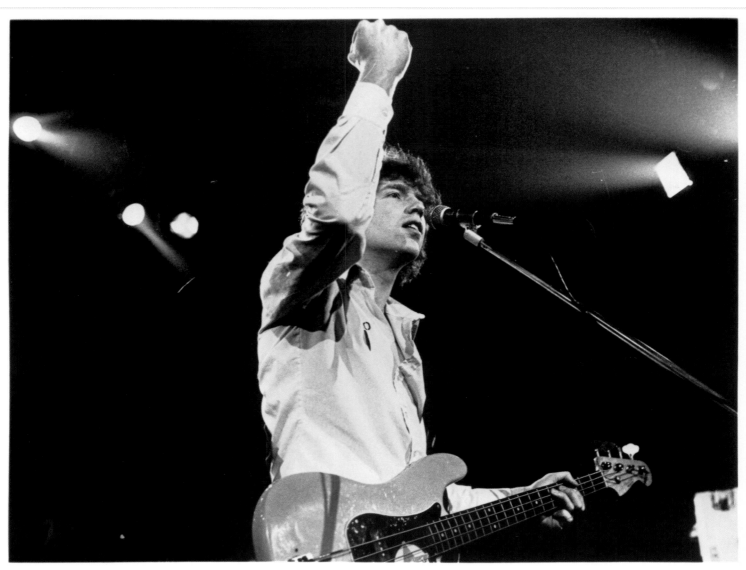

TOM ROBINSON

HARVEST
REG. TRADE MARK OF
EMI RECORDS LTD.

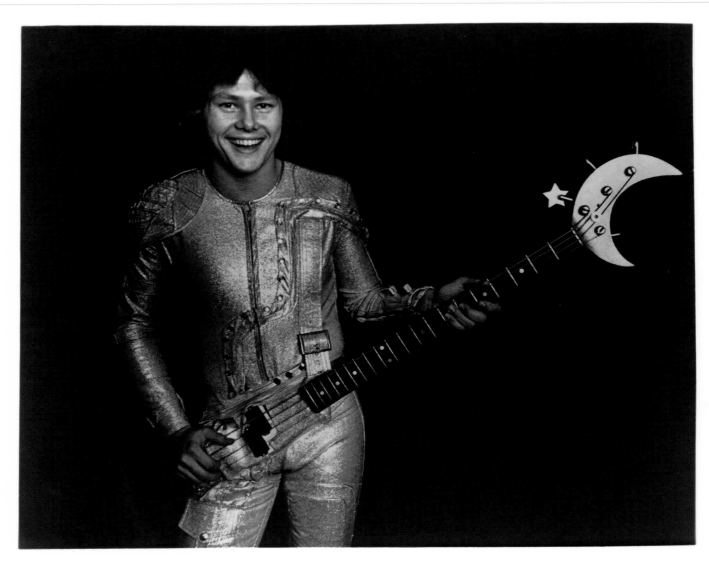

 DAN HARTMAN

photo/Jim Houghton

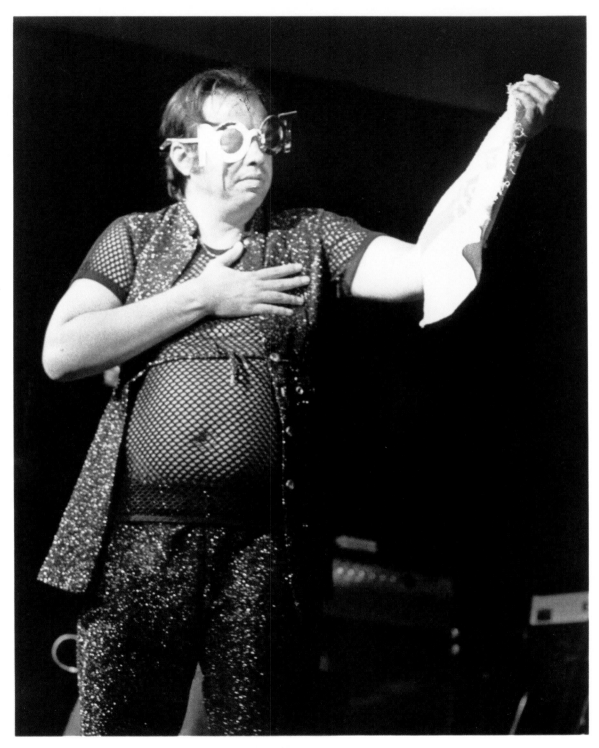

Alas, poor ROOT BOY SLIM
we know him well.

Photo: P DYKSTRA

WARNER/REPRISE

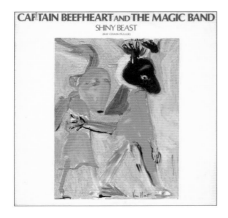

A true trailblazer in modern music, Captain Beefheart reemerged and gained critical approbation with the eccentricities of *Shiny Beast (Bat Chain Puller)*.

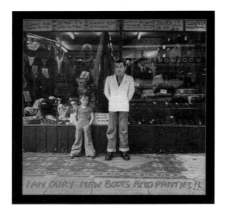

Ian Dury mixed a bizarre fusion of punk and disco with his love of music hall on "Sex & Drugs & Rock & Roll," pushing him to stardom in his native England.

Billboard 200: *New Boots and Panties!!* (#168)

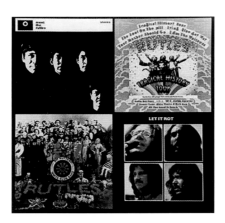

The Rutles, a fictional British rock band devised by Neil Innes (Bonzo Dog Band) and Eric Idle (Monty Python), lampooned highlights of the Beatles' career.

Billboard 200: *The Rutles* (#63)

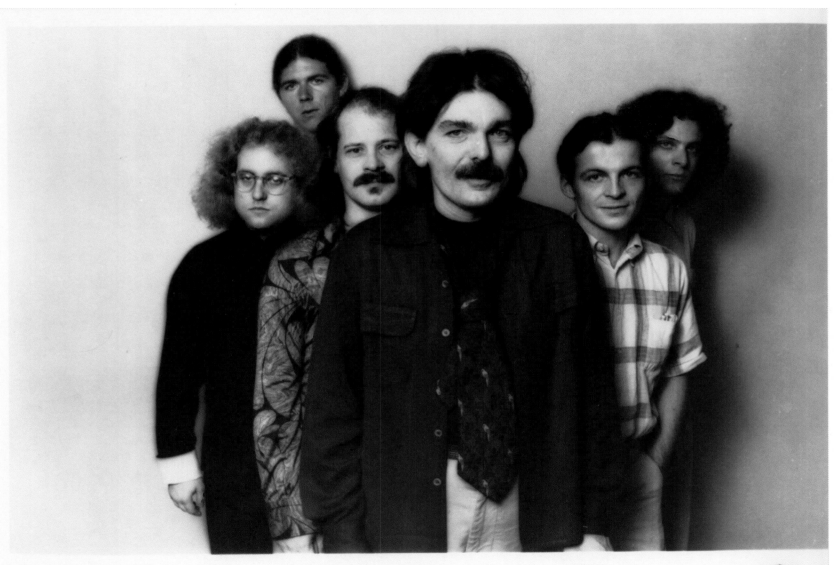

CAPTAIN BEEFHEART

AND THE MAGIC BAND

WARNER / REPRISE

IAN DURY

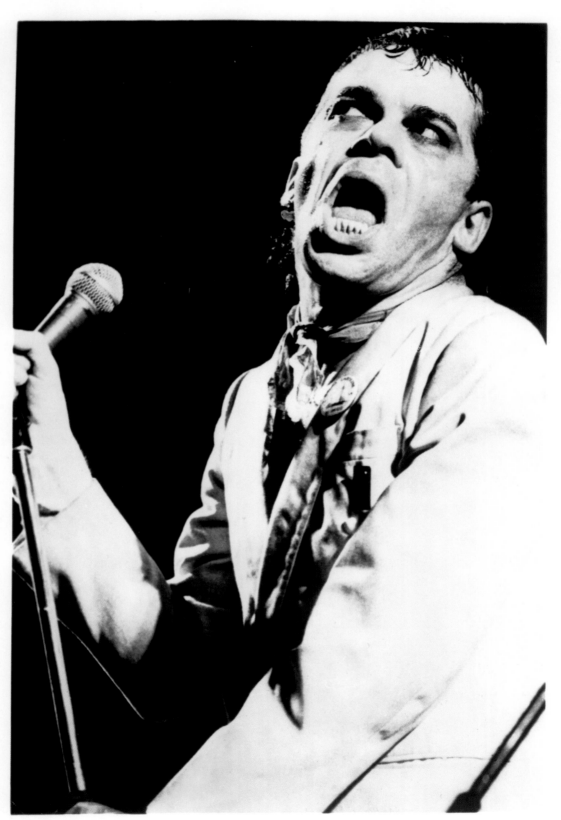

Distributed
by Arista
Records, Inc.

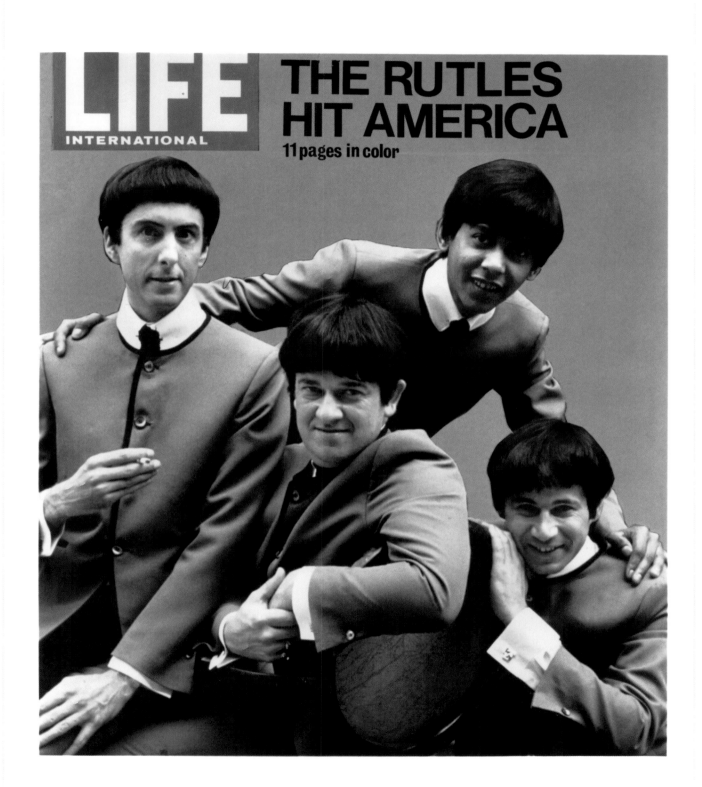

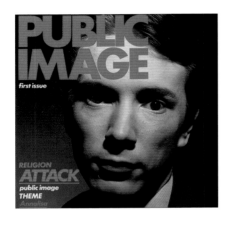

Following the Sex Pistols' failing, singer John Lydon (a.k.a. Johnny Rotten) sought a more radical "anti-rock" undertaking, organizing Public Image Ltd.

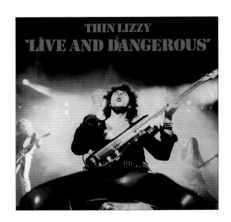

Hard rock act Thin Lizzy issued the superb double album *Live and Dangerous*, but guitarist Brian Robertson's departure dimmed the accomplishment.

Billboard 200: *Live and Dangerous* (#84)

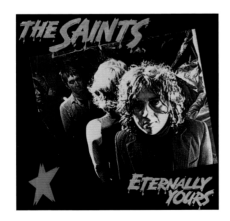

The Saints, an influential Australian punk band, gave a boost to their second album, *Eternally Yours*, by intermingling a brass section and R&B accents.

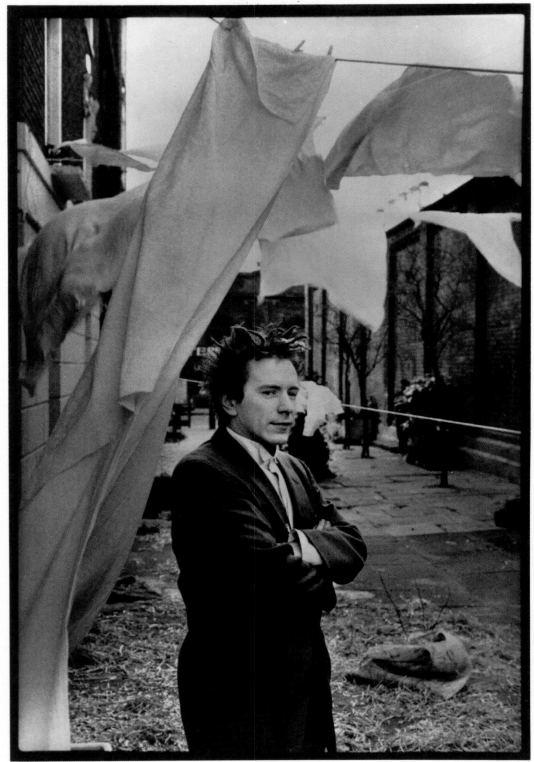

PHOTO OF ARTIST

Virgin RECORDS

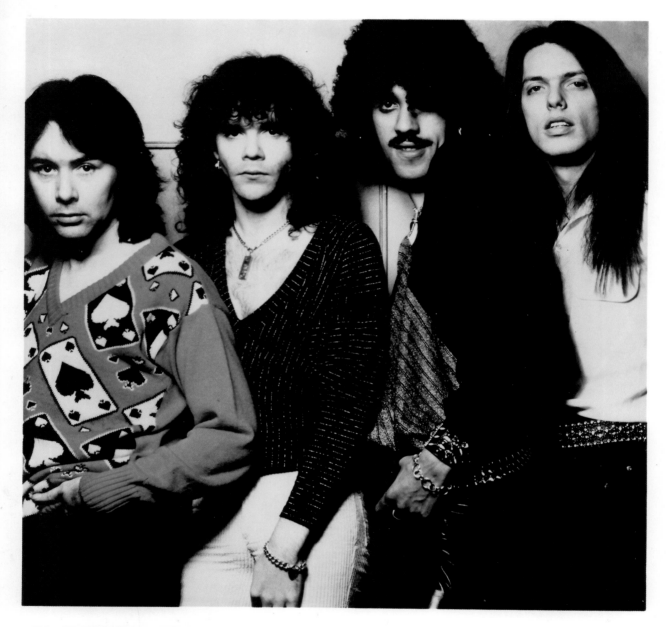

THIN LIZZY

BRIAN DOWNEY, BRIAN ROBERTSON, PHILIP LYNOTT, SCOTT GORHAM

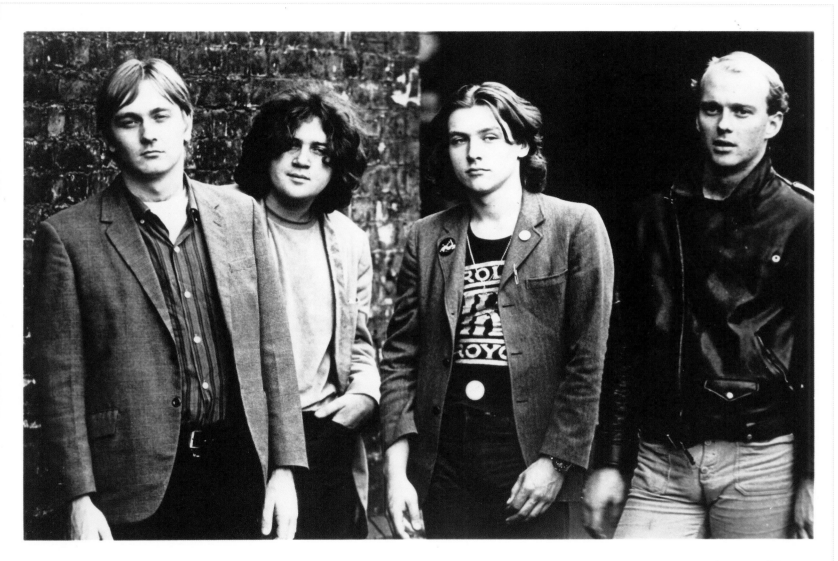

THE SAINTS

SIRE RECORDS

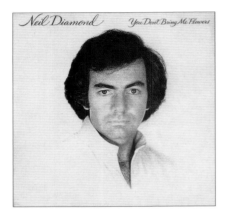

A year after "You Don't Bring Me Flowers" appeared as a Neil Diamond track, the singer-songwriter re-recorded the song as a duet with Barbra Streisand.

Billboard 100: *You Don't Bring Me Flowers* (#4)
Billboard Hot 100: "You Don't Bring Me Flowers" (No. 1);
"Forever in Blue Jeans" (#20); "Say Maybe" (#55)

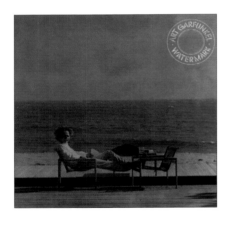

Art Garfunkel's version of Sam Cooke's "(What a) Wonderful World," a No. 1 easy listening hit, featured harmonies from Paul Simon and James Taylor.

Billboard 200: *Watermark* (#19)
Billboard Hot 100: "(What a) Wonderful World" (#17)

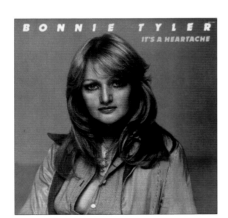

Known for her distinctive raspy vocals, Welsh singer Bonnie Tyler gained increasing prominence around the world with the passionate "It's a Heartache."

Billboard 200: *It's a Heartache* (#16)
Billboard Hot 100: "It's a Heartache" (#3)

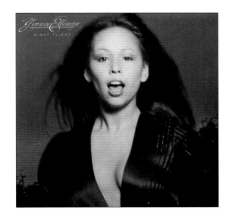

The Bee Gees wrote "If I Can't Have You" for Yvonne Elliman, the fourth No. 1 hit from *Saturday Night Fever* and the highlight of her album *Night Flight.*

Billboard 200: *Night Flight* (#40)
Billboard Hot 100: "If I Can't Have You" (No. 1)

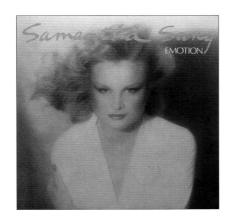

Australian singer Samantha Sang recorded "Emotion," a large-scale hit worldwide that was penned by brothers Barry and Robin Gibb of the Bee Gees.

Billboard 200: *Emotion* (#29)
Billboard Hot 100: "Emotion" (#3);
"You Keep Me Dancing" (#56)

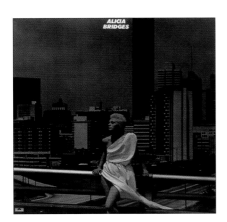

The success of Alicia Bridges' international hit "I Love the Nightlife (Disco 'Round)" drove sales of her debut album and earned her a Grammy nomination.

Billboard 200: *Alicia Bridges* (#33)
Billboard Hot 100: "I Love the Nightlife (Disco 'Round)" (#5)

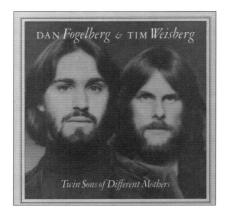

Dan Fogelberg & Tim Weisberg collaborated for the hit single "The Power of Gold,"
an ambitious alliance between the singer-songwriter and the jazz flutist.

Billboard 200: *Twin Sons of Different Mothers* (#8)
Billboard Hot 100: "The Power of Gold" (#24)

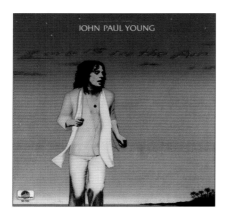

John Paul Young scored an international smash with "Love Is in the Air," a disco song
birthed by the famed production duo of George Young & Harry Vanda.

Billboard 200: *Love Is in the Air* (#119)
Billboard Hot 100: "Love Is in the Air" (#7); "Lost in
Your Love" (#55)

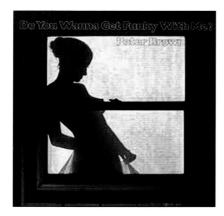

A Fantasy Love Affair, **Peter Brown**'s debut album, produced the pop and disco hit
"Dance with Me" and earned the singer-songwriter a Grammy nomination.

Billboard 200: *A Fantasy Love Affair* (#11)
Billboard Hot 100: "Do You Wanna Get Funky with Me"
(#18); "Dance with Me" (#8)

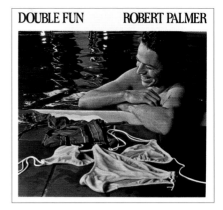

Robert Palmer scored with the album *Double Fun* and the Caribbean-flavored "Every Kinda People," the suave British singer's first Top 20 single in the US.

Billboard 200: *Double Fun* (#45)
Billboard Hot 100: "Every Kinda People" (#16)

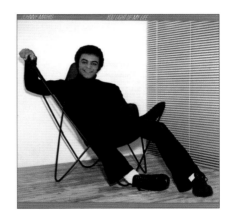

The hit single "Too Much, Too Little, Too Late" by Johnny Mathis with singer Deniece Williams made it to No. 1 on the pop, R&B and easy listening charts.

Billboard 200: *You Light Up My Life* (#9)
Billboard Hot 100: "Too Much, Too Little, Too Late" (No.1)

Popular singer and pianist Ronnie Milsap produced the No. 1 country hits "Only One Love in My Life" and "Let's Take the Long Way Around the World."

Billboard 200: *Only One Love in My Life* (#109)
Billboard Hot 100: "Only One Love in My Life" (#63)

Joe Ely's second album, *Honky Tonk Masquerade*, helped define the Texas progressive country scene and set up a future tour with the London-based Clash.

One of the finest songwriters of his generation, Texan troubadour Townes Van Zandt released *Flyin' Shoes*, another strong collection of country folk songs.

The popularity of the Texas quintet Toby Beau unexpectedly skyrocketed when the pop ballad "My Angel Baby" went to No. 1 on the easy listening chart.

Billboard 200: *Toby Beau* (#40)
Billboard Hot 100: "My Angel Baby" (#13)

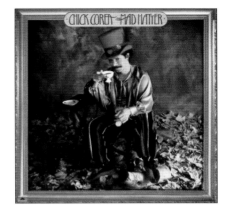

The Mad Hatter, inspired by Lewis Carroll's novel *Alice in Wonderland*, was one of three studio albums released in 1978 by jazz keyboardist Chick Corea.

Billboard 200: *The Mad Hatter* (#61)

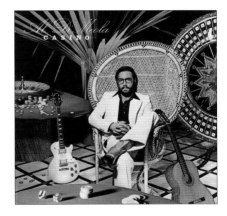

On *Casino*, guitarist Al Di Meola continued to explore Latin grooves and rhythms, displaying his touch on the acoustic "Fantasia Suite for Two Guitars."

Billboard 200: *Casino* (#52)

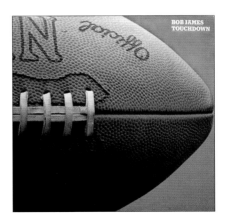

A commercial breakout for smooth jazz progenitor Bob James, the *Touchdown* album included "Angela," the melancholy theme for the television sitcom *Taxi*.

Billboard 200: *Touchdown* (#37)

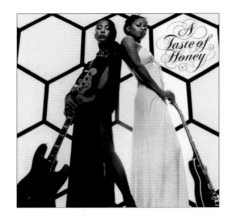

"Boogie Oogie Oogie," A Taste of Honey's distinctive chart-topper, sold two million copies, and the disco group won the Grammy Award for Best New Artist.

Billboard 200: *A Taste of Honey* (#6)
Billboard Hot 100: "Boogie Oogie Oogie" (No. 1)

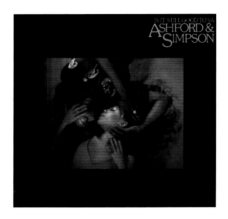

After years of acting as a husband-and-wife songwriting-production team for other R&B hitmakers, Ashford & Simpson stepped out as a recording duo.

Billboard 200: *Is It Still Good to Ya* (#20)

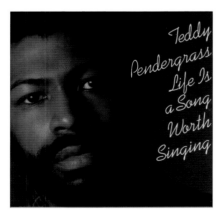

Life Is a Song Worth Singing, rising singer Teddy Pendergrass' second consecutive platinum album, featured the erotic No. 1 R&B single "Close the Door."

Billboard 200: *Life Is a Song Worth Singing* (#11)
Billboard Hot 100: "Close the Door" (#25)

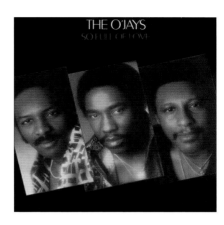

The O'Jays, already having placed numerous songs on both the pop and R&B charts, celebrated one of their biggest hits, the enduring "Use Ta Be My Girl."

Billboard 200: *So Full of Love* (#6)
Billboard Hot 100: "Use Ta Be My Girl" (#4); "Brandy" (#79)

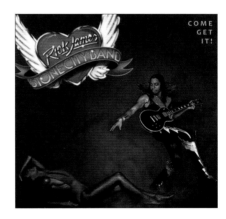

Rick James released *Come Get It!*, his debut solo album with the Stone City Band, generating the hit "You and I" and the "punk funk" style of "Mary Jane."

Billboard 200: *Come Get It!* (#13)
Billboard Hot 100: "You and I" (#13); "Mary Jane" (**#41**)

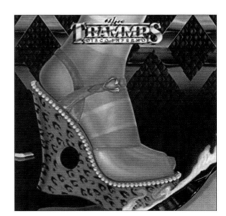

The Trammps' "Disco Inferno," recorded in 1976, had limited success until it was heard on the *Saturday Night Fever* soundtrack and became a giant hit.

Billboard 200: *Disco Inferno* (#48)
Billboard Hot 100: "Disco Inferno" (#11)

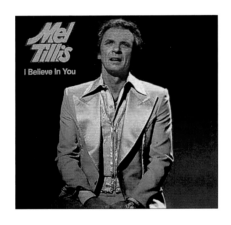

One of the few African-Americans to become a top Nashville artist, Charley Pride racked up his 20th country No. 1 song with "Someone Loves You Honey."

An endearing personality known for his cracker-barrel wit and ingratiating stutter, Mel Tillis earned his fourth No. 1 country single with "I Believe in You."

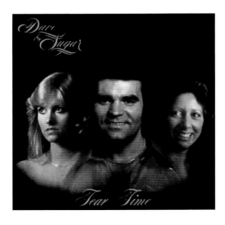

Dave & Sugar, a country music trio fronted by the charming Dave Rowland, shot up the charts with a rendition of Wilma Burgess' 1967 hit "Tear Time."

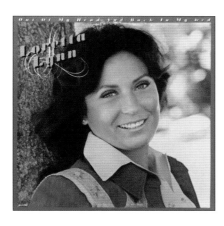

A pioneering performer in the male-dominated world of country music, Loretta Lynn recorded her twelfth No. 1 hit, "Out of My Head and Back in My Bed."

Country vocalist Margo Smith's rendition of "It Only Hurts for a Little While," first recorded by the Ames Brothers in 1956, was her second chart-topper.

The Kendalls' "Sweet Desire," the father-daughter team's "cheating" song, outraged country music's moralists but emerged as the duo's second No. 1 hit.

From Vallejo, California, Con Funk Shun developed a string of funky cuts and slow jams on the soul singles chart, culminating with the No. 1 "Ffun."

Billboard 200: *Secrets* (#51)
Billboard Hot 100: "Ffun" (#23)

The ballad "It's You That I Need," Detroit vocal group Enchantment's most notable song, topped the R&B charts and crossed over to the pop rankings.

Billboard 200: *Once Upon a Dream* (#46)
Billboard Hot 100: "It's You That I Need" (#33)

The Spanish-flavored disco group Santa Esmerelda, the creation of French producers, scored a hit with a dance remake of "The House of the Rising Sun."

Billboard 200: *The House of the Rising Sun* (#41)
Billboard Hot 100: "The House of the Rising Sun" (#78)

Foxy, a Miami-based Latino disco group, burned up dance floors across the US with "Get Off," written by frontman Ish Ledesma and bandmate Carlo Driggs.

Billboard 200: *Get Off* (#12)
Billboard Hot 100: "Get Off" (#9)

Highlighted by the lead vocals of Precious Wilson, Eruption's disco-oriented remake of Ann Peebles' "I Can't Stand the Rain" turned into a worldwide hit.

Billboard 200: *Eruption* (#133)
Billboard Hot 100: "I Can't Stand the Rain" (#18)

Three-piece female vocal group Stargard provided the theme song from the Richard Pryor comedy *Which Way Is Up*, which reached No. 1 on the R&B chart.

Billboard 200: *Stargard* (#26)
Billboard Hot 100: "Theme Song from *Which Way Is Up*" (#21); "Disco Rufus" (#88)

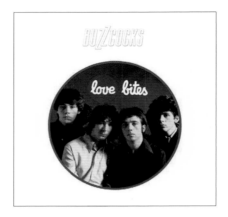

With Pete Shelley taking on vocal and songwriting duties, the English punk band **Buzzcocks** highlighted the song "Ever Fallen in Love" on *Love Bites*.

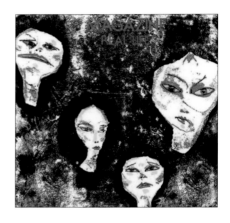

Formed by Howard Devoto after leaving Buzzcocks, **Magazine** made the UK charts with *Real Life* and the arty pop-punk single "Shot by Both Sides."

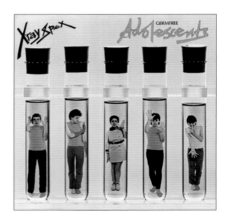

British punk act **X-Ray Spex**'s *Germfree Adolescents* earned critical acclaim for its saxophone wailing and intense vocals from songwriter Poly Styrene.

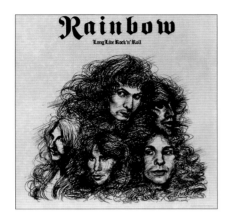

Featuring guitarist Ritchie Blackmore, singer Ronnie James Dio and drummer Cozy Powell, hard rock act Rainbow returned with *Long Live Rock 'n' Roll*.

Billboard 200: *Long Live Rock 'n' Roll* (#89)

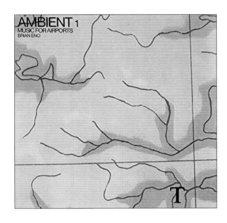

Brian Eno perfected his "ambient music" concept with the unobtrusive *Ambient 1: Music for Airports*, layered tape loops designed to calm air passengers.

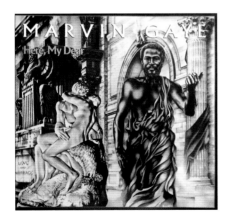

Galvanized by his rancorous divorce from his first wife, Anna Gordy, Marvin Gaye recorded the brooding *Here, My Dear*, a devastating, candid soul opera.

Billboard 200: *Here, My Dear* (#26)

{ IN MEMORY OF **LILA M. BROWN** }

ACKNOWLEDGMENTS

Many people were essential to the creation of this book. My first thanks go to my amazing publishing team—Jon Rizzi for bringing his special brand of editorial wit and intelligence, and Kate Glassner Brainerd for her design artistry and unflagging pursuit of excellence. Special appreciation goes to the Boedecker Foundation and the Michael & Patricia Matthews Fund, whose facilitation was indispensable.

Chip Garofalo, Mark Zaremba, Jay Elowsky, Dave Zobl, Jennifer Soulé, Matt Rue, Sandra Jonas, Mark Lewis and Mike Dickson contributed expertise and resources. I am especially indebted to my dear friend Michael Jensen, as well as Sue Satriano, Janice Azrak, Bryn Bridenthal, Byron Hontas, Kathy Acquaviva, Shelly Selover, Sue Sawyer, Glen Brunman, Rick Ambrose, Bob Merlis, Bill Bentley, Heidi Ellen Robinson, Les Schwartz, Rick Gershon, Judi Kerr and Susan Blond—all of whom supported my efforts.

I specifically treasure the beneficence of Dave Rothstein, Greg Pfifer, John Tope, Kevin Knee, Dick Merkle, Jeff Cook, Michael Brannen, Zak Phillips, Rich Garcia, Jason Minkler, Burt Baumgartner, Mitch Kampf, Don Zucker, Carl Walters, Charlie Reardon, Robin Wren, Jimmy Smith, Sharona White, John Ryland, Geina Horton, Michael Linehan, Mike Prince and Jeffrey Naumann, who all graciously furnished information and assistance.

I also salute Leland Rucker, Steve Knopper, David Menconi, Mark Brown, Gil Asakawa, Mark Bliesener and Justin Mitchell, whose writings formed a vital index for the music-obsessed.

Finally, I would like to acknowledge with gratitude my beloved wife, Bridget, for her constant devotion and kindness. I cherish her—the love of my life.

BIBLIOGRAPHY

⬥ Bright, Spencer. 1988. *Peter Gabriel: An Authorized Biography.* Pan, London.
⬥ Clapton, Eric. 2007. *Clapton: The Autobiography.* Three Rivers Press. New York.
⬥ Martin, Steve. 2007. *Born Standing Up.* Scribner. New York.

EDITOR | **JON RIZZI**
ART DIRECTOR | **KATE GLASSNER BRAINERD**

ISBN 978-0-9915668-3-9 PRINTED IN CHINA | Asia Pacific Offset

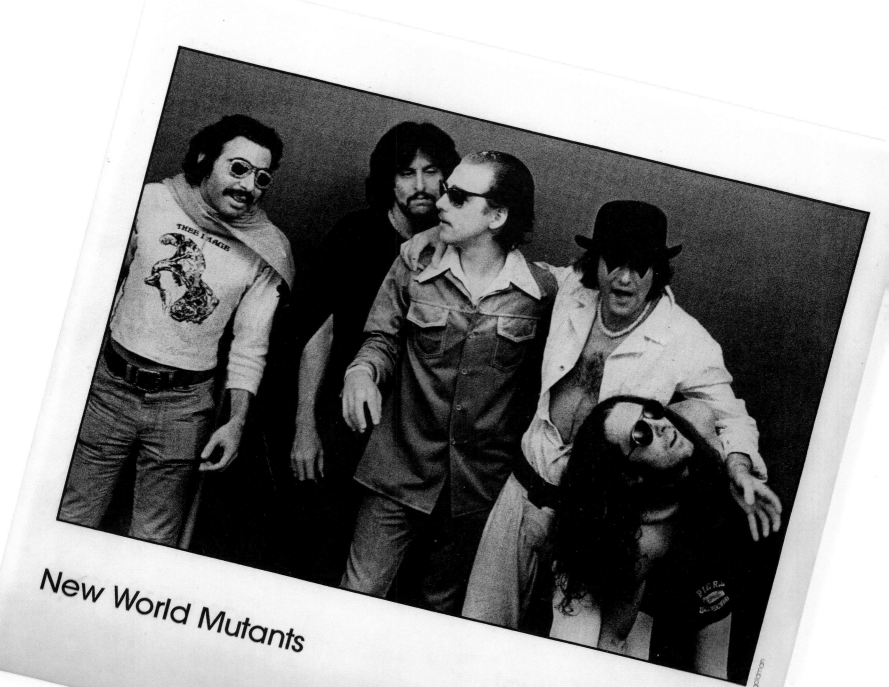

New World Mutants

Laetrile Records
"It's The Pits"

Next in the *ON RECORD* book series

Vol.2 1984

ON RECORD 1984

IMAGES, INTERVIEWS & INSIGHTS FROM THE YEAR IN MUSIC > G. BROWN